THE AMERICAN ART TAPES

For my sister, Rachel Clark,
and in memory of our exceptional parents
John Jones (1926–2010) and Gaby Jones (1934–2020)

THE AMERICAN ART TAPES

JOHN JONES AND
NICOLETTE JONES

★ ★ ★ ★ ★

VOICES OF ★ ★ ★ ★ ★ TWENTIETH-CENTURY ART

Introduction 7

Interviews

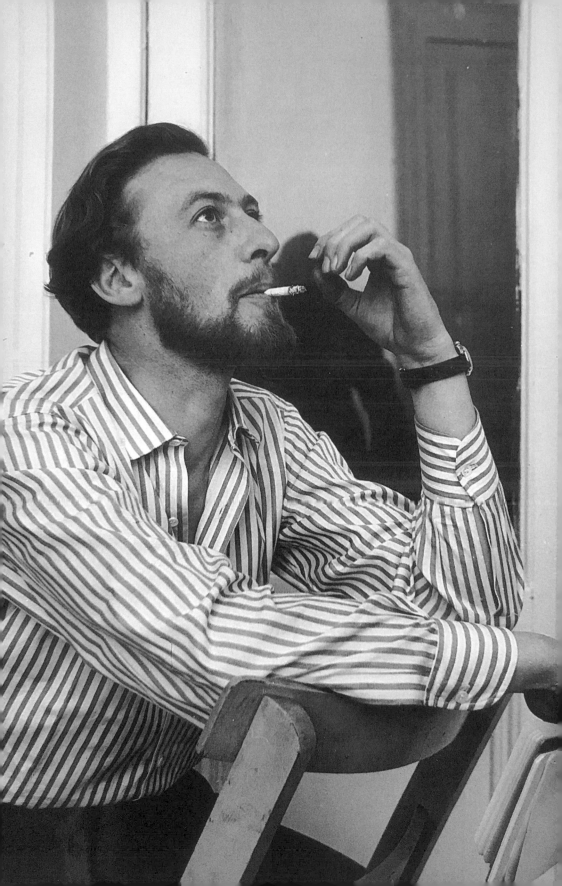

INTRODUCTION

In September 1965, when I was five years old, I stood on the dock in Southampton, on the south coast of England, and looked up at the towering sweep of the side of the Queen Mary, the giant Cunard liner that was to carry us to New York. I can see it now. My father, John Jones (pictured opposite), was taking his family to the US for a year, on an American Council of Learned Societies grant, with a plan to interview as many artists as he could and explore what was going on in American art at the time. During that year he spoke to more than 100 artists, and his recorded interviews were the basis of his lectures for decades afterwards. They present a cross-section of practice in that moment: sculpture, painting, 'assemblages', prints, drawings and happenings, in genres including conceptual art, abstract expressionism, surrealism, figurative painting and pop art. Most of these labels were at least partially rejected by the interviewees when asked about them.

During the crossing, a fellow passenger recommended a German Uher tape recorder as the best reel-to-reel model (the 1965 word-of-mouth equivalent of five stars online), so my father ordered one from Germany and awaited its arrival in New York. Despite the recommendation, there were sometimes technical hitches, and often background noise. As Jones remarked later in a lecture: 'I have probably the best collection of dogs barking and New York Police sirens in the world.'

My father, then aged thirty-nine, was a practising artist himself, Gloucestershire-born and trained from the age of sixteen at the Royal West of England Academy in Bristol (he studied there twice, in fact, because his learning was interrupted by military service in 1945–8, and afterwards he took the whole course again).

He went on to the Slade School of Art in London, from which he graduated in 1954, having distinguished himself as a draughtsman and won the History of Art prize. He trained art teachers at the James Graham College in Leeds (and was promoted to Head of Department in two

years) and from 1963 was a lecturer, also running the studios, in the Fine Art Department at the University of Leeds, under the professorship of Quentin Bell (nephew of Virginia Woolf), who became his close friend. 'Oh how I long for your return,' wrote Quentin from Leeds during my father's year away, 'even though I shall have to lay in an extra store of match boxes.' My father was a chain-smoker, then, who rolled his own cigarettes out of loose Old Holborn tobacco and red Rizla papers. He was not alone: a characteristic of the tapes is that everyone (except austere Ad Reinhardt and purist Yoko Ono) is evidently smoking. Marcel Duchamp, for one, had strong opinions about Cuban tobacco.

Although his art training was traditional (including anatomy and life-drawing), my father had explored a range of techniques and styles in his own work and was open to everything, including all kinds of experimental art and cinema. At Leeds University he had established and begun to run a film course, which embraced both the history of film and the practice of filmmaking. Besides his talents as artist, lecturer, teacher and filmmaker, he could juggle – a skill acquired, along with magic tricks, for performing in village halls as a boy. This came in handy for a December 1965 happening with Claes Oldenburg.

My mother Gabriela ('Gaby'), then aged thirty, had grown up in Argentina, of German Jewish heritage, and spoke five languages. She had studied at the Central School of Art and Design in London, while living in the house of her uncle, art historian Rudolf Wittkower. She was also a beauty with a wide smile and a charming Latin accent. She met charismatic art student John, bearded and broke, at one of her uncle's lectures. After Gaby graduated with distinction, John accompanied her home to Buenos Aires, where they lived for three years, and where John taught, lectured, painted and made jewellery and textiles. They married, and their first child, my sister Rachel, was born before their return to England in 1959. Rachel was seven when the American adventure began.

My memories of the White Star Line week at sea include a fancy-dress contest (Rachel with a burnt-cork moustache dressed as a gaucho), a deep pool on deck with a ladder down to the rolling water (I couldn't swim), the spectacle of gymnasium machines with belts that were supposed to vibrate your waist to thinness, and the four of us in the crowd standing on the deck on the final dawn of the voyage as we sailed past the Statue of Liberty and into New York harbour.

Through a newspaper ad, we swiftly found a top-floor two-bedroom apartment to rent at 51 Charles Street in Greenwich Village, an area that was already the heartland of artists' studios, on the corner of Charles and West 4th near Washington Square, where Man Ray and Marcel Duchamp

played chess that year. School places were found for Rachel and myself in second and third grade at PS41, which was a six-minute walk from home. As it happened, abstract expressionist painter Robert de Niro had, more than a decade earlier, sent there his son, Robert Jr, who became an actor. And in 1963, parents and community leaders had successfully protested against a plan to send the school's black students to another school.

When the practicalities of the ideal centre of operations and a commendable school were in place, my father's project could begin. From lecture notes some time later, he looked back on his US assignment:

> Art historians and analysts can always be relied upon to come up with diverting and entertaining ideas, but for me, as a painter, the most stimulating talk has been what the artists themselves have had to say.
>
> For this reason in 1965 I applied for and was given a fellowship to go to America and talk to its artists. My official theme was their relationship with the tradition of art in Europe, but I soon found that the interviews I had with artists – about 110 of them – ranged much wider than my official enquiry. As I went from studio to studio with my tape recorder, I began to feel more and more strongly that I was a chairman of a vast discussion going on between the artists I was interviewing. Over and over again, conversations centred around similar issues raised by the practice of art, and from each studio I picked up a point of view which jigsawed into other points of view to form a many-faceted survey of the current preoccupations of the art world. The artists' remarks, in other words, were not a shapeless grab-bag of isolated manifestos, but a kind of dialogue or exchange where one artist's position was an answer to, or a comment on, another's.
>
> I came to realise that art in America, and particularly in New York, was itself a jigsaw of interconnected responses, like a kind of debate.

These are not journalistic interviews. In fact, my father uses the word 'journalistic' disparagingly. It suggested to him a reductive failure to understand the making of art from a practitioner's point of view. To begin with, his questioning pursued the central academic theme of the proposal for his fellowship and set out to explore the connection, if any, between American and European art. Questions recur between sessions, though the answers are widely various, as my father tried to establish if there was truly such a thing as 'The Break' – a deliberate American refutation of the lionised transatlantic tradition. Or if there was a traceable continuity between the

work on both shores, particularly since some of the artists were originally from Europe (Louise Bourgeois and Willem de Kooning, for instance, French and Dutch respectively) or had spent time studying there (including, for example, Isamu Noguchi and Ed Ruscha). How new was the New York School?

There were related questions too, about where influences came from and how ideas were exchanged – whether experiences that brought artists together, like the Abstract Artists' Association or the Eighth Street Club founded in the 1950s, helped to nurture common aims and techniques. Did American art have identifiable characteristics? Was the genre known as pop art, and its antecedents, intended as a critique or a reflection of American society or popular culture? Was it social comment?

The context for this inquiry reached back, arguably, to the painter Thomas Eakins at the end of the nineteenth century, who urged American artists to 'peer deeply into the heart of American life', and to the group of painters exhibiting together in 1908 who called themselves the 'Eight', and who asserted their distinctive independence. My father's conversations concentrate on the ongoing areas of European influence, of which the presiding triumvirate were Paul Cézanne, Pablo Picasso and Henri Matisse, and on the movements which enabled abstract expressionism and pop art, notably cubism and surrealism (and its younger, madder relation, dadaism). Marcel Duchamp and Man Ray, interviewed here, were gamechangers in the areas of conceptual art and surrealism, and were rediscovered in the 1960s by a new generation.

Many of the artists interviewed had worked in the 1930s on Roosevelt's Works Progress Administration (WPA, 1935–43) – later the Work Projects Administration – which generated employment during the Depression, including in the arts. The WPA kept artists going while they developed their craft, even though some had reservations about the public projects they were working on. The arrival of refugee artists and thinkers from Europe during the war – among them Fernand Léger, Piet Mondrian and André Breton – was also important in encouraging both influence and independence. By the 1950s there was a new sense of freedom. 'The Club', an American-style saloon with a gallery and theatre had been founded by the sculptor Philip Pavia. The term 'New York School' had been coined to denote the innovative postwar work being produced by an informal group of artists, and pop art had arrived. The label 'pop art' was already in use by 1955 to describe works that referred to popular culture and mass-produced objects. Three artists who were significantly influential on the abstract expressionist movement died suddenly: Arshile Gorky in 1948, Jackson Pollock in 1956 and Franz Kline in 1962. And the drive towards objectivity helped give rise

to op art, which used geometric forms, colour theory and the psychology of perception to create optical illusions.

By 1965 there had been an unprecedented boom, not only in creativity and ideas, but in the prices of art and the profile and celebrity of its creators.

Events outside the art world had a bearing, too. Artists over the age of forty had lived through the Spanish Civil War (1936–9), when all sympathies were with the left, and McCarthyism (1950–4) which hunted it down. Both Yoko Ono and Isamu Noguchi had suffered from the anti-Japanese climate in the US during the War. Noguchi spoke about the atom bomb and the precariousness of the future: the Cuban Missile Crisis (1962) was a recent memory. Grace Hartigan cited the effect on her creativity of the assassination of John F. Kennedy (1963). The horrific attack in Selma on civil rights protesters in March 1965 had found its way into the work of Robert Indiana. And Yoko Ono was concerned with the war in Vietnam, which had, by the time she met my father, been going on for ten years. Student unrest was stirring in 1965.

It was an era of redefinition of the United States. This period also makes the present, in both the US and the UK, look decidedly stuffy. Social progress went on to be made, particularly (and, as it turns out, precariously) in the areas of race, sexuality and gender rights, but some of the thinking in this collection of interviews suggests possibilities we have tended to forget. My father was often asked: 'Is London really swinging?' By comparison with New York, he thought London practically immobile. These interviews are not only a window into the minds of the artists, as they were meant to be at the time; they offer a view onto a society and a culture more than half a century away.

Meanwhile our family was immersed in that society and culture. Here are a few of my childhood memories of that time.

The size of PS41 was daunting at first to two little girls who had come from a three-form infant school in Yorkshire (I cried a lot the first month), but in time we settled and were happy. We walked alone to school, though Mum revealed that she watched us do so from the apartment window for most of the way. We swore allegiance every morning to the American flag. We got used to 'show and tell'. We ate our 'brown bag' lunches in a playground that looked like the set of *West Side Story* (the canteen was noisy and terrifying). We read Puffin books that my mother ordered from England because she thought the choice was wider than in America; hooray for *Pippi Longstocking*! We never learned the twelve times table (more use in countries with shillings than dimes). A supply teacher awarded 'hygiene crowns' at the end of the week to children with dirt-free fingernails. I got engaged at recess to a classmate with a ring-pull from a Coke can. We once ran

home barefoot in summer rain. And we stood on chairs at birthday parties and taught the other kids English words: 'tap', 'pavement', 'crisps' (instead of 'faucet', 'sidewalk,' 'potato chips'). One such party was, by coincidence, the seventh birthday of my friend and classmate Michael Kimmelman. He grew up to be the art critic of the *New York Times* (I have been reading his pieces as background for this book).

Some details of our lives reflected the culture that gave rise to pop art. We collected superhero cards that came with bubble gum (Spiderman, the Incredible Hulk). We accumulated enough Green Stamps to buy my first watch, a Timex, and I learnt to tell the time. We dressed as Batman and Robin for a costume day. We played skipping games on the street with a circuit of elastic bands around a fire hydrant. We watched cartoons on TV on Saturday mornings: Huckleberry Hound, Deputy Dawg, Yogi Bear and, our particular favourites, Bullwinkle the Moose and Rocky the Flying Squirrel. Rachel acquired a taste for peanut butter and jelly sandwiches.

We also experienced the largest blackout in history, on 9 November 1965. The electricity was out for hours not only in New York but in eight whole states and part of Canada. Dad amused us in the dark by creating a vacuum, with a jam jar and a candle, that sucked water upwards.

Several times that year my mother took us, once with friends for a birth-day party, to see a children's theatre group called The Paper Bag Players, which performed with minimal sets. It turns out the group's raison d'être was to 'create a theater for children that would incorporate the experimen-tal art scene of downtown Manhattan' (*Dance Magazine*, June 1964).

Dad, for his amusement and ours, enlisted three friends as actors and made a fifteen-minute silent children's film, featuring his daughters, which was set on the roofs and fire escapes and streets of Greenwich Village. It was called *The Pink Purse*, had a denouement in which good and bad characters were all reconciled, and its soundtrack – long before Woody Allen made *Manhattan* – was George Gershwin's 'Rhapsody in Blue'. For Christmas Dad built us a wooden puppet theatre, painted gold (a homage to Louise Nevelson's gold-painted, wooden sculptures?), with fairy lights around the stage. And he drew us in his notebooks, between his jottings.

It was important to his interlocutors that my father was also an artist. Many of them had clearly conversed with him before the recording, and the tapes allude to a studio tour, or unrecorded discussions about the work. It often sounds as if we have dropped in as artists are in the middle of com-paring ideas. The common experience helped to create a candid climate in which anything could be said. Increasingly, Dad worked on the principle that if artists were given the freedom to talk, with prompts, they would reveal their approach. They did. And they also revealed themselves.

Perhaps it was not only the difference between academia and journalism, but also the fashion of the time, that the interviews did not set out to be personally intrusive. They are unlike the interrogations we now expect. My father did not ask about relationships (except professional) or sexuality (perhaps because the homosexuality of several he spoke to was, at the time, illegal – although in some instances I am sure he was aware of it). There were no questions (putting today's interviewers to shame) to women about the men they were romantically involved with (except, very apologetically, to Lee Krasner about her late husband Jackson Pollock, since she was an authority). He did not, for instance, ask Helen Frankenthaler about being married to fellow interviewee Robert Motherwell. Or vice versa. He quizzed the women about their work and their working experience. Though he did ask Grace Hartigan and Krasner if there were particular hurdles to overcome, working as women; both said, in effect: 'Bring it on.'

Research was also very different then. My father had only a few letters of introduction, and his affiliation with the New York University via his fellowship. He could not, as now, find biographies on the internet and images on an artist's website. He read art journals and newspaper articles and underground magazines (such as *It Is*) past and present. He relied on personal contacts and recommendations from one artist to another. And he went to galleries and openings and happenings, immersing himself in the art 'scene' as much as the scene would let him. It meant that he saw some works first in the artists' studios, and occasionally he is unaware of information that today an interviewer could readily uncover. He may have found out the hard way but his approach was also the most direct. And some subjects are left untouched. It was probably discretion rather than ignorance (since he heard plenty of gossip) that stopped him, say, asking Isamu Noguchi about his affair with Frida Kahlo. We are used to our right to snoop. In comparison, these are refreshingly professional conversations (though both sides could be outspoken).

They did lead to the volunteering of unexpected personal information. Louise Bourgeois, for instance, was candid about her resentment of her late brother. Yoko Ono revealed much about her history of mental illness – triggered perhaps by Dad's rather untoward (if unknowing) remark that her work might make people think she was 'insane'. Louise Nevelson expressed her rage about her work being overlooked. Claes Oldenburg gave an uninhibited Freudian interpretation of his childhood obsession with maps.

The meetings were set up, too, using old-fashioned means – by letter and telephone, and sometimes by showing up unannounced. There is a draft in Dad's notebooks of a written request to Marcel Duchamp for an interview, and his diary is full of artists' phone numbers. He was given the

inside information that to speak to Roy Lichtenstein you had to let the phone ring once, hang up and ring again.

After nine months in New York and a farewell meal for my parents the day before, we set off on 1 June across America as a family, in a green second-hand Ford stationwagon, for a three-month road trip. Artists were interviewed on the way. Some of them got no notice. We would arrive in their towns with no precise address. In June, for instance, Dad tracked down the abstract artist Syd Solomon (not included here) in Sarasota in Florida by asking at the local *Herald Tribune* office. A surprising number of artists agreed to talk if doorstepped, although Georgia O'Keeffe, in New Mexico, declined. She had, aged seventy-nine, done enough interviews.

Our route began on the East Coast, travelling down through Washington DC, where we saw the White House and the world's largest stuffed elephant. Further along, in South Carolina, while we were staying in a scruffy motel, a spacecraft landed on the moon. We passed Jasper Johns's house on Edisto Beach in Florida. We visited Vizcaya, a rich man's folly near Miami, with my mother's foster sister, who had five Spanish-speaking children. We saw (shame on the 1960s) dolphins doing tricks, as well as alligators, snakes and giant tortoises in the muggy Everglades. Visiting a circus museum, we missed weather warnings and were nearly caught by a hurricane in a precarious beach house (arranged for us by Solomon). We headed inland to find a more substantial hotel as a black cloud pursued us.

In New Orleans we breakfasted at Brennan's (founded 1946) in the French Quarter – the first time I ever saw anything flambéed. We swam in the rooftop pool at the Hotel Monteleone – or rather I stepped out of my depth without a rubber ring and the lifeguard dived in. Somewhere en route through Texas, New Mexico, Arizona, Nevada, California, where we were always on the lookout for the signs of Thunderbird motels so we could flop from the car into outdoor pools, I learned to swim. Beaches punctuated the journey, and art galleries (the Delgado, the Sweeney, the Fort Worth Art Centre), were among the looping freeways and neon signs and drive-in cinemas.

Rachel and I remember catching fireflies in jars in an artist's garden. (Whose?) We had never heard of an amusement park until Six Flags in Texas. We bought at a roadside a watermelon the size of a coffee table; we gorged until we had to throw the rest away. We saw the mud houses of Pueblito in New Mexico. We watched bucking broncos at a rodeo. We walked through Arizona's Petrified Forest, where mineral deposits had turned logs to stone. We arrived at the Grand Canyon at dusk, where a Native American was selling beaded trinkets. We drove across the Nevada desert at night – it was too hot for daytime – and Rachel and I went to

sleep stretched out in the back of the car, watching the stars. At some point we were put to bed in a hotel while our parents hit the Las Vegas casinos. We visited Simon Rodia's Watts Towers in Los Angeles, thirty-three years in the making from broken glass and ceramics, almost a year on from the Watts riots.

July and August were busy for Dad interviewing West Coast artists. But in July, when the car was parked by Long Beach on Ocean Boulevard, a window was smashed, and a tape recorder and a suitcase with tapes of interviews and films from the trip were stolen. Fortunately the New York interviews had already been packed up and sent to England. The theft made the local papers. Later, I believe, some of the tapes were found in irretrievable condition strewn on the beach.

And Rachel remembers a glorious closing shot of us at our final destination, driving across the Golden Gate bridge, singing in the car.

On 11 August, having sold the stationwagon, we flew back from San Francisco to New York. Final interviews were conducted and on the last day of the month we boarded the Queen Elizabeth to sail home.

My childhood memories of the trip are glamorous and idyllic. When I said this once to my father, he laughed. From an adult's point of view, there were a lot of nasty motels and cheap eateries.

As for the tapes: sometimes artists talking about their work are luminous and inspiring. Grace Hartigan, for instance, has a notable clarity. But the abstract expressionists were inclined to express themselves very abstractly. Sometimes their thoughts are obscure, and some of the more opaque passages have been pruned, for the sake of readability. Elsewhere a certain abstruseness has been left, because the nature of the thinking is itself illuminating, and there seem to be glimmers of meaning shining through. Overall I have tried to preserve the flow, the voice and the highlights of the twenty conversations selected here, even where the original interviews were two or three times as long. I hope each reads as distinctively as it sounded. False starts, hesitations, repetitions and fillers – 'like', 'you know', 'you see', 'I mean' – have been whittled away, though not entirely, if they were characteristic of the speaker.

In his conversation with Saul Steinberg, my father spoke of the 'unbelievable gap' between listening to someone talk, seeing their expression and the 'cold word on the page'. Steinberg described the spoken word as reality, like a magnificent landscape, and the written word as 'like a drawing or a painting of the thing'. It was one reason why my father chose to use extracts from the tapes in lectures rather than simply publish the million words he had accumulated. He believed that the voices themselves told you more. But he did draft a plan for a book that puts the extracts into a historical

context, and in a sequence that expressed the to and fro of the debate he felt he was chairing.

This selection, chosen for importance and variety, illuminates not only a score of fascinating individuals, but the interplay of the thoughts they expressed. The sifted interviews appear in the order in which they were conducted – since questions often arise out of earlier encounters. The biographical introductions set the scene, up to the date of the interview. All together the aim is to retain some of the magnificence of the experience of being there.

Many of the interviews had been transcribed, a painstaking job on a typewriter, though the transcripts were full of inaccuracies. Names, places and titles of works of art were usually misspelt, and much was misheard. Everything had to be checked, and detective work was needed to identify what was actually said. Some misrepresentations were amusing: Andy Warhol was famous, supposedly, not for his soup cans but for his suitcase.

Some of the artists offered a few remarks into the tape recorder for an hour and disappeared from our lives. Others continued to be sociable or made kind gestures. Artist Richard ('Dick') Diebenkorn (not included here) sent a postcard after his interview saying, 'I was impressed by the way you went about your project. The rare combination of warmth and penetration that you brought to the whole thing moved me, and I want to wish you the luck that you deserve.' Louise Nevelson signed a pencil draw-ing (illustrated in the plates section of this book), 'To John Jones.' Robert Indiana wrote a dedication to both my parents. Marcel Duchamp invited them to dinner. (My mother's glamour may have enhanced Dad's popular-ity. She was taken by Duchamp's manners and his accent, and remembers him holding forth at one end of the table while everyone listened.)

My father became friends with Claes Oldenburg, and took part in a happening of Oldenburg's in the Cinematheque of the 41st Street Theater in December 1965. The performance, *Moveyhouse*, was one of three: the other two were by Robert Rauschenberg and Robert Whitman. In Oldenburg's, the audience was made to sit in the aisles of the cinema while three or four performers occupied the seats. They spoke a few lines, including 'Excuse me', 'I think I've seen this before', 'Get your hands off me', and 'When will this end?' They smoked and coughed and changed seats by flashlight, and took food from rustling paper bags. The scene took place in the half-light from the projector, which threw a blank rectangle on the screen. Some spectators wore Mickey Mouse ears that cast shadows on the screen, and one was dressed as Santa Claus.

At the back of the audience there appeared a burglar, who closed each seat in every row, one by one, until he reached the front, found a huge

bicycle, and immediately carried it all the way to the back of the auditorium. This took a long time. Meanwhile a girl played a very quiet nursery rhyme on a piano, on which stood a glass of milk. There was also a doctor in the house, the actor unidentified in Jill Johnston's review in the *Village Voice*. The actor was my father and he wore a round mirror on his forehead and juggled balls through most of the performance, stopping from time to time to examine members of the audience with a stethoscope that had a rubber hand on the end. Afterwards (the happening lasted about twenty minutes) the only member of the actual audience who sat in the seats throughout, Marcel Duchamp, said how much he enjoyed it. The critic David Sylvester said: 'Go back to your easels.'

My father told me: 'People asked him [Oldenburg] what it was all about. He said that it was about circles. The reels on the projector, the bicycle wheels, the balls I juggled with, and the mirror, and he said: "I wanted to get the moon in. Did you notice the glass of milk on the piano?". No one would ever have guessed the underlying abstract element.'

A film with Oldenburg followed. In my father's (spoken) words: 'After the happening I said: "I would like to try and make a film if you did it again, but the trouble is that you can't see it from everybody's point of view. Most happenings had different things going on which could only be seen by some people."' Dad thought the solution was to make the film with the same subject, a small incident, shot repeatedly in different ways: 'We decided that it would be about him hanging a picture.' In *Claes Oldenburg Hanging a Picture* 1965, an action shot is seen again in part and then moved forward. Eventually he hangs the picture on the wall. The shots showed a ladder, the hammer, Oldenburg and the picture, which 'happened to be a painting by numbers of the American Civil War'. 'After I had shot it, it was too dark to see it very clearly and I had to make it all over again.'

Dad also shot some film of Oldenburg's work. 'One day a plumber came into his studio and was interested in what we were doing. He had a huge beard and was in fact a painter himself. Claes said: "When you cut your hair, we will make a film about that."' The plumber returned some time later, saying he planned to cut it at New Year.

There were several members of the audience in the bathroom for the cutting, including Yayoi Kusama, with whom Dad also made a film, of her polka-dot-covered studio. After the plumber's event, Dad edited the filmed material. 'Many underground films at that time were stuck together without any reason, but I tried to make sequences which showed the hair getting smaller. I offered this to Claes and asked to keep *Hanging a Picture* which I had edited so carefully, but some years later he phoned me from New York and asked for it.' *Hanging a Picture* was shown in Washington,

as Oldenburg's film, and is now part of his archive material owned by the Museum of Modern Art in New York – 'As,' said Dad, 'must be the hair-cutting film.'

My father also made a connection with Yoko Ono. Before he interviewed her he had witnessed her happening in which audience members were given a pair of scissors and invited to cut off part of her dress. A drama of anxiety and anticipation unfolded in their minds. Even those who displayed lascivious enthusiasm at the beginning tended to cut off small snippets 'or a decorative button'.

From a sales list of Yoko's works (available to order by mail from the neo-dada group Fluxus), Dad bought, as he wrote, 'a loop of tape on which, it turned out, nothing was recorded. That may be misleading. Reading her list again I see that I may have bought "Soundtape of the Snow Falling at Dawn … 25c per inch. Types: a. Snow of India, b. Snow of Kyo, c. Snow of Aos". Playing it again I can no longer be sure which snow mine is.'

From the same list, he could have bought 'custom-made underwear in vicuna to "accent your special defects".' Or, for $3000, 'a crying machine "which drops tears and cries for you when a coin is deposited"', or (for $1500) 'a Sky Machine' which 'produces nothing when coin is deposited'.

There was a postscript to their US encounter. Months after our trip, Dad heard that Yoko had been invited to perform at the local art college in Leeds. She, her husband Tony Cox and their daughter Kyoko accepted our invitation to stay. She and Tony performed her *Bag Piece* at the college, as well as a happening (like the game 'Telephone') in which a whisper was passed along – and revealed to have been silence at the start.

Staying with us in our Victorian terraced house in Headingley, they were 'easy guests' and Yoko made origami birds and animals to amuse us children. There was a drama when I took Kyoko for a walk and she was frightened by a local (friendly) dog, who put his paws on her shoulders. I was mortified to return her in tears, to the distress of her mother.

Yoko was planning a film and needed funding, so my father lent her £50. He is credited in the titles of her film *Bottoms* 1966: 100 startlingly various behinds filmed for twenty seconds as their owners walked an endless belt, with a soundtrack of the subjects at audition talking about their experience of experimental theatre.

Yoko later sent a cheque for £25 to repay half the debt, and Dad was instructed to collect the rest from The Beatles' Apple offices (events had moved on). Dad waited with the teenybopper fans and was repaid in cash. Months later a huge bouquet of white flowers arrived at our house with a card that said: 'Love and Peace. John and Yoko'.

Much has been written about many of these artists since. But the

synchronicity of these interviews uniquely crystallises a moment. John Elderfield, who was my father's student, attended his lectures about US artists, and went on to be director of the Museum of Modern Art in New York, has described Dad as 'a modern-day Vasari'. These interviews have given me, and all of us, a glimpse of what he discovered.

And an addendum. My father's notes, letters and diaries offer anecdotes that were not recorded. Here is a sample of the snippets he wrote down:

Rauschenberg's family tree

Rauschenberg observed that his name meant 'Smoky Mountain'. His (great?) grandfather's marriage to an Indian [NATIVE AMERICAN] was not mentioned in the family. He had seen a family tree put together by one of the family in which his Indian [sic] ancestor was omitted. 'It was the sort of family tree,' he said, 'that when you had it all you could do with it was destroy it.'

Oldenburg's view of Warhol

Claes Oldenburg, going to Vassar for a conference with [ANDY] Warhol, [JAMES] Rosenquist, [ROY] Lichtenstein and others, said: 'The girls want to see Andy. We're just the supporting cast.'

A de Kooning technique

De Kooning draws nudes, male and female, with his eyes closed (or looking away from the drawing at television) and has them photocopied so that they can be put in an episcope and projected on a large canvas. He draws and then paints. He likes how beautiful the drawings look when enlarged on a screen (the light embellishes).

Minimalist sculptor Robert Morris's story about Jasper Johns

John Cage went to Bob Morris's first show at the Green Gallery. It included a large sculpture – a block 8' × 6' × 1'6" [2.4 × 1.8 × 0.4 m] painted grey. He telephoned Jasper Johns to go and see it.

Johns went and rang Cage. 'I didn't see any sculpture', he said. 'Only the base.'

When it was being built in the gallery, a workman who was altering the walls kept coming in and putting his hammer on it. Bob had to keep asking him not to do it and he couldn't understand.

Mark Rothko declining an interview

Rothko refused to be interviewed on the grounds that there was too much talked and written about the arts. Too much art history. Too much education generally.

ROY LICHTENSTEIN

Roy Lichtenstein was interviewed on the morning of 5 October 1965 in New York (11am). His voice was cheerful and confident, with a sense of laughter bubbling under, which often came to the surface. Lichtenstein was forty-two. John Jones was thirty-nine.

At this point in his career, Lichtenstein had been working as an artist for more than twenty years. He had his first solo show in 1951 at the Carlebach Gallery in New York, and made his name with his comic-strip paintings at a sellout show at the Castelli Gallery in 1962, which was followed by a second show there in 1963. The comic-strip paintings made use of images from magazines, and, to suggest shading, his trademark Benday dots, which were borrowed from commercial engraving.

The artist's style of tongue-in-cheek parodies had begun early, with playful treatments of medieval imagery, and cubist cowboys and Indians. He had also been a prolific printmaker, sometimes incorporating mechanical elements (he taught industrial design at Oswego, New York, in the 1950s) into his work.

Lichtenstein was associated with the pop artists (Jim Dine, Robert Indiana, Jasper Johns, Claes Oldenburg, Robert Rauschenberg, James Rosenquist, George Segal, Andy Warhol, and Tom Wesselmann). Together their work was seen by some as a slap in the face of abstract expressionism.

There had been some backlash to Lichtenstein's success, including critics who called his work 'vulgar and empty', and a disparaging profile in *Life* magazine in 1964 which was entitled: 'Is He the Worst Artist in the US?'.

JJ First of all, really, I'd like you to talk about your own stuff ...

RL In relationship to how I feel it fits into the tradition? Well, I guess that most art fits into a European tradition in the sense that [THE] European tradition is based on perception. And there are certain aspects of perception which remain constant. The purpose of art I think basically is still unity, and this is really the tradition. In a sense there's no real tradition of European art: when you've produced everything from Titian to [JOHANNES] Vermeer to [PIET] Mondrian, there's very little similarity in these works. And American art, although we like to think of it separately, is no further away than those painters are from one another. I think what we're doing is something that maybe hasn't been done in Europe – but then those European artists were also doing things that weren't done before in their own tradition. But I think there's really a very small difference between American art and what we think of as European art, although we seem to be making a lot of it.

There's the apparent lack of subtlety and sort of make-believe anti-sensibilities connected with American art. I think this is a style, and it does relate to our culture ... But you see these same things going on in [JOAN] Miró and Mondrian, and [JEAN] Arp, except that the so-called pop artists are attaching this form to subject matter in our highly-industrialised life. I think there's very little difference in the art. But you can look at it either way. You can say there's a great deal of difference [LAUGHS] or you can say there's not much difference.

JJ When you say that the differences somehow reflect American culture generally, in what respect? Could you be specific about it?

RL I think that it's a matter of degree. In America there's just more industrialisation and it permeates everyday life: from the way you

make coffee instantly to the kind of furniture most people have, and the kind of apartment most people live in, and the garage and the car and the transportation and the television, whereas I have the feeling – and it isn't true of course all over Europe, because certainly England is highly industrialised and Germany is, and France to a degree – but I'm not sure that it permeates the everyday life of most people in these countries in the way it does here. There's no real tradition here, and a thing like antique furniture is specially imported and belongs to only a few people, whereas most people in foreign countries are living in an old setting. Even though there are the same objects in their environment: there are trucks on the road [LAUGHS], for instance. But somehow this is really the only life that we've had. And I suppose the Iron Curtain countries (it's a funny way to put it – 'Iron Curtain countries' – but we're so used to that language), they probably had nothing to begin with, so objects are new, but I don't think that the full force of the tremendous traffic involved in highly industrialised civilisation really reaches the people the way it does in America.

JJ I'm sure it's true. How does this relate to painting then?

RL Well I guess it's a shift from Europe. Because I think we were all trying to do European painting if we went through art school, and we tended to think of the commercialism as a kind of intrusion. We would try to live in a way that would remove ourselves from this. I think this is even true of abstract expressionists. Their tradition seems to be much more European than the more recent painters because of the interest in paint. Even though they think of it as an American art, it seems to me so close to expressionism in Europe that it's very hard to tell the difference.

JJ What sort of training do you have?

RL I went briefly to the Art Students League¹ but most of the training I had was at Ohio State University, and you're studying European art most of the time. Because until very recently American art was definitely second-rate and would occur several years after the same movement occurred in Europe, and would be, as you said earlier, watered down. We had realists and impressionists, but none of them could compare with the Europeans.

JJ You used the phrase 'an interest in paint'. Do you feel that this is somehow not a timeless quality that painting should have?

RL Yes. I think it is not a timeless quality; I think it's something that occurred. It's really Venetian in origin, I guess, and occurred in Italy, even though for some reason or other oil painting began in the north. Then it's in impressionist and expressionist times that the concern with paint comes about again.

JJ I meant that the artist's concern in the past, or at any rate the kind of concern that one learns in an art school, is a formal language to do with the material itself, the language you employ to express yourself: the grammar of materials.

RL Yes. We're still, I think, completely involved with it to the same degree as it's always been, except that you find other qualities in it. And whatever the quality one generation has, it is boring to the next. And so you look for something else, and something that seems like amateur art-school scratching that everybody disliked at one time becomes a way of painting in the next generation because you find something interesting in those elements.

JJ Apart from the boredom that one generation feels for the past generation, did you consciously look around for themes which were different?

RL I think once you happen upon something, you like to think that you thought it up purposely. I did what I did rather than consciously looking around for something new. I don't think you can really do that successfully.

JJ Larry Rivers talked some time ago about painting *Washington Crossing the Delaware* for just this reason, that such a theme would be anathema to the art scene, and I think he did consciously decide on it …

RL I think it's possible that, because when he did *Washington Crossing the Delaware* he had also done similar themes before that, he would be in the set of looking for things that would be preposterous – and I did, too, after I started. I guess as you're doing it you realise that the theme would be rather outlandish, or you can certainly see how people will take it. Now I'm working on these purely abstract works, that I do most of the time upside down anyway because I'm looking as I'm doing them, and I've kind of lost contact with the way other people would see these. But I know they're preposterous in the experience that most people have.

JJ Did you at first feel that you were forsaking some of these abstract qualities for the sake of the intriguing impact?

RL Yes. It actually worried me really because I've been out of art school now since '46. I got my Masters in '49, and I've been painting a long time, and you begin to believe in the qualities that you're working in. Suddenly the change is kind of traumatic. I knew that there was something there that had great impact, and the importance of it I felt but didn't know thoroughly, and I kept worrying about the other work. I even tried to do both at the same time in a funny way. It just didn't work.

JJ I read in this book *Pop Art*, published recently,[2] that for a while you tried to paint from comic-strip characters, but in a looser way …

RL Well, that happened before I actually changed. But the paintings are really unsuccessful. I was working with things like Donald Duck and Mickey Mouse; you could make them out, but the paint was sort of a mess actually.

[INTERRUPTION FOR TELEPHONE]

JJ You were saying that, for a while, when you began to paint these things you tried to do both at once – that is, the kind of painting you were accustomed to painting, and to introduce this new thematic subject matter [THE COMIC-STRIP PAINTINGS]. And then came a point when you in a sense abandoned the art for the sake of the other.

RL Yes. And all of this was very quick, too. It happened within a period of, oh, a month or so. But it's just so hard to give up what you're used to that I really couldn't abandon it.

JJ Would you say that since then it's been a process of bringing the two together again? I mean you said just now that you were thinking of the pictures as abstract pictures.

RL No. I think I did that pretty much from the beginning. I thought of them as abstract just at the point of painting them. There was sort of a process of selecting subject matter first, and once it was selected and drawn on the canvas, it really became a process of painting in the traditional way, but not with traditional means.

JJ Would you say that the process since then has moved away from the first 'vulgar' impact of the comic strip toward something more tasteful? Or is that unfair?

RL No. I think it has. I think the subject matter has become abstract and it's partly the choice of subject matter, and also a desire to pick subject matter which suited my feeling. But once the idea of the vulgar has been brought across, you can't keep repeating the same thing all the time. And then to try to find more subtle things in which to re-see the landscapes that I did – and they're really vulgar landscapes. But because they're landscapes, and the way I did them, they tend to be a little more abstract and a little more tasteful. It's a word I really don't like, but I'm afraid it applies.

JJ Well I used it hesitantly.

RL No, I think that it probably is true and as you can see, I'm doing brushstrokes[3] and things now which look a little bit like abstract expressionism, but it's still humorous, I think, in the way that the landscapes were, in that it's taking something that originally was supposed to mean immediacy, and I'm tediously drawing something that looks like a brushstroke.

JJ And you're actually employing this parody of commercial technique to the –

RL To the brushstroke, also. People will love me for that [LAUGHS].

JJ What you're doing is a negation of the whole point of those brushstrokes.

RL Yes. Uh huh.

JJ There is a kind of anti-art, dada attitude that says: art, acceptable art, has these values. I will mock them and parody them. Is there an element of this?

RL Yes, I would certainly think so, in that they're done in almost the complete opposite spirit that the original paintings were done. Though even in the paintings – you think of [FRANZ] Kline,[4] for instance – it's not an immediate brushstroke, it's something he did on paper and even projected up, I've heard, on the canvas, and certainly re-did over and over again. You can see in the canvases that he worked on this, and it isn't done, oh, like Chinese calligraphy or something, because it's been restated over and over again.

JJ Wasn't there a concern that it should have the appearance of immediacy?

RL Yes.

JJ Yes. But there's no such concern in your treatment of it? In fact, just the reverse.

RL I want it to look as though it were painstaking. And it's a picture of a picture really. It's a misconstrued picture of a picture, and that is something that was also in the Picassos I did.[5] It looks more like an idiot painting of [PABLO] Picasso ... as if somebody didn't understand what the paintings were about.

JJ Do you feel your painting stands or falls in these humorous terms, or do you think that essentially – sorry to keep harping back to this – one might say that French painting stood or fell by the quality of the paint, the relationship of the parts and so on, the pictorial integrity of the work?

RL Yes. That's the major concern. The fact that it's a concern doesn't necessarily mean that it's there of course, but that's what I think I'm doing anyway. I really don't think of it as anti-art. I think of the painting as holding together because very shortly the joke historically will disappear. The joke part is part of the immediacy though, too, and the fact that it's usually very shallow humour which should die in six minutes. And if the painting doesn't hold up after that it's really a disposable painting – which would tie in with the culture, but it's not really what I'm trying to do. And in that way I think it relates to the tradition of art. Of course we can all fool ourselves very easily, but really the major work in the painting is not the idea, which could be done very quickly, but it's in trying to make the painting hold together. I don't use modulation, for instance, of colour, but I try to use the line and the form so that it will cause a sense of change within the colour. But this isn't far from the way Miró worked.

JJ You twice mentioned Miró. Is he a painter you greatly admire?

RL Yes.

JJ Are there any others?

RL Well, I admire almost all of them, you know. I think the painter I like best is Picasso, because of the variation and the insistence of his images, and of course [HENRI] Matisse also. But it's very easy to like Picasso and Matisse. But I think I like them better than I like painters since. I like [WILLEM] de Kooning's work very much and –

JJ And the surrealist thing in a sense informs your work?

RL Everyone thinks I should be tremendously interested in [FERNAND] Léger, let's say, and the surrealists. The surrealists really don't interest me very much. And Léger only recently has interested me. In fact I never really liked his work at all, but I saw recently the museum at Biot, the Léger Museum, and was really very impressed with it. But I think it's possible that they keep all the good paintings there or something [LAUGHS].

JJ Do you feel that he'd been doing things you were trying to do?

RL I didn't realise that at first but I can see that certainly the industrialisation and standardisation and all of that seem to be part of it. I really just looked at it as kind of clichéd art. I think I missed the point of it completely to begin with. Now I think that this is the reason for the kind of form that he uses. Still, his paintings to me, many of them, seem as though the parts are individual still rather than really put in context, but I'm learning to like him.

JJ I'm curious about aspects of your comic-strip things. I understand that you look through an enormous number before you select one. What you're saying about the theme, the subject matter is that it amuses you long enough to get you going and keep you involved with the picture while you're concerned with these other pictorial qualities. It's a personal thing that gets you going. I think most painters have pet themes. And subjects which intrigue them enough to allow them to make a picture.

RL Yes.

JJ But having selected these frames from the cartoon strips, do you ever feel that they have some universal significance, that you select them because they are potent images in the newspaper where you find them? Recently I was at a discussion following a film festival, and Rudolf Arnheim* said that looking at Dick Tracy cartoons he had the idea that they were very much like folk art, not just for the obvious reason that millions of people read them, and that they were in a sort of non-academic style, non-art style, but the Dick Tracy stories were very similar to folk tales in their violence and magic and mystery, and black-and-whiteness.

RL Yes.

JJ And it seems to me that in one or two of the things that you've done – I haven't seen many, but in one or two – you seem to isolate a figure in some timeless, almost archetypal situation.

RL Well, I don't know if they have universal meaning, but I picked them so they would have at least an American-European link that people would understand, it's usually the hostility or romance or something, and I do take the ones that epitomise most. It's the kind of thing we would all frown at but we all do at times talk like comic books to people. And, you know, they're really the most potent situations of our lives, but they're also laughable if you're not in it.

JJ Yes. Somerset Maugham once said that man in extremity sounds like a cheap novel.

RL [LAUGHS] That's right. And it's that kind of thing which seems to stimulate me. But you know when you think of comic strips you think they're all like that, but if you go through them you'll find that there are very few frames that you can really pick out that would be useful, that most of them are in transition, they don't really sum anything up. And it's the ones that sum up the idea that I like best. But also I pick frames that I feel I could do something with aesthetically. Some of them are too mixed up, or too disparate to be pulled together. And so I may take an idea from one comic strip and the actual image from another, although sometimes they both occur at the same time.

JJ And so when you're choosing you are concerned with their aesthetic possibilities as well?

RL Yes. It's sort of total impact that I'm looking for.

JJ I saw a poster the other day, 'This Must Be The Place.' It seemed to me that this is a very funny joke, this extraordinary place and this comment together are very witty, but I wondered if they are more than this. Do you see that arrangement of houses as you might, say, a cubist painting; as an arrangement of forms?

RL Yes.

JJ And the placing of the letters and the balloon are all related?

RL I really think they're almost academic in that sense, yes. When I can do it with the subject matter they either get into a kind of

cubist composition, which that does. Or they're almost completely isolated like *Roto Broil*,[8] where it's a complete single statement. In that way it is very much like a Noland;[9] there's almost no ground around. The figure just exists there. And you have to make some positive composition out of it. It either should be all isolated and only one thing, like a soda or something, in which the surrounding ground is usually dots in my painting, and there's an appropriate amount of ground – so it's like a drawing on a white piece of paper – or you have to involve the whole thing in the composition. I think if you look at my work it's either one thing isolated or the whole arrangement. It seems to work out best when I do that.

JJ When you isolate a thing – perhaps in all your work – are you making some kind of observation about American society?

RL Well – yes, because advertising does that. It just tries to communicate the object. And I do it mostly because it seems to be anti-tradition, in that the whole history of art goes from symbolism through to organisation, and finally the complete disappearance of subject matter. So, in a [JACKSON] Pollock, or even an analytical cubist thing, it's all order and grounded figures, and inextricably integrated. And then suddenly you just take the picture of a thing, like a Campbell's Soup can, that Andy [WARHOL] did, and say that's art. And it seems to defy the whole tradition. I think everybody understands – not everybody, but artists, art historians – that we don't have to teach this [TRADITION] any more. The whole painting is not symbolic of the kind of order we understand, the way analytical cubism was, but it was really teaching us that art is this complete integration of parts. I think that abstract expressionism took the same cubist order and relaxed it a little.

JJ Juan Gris was asked why he bothered to turn the abstract arrangement, this integration of parts on his canvas, into recognisable objects, because he did say that he began with the formal arrangement and turned it into recognisable still life paraphernalia: 'Out of the painting I make a subject ...'[10]

RL Yes. And of course Picasso always used some subject matter, no matter how vague.

JJ Yes. And [JUAN GRIS's] reply was that people looking at paintings tend to look for subject matter, and he provided them with some subject matter so that they could quickly see what it was supposed

to be and then get on with looking at the painting for its own sake, rather than giving them a set of abstract shapes in which they could find whatever they liked and would spend a lot of time guessing what it was. He said [THAT], by turning it in to a bottle or a knife or plate, they immediately saw what it was and they could read it as a painting from then on. Do you feel that with images that are as strong and as immediately readable as yours, there isn't the possibility that people will not see the other thing?"

RL Well, yes. I think that's done consciously because of the expectation of seeing an abstraction now, and we have almost the exact opposite expectation of when Juan Gris was working. But I think, for instance, [PAUL] Cézanne was really doing abstract paintings, but he himself was tied still to looking at the mountain or the apples, and felt that he projected this abstraction upon the world. Even though, if you look at his paintings of course, they're really abstract paintings. But he could never really get away from thinking that this order really existed in nature. I think the cubists realised that it didn't exist in nature, but they felt it was still necessary to attach it to nature. And I think you see a different kind of space when you think it's subject matter than when you think it's painting. I think they liked the duality of this. Then abstract expressionism really does away with the whole system. It can be done in a studio without looking at anything and it becomes pure order, which it really always was. And now the expectancy is built up of looking at pure order, and then we confront them with looking at pure subject matter apparently, and that's part of the joke too, it's a kind of humour. And it's so full of subject matter and literary content that you can't possibly see any art in it. Now I think people are getting used to looking at that in an abstract way, but it's a way of shaking people's confidence in their vision – and not so much people's as your own. Because once you feel secure, in order to grow you have to do something for yourself. It's probably more for yourself than fooling people or amusing them. But you can't help but realise how other people react to your paintings. So the over-emphasis on subject matter was done almost for that reason. Now that is kind of understood, and my subject matter is getting more abstract, but still for humorous reasons. I don't know why the tremendous preoccupation with humour in my work, but I've always been doing it somehow or other.

JJ Humour is of more interest to you than the apple or …

RL It's a way of getting into a painting.

[MICROPHONE TURNED OFF]

RL It's very hard for me to read my own paintings because when you work on them that long you know what's involved and the freshness, if any, is not apparent to you at all. Whereas someone else, particularly Claes [OLDENBURG], whom I admire very much, always seems to be purely involved with getting, you know, a hamburger to look like a big floppy piece of nonsense, but there's so much in it that it's amazing. His drawings are really outstanding.

JJ I haven't seen those. I must.

RL They're really fantastic. So it doesn't really make much difference what you're fooling with, providing you're showing people something they haven't seen, showing yourself something that you're not aware of. Otherwise you're repeating the art idea, which is better than not being in the realm of art at all, but it's a way of just increasing your own competence in pictorial organisation and that's fine, but not interesting enough any more.

JJ To put it crudely, do you feel that your work makes some kind of social comment, that it is an observation about American culture?

RL I think it does. It's not really a preoccupation of mine. I don't feel strongly about getting messages across, but I think it reflects at least industrialised life, and by way of that, American life.

JJ You don't feel that it reflects it with approval or disapproval?

RL No. No.

JJ You accept it?

RL Yes. Pretty much in the same way that the realists painted slums and garbage cans, that it is not approving of these conditions. I mean, I certainly don't think that popular life has a good social effect. In fact I think just the opposite. But there are certain strong and amazing and vital things about it anyway. It's not the society that I really would like to live in. I don't mind living in it now because in a way I'm seeing it through other eyes, having been schooled in what is essentially European art tradition. I wouldn't want to be taken up in the culture seriously. But at the same time there is this tremendous vitality about it.

JJ You're glad that you stand outside it?

RL Yes, I think so.

JJ Glad you don't believe in it?

RL Yes.

JJ About this question of communication – and I ask this out of the context of the sort of attitude which prevailed for a while, that the artist didn't care if people didn't see anything in their work, a what-the-hell sort of attitude. I know it may be part of a pose, or part of a policy, you might say, in someone like Andy Warhol, that when asked a straight question about it he'd give some oblique reply. Is your painting just for you, or is it about things which you want other people to share?

RL I'm very, I think, involved in how other people would see the painting. It is for me when I'm working on it, but I do care about how other people see it. I really think other artists do, too. I think that the abstract expressionists not caring – this is part of the policy probably, because nobody *did* care, so you might as well go along with it – certainly cared whether their friends liked it, and it's just that the audience at that time was so small for art. It's still small for art. There are more people who might buy art, but I think the people that 'read' art are still a very small group. There are more people that pretend to be interested, or maybe are interested, in it today, but I really think that artists are interested in how at least *some* other people see their work. I think my art can be seen in different ways and I'm kind of amused when somebody just gets a kick out of it for completely non-aesthetic reasons anyway, and so even that interests me. And, for instance, I'm worried about whether a form looks like a coffee cup, or whatever it is I'm doing, and I might even ask somebody, being very insecure [LAUGHS], whether, you know, 'does this really look like a coffee cup to you?' I realise that I've got to make the painting work, and all of that is in there. I'm interested in the immediate acceptance of the painting and I really do care about it. I'm interested in whether the few people who I believe in would read it correctly. I think even the abstract expressionists and other painters through history have been painting, besides for themselves, for a small audience of people who they felt understood it.

JJ A lot of painters have said just this, that their paintings are for one or two other people whom they could name, the fellow upstairs and so forth. But there's a sort of paradox in this business now. I was at Larry Rivers's opening the other night and that must have been one of the biggest social occasions of the year.

RL Well, here we have a lot of these, it's amazing. Are you going to be here for a while?

JJ A year. I hope to be here.

RL You'll be amazed at the amount of social activity connected with art here, and I hear in England it really isn't, you know, that much.

JJ No, it isn't.

RL Everybody comes to all these things. The calendar is full of these things, I don't know how I'm going to get any work done.

JJ I'm interested in the importance of American painting in the world. It's a phenomenon because it's not just about painting any more. There is such an interest, and such universal awareness of what everybody is doing here, which is probably unique in the history of painting. I don't think it is entirely to do with painting, it has more to do with the speed of communications.

RL Yes.

JJ There is the tremendous success you people have had, too. It is probably unique in the history of art that, without being a bad painter, you've had such success. In the past there have been society painters in London, and certain portrait painters expected to have 'a palace in the Mile End Road', I believe is the phrase, because they were so successful. But now one feels that *so many* painters in New York, for example, are making a lot of money.

RL The reason for the amount of interest in the work, as you suggested is partly the build-up of communications. That someone can do a painting and five days later it can be reproduced in a magazine and seen in Japan or something, which of course couldn't happen before. But I think it has to do with American collecting, which never was a factor before. There have always been collectors. They say that out of the 500 known Corots, 2,000 are in America. There has always been collecting because there's been money, but rarely collecting of modern art, and particularly American art.

[INTERRUPTION FOR TELEPHONE CALL]

I think that a lot of collecting went on in America, but not collecting of Americans, and the abstract expressionists of course had a very difficult time. But they did manage to establish this group of collectors, and get museums interested in their work, and so now I think that it's just built up and everybody now collects. By everybody, I mean four people [LAUGHS], but you know how it is. There's so much written about collecting, and we're in a very affluent period now, and this combination of easy communication and affluence, and the fact that American painters have come into their own, has permitted a great deal of collecting. I think there's much less, say, in France – there aren't too many collectors of modern American works – probably four or five major collectors anyway. And there are more in England, more in Germany, more in Italy than there are in France, which we felt was the centre of art. Now London is much more important – I think it's the presence of American collectors that's helped all of this art, because they can afford to collect, and they didn't have the sensibility for it before, but now apparently they do. So it's a good market worldwide.

JJ How did you come to achieve this sort of success? How did it happen for you? Were you suddenly taken up by a gallery, or did collectors seek out your stuff before you dealt with Castelli?

RL No. I'd only done, you know, maybe a dozen paintings and [THE PAINTER] Allan Kaprow, who was teaching with me at Rutgers, made an appointment for the Castelli Gallery to see it and I brought the work up and they liked it. And Ileana was in town,[12] and she came out – I was living in New Jersey at the time – and then a lot of people saw it at the gallery and there seemed to be quite a bit of interest. Still, it was a few collectors, but they seemed to buy in quantities. That's another strange thing that I didn't realise, you know. I had always been with a gallery pretty much – but, you know, maybe a collector would buy one. Now I find collectors buy five at a time. It's very gratifying. I think David Hayes, who was one of the first collectors that I had, had the Tremaines, and so on.[13] He doesn't seem to collect too much any more.

JJ I heard that someone by the name of Scull collects.[14]

RL The Sculls haven't collected a lot of my work, but they have some.

JJ They're auctioning it all off on Thursday.

RL Well, they're auctioning off Klines and de Koonings really. They have a very big collection of Rothko and Kline, and de Kooning and they're just auctioning *some* of the work. They're not unloading it or anything, they just like to collect, to keep collecting, and I think so they can afford to do this they're auctioning some examples of each of those people's works. But I don't think they're auctioning off recent artists.

JJ Now this can be off the record, or not at all, if you like. In this statement of yours, this rationalisation, about 'we looked around for something which nobody would like but they didn't hate that enough' there's an element of cynicism about the whole scene. Do you feel this strongly?

RL Not really. I think [IN] the way I phrased that, there is. But it just means that I think that the collectors are so sophisticated now about buying new work. I remember when I first went around to galleries in '49 or '48, I was never old enough and they wanted mature artists who, you know, had proved themselves, and now it seems that you can't be young enough, and there's nothing you can do that would be daring enough that nobody would take it. So it's not a bad situation, it's a rather educated situation.

JJ Does it depress you at all?

RL No. It really doesn't. In fact I'm rather happy with it except that the desire for the new could lead to the buying of almost anything no matter how bizarre. But that's not as bad as being reactionary and not taking it because it's bizarre.

JJ Is there some kind of feedback on you?

RL It's a kind of good feedback in the sense that it keeps you jumping really and exploring.

JJ Does it keep you seeking out the bizarre?

RL I think you'd be very hard put to find a painter who you thought was truly outlandish and new and not good. In a way it's almost impossible to be that wild without some insight, you know.

JJ You mean a good painter, an original painter – ?

RL I think tends to be good. I don't think this is true in theory because it's very possible I'm sure to think up something outlandish that has absolutely nothing to do with art, but I think that the good

painters tend to be innovators. Innovation itself in theory won't have anything to do necessarily with art – when I say art, I mean the plastic, visual image that holds together – but in practice you really can't name anybody like this. I think that people who are not really artists try to do art because they don't really understand what it is, and so you keep getting repetition of the images, and people who see what art is about are then freed to find other images. There have been very good, competent painters who were not great innovators, but there have been very few innovators who haven't been good painters. Of course it may be just that you don't know about them because they never got anywhere [LAUGHS]. But in the galleries nowadays it would be very possible for a good innovator who is not a good painter to get a show because they're looking for that sort of thing, but I think they would be pretty hard-pressed to find somebody with really unique ideas who wasn't also an artist.

JJ This is a very optimistic point of view. A critic like [CLEMENT] Greenberg might say – I'm just guessing from what I read – innovation has taken over and that the art bit is minimal in the scene now. Although the artists themselves believe this is their central concern.

[BREAK]

RL Of course this, say, comic strip looks like a Japanese woodcut if you want to look at it that way, and there's not much difference between the two, and you can say: well it's the same old thing. But at the time it always seems to be much more dramatically different than it does in retrospect. I wouldn't go about it by saying that if you're original enough you'll really be an artist. I would never approach the problem that way, and innovation really isn't what I'm looking for. I think that it's a product of keeping yourself interested within the context of art. Otherwise I don't think you could look for it, you'd never find it; you couldn't just sit there thinking it up or 'what could I do?' Any outlandish thing you think of doing would probably again be just either a combination of other people's work or some extension of it. I think it would look immediately banal.

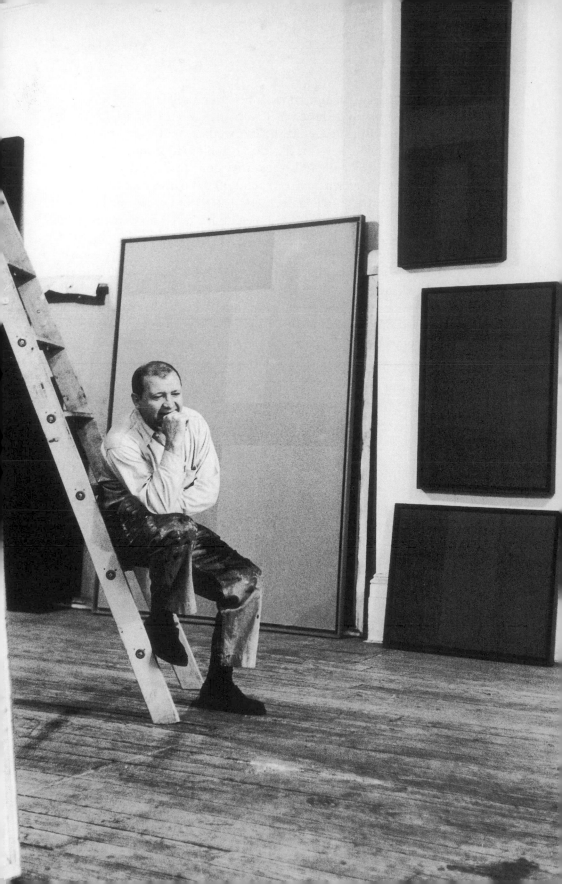

AD REINHARDT

This interview took place on the afternoon of 8 October 1965 (3pm) at Ad Reinhardt's glass-walled, wooden-floored studio on 732 Broadway, New York. Reinhardt was fifty-two. On the audio recording there is background noise of traffic, with sirens and car horns. Reinhardt speaks quite softly and precisely, with some thoughtful pauses, and his voice tends to have a dying fall. Though he laughs, too, notably at himself.

Reinhardt was a member of the American Abstract Artists group, with whom he exhibited through the 1940s in group shows. He also had regular solo exhibitions at the Betty Parsons Gallery, and was known for 'hard-edge' abstraction and minimalist geometric work. Increasingly he took the reductive principles of abstraction to a logical conclusion, arriving at canvases of single colours (in fact in subtly different squares), and culminating in the black paintings he was making when this interview took place. The black paint was steeped in turpentine with tiny amounts of red, green and blue, and layered onto the canvases. He made about 100 of these, and claimed they were the 'last paintings' anyone could paint.

Reinhardt had become known in London in the 1960s after a series of shows, including one at Tate in 1964 in which his work hung awkwardly with the abstract expressionism and action painting he rejected. A few months later there was a corrective exhibition of eight nearly black paintings at the Institute of Contemporary Art.

Reinhardt's austere philosophy of art-as-art gave rise to labels and nicknames: 'The Black Monk', and 'Mr Pure'.

At the time he met with Jones, Reinhardt was teaching at Brooklyn College, and had been since 1947. (Reinhardt died of a heart attack in the summer of 1967, less than two years after the interview took place.)

AR I've never liked the way art history's been written and talked about,
 and there's been a neglect of one of the great art historical styles:
 Islamic art – the abstract ornament, the monumental architectural
 decoration, which doesn't have anything to do with structure. You
 can talk about it pretty much the way you can talk about what
 I call new abstract art. This has to do with all-over patterns, cold,
 unemotional, imageless, useless patterns, and that's the abstract art
 I'm interested in, and that would be new. The artist as the artist is
 the same in all time and all places; it's a timeless conception.

 Another thing, the separation of fine art from practical or applied
 art, or commercial or industrial art was a great achievement, and
 I hate to see the demarcation get blurred or lost. Then everything
 becomes like everything else. I think the whole business has to
 go, the whole art-as-a-business, or business in art, the profession
 of pleasing and selling, that's extremely distasteful. It's hard to say
 that to artists who are making money, or even who are not making
 money, or want to make money – it's like telling the poor to remain
 poor so that they can remain virtuous. But I don't mind advocating
 sackcloth and ashes, all the way down the line.

JJ There is an element of this in your propositions, isn't there? That it's
 a question of virtue as well as art? Almost a kind of moral attitude.

AR That's right – the artist as artist is in an aesthetically moral, an
 absolutely moral, position, and the artist as a human being is
 in an absolutely corrupt one, from the aesthetic point of view.
 I remember [ROBERT] Motherwell once saying that he thought
 'abstract expressionism' was a good name, because the abstract was
 the art part and the expressionism was the human part, and to me
 this is pretty disgraceful. The mixture of the arts that we witnessed

a few weeks ago – there was a section in one of the magazines of painters illustrating poets, or poets writing about paintings, and there was a poet at the Museum of Modern Art that presented Motherwell's paintings (he's the curator – a poet curator), and I was embarrassed for Motherwell, about all the poetic interpretings. What I thought were doorknobs, they announced were bulls' tails and testicles, hung on the wall; and [THEY IDENTIFIED] brontosauri rising out of the primal sea, and seeds trapped between prison bars – it was endless. I'm embarrassed because I don't know why an artist should want that. I would be critical of work that makes itself that available, like a Rorschach test perhaps. But an artist who feels uncertain about his work, perhaps likes or wants that. The idea that this is a bridge that gives people a clue or a front idea – and then haul in the art underneath through the back way.

JJ Medicine with a spoonful of sugar …

You advocate an art so pure that in a sense it cannot be other than the paintings which you paint, one feels. And this is asking too much of artists, perhaps, that they should be so …

AR Well, it isn't asking any more than I would ask of myself [LAUGHS].

JJ Do you see what I mean? It's almost a kind of religious requirement.

AR Someone said I was the most logical painter, and the most illogical.

JJ Well, I think you're the most logical.

AR On the logical side, yes, I do the kind of thing that I do because there's no reason to do anything else. (No thank you [DECLINING A CIGARETTE?].) Unless you're up to no good, like making a living, or using art for status, or symbolic purposes, or – any use, or any meaning or imagery, by now, I would say, is absolutely disreputable.

JJ Religious art is by your definition a contradiction in terms, is it not?

AR Yes, I think a few religious writers, perhaps [PAUL] Tillich[1] and [MARTIN] Buber[2] and [D. T.] Suzuki[3], and [ANANDA] Coomaraswamy[4] and [JACQUES] Maritain[5] – that covers five religions – they hold out the possibility of, I suppose, the [ANDRÉ] Malrauxian[6] idea of the religion of art itself, where the art process is a religious ritual, or like it, and then there's the cult of art, and the museum that's the new cathedral. I wouldn't get involved in that idea at all, [BUT] it's a little more dignified than most other gimmicks.

It's certainly wrong to think about art as having some kind of qualities that you could check off, like good colour or nice composition, or something like that, or especially images and meaning – that's impossible. Even though the object is something itself, it does belong – as [GEORGE] Kubler says in that book *The Shape of Time*[7] – to a sequence, or series of forms that come before it and afterward, so a work of art isn't isolated. And then I think it must be apparent that somebody looking at a work of art has to meet the work more than halfway, so the onlooker brings so much to the work of art. I'm willing to say that most of it's in the mind.

JJ The art.

AR And the art as a thing will be nothing. I am willing to say it's not a thing. And I'm willing to say it's nothing if you think there's something to exploit, or something to make something of, I would certainly say then it's nothing.

JJ But you define art really by saying that it is not anything else, but the moment one thinks of any kind of word to describe it, in fact the moment you have the painting in front of you, this becomes one of the anythings it is not – do you see what I mean? You're saying that art that's so pure is not art at all – not anything at all?

AR Well, leaving the question of art out of it, what I do make is an easel painting, and it has canvas and stretchers, and a protective frame, and I settle on a certain size, so that it shouldn't be so large that it looks like a wall, or an expression of an individual image or ego, or some damn thing, and it's not small enough to be a decoration to hang in somebody's apartment, so then I settle on that size. But it's still a painting, and I'm not making an object, which a lot of young artists are, that's made as an art object but looks like any other object. I'm not making paintings too large for museums, or for anybody to make anything of. At one time abstract expressionists were making large paintings for higher prices, or for a more violent impact or impression, and it was kind of aggressive.

I was making paintings at one point that were pretty close to invisible. This was a painting then, that was unsaleable and unusable, and nobody knew quite what to do with it. The amount of angles or gimmicks that I've rejected is sort of interesting – I could have been – a Buddhist I was called – probably one of the first Zen around here. As a kind of joke, I've been palming myself

off as a Muslim, simply because I got interested in a point in time when the youngest and the latest of the great religions maybe was the first religion that didn't use art as a handmaiden.

I found out the other day that a great many Islamic craftsmen were illiterate. They didn't know what they were doing when they incorporated that beautiful Kufic and Arabic writing in the architectural decoration. They weren't able to read it. It's interesting. But this makes them more artists rather than less artists.

No, an artist who is up to something else – I can think of a few maybe, like [ALBRECHT] Dürer or Fra Angelico, who claim that they talk to God – the only thing you could say is that they lied, or they didn't believe it, but there're no artists in history anywhere that are visionaries or obsessives, or possessed people. William Blake isn't an artist. I'm not taking any credit away from what he is, probably a poet and a madman of some kind, but recently I was asked to participate in some kind of a show set around some Blakean idea, and I turned it down by saying that I was a [JOSHUA] Reynolds man,⁸ which is the only decent position a professional painter can take [LAUGHING]. But it was very common for abstract expressionists to talk about their visions. It was pretty distasteful.

JJ I know the answer to this, I suppose, but … you don't feel that the mode of procedure that the abstract expressionists claim to have employed – that is, of working themselves into a sort of state of mind, when they made marks on the canvas …

AR You mean the idea of action painting? Also painting as an area where a great deal of action or struggle goes on, and it shows the signs of the struggle?

JJ Yes, but not a conscious struggle. This is one of the things they claim: after the event they looked at it, and they wondered 'what is this thing I have done – how did it happen?'

AR Well, that's – oh, that's therapy. [JJ LAUGHS] I don't know any other word. Anybody expressing himself is being therapeutic, and I think an artist never does this.

JJ No, so – the point I was getting to is, that what you prescribe for the artist is a much more cold, impersonal procedure.

AR Well, the question of cold and impersonal, and even inhuman – I don't mind – I've taken on all the bad words like dogmatic and

absolutist and meaningless and ivory tower-ist, I've taken them all on because they were all right. And there's no such thing as divorcing thinking and feeling really, so one would wonder what one talks about when one is talking about feeling. Some artist recently said: 'An artist is a man of feeling,' and the only thing I would say: 'Feeling about what? … Feeling what?'

JJ You don't have an answer to this question?

AR Oh, I know it's wrong. It's disreputable, and at some point an artist doesn't have to be told. It's not any kind of pressure from the outside, for an artist anyway, it's from inside, and an artist who's up to no good knows it, and then he suffers himself … I think it's right that all those German expressionists were suicidal, and that's proper – they wanted to mix their art and life, and they paid for it, with their life. That's not admirable, at all. I think [PIET] Mondrian is absolutely clean and clear, whereas other painters wanted to go into architecture and industrial design, and all kinds of other things.

JJ You don't feel any sympathy for the popular [MARCEL] Duchamp attitude which stops painting altogether?

AR No, no, I suppose that's the exact opposite, and I've always disliked surrealism and expressionism. I certainly disliked all the social surrealism, and the social protest painting of the Thirties.

JJ It really does muddle it very much, doesn't it?

AR Yes, and it isn't as if I wasn't socially conscious or politically active. I just didn't feel that it was proper to use painting for anything like that. The artist as a human being is a human being, just like anybody else. And I think it's offensive from an artistic or aesthetic point of view, for an artist to make anything of it. It's fashionable now for artists to give out the recipes for their cooking and the pretension of a lot of artists to be gourmets or something – that's insane, but you'll find artists falling for that, and usually the artists that do have had enough publicity and are known well enough, and get their work shown, so I don't know why they do these things, except that they're quite mixed up. And I'm against the mixture of anything, the mixing up of art and life, and the mixing up of the arts – there's nothing worse than poetic painting, as far as I'm concerned, and the poets around have been a real pain in the ass. Also, there's nothing worse than to say this is literary or dramatic

painting, or musical painting, gee. It's even bad to say that a painting is painterly.

JJ But don't you feel that it's somehow valid that certain pieces of music do have, in musical terms, the purity which you seek in terms of painting – in easel pictures – so that when one finds a painting that has this quality, then, because words are so inadequate, you employ the expression 'musical', meaning, I suppose, 'pure', as certain pieces of music can be pure.

AR I think it's all right up to a point. It's also all right to say an arabesque interlace in Islamic art is contrapuntal or fugal …

JJ It does seem to be that the terms of music are more useful than any terms that painters employ, oddly enough.

AR I don't know … [SOUNDS DOUBTFUL]

The importance of negative terminology is good. As a matter of fact, this has been done over and over again by artists who have taken an 'art for art's sake' point of view in which the whole position is always stated negatively. I read about [GUSTAVE] Flaubert, who wanted to write without sentiment, without impressionism, without – he had a whole list of nos. And all through modern art you have that. Braque saying one ought to have two notions – some kind of a notion and then another one to destroy it. Sometimes those are the best statements by painters and artists. I suppose I made a racket out of the writing in the sense that I made negative manifestos, and the writing has always been (I always said) 'too serious to be taken seriously' – so partly tongue-in-cheek. But I've not taken up a position. I've felt that for thirty years I was forced into my ideas by everyone else. Again, a negative thing that I was forced into a meaningless position because I was sure that I wasn't involved in the meaning somebody else was pointing out.

JJ Each time they took up a position, you knew that this wasn't yours?

AR Yes, and there was something that one couldn't pin down. But a definition of art that would be, oh, I don't know, something that you could put into words, would be almost always not true. Yet everyone in a museum or every artist makes judgements, decisions all the time, and the problem is clear: you have to decide what's art and what isn't. Even if you have a committee of advisers, the decision is made usually on the basis of a purely aesthetic

consideration. Which is the only proper one. And that goes on all the time, so it isn't a mysterious activity at all, it's very concrete, seen, everything is really transparent in a way. So I'm not involved in any kind of mystery or obscurantism, or anything like that.

JJ The aesthetic decisions which are taken on a level that you're talking about are much more complex than the simple, pure aesthetic attitude which you express. For example, just now, you dismissed questions of analysis of pictures in terms of forms and balance and colour, and line and composition. Aren't these words only an attempt to verbalise the intuitive aesthetic thing?

AR I think it's conceptual, conscious and deliberate. It's not accidental or intuitive, or instinctive or animal; it's a rational activity.

JJ You think that aesthetic assessment is a rational activity?

AR Sure. This term, 'aesthetic', comes from the rational eighteenth century, or the term fine art comes from the seventeenth century, the *beaux-arts*, and the whole idea. This is all an increase in awareness, and there's progress in awareness in art. Even though one can't say that there's progress in the sense that the later object is better than the earlier one, but there's no question there's a progress onward and upward to more awareness.

JJ Do you feel that in your own work there is a progress?

AR Yes, there was always a casting out of things, and the important thing was throwing away things. There were all kinds of things that I threw away, that all kinds of artists try to make, or have made, careers of. That's pathetic to have to latch onto a line or a blob or a pattern, and to stick with it, as if it's a kind of personal image, a personal property or trademark, and then you manufacture it for the market of consumers and clients. That's an insane structure.

JJ I saw over a year ago paintings rather like this one on the floor here, and I take it this is a recent one?

AR Well, I'm laying in colours. I've been building up paint surfaces so that there's a proper absorption of paint by paint.

JJ So this is a stage in the progression, and it's more a technical problem for you to get closer to what you were doing before?

AR I guess I've a feeling I was always doing the same thing, whether the paintings looked like a million other paintings. I did things that

looked abstract expressionist, abstract impressionist, one or two things that might even be called surreal. But they were paintings in which the thing was thrown away – it wasn't exploited, anyway. And there was a time when in an abstract expressionist painting, I dropped calligraphic elements and so then I had a kind of abstract impressionist painting, and then that moved from small dots and dashes of bright colour to large dashes almost like brickwork – [THAT] looked like walls. And then at the same time I was doing black-and-white calligraphy, which was then separated from the colour and I dropped that. Then at some point the colour areas got larger and I dropped the asymmetry, and the all-overness. I made things symmetrical and also dropped the colour, made them colourless and monochrome. And even now, I mix colours together and repaint them over each other. I don't – as some people still think – mix and prepare three pretty black colours and lay them next to each other, so that you get a very subtle beautiful painting.

JJ What do you do then? Each square of each area of black is arrived at by painting over and over and over?

AR Yes. I just trisect a canvas. You cannot bisect it because that makes four divisions – trisecting it gives you symmetry. Or anyway, bisecting wouldn't give you a symmetry. But then I don't retain the cruciform or plus sign, or whatever it is, even though I've had nuns look at my paintings, and find a cross emerging, making them very happy. I was asked about that once and I suppose that was the time for me to have said that I was the great Christian artist. [LAUGHTER] I suppose that I've never been tempted with any kind of wrong credit, to art. I think that's the problem, that I don't know why artists will accept the wrong credit in their work. I don't know why somebody would be pleased if you were called a Zen Buddhist. I was tagged 'The Black Monk', and there isn't anything more monkish about me than any artist that ever lived. I have a family, I go home at night, I live like anybody else, I watch TV; I'm not monkish. I teach, and I'm willing to participate in a social or intellectual milieu. There doesn't seem to be much of one left now, but at any rate, 'The Black Monk' is not a term at all, not a label.

JJ When you talk about teaching –

AR The last thing I want to be known as is a great teacher, too …

JJ Well, as a teacher, don't you feel you present your students with a

dilemma? You give them an example which is so terrifyingly pure.

AR I suppose a lot of them know what I do; for years they didn't know what I did – and they were learning what a painting is. And then they were learning how to make one, and they did it in their own terms. I would help them do that, complete or destroy, or whatever they were doing – they were not simply carrying out my ideas …

JJ No, but wasn't your teaching constantly coming back to saying to a student 'Take that out of your painting, or that or that, because that's got nothing to do with art?'

AR No, it would be a question of asking why a student would do this, and if he had some conviction about it he certainly had a right to do it, so I would test the conviction that way. I would also point out what didn't fit or hold, or what was inconsistent. It's terrible sometimes when painters like [JOSEF] Albers' or [HANS] Hofmann¹⁰ were called great teachers. That became a derogatory term, as if it was a way of avoiding accepting them as painters. I don't know what to make of teaching. I teach art history because I want to, and also some areas I've had to teach because nobody else has known anything about them, like Hindu and Buddhist art, at some of the city colleges here. All seem to be negative reasons for doing things.

JJ Do you feel that your work is more informed by these Eastern arts than Western, European art?

AR I told a few of the abstract expressionists one time that I felt closer to the tenth-century Chinese artist than I did to my contemporaries. I'm interested in the timeless idea of an artist, and I think artists work the same way all the time, whatever they do. There's a tendency to think of the artist as a craftsman, but I think a craftsman is a little better than a poet or a philosopher as a painter – even though I certainly don't understand anybody making anything of crafted technique. I think the worst paintings in the modern world are done with new materials, whatever they are, plastic or painting on glass, or whatever it is.

Then luminous paint was the best. I made a little cartoon mural for a nightclub once in which I used a little of it – it's terrific. I don't know why painters never made anything of that, if they were looking round for new materials … [LAUGHING]

JJ Don't you think that perhaps a new material gives an artist an opportunity to shed all these non-art elements which are somehow associated with painting? For young painters, it may be easier to go straight at the problem of what art is with a new material.

AR Perhaps it sounds all right when you say it, but in my experience – let's say you start new or fresh – you have to go through a lot of denying or destroying old materials. At any rate you finish up with a nothing, a something new on another level – you're not back to the original nothing, and there's no place to go with a new material.

In fine art I would say that the first collage was the first bad thing, or the first corrupt thing in painting, and then the collage became the combine and the assemblage, and then the junk art and then the pop art, and then the op art, and I don't know how much of that will remain as art. The surrealist collages are always impossible, where a rope represents possibly somebody who was hung. At least in a cubist painting or collage, the rope was just a linear element. And the great cubist paintings don't have that mixture of real material in them. And then the great thing about Mondrian is he never got involved in that. He used collages I guess to test out paintings: that one only collage he left maybe is that last painting, which he never finished. I used to make a lot of collages, and it seemed easy and fun, like making movies or something – but the introduction of old materials, I don't see the reason for that. Making anything of matter or material, craft or skill, is suspicious.

When I want to say something, I don't want to make it my point of view – I want to say it, and if it's right, it's right, and if it's wrong, it's wrong. And I wouldn't place any value on a personal point of view; there's been too much of that in which everybody has a right to his own point of view and a right to express themself.

One other thing I want to say, maybe Schopenhauer – someone – said art or beauty or something, is without interest. I've been making a great deal of that, that fine art isn't really interesting, and the attempt to make it interesting, the fact that the Metropolitan Museum here has a larger attendance than the Yankee Stadium, is curious because I think boredom is an important part here. Again back to Islamic art, I think most travellers who go abroad looking for a lifetime of adventure in three weeks – if they go through the East, I guess they could find erotic temples, Hindu temples, but

in the Islamic world, the expression is 'if you've seen one mosque, you've see them all.' And that's precisely the point, that there isn't anything more boring than Islamic art, and certainly nothing more boring than the history of abstract art, in the sense that there isn't even vested interest or entertainment, or pleasure – all those are not really proper to this area. Whatever you can call show business, or the theatre, and so on, it's not a fine art; and playwrights and actors, those people call themselves artists, but when they sit around waiting for a review in the morning to tell them whether they were good or not – that's absolutely impossible in the fine art process.

For some reason, this area called fine art has the prestige, and I wonder why because ideally it has no use, or meaning or interest. The only thing you can say for an artist is if he's not involved in making money or exploiting somebody else – maybe that's the best thing you can say about a human being. But the idea of an artist being the freest man in Erich Fromm's idea,[11] or the artist being better in the sense that he's more sensitive, or he lives better – it's wild again – and it's surprising how many people slip into that.

It's fashionable these days to blame everyone but the artist. You can blame the dealers, or curators, but then dealers I suppose are just in business, so there's nothing you can say about that. Same with the curators or collectors – they're just doing a job, so you can't really criticise that. But artists who make themselves available, or who get sucked into this situation, you can raise the question there. I would always blame the artist for everything, not society, nor anything else.

JJ Yes, but you're talking about the artists whose work is modified because of these considerations, questions of money. Although you deplore the situation that art has to be sold in this way, this doesn't mean that you personally don't get involved in selling?

AR Well, it's always a problem, and I don't know what to do about it. I think an artist has to show whatever he does. There isn't any artist that works for himself; that wouldn't be true of anybody except mad men again, so the only way to show, at least here, is in a commercial gallery. That means you have to make your work available for sale – a dealer puts a price on it. I had a show in three galleries last year to avoid the problem of one gallery, though it looked like I was just whooping it up three times as much. I liked showing at the ICA because there was something nice about a non-commerical gallery, and we don't have that here.[12] It seemed nice and free. The Jewish

Museum in the last couple of years seemed to be a little freer, but then it got involved too much with some collectors and some critics too that were promoting a certain kind of thing, so it became like a commercial art gallery in a funny underhanded way without the ...

JJ Without the honesty ...

AR Yes.

JJ When you actually sell a painting to someone, don't you feel that this is playing with fire, in the sense that you're inviting financial pressures for future paintings?

AR No, I've been a teacher now for about fifteen years, and I made sure that that took care of whatever I needed to make a living. The most corrupt statement an artist can make is that an artist has to eat. That lets them open for anything at all; it opens a door about as wide as you could want it. But since 1960, I've been making the same painting over and over again – I think I only sold two.

JJ What are your prices – about?

AR Well, I think the price that one gallery put on it once was $5,000; I don't have any feeling about whether they should be $500 or $50 or $50,000. There was a kind of thing along with action painting called action-pricing, in which artists were one-upping each other on the price, and I got into that a little. I refused to sell a painting once, because somebody was buying somebody else's painting at a certain price. Anyway, I really have very little to do with that, but in the two or three instances, there were some funny stories.

One was the Museum of Modern Art bought one and it got spattered with detergent one night by the cleaning company and it was spotted – didn't show on any other paintings, but it showed on mine. So I was going to fix it – but then I offered to substitute one exactly like it, which I said was 'more like it than the one that they had' [JJ LAUGHS] ... and one of the curators was a little horrified because she said 'but the committee bought this one'. Anyway the problem of the unique object came up there, because there were nine directors or something like that, sitting around deciding on this one particular thing, and here I was making it interchangeable.

And then in the other case, I think it was Art USA, the Johnson Wax collection, they bought one and the director of that came in and bought it without looking – he looked at it, but without

seeing it. It was dark, not that there was anything to see. Anyway, those situations were funny. [JJ LAUGHS] Well, I was on the list of a man who felt that he had to have a painting. I could have sold him pieces of floor, you know … which is all right. I heard there was a problem of hanging my painting. It was hanging next to [FRANZ] Kline and Albers, and it raised too many questions about the paintings that were hanging alongside it. So, they were hanging it in the middle of the gallery on a screen, all by itself, and there everybody put their marks on it, scratches and signatures. They don't write 'Shit' or anything any more, they just sort of scribble – one painting of mine that came back from the Brussels World's Fair looked like a negative Twombly – do you know [CY] Twombly's painting? Things which are just scribbles, pencil on a canvas, these looked like negatives of things like that. I made a statement once that I make a pure abstract painting and then I send it out in the world and it makes its own experience there, which means it takes a beating and then comes back to be fixed up, and I accept that whole process.

JJ Yes, I remember reading that.

AR One collector – I've restored his painting about three times, and he's worried that I'll die, because nobody else can restore them. That's another problem. The other night somebody asked me, why can't somebody restore them, and I wondered, why can't somebody do it? After all, I could mix up the paint and I could have them go through the same ritual that I go through, why shouldn't they do it?

This would be the exact opposite from somebody like [LÁSZLÓ] Moholy-Nagy[13] or Andy Warhol saying, 'I want to make a painting that anybody can do', or 'you can't tell I did it'. Now, see, I'm not involved in making a personal statement at all, but in most shows my paintings seem to be the most personal. Now, that's curious.

JJ It's full of paradox. A great deal of what you say is full of paradoxes.

AR Yes, and that's all right.

JJ What did you conclude about someone else restoring your paintings?

AR Well, there wasn't any reason to, because there wasn't any reason to think you had a valuable object here with qualities. You see, you question things all the way down the line, and if somebody made it then it would be theirs, I guess – it wouldn't be mine.

JJ There's another paradox in this – when you talk about the timelessness of art, do you mean the timelessness of art values?

AR Eventually I think a work of art belongs in a museum, not a private home or somebody's private collection. A [DIEGO] Velázquez and a Rembrandt, or something, burned down in Billy Rose's house in Hollywood.[14] If works of art are to be valued and treasured, then they shouldn't be the responsibility of an individual.

JJ This is what I was going to say – in a sense, all works of art are fleeting – and they must decay, eventually, and yours seem to be particularly accident-prone, I mean the detergent. You could stub a cigarette out on a lot of abstract expressionist paintings and it wouldn't make an awful lot of difference.

AR No, it might add interest – it has added interest, sure.

JJ But in the case of your paintings –

AR No, it is just damage. All paintings, if the paint is on long enough, the crackles appear, that's all right. They don't affect the painting. Whatever happens to it, by itself, you have to let that happen; it gets dusty or dirty, or the paint changes. You don't mind looking at a Venus nude even though it looks like Chinese ceramic, crackled.

JJ You don't feel then that it somehow is an impurity, which intrudes on the purity which you have achieved?

AR It is, but there isn't anything you can do about it, otherwise you'd be completely out of the realm of all matter, or time. The interesting thing in certain Chinese painting is that sometimes the original work doesn't exist, but an eighth-, twelfth- or fourteenth-century copy [DOES]. You may have four copies where the artist tried to copy the old master. Here's a completely timeless situation where you have an ideal thing, and the only thing was for an artist to copy it to regain the same spirit, and all you can say is you can't capture the spirit.

JJ It is possible to conceive of a painting, and possibly yours are such paintings, that could be copied you know, two centuries later, so that a historian might not to be able to distinguish them.

AR Well I don't know …

 [THEY DISCUSS REPLICAS, BUT COME BACK TO WHAT AN ARTIST DOES.]

AR The pathetic modern artists around are the ones who think that
 they are making a product to sell, and it's pathetic to watch them
 when the product doesn't sell, or when the good thing that they've
 latched onto turns out to be not such a good thing. Then they don't
 know what to do. I would say an artist always knows what to do.

 When I hear of an artist who can't work, for whatever reason,
 I don't know what to say about that. In one sense a fine artist is
 working all the time. I remember I had a job on a newspaper when
 I was young. I had a family and I was working all day and painting
 all night. I don't remember when I slept, but if you're painting,
 you're painting, and you paint even if you don't you paint. In the
 Thirties everybody was painting in the sink if they didn't have
 a studio. I have a reason for doing it, and if you don't have a reason
 then you can find a million excuses, and if you allow yourself to
 be distracted, it would be better to go out and have a good time
 – go to the movies or out in the street – and sometimes I do that,
 but not very often; and I come over here and I don't have a good
 time here at all. Lots of people think you have a lot of pleasure by
 yourself. But on the other hand, I would not make it a struggle
 either. The suffering business is just the other side of that. That's
 very attractive these days, in an affluent society, the struggling artist
 – not the poor struggling artist – maybe the rich struggling artist.
 Part of the action art was that it was a struggle, and you had an
 unhappy love affair somewhere, and you came back to your studio
 and you hit the canvas [LAUGHS]. Artists geared their lives for
 that – they went out and deliberately had a bad love affair so they
 could come back and hit the painting. Or, at least when a critic was
 around. Some of the famous artists lived like Elizabeth Taylor, their
 whole private life is known. A fellow's marital problems, or the girl
 he's going around with, or the house he's building, what he's eating,
 or what condition he's in after a night of drinking – all those things
 are, if not in the gossip columns, involved in the slick magazines,
 and all the critics know that, and then we have the artist celebrity.

JJ I have heard the view expressed that some of the artists in the New
 York scene now live as personalities.

AR Yes, and then as an artist, as a celebrity, it's even better than
 Elizabeth Taylor: there isn't anything you can do that's wrong,
 everything is colourful. With the artist, there isn't anything he can
 do that's not interesting – and nobody believes an artist if he says
 he has a boring routine. Recently somebody who was inviting me

on this religious panel was telling me that there was an artist from the West Coast – I don't remember his name, famous out there; evidently he screams, or cries in a studio when he paints – and you know – I held my head, and one thing you can absolutely say was that this fellow is ridiculous. I don't know who could possibly consider him an artist except the worst philistines. I'm willing to wager everything, he couldn't possibly be doing anything good.

JJ You wouldn't allow that some artists, before they can begin to do this wholly rational business, need some sort of ritual to get into that state of mind, as it were, to shake off the world before they do art, and that it's conceivable that somebody's routine might involve –

AR Of course, you have a sweeping-out routine, or opening your mail, or taking a nap – sometimes you do everything else, so that the painting is always last. But it's as if you are hanging around, loafing around, making yourself available for the muse to visit you. And if you're riding on the subway, or having a good time in a nightclub, and the muse visits you – it isn't any good, so you have to be alone.

JJ The question of being visited by the muse, this question of inspiration – it's not something you feel very seriously about, is it?

AR No, inspiration is what you get as end process after you work hard and you forget what you've been up to, or after you're done a lot of routine work and then you do something easily. You need all those disciplines before that, then it seems like you can work intensively, obsessively – and that looks like inspiration from [THE] outside.

JJ You say that for the last few years you've been painting the same picture over and over again. Do you think you're satisfied with this particular picture enough to go on doing it – well, for ever?

AR Somebody said, 'What are you going to do now?' and as a joke I said I was going to make 2,000 of them. But, I don't know – I have about five going, and I've been working on them all summer. I felt I was unhappy because the paintings gave me trouble; they didn't turn out the way I wanted them to. And then it looked like I was making them with some idea in mind beforehand – which you have of course, all the time. I would never not know what I'm doing, or not have any plan. But then I'd question that idea, and then I'd let the painting realise itself. Some of the paintings are going to be what they are at the end and that'd not be bad, too. There is, you know, a problem of making them matt …

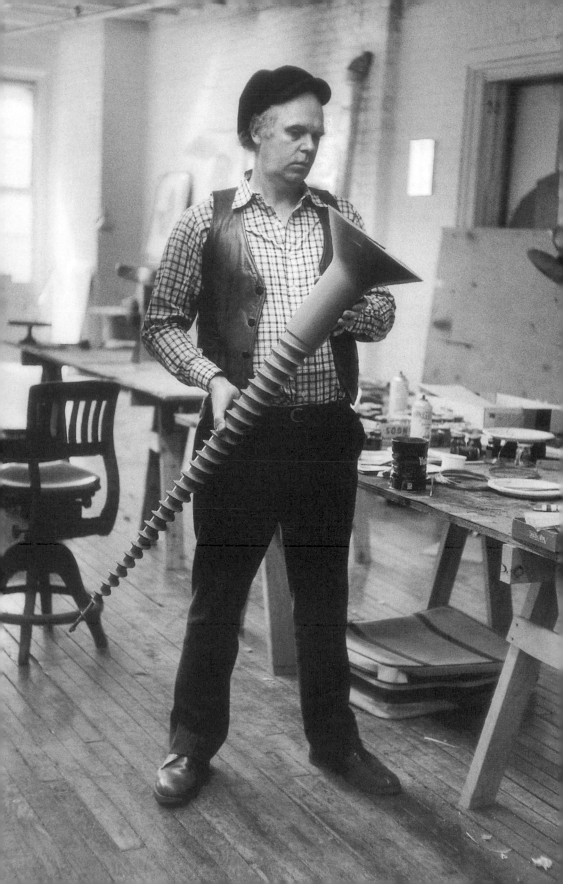

CLAES OLDENBURG

Claes Oldenburg was born in Stockholm to a diplomat father and a mother who was a singing teacher. At the age of seven he came to the US, and grew up in Chicago. He graduated in English from Yale, took studio courses in art, and after college continued his art education at the Art Institute of Chicago. He worked as a reporter in Chicago, became a US citizen in 1953, and came to New York in 1956.

His earliest sculpture was made of burlap, cardboard and newspaper, and in 1959 he had his first solo show at the Judson Gallery in Washington Square. He moved on to everyday objects made of chicken wire and plaster. In the 1960s he was associated with pop art, and made large, soft sculptures of everyday objects, which were sewn together by his first wife Patty Mucha (aka Patricia Muschinski). In 1961 he rented a building on the Lower East Side, called it The Store, and filled it with such objects for sale. It was here, in 1962, that his 'happenings' were performed by his 'Ray Gun Theater'.

In 1965 his *Proposed Colossal Monuments* included a drawing for a giant teddy bear over Central Park.

Jones interviewed Oldenburg on the afternoon of 10 October 1965. Oldenburg was thirty-six. In the audio recording, Oldenburg's voice is quite deep and warm and full, like an American movie star.

John Jones became part of the cast of Oldenburg's 1965 happening *Moveyhouse,* 'a sculpture in light, time and space', which took place in the Cinematheque at the 41st Street Theater (see pp.16–17 for details).

Jones and Oldenburg also went on to make films together. Jones filmed Oldenburg's work, and his plumber cutting his own beard. And Jones's *Claes Oldenburg Hanging a Picture*, which uses the exercise for students Jones describes in this interview, is now in the Museum of Modern Art in New York.

JJ Tell me: what relationship does contemporary American painting
 have to the European tradition?

CO Well, I went to school at the Art Institute [CHICAGO] for a
 couple of years and there the tradition is very strongly French.
 Impressionists. They have an important collection. That's really all
 you see, and when you come in there – this was 1953 or something
 – they give you Cézanne and [ÉDOUARD] Manet right away. That's
 the way it has begun for people who went to school in the 1950s:
 with the French, and you have to find the rest on your own. So
 probably American art is very much, at least in the teaching, tied to
 the European. Also, when you grow up in America, you're told that
 painting is something they do in Europe. Like they also compose
 music in Europe. So you have to shake that off, that's the first thing.

JJ How much did you shake off?

CO Going back to my own experience: you develop a kind of attitude
 towards it, and you want to find something else, and go your own
 way. At least that was my reaction. Also, in some schools there's a
 very strong Bauhaus influence, especially on the East Coast, and
 this was also present in Chicago in the 1950s through the Institute
 of Design, which was founded by [LÁSZLÓ] Moholy-Nagy. That
 was almost the Swiss-German side in Chicago, and then the Art
 Institute was the French impressionists, and then there was a
 kind of native expressionist tradition which reflected also German
 art. Of course you could read about the American artists at this
 time, but they were all in New York, and it was very rare to see
 a painting. Now and then the kids would get together and rent
 a car, or do one of these driveaways,[1] go out to New York and see
 what they were doing there. I suppose this is very typical if you're

going to art school outside of New York. They would go and look at the paintings, come back and then try to figure out ways that they could get the artists to come out to the country.

JJ Something like this [IS HAPPENING] in England, too.

CO They had a sort of independent annual outside of the Art Institute, called *Momentum*. They had three judges for this show, and they were always the latest contemporary artists, people like [AD] Reinhardt or [FRANZ] Kline, who'd be brought out and then they would just pump them, and try to find out what they were doing. There was a strong European influence in the beginning, I think.

JJ Do you feel a strong dichotomy between what was going on in New York, with Kline and Reinhardt and those people, and the traditional training?

CO Oh, yes. That's a very conservative school – and yet it's considered one of the more advanced schools.

JJ A name that keeps coming up is [PIET] Mondrian. Wouldn't you have heard about Mondrian, so what Reinhardt was doing would be a kind of extension of something you were already familiar with? Or cubism, for example; was this part of your school training?

CO Well, of course you'd know about it. You'd be in contact with it, but certain painters looked more new than other painters, like Reinhardt. You bring in Mondrian – at first glance you don't see the connection, but then you realise that even a painter like Joan Mitchell was immensely influenced by Mondrian structures. When you see the thing a little better, then you put it together. I think in general American artists are very proud to relate themselves to tradition. They seem to be rebellious, but actually they have a kind of a pleasure in putting themselves next to the masters.

JJ You're talking about yourself, too?

CO Well, yes, probably myself, too.

JJ Do you at any point consciously reject the European tradition?

CO Well, let's talk about my case more. What I tried to do was a little different. I think that a lot of these painters have thought too much about putting themselves into tradition. That's especially true in the New York School. What I tried to do was just to find out what art is, for myself. Which meant that I tried all kinds of experiments on

my own. I thought, for example, of [PAUL] Klee, and how he set out to be more or less a very sophisticated primitive. And I was more interested in sources like children's art and psychotic art, and things I found in the street, and reality and my dreams – whatever was the material of art, and trying to experiment with it.

JJ Did this bring you to an interest in surrealism?

CO Yes. It brought me to surrealism. The Frenchman that I liked most of all is probably [JEAN] Dubuffet. That goes along with Klee, too, and that idea of looking for yourself through the materials. I was really drawn to things like South Pacific sculpture and African sculpture, which surprised me. And now and then I would sort of regress and start painting like [PIERRE-AUGUSTE] Renoir or Manet for a while, but I think that was mainly to do with going out with girls, you know; painting nude girls. There's kind of a seductiveness about figure painting which has much to do with the romantic idea. So I would regress then. My first show, I didn't show the figure paintings, I showed the more experimental things. But I tried to get as much as possible into my work and so I just wanted to try everything. See I'm sort of independent from American problems in a way because I was not born in America, and also, I always felt a stranger in America. I was an outsider when I grew up in Chicago.

JJ Your parents didn't live here?

CO My parents lived here, but they were representatives of a foreign country. They were Consul-General and his wife. We participated in American life, but always at a little distance. We had special privileges because of this position, which allowed me to get into all kinds of places, but always as an observer or somewhat of an outsider. So I always felt quite independent, and as if I were more concerned with creating my own tradition. I was interested in America and I adopted a lot of American attitudes and poses, but only experimentally. I'm always a little bit out of my skin, always a little bit behind.

JJ You still feel you don't quite belong?

CO No. Now this is a nice feeling. I feel fine because now I have my own country, which is what I invented and so it doesn't worry me any more, and I feel kind of happy about it.

JJ This own country that you made has its roots in American culture?

co Yes, but I put it together just as much out of what was inside of
 me as what was outside of me. It resembles somewhat the world
 around me, but then it's very peculiar, too, if you look at it closely.
 It's an illusion really that it's realistic. It's simply that I made what
 I had to make out of what I found available.

JJ Are the events that take place in the happenings – for want of
 another word – is this the behaviour of the people who live in
 this world that you've invented?

co Yes. In the happening, it's almost like the way I make the objects.
 The people participate as themselves to a certain extent, but at
 crucial points they have to behave like I want them to behave.
 But then they have the illusion that they're behaving like
 themselves, because I always pick something for them to do which
 I know that they will be inclined to do. But then I twist it a little
 bit, which is what I do with the objects, too. I take a shape and then
 I turn it a little bit, so that it's somewhere in between the thing and
 my imagination of the thing. When I was a kid I actually had an
 imaginary country, which a lot of kids do, and it was a very strange
 country because I was speaking both Swedish and American.

JJ This was all in your head?

co No. I documented this. I put out books with topographical maps,
 and climate and facts about life in this country. It was very much
 promoting, like *Fortune* magazine, what a great country it is and
 how rich it is and how many people live there. That was a lot of fun.

JJ Was this country constructed according to a system of logic, or was
 it just haphazard?

co Well, how do you construct a country according to logic?

JJ In the sense that when my children play, halfway through a game
 they suddenly decide to switch it and it's all something else, so it
 doesn't have a logical consistency. My daughter will be somebody
 and then at some point in the game it becomes necessary to be
 someone else, so all that is dropped suddenly. I wondered if writing
 down such details as the topography and the number of people that
 lived in it, you were consistent about it?

co I attempted to be consistent. I would forget how many people lived
 in one city from time to time. I also had trouble because it was
 necessary to draw the country over and over again, and to have a

form of the country that was easy to draw. So I had a form that was roughly rectangular, with a coastline of ragged edges which looked something like these sculptures. They're also like little countries.

JJ Do you think they're related?

CO Everything that I look back on in my life has had a formal impulse and this was a formal impulse. In those days I didn't even know there was such a thing as painting. So instead of painting I was drawing maps of countries. Also, it was being done in a typically American matter-of-fact style. Here was a completely imaginary country and it was all being documented very carefully. There's a stage, I guess, when a kid does that anyway; he wants to be like the grown-ups. But this was a very serious thing.

JJ Now, when you're working on a piece like this, is it a conscious extension of this game you played as a child or do you feel, after the event, that there is a connection between them?

CO Oh, there's definitely a connection.

JJ A conscious connection as you're making them?

CO Well, it's a consistency of shape, of line, of preference for colour.

JJ Can you trace a constant thread? You started by drawing maps of countries and then they finally turned into this. Or is it that, in making these, at a certain stage you realised you were doing the same thing you had been doing as a child? Which is rather different; there's a gap of unknowing between –

CO Oh yes, there's a great gap of unknowing. Sure. That's the nice thing when you come back. That's always a great comfort when you find suddenly that you're doing something that you did a long time ago. Then you feel that you have hit something consistent.

JJ You mentioned dreams and I seem to have got hold of the information, probably in one of the books I was reading about you, that at one time you wrote down all your dreams.

CO Yes. I did collect them for about a year. I was looking for consistencies, for the form of my consciousness, the consistent form. If you're an experimental artist the way I am, I never know when I walk into my studio in the morning what's going to happen. The most important thing is to have certainty, because you've got to know what's worth working on, and you look for methods of

certainty, and that's one of them. So, I collected the dreams to see if they would develop any kind of pattern that I could use. And of course, it's depressing to collect dreams because they're so rich and beautiful, and so impossible to transcribe. You get a lot of surface, but you don't get the real feel of the thing. After a year, I gave it up. I did find a pattern, but it had more to do with behaviour than it did with something visual or formal. It became more related to literature – or psychoanalysis, naturally.

JJ Is this something that you took time to study – psychoanalysis?

CO No, I wish I had. I haven't undergone analysis and I guess I really don't know much about it except that sometimes I believe that I understand it quite well, only I'm doing it in my way.

JJ Well, looking at dreams to try and find some recurring pattern is a basis of psychoanalysis.

CO I enjoy reading case histories and dreams, and the way I write up a happening is based on the case-history style. It's terribly factual. You do all kinds of crazy things, but it's all described in a clinical way.

JJ Does it have a beginning and an end, as case histories tend to do?

CO Well, the happening incidents are usually very fragmentary.

JJ You said the other night in passing that you would map the streets of Henry Miller novels. Is this related to your mapping of streets in your childhood world?

CO It probably is, because I'm terribly devoted to maps, which started when I was a kid. I had an enormous collection of maps and it is, again, the form impulse. Also, I suppose it's a very erotic thing.

JJ Why is it erotic?

CO Well, I remember vaguely that to be obsessed with maps has to do with obsession with your mother's genitals or something like that. There is a kind of relation between the map edges and the edges of the vagina.

JJ Really? I didn't know that.

CO I don't even know where this came from, but it's an interesting thought. I guess children get hung up on all kinds of things.

JJ So when you make a thing like this, it has a connection with the childhood maps you drew, on some psychological level it's erotic perhaps, and it could be regarded as some sort of landscape. All these aspects underly the immediate impact of, say, 7 Up bottles. All this is part of it?

CO Yes, but I also feel it's part of the original image. The guy who makes the 7 Up sign – he's involved that way, too, and everybody's involved with everything they do. I'm only doing it my way.

JJ You don't feel that you project these concerns onto the 7 Up bottle?

CO No. I actually believe that form is not an accident. Things have shapes because man wants them to have certain shapes. Form is obsessive. I feel that way about industrial design, too.

JJ And you think those shapes relate to their erotic preoccupations?

CO It's a collective eroticism, I think. In America you feel this especially; people turn themselves on by making objects. When people ride the subway and look at all these objects, they're getting a charge out of it. And the objects are made for that and are very carefully calculated, I think – and also the advertisements, to suggest all sorts of erotic situations.

JJ Would you equate this with aesthetic appeal?

CO Well, I don't know how to define aesthetic.

JJ I'm thinking of Reinhardt, when he talks about art having art values and life having life values. I was wondering if you were saying that really they are the same things?

CO I think it's absolutely just a big mess, a big ball of everything. If you're a good reasoner, you can analyse the thing into parts. But, when I make a work, there isn't any one road that's going to lead to the end of the work. I may start with the most blatant and ugly erotic imagery and wind up in a completely what you call 'aesthetic' solution. And yet that other stuff would be in there. It's all involved and who can separate motives?

But the erotic is one of the guideposts to me of certainty. If I'm engaged with a material in a form that I feel is erotically stimulating, then I feel that I'm on the right track. For example, in using a material like plaster, which is a very suggestive material, there's a pleasure in doing it, which goes back to very basic

pleasures, you know, playing with shit, except this is white shit, and it has to do with sperm, which sort of makes it pleasant to work. And I guess that's all part of painting, too. But of course if I just came out with that solution, it wouldn't be the truth. There's so much more to a thing. I don't want to overemphasise it because it has a certain sensational value and people start interpreting everything that way, saying that he makes ice cream cones but they're really pricks and he makes hamburgers, but they're really c***ts and then it gets ridiculous because it isn't that simple.

JJ But there's a truth in it?

co Yes, obviously.

JJ You mentioned the other night something about scale being of immense importance to you.

co The best way I can explain it is I feel that everything I do should have an architectural natural existence, and there the question of scale is very important. But the scale is not necessarily related to man; it can be larger and smaller than he expects it to be. The first thing I have to think of an object is what size is it going to be? I wouldn't naturally jump to the conclusion that it should be my size. It has to have a scale of its own, which is part of its dignity and part of its character. I imagine that man simply doesn't exist, and I just think of a world of objects, rather than a world of human beings. Like in Antonioni movies where you feel that people are disappearing and there are only the objects left.

I'm going to try to build a car now, and to decide how big the car should be is very important.

JJ Will it be larger than the cars you know?

co I haven't decided because I can't imagine it. I have to build it first to see. I'll try building a scale model. Sometimes you can imagine a thing by using your eye, putting it closer and further away in relation to other objects. Scale is completely relative. Even when you're just sitting in a room, everything is completely out of whack if you think about it. The glass is enormous in front of me and you're smaller than this pad. But people just assume that everything is a size, whereas everything is all different sizes, changing all the time. I'm fascinated with vision, the relation of the tangible to the visible, the idea that things look different than whatever they are.

And that's why I construct things according to my own perspective, and put them into the world, which has perspective because of the way we see, and that twists it all up.

JJ Yes. This is a preoccupation of mine. Books about perception talk about the actual, measurable size of things, but the mind making an adjustment between the thing we know is there and the actual retinal image. This adjustment is going on all the time. One thing I was doing with my students was trying to get them to make a movie of retinal images rather than to recount an experience in film in terms of what they felt was significant. When you fill a kettle, for example, you *think* you look at the tap and the kettle, but actually you see many other things you reject unconsciously; they're on the retina, but that's all. And to somehow break through this barrier of habits of perception to an awareness of retinal images that haven't been modified by your mind.

CO How does it work as a film?

JJ As they do it, they observe exactly what they look at. Then you point the camera at the things they looked at for as long as they looked at them, and you get a film of what they really looked at, not what they afterwards *believed* they looked at. It's almost impossible because when they're filling the kettle the moment they become *conscious* of looking at these other things they break up the normal procedure. In a sense it was pointless, but it was just one of those exercises to get something going, you know.

CO Yes. My happenings have had a lot to do with watching a very simple thing for long periods of time, and that's one of the things that people really can't do. And we have Andy's [WARHOL'S] movies which have some of the same obsession. It's an obsession that's been on the New York scene for a number of years, and people have been working with this and the audiences have turned their backs on it. They just can't tolerate it.

JJ But it's strange how, though it is almost intolerable at the same time, it has a tremendous fascination. I was watching some of Warhol's movies the other night in the underground cinema and really it is intolerably boring, and yet at the same time you simply cannot take your eyes off it. You could go on watching it and watching it. I'm sure I would have been one of the people that sat through the eight hours in that studio.[2] I can't drag myself away.

co I had a scene in 1962 in a happening where people sat around
 a table eating in slow motion. I had the waiter come from the door
 to a table and it took him twenty minutes, and meanwhile we were
 playing this very slow music at a very slow speed and people were
 trapped in this room watching this scene. It would take a man
 a minute and a half to bring something up to his mouth. It was
 a great scene. Finally somebody screamed and ran out.

 If you're sitting in the summertime at the side of a lake looking
 at the water, you can do that for a long time. It's very pleasant.
 But everything is so wrong with audiences in the modern world,
 but especially in America. If you don't do something very simple
 for them, they resent it terribly. So you can't get very far with
 happenings and with films here. It reaches a point where there's
 a novelty value, and people come for the novelty and then they
 can't stand any more, and they just want something new.

jj You don't think it's the nature of the medium? It really is the
 audience? You don't think that maybe the happening is not the
 kind of form which can go on and on, that there's something
 fleeting in its very nature?

co Well, there's argument about that now. Whether a happening is
 a thing that just came along at a particular period, or whether it can
 be developed into something for theatre, and so on. I've been trying
 to maintain that it is a form. At least it is a form that I like to use.
 The way I use it is very natural to me because I have an interest in
 the dramatic and in theatre, and yet I'm not a verbal artist. I have
 to do it through images, and through form and tactile experiences.
 And the happening is the way to do it. I can use water, feathers,
 all kinds of things, and I can also use found objects, which I never
 use in my work, but in a happening I use enormous amounts of
 objects that I just buy because I'm attracted to them without any
 desire to transform them, just to use as they are. And that usually
 is very stimulating. When I'm commissioned to do a happening,
 like in Washington, and they give me something like $800 to
 do the happening, at least $300 is spent in Woolworths or some
 department store, simply buying things that I feel like buying. And
 it's like Christmas for me, you know, it's great fun. That kind of an
 experience is very unusual. You don't spend your money like that.
 You don't go into a store and buy everything you want unless you're
 a very rich man. At least I'm not accustomed to doing that.

But here it's a very serious occupation, you're doing a happening and it's part of the happening to do this crazy thing. You tell yourself that, anyway. And it does work. It's stimulating, which is why I have all these souvenirs and toys. It's sort of serious play.

JJ When you talk about it being an exciting experience for you, recently I read that [ALLAN] Kaprow is performing happenings without an audience at all, as if the whole thing were for his own benefit. Are happenings really just to satisfy *your* desire to create an imaginary world, or do you feel any need to communicate something to an audience? Is an audience a necessary part of it?

CO Absolutely! An audience is necessary, and I certainly don't agree with Kaprow – on anything almost.

JJ Except in this respect, that the moment you get $300 to spend *for you*, it's a big kick to do this, and it's part of the happening.

CO Yes. But you need the audience because the audience is part of the thing, the definition. A happening is a thing that takes place. It's like making a sculpture. You're not playing to an audience, you're not amusing them or entertaining them, you are asking them to participate in the creation of something that exists. The reason for the happening is itself. It takes place. That's the important thing. And to make an object take place in time on such a scale and with so many elements is a very challenging and exciting thing to do. And I expect that the audience, and the players and everybody feels the problem involved and feels the existence of this gigantic object, which will live for only a few days or moments. They're supposed to feel the excitement that goes into the making of such an object.

JJ So, to put it crudely, it is a kind of communication except that the communication is on the level of somebody participating in something and feeling something which you want them to feel?

CO Well, what they feel is really up to them. I'm just arranging this thing. I'm just putting together this gigantic object.

JJ Herbert Read wrote an article about a year ago in which he rather slammed down the pop artists. He said that they had forsaken one of the functions of art, which was communication. I'm not sure that I agree with him because I remember reading a preface by a poet, I think it was Walter de la Mare, who said that the function of poetry was not communication but revelation. And I prefer this really.

co Well, what does Read mean by communication?

jj He was speaking specifically about the utilisation of the formal language of art to communicate something that the artist wants to get across to the spectator.

co I think all pop art communicates tremendously, and I don't mean on a simple-minded level either, but I'm not sure that it's under control. You're not sure whether Roy Lichtenstein is communicating or whether he is just the agent for some sort of communication which is not very specific. I guess that's the problem: the idea of the artist being someone who is saying something or feeling something and being somehow an important person. That's why pop art has made people so angry, because the artist has simply stepped out. And the commercial style is simply a method for leaving the work of art. All Andy [WARHOL] wants to do is to disappear: that's his dramatic, stated ambition. So his silkscreen is a technique for doing that. Actually he communicates a great deal with his electric chair scenes and his disaster series, and I think his work is enormously sad; on the whole it's very suicidal and has a lot to say. And Lichtenstein is the same way. I think the funny thing about the pop artist is that he's shy about speaking out: the whole thing is kind of a mask and people are misled by that. They think that the artist really is trying not to say something, but it's almost like he's shy. Like [JAMES] Rosenquist interprets his pictures down to the last detail, but when you see the pictures you just get a kind of a cold objective sensation.

jj Do you feel you're like this?

co Well, for me, this idea of being outside a work goes back before pop art. I like the idea of a work existing by itself and communication being ambiguous and suggestive, but not necessarily very specific. Or subject to a different time and place and different people. But I certainly feel that my work communicates. It probably communicates a lot more than I want to admit. It's again a shyness, which may be a sort of snobbishness, or a style of the time. I think these works that Andy and Roy have done will probably be re-interpreted and shown to be very full of meaning and statement.

jj Roy Lichtenstein himself says that he thinks of them as abstracts.

co Well, I think that's a little of an affectation. And that's what Rosenquist says, too. He says, 'I started looking at these abstract

painters from New York' and I said, 'why do they have to have colour? Why couldn't they have an image instead of the colour? Why is this? Is it so important to eliminate the image? The image doesn't necessarily mean anything.' So he just put the image there instead of the colour. So he thinks of himself as an abstract painter, too. But I think that that's a little affected.

JJ Roy said that the impact on the level of the subject matter can be quickly assimilated. The joke, for example, in some of those cartoon things dies in six minutes, he said, and if the work doesn't have this other kind of formal abstract quality …

CO Then why bother using cartoons?

JJ It's the ritual that he needs to go through to get himself painting.

CO Yes. But he must be getting something out of those cartoons. And I know for a fact that they change as he changes. Like when he lives with a different girl they change. You can read his whole life story in what he chooses, because he doesn't use chance procedures to arrive at these things. He obsessively picks certain things. And what about these parodies of painting that he's doing now? He can't say he's just an abstract painter. Of course he likes to believe that because that's what gives him strength. He's somewhat of an academic person and that's the idea of tradition again. To be like Cézanne. But that's not the whole story.

JJ It could be that the rest of the story is something very personal to him. And perhaps not very relevant to the spectator.

CO Yes. You may be right. So that's not a question of communication.

[BREAK]

The thing is that one's work always gets overemphasised in some particular direction. Critics who write about my work tend to neglect the formal. And I think that the work is extremely formal and that's very important to me, the formal element.

JJ Now you're saying the kind of thing that Lichtenstein said.

CO Right. But how can I speak about all my motives at once? So I speak about my motives singly, and then find I am misunderstood.

JJ Well, maybe it's asking too much of words. I mean, you do it in the painting, or the object you make, the happening.

CO Yes. Of course poetry can do it. But I get very put out with
 criticism that doesn't concern itself with the beauty or lack of
 beauty of my form. That's a very sore point. Most people if I say
 'Isn't this beautiful?', they laugh. They think that I'm setting out to
 make ugly things, or that I'm fascinated by the ugly, or that I have
 no notion of what is beautiful, and no desire in that direction. And
 sometimes I think maybe I'm the victim of a joke on myself: I go
 through thinking that I'm making beautiful things and actually I'm
 being celebrated for making ugly things. Like the ugly duckling in
 reverse. That's very depressing to me because I would like to be seen
 as someone who – though I take difficult material, not necessarily
 ugly or beautiful, but difficult, problematical – manages to solve it,
 when I'm through with it, as something I consider beautiful.

JJ When you talk about beauty and formal considerations, are you
 talking about the same sort of thing, that you find in a Cézanne or
 a Mondrian, or a cubist painting? Some kind of timeless, painterly,
 pictorial quality which is really what art is about? A work by
 Oldenburg is about all your motives, but art by itself has a common
 quality. Is this what you mean by beauty: this common quality?

CO Yes. I think there's no way to talk about this except in simple terms
 because it's an impossible subject, beauty. You have to believe that
 there is a consistency of form which man has returned to. What
 it's beautiful in relation to, nobody knows, but it's something that
 gives him satisfaction. And man seems to go between agitation and
 emotion, and then order and serenity, and there are different kinds
 of beauty, but usually what's thought of as beauty is the restful –

JJ The orderly.

CO The orderly, the serene. And perhaps that's the element I'm talking
 about. That if I make order out of things, the way Cézanne would
 go into the romantic, luxurious woods and make order out of it
 – there is a certain way that man likes to see proportions and you
 can't disagree with that. You can play with it, you know what the
 golden mean is, and you can push it a little bit this way and that
 way, but you can't really escape it.

JJ Fundamentally your attitude is a kind of classic one, isn't it?

CO Yes. Though I start in a great chaos and turmoil usually, I come
 out with a very classical statement which is my whole theory of
 living and working. I should live in disorder. I have to have disorder

and I have to upset myself. If I don't have disorder, I have to make disorder and it becomes more and more difficult to make disorder. It was easy when you had no money, but now, for example, when I lost 40 lb, that was one way of creating a certain change, over the summer, just to see how I would feel being light, lighter.

JJ Did you consciously lose?

co Yes. I always have to invent some kind of change to upset me. Sometimes you cease some very stable situation, like if you belong to a gallery and they've taken good care of you, and you one day say, 'I'm leaving,' which produces tremendous tumult and confusion and misunderstanding. I've done that several times. I haven't always left the gallery, but it's created turmoil which has produced all kinds of funny results. And it's not nice to play like that with reality, because most people think that you should have sensible motives. It's very arbitrary, like tipping the boat over. It's kind of dangerous because if you start doing that too much you're going to be in trouble.

JJ Yes. But the alternative could be …

co Death. Absolutely. It's a thing that you have to do. Say when your married situation is very stable, we have to think up all the time ways of changing our married life, to keep that alive. I'm so aware of change. I use things up so fast and every time I've done a show so far it's been an entirely different show, it's explored something new. It's something I sort of pride myself in doing.

JJ This is rather like what [PABLO] Picasso says about the necessity to keep on destroying – pushing away, in a horror of copying oneself.

co He didn't wind up so well though. He copied himself a little bit.

JJ But this may be his inescapable nature. Nevertheless he feels the necessity.

co Yes. I like his rules. His rules are good. But of course you must always end up with some kind of order. See even this apartment is constructed that way. This is a very orderly part when it's cleaned up and then back there it's utter disorder. And I go between these two poles and that's how I get things done.

JJ Yes. About mapping the Henry Miller streets. Here again there's something relating to making order.

CO I didn't go into it that much, and the neighbourhood has changed
 quite a bit. It's across the Williamsburg Bridge. I guess if I read
 about a place I always want to make the thing tangible and see
 what it really looks like.

JJ Like your imaginary world. Making a map.

CO Yes. But I didn't actually draw it up. That's a thought. There are all
 kinds of arbitrary ways to start a work of art. That could be a start
 of a whole series of paintings. Like Jasper [JOHNS], with his flag.

JJ Yes. Do you think this was arbitrary?

CO I think so, yes. In the only way a thing can be. We talk about
 personal motives, but I always wanted to see it that way anyway.
 And there's the story about the beer cans. [WILLEM] de Kooning
 said of Leo Castelli: 'That Leo is such a smart salesman he could
 even sell a couple of beer cans.' And that's supposed to have been
 the arbitrary thing that started Jasper on the beer cans.[3]

JJ This tendency for pop artists to choose subjects like the flag and the
 vulgar images of every day, to admire the corny – I was wondering
 how far this motivated you, this selection of 7 Up bottles simply
 because they are in a sense unadmirable? It is a sort of camp. And
 the idea of you making cars. I remember my painting master saying
 that you simply cannot paint cars. It's all right to do stagecoaches,
 or the hansom cabs of the impressionists because these somehow
 have been absorbed into art, and while a contemporary painter
 wouldn't paint a hansom cab, a car cannot be painted. And there's
 a perverse desire the moment this is said to paint a car.

CO To paint a car, yes. In the first place the camp idea has never hit
 me very hard, and when I decided to do a car it's because I really
 wanted to do a car. I remember when I was a kid that I made cars,
 and I'm selecting a particular car that I built when I was a kid.
 I built scale models. So it's just something I'd like to do. And then
 of course people are going to say, 'Well, look isn't that funny, a 1937
 Airflow, and isn't that very campy and sweet and he's bringing back
 the 30s.' But that's okay if they want to say that.

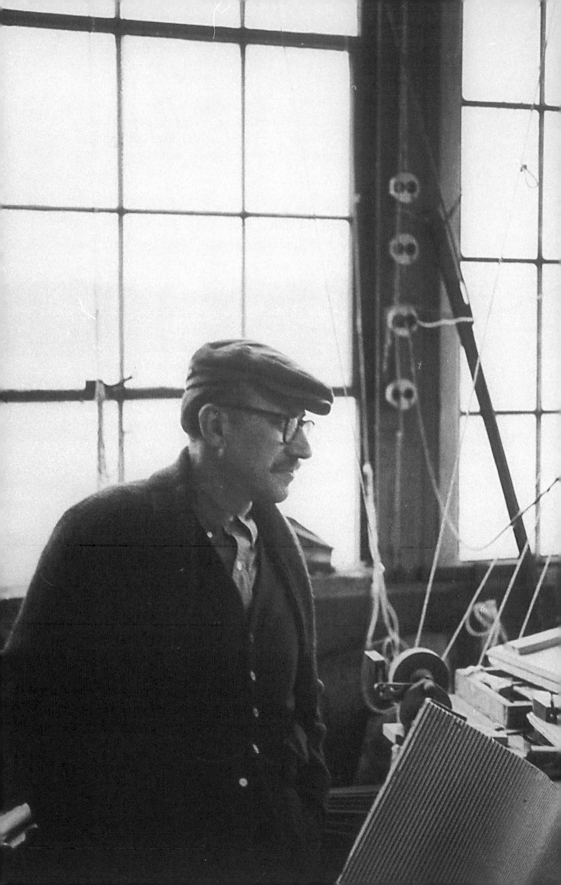

SAUL STEINBERG

Saul Steinberg began his career as a cartoonist in his native Romania, fled the Nazis, served in the US army and began to work for the *New Yorker* and other American magazines. But he also established a career as an exhibiting artist, appearing in 1946 at the *Fourteen Americans* show at the Museum of Modern Art in New York, with Robert Motherwell, Isamu Noguchi, Arshile Gorky and others, and having many subsequent solo exhibitions, including at the Betty Parsons Gallery and Sidney Janis Gallery. His work, which was full of visual paradoxes and played with what drawing could do, defied categorisation, as he admitted. He described himself as 'a writer who draws'.

This interview took place on the afternoon of 12 October 1965 (4pm) in his apartment at Washington Square in Greenwich Village. This was minutes' walk from Charles Street, where John Jones's family were living. Steinberg (then fifty-one) and Jones were neighbours.

Steinberg spoke with a Romanian accent, with rolling 'r's, notably in the word 'art', and, although his English was fluent and exact, with the occasional mispronunciation: 'realm' as two separate syllables, for instance, or Trojan with the 'j' pronounced as a 'y', before he corrected himself.

JJ I once heard an interview in which Adolph Gottlieb[1] said that in the Forties Americans felt that they were no longer the country cousins of art, having to go to Europe to get a sort of certificate to practise art. That they in a sense were defining art freshly, newly. That European art had been discarded for the sake of a new definition of art. His actual words were: 'I started to do something in my work and I didn't care if it wasn't art. I hoped that it might become so but nevertheless it was some form in which I found I could express myself.' How far do you feel that contemporary American painting is essentially different from the European tradition? Or do you feel it's an extension of the same old values?

SS What happened was that the Americans decided to take [THE] history of art in their hands. This is the essential thing. They were ghosts or victims of somebody else's script. So the Americans discovered [THE] history of art, and they decided to exploit this history of art. Something that has always happened here: the news is caused by journalists. And so now the artists have decided to take [THE] history of art in their hands. The museums started to do that afterwards; the museums decided to cause art to happen. And now there is a complete Vaudeville; the whole thing is based on how to create history, and art is more history than art. One never questions this thing. It's natural. So what happens in America was done on a larger scale and to the point. We brought – *we*, huh – well, let's say we, brought organisation to the thing.[2] There was nothing amateurish about making a gesture, and being absurd. And we brought witnesses along. We brought photographers.

JJ When you say that artists took art history into their own hands and you used the word Vaudeville, do you mean in a sense that art ought to have natural growth, and this was an artificial growth?

SS Yes. I think that art has to do with the creation of a very curious, unique sort of personality. This is done slowly and mostly through the using of errors and weakness. While the so-called regular people are positive, they are favouring qualities only. The artist has this – that is unreliable and antisocial – the using and the favouring of non-qualities. This is why the strangeness, the uniqueness of somebody who comes out this way, like a curious architecture that starts wobbling and going this way and that way, eventually ends by being solid and unique. An artist who becomes a student of art history, and an art historian, becomes a planner of his strangeness, and there is no such thing.

JJ Yes. I agree. When you talk about favouring qualities and favouring non-qualities, though, I don't quite follow this.

SS Well, it's like the regular life of people. If one has a certain talent, this talent is exploited. Let's say, one proves to be patient and persuasive, he becomes the insurance company salesman and he makes progress, he becomes the director and the president. While an artist who exploits his talent is usually a mediocre artist. He becomes an illustrator, whatever. In all cases I notice that artists who have talent feel handicapped by it, and try to recreate themselves by forcibly getting into clumsiness, because clumsiness makes the reason to start all over again. Good artists have a very moderate amount of talent; they have no talent at all some of them. The great inventor of non-talent is Cézanne … in a sense [EUGÈNE] Delacroix, and [VINCENT] van Gogh of course. One of the corniest games of the people who have talent – their ambition is to paint the flickering of fire reflected on people's faces in darkness, sunset, the sun, all these things. And van Gogh tried to paint these things and what saved him was his clumsiness, his inability.

JJ It's interesting that you should say that because this was one of the strong features of the teaching that I received. It was almost accepted that anyone who had immediate facility had the biggest problem of all. The clumsier ones were the ones who would find their own way some way or other, and people that already had a way had to somehow destroy it before they could begin to draw.

SS Sure. So what I mean by talent and exploiting talent is the knowledge of doing something that you know already.

JJ And since you think this is not a very profitable thing and produces

the mediocre, would you say that generally contemporary art in the States now is mediocre, because it has cultivated its talent?

ss No, it depends on an artist – art after all is still done by an artist – and the way one does it. Where now we have this crookedness of the museum and this wedding between art history and the museum and the public, you had at one time other handicaps which were just as serious – the salon, the demands of the rich. I feel that there is something more dangerous now because while the enemy was visible before, now it's of the nature of a fifth column or Trojan horse. And, still, it's more interesting. Why should one fight the visible monster once you get accustomed to the fact that the monster is a pleasant-looking devil? So in the end you can't say it's good or bad. It may be good; it's probably good. Certainly it's more amusing, what goes on now. There was something very sombre in the galleries ten years ago even. Now it's gay, it's silly. It's a transition. This is a place of evolution, America. We demolish skyscrapers a few years after they've been made. They're obsolete, voom, it's a novelty.

JJ When you say it's transition, do you mean this mood of gaiety and silliness and success and affluence, for the artist will persist, or do you see it being dropped, like one talks about certain periods of history as being particularly gay, then came some dreadful tragedy?

ss Oh, it's going to change. It's natural. Everything changes here. Everything is going at a great pace. Not only this, the tendency here, and in the rest of the world, but more here because there is something like a lack of tradition and the belief in what's called – in baseball we have an expression – a 'money player'. The money player uses his reason; he's very good when he's needed. And the country is full of this sort of thing. People see what's good and what's bad, and what's practical and what's not. In a way it's applied in art, too. They abandon railways in favour of airplanes. They will not remain faithful to something, they are not sentimental. So art got involved in a different sort of realm. It has become a commodity, but this has always been everywhere. During the movement, during the generation, the ones who saved themselves are the usual one or two who are the artists; the rest is culture and this is something the country needed. I think this involvement with the history of art in America was parallel with the involvement with history in general, that America got stuck with when it found itself being the winner, responsible for the world. It was a natural

phenomenon. This country, becoming a number one power, had to become a number-one power in arts.

JJ The situation made the artist, found the artist.

SS Of course, the artist lives in a cultural and moral atmosphere. You can't have art isolated. The essence of art is society and the philosophical things that go with –

JJ I was talking the other day to Ad Reinhardt who holds exactly the opposite view; that art and life must be kept separate, that when one intrudes upon the other art becomes impure in some way. He has the idea, which one associates with the academies or with the classic, that art is something to be served by the artist, something which is very much superior to the rest of the artist's life, and that he must somehow strive to make things which are not pretentious, which are not utilitarian in any way, which don't serve anything but art. And consequently he paints pictures which are almost black, as you know. It's an extraordinary, pure view, and yet he finds theoretical justification in statements by countless artists of the past which he seems to see lead to an absurd but logical conclusion.

SS He is most involved with society because he has been the great educator of the art lover. He forced people to look. He educated them in looking at something that could and should be overlooked, except that it's in a gallery. He went so far as to make it difficult to see. He always sneaks in some off-black, so that one is aware there is something to look at. In this sense, he has been a great educator and his function is of a philosophical nature.

JJ Yes. But it's an art philosophy and not a life philosophy. I find it hard to see a distinction, but he makes the distinction quite definitely; there is a line drawn, a gulf exists between the concerns of life and the demands of art, which he thinks are separate.

SS But no good painter has existed who educated his public in Tolstoyan terms – of telling them something. This is the education of the eye. It teaches the eye to use its poetry, and in this sense it's a moralistic thing. But that's what I meant. You said, in a simplified way, that Reinhardt holds in an academic way that there is no possibility of painting with a public in mind?

JJ He said simply that the concerns of life, one's subjective concerns, social concerns – you may have all these as a man, but as an artist

you must leave these outside the studio, and that you prepare on the easel an object which serves only art and none of these concerns.

ss Oh, I agree with you. This is how it should be. This is how it is, but this is implicit in the impractical and antisocial nature of the artist. No matter how hard-boiled and crooked some of them would like to be, they're still innocent, because if they had any sense they would go into something else, where they would be much more successful. But any sort of quality that is thrown into art becomes pure quality. The act of working, itself, moralises one. So even if one started, as it happens often, with all sorts of intentions which may be low, one slowly becomes a different sort of man, for the simple reason that the working itself is a barometer of your right and wrong. As you work, you are conscious of how honest or dishonest you are. So working itself is an educational, moralising process.

JJ Apart from these observations about the nature of art – to go back to the question of art in America, how do you fit into the scheme? You said the other night you weren't an artist at all, but a writer.

ss Oh, I consider myself more of a writer, but I use the medium of drawing. So I am on the fringes. I am a writer, but I don't write. I'm not a painter. I draw. Am I a draughtsman, am I a cartoonist? I don't know, it's hard to say what I am. I'm not even funny any more. I used to be funny. It was a pretext. I still am funny but I am playing now with the drawing itself, not any more with the situation where drawing was a means of representation of something. I am in a region where I feel that I am alone and I don't need to explain myself so much, but I feel the uneasiness of the specialists who don't know how to catalogue me. I don't behave like the regular people because most of them behave in groups and they reach one or another of the fraternities, and they can be then called Number One or Number Ten in that file cabinet. But I wouldn't know myself how to explain what it is. I feel that my work is of the nature of the artist if only because my work is of a poetic nature.

JJ Did you find yourself turning into this person? Or were you always like this? Your earlier drawings, as you said, were more like the kind of thing one expects a cartoonist to do. Capturing funny situations involving human beings, which you recorded with a minimum of linear treatment and technique, but they have changed, as you say, to become sort of jokes about lines sometimes, or about forms.

ss Yes. Well, it's like our life, too. In the beginning we build up
 ourselves to fit into society or to understand the world we are in,
 the social world, political world. And later on we are involved
 in life itself outside society. The essence of it. I guess this is one's
 evolution. If I'm now concerned with the drawing itself and I play
 with it, it's maybe a thing of a metaphysical nature. But this I feel is
 the natural evolution of people, of artists, too.

JJ When you say you play with the drawings, do you feel any
 obligation to serve any classical formulae or attitudes about art? Are
 you conscious of conventional composition, or any of the things that
 might have been taught in an art academy? Or do you play with
 them in a wholly personal way, without reference to art principles?

ss Well, I can answer yes or no to this thing. It doesn't matter. I don't
 know, I had no official training as a painter. I don't know about
 composition. I'm an architect. This was my training. And I frankly
 never think of these things, of composition, but it's part of the
 whole thing. It's like if you ask me whether the water I drink is
 liquid or not, well, it's by definition.

JJ I was really fishing for some kind of interest in art theory, but put
 it like this: do you find much sympathy with, say, the surrealists,
 that their attitudes about art influence your thinking about how
 you draw? Or do you feel separate from them, and if there may be
 some similarity between what you do and what they did, really it's
 wholly arrived at quite independently of that movement? Would
 you associate yourself with the surrealist movement?

ss [LAUGHS] Let's put it that way. No, not at all, no movement at
 all. For me the surrealists are like the Egyptians, or Aztecs. They
 are something I read about. So, why the surrealists and not [THE
 RUSSIAN AUTHOR NIKOLAI] Gogol? No. If you mean to ask by this,
 my influences. Everything is influence. And not only what's called
 art, but things that derive from art or cause art, it's a mixture of
 things. Sure, there are all sorts of people that I admire, but there
 are so many, so many, practically everybody.

 I admire so many people because I admire not only the ones that
 we all admire, but I admire things that are not so admirable like
 lousy paintings, primitives, cranks, ugly drawings, insane things …

JJ Is there a very bad painter you're particularly fond of?

SS No. Not that I can think of.

JJ I mean you don't – you wouldn't – I mean I can imagine someone having a passionate interest in some obscure Pre-Raphaelite,³ for example, just because his painting was so odd.

SS No. No. I put them in the right place, whatever they are. What interests me, what I like, what I admire, is sometimes I see in a painting a person. I can look at some drawing or painting and read the graphology of the picture, then I see a beautiful, harmonious character who made this thing. And what I want to like and to admire is the strange, unusual type of man that made this thing. So in the end, what I like to look at is how people invented their professions and their lives. Somebody who had this passion for the confetti, for the dots – [GEORGES] Seurat. I look at Seurat. I admire him very much. I wish I knew more about his life. Some biographies came out – nonsense, he appears to be like a professor. There must have been something very special about him.

JJ Signac wrote about him, but mostly of his period, not of the man.

SS Yes. Well, these are impossible, they are all lost. And if anybody writes a biography they try to give you a few facts, and then they invent something based on how they imagine somebody who made dots would be like. And it's not so. These people are strange; there is a combination of right and wrong, something delicate, something – well, these biographers tend to make everything into one level, make a success story out of it. But the example of Seurat, I look with interest at this beautiful thing that comes out of him. What's essential about the good people is that nobody is like them. While it looks like Seurat could be imitated, he can't. Nobody can do it.

JJ Signac is an obvious case of someone who tried to work like Seurat.

SS Yes. It's obvious. The same quality – strange, two people of dots in a way – Bonnard. [PIERRE] Bonnard has something very special. When I enter a gallery where there is a Bonnard, it's the first one I see. The more I come to it, the more humble and unimportant it looks. And then again it looks majestic, it looks beautiful, something angelic about the man. Then there are the mean ones.

JJ I know exactly what you mean about Bonnard.

SS The sort of mean people, more like the anarchists of art, like [GIORGIO] de Chirico. His pencil drawings are beautiful. It's sort

of a pastiche he is doing, satire about art, very interesting. They're made with taste, with amusement. He must have gone through a nice period when he made these things. Later on he became cranky.

JJ That's an odd case of an artist who became cranky and less interesting. Usually it's the other way.

SS Oh, he's always been interesting except for a few horses that were really ugly. Even the flat still lifes that he made, those Roman landscapes with his self-portraits; there is something clownish and disrespectful about it [THAT] I like, like the man still had some sort of a freedom. Sure, he is a cantankerous man; he turned against himself and against art historians. It happens. Another one who is of the same nature – Derain. [ANDRÉ] Derain also was fishing here and there. These people did one thing that's admirable: they were not faithful to the role assigned to them by art history. And they appear to the art historians like disgraces. This is probably one way they had of defending themselves against mummification. In the end, the art historian is the embalmer. And the man who rebels is the one who doesn't want to be a cadaver, but wants to continue to make mistakes. The art historian says, 'Hold it! It's perfect' [LAUGHS].

JJ Yes. The other anarchists, the self-confessed anarchists, the dadaists and so on, these are Egyptians for you, are they?

SS Well, the difference between the dada gesture when it was done and the status, the celebrity it's acquired through art history is immense. It was done out of pure boredom and innocence. For good reasons, too. But if they had known how important it would be, they wouldn't have done it. Any prank is good when it requires little effort. An elaborate prank, it's worth it sometimes, but while it's worth hearing about it, it's not worth doing. What is consoling about the dadaists, is they were doing it as an amusement.

JJ I was thinking in connection with your work. It does seem that there is a streak of crazy whimsy in your work – I can't really find words and you probably won't like these words, but that's the nearest I can get – an oddity about some of your drawings which I think is irresistible, and this relates it, a little bit to the oddness of surrealism and some of the prankishness of the dada people. But at the same time there has been a certain strain in your work which is more like serious social comment; observations about the way

people are and the way they behave – as if you were taking a strong attitude for or against them. Now that I've said this I can't think of an example. Yes, I can. I remember some drawings of women dressed in cowboy outfits. I think these drawings could be read just as drawings, in a sense rather like Picasso drawings, some of them, or they can be read in the same way that some of [PABLO] Picasso's drawings can be read, but at the same time they are strong social – social comment is not really quite the right the way to put it, but –

SS Well, it is, it is, it's –

JJ – a kind of observation about the folly of people.

SS As I told you earlier, it was my way of explaining to myself this world, and the strangeness of America when I came here. I saw these things, they had the quality of unknown territory. I was like an explorer. These things I drew had never been drawn before.

JJ Only recently pop art has taken them up.

SS Pop art took it now, but I made these things that looked not like reality but like a work of art, so that by copying them I was copying a thing that was invention, a collage, if you want. And it was new. It had never been done before. But to go back to this thing about, on one side, a certain concern with the drawing itself, [AND] on the other, the social aspect of things. That's where my nature as a writer comes in. I don't think of myself in relation to the surrealists or dadaists and so on, because they were concerned always with the canvas more than anything else. Where literature comes in is if you think of another sort of influence that could be stronger – [JAMES] Joyce, for instance, who has these two parts. The social comment is the camouflage for his words, for the construction of phrases, and so on. And the dialogue sometimes is, you could say, abstract, although it pretends to be social comment – abstract in the sense that it's a poetic, verbal thing, and has to do, or not to do, with people. It's a mixture. One goes from one thing to another. The same thing goes with Gogol.

JJ So you feel that this is a serious part of your work – this social observation thing?

SS Oh, it used to be. Now occasionally I look around with amazement.

JJ Perhaps you've adjusted to America too much now to feel like an explorer any more?

ss There is something of the – you see the writer who observes has always to do also the labour of the journalist; he has to deny himself certain things. If I look outside, and if I want to do something that is exciting for what it is, then I have to deny myself all sorts of pleasures of improvisation. I have to subject myself to discipline. Sometimes it is very beautiful, I enjoy it. The last time I did things like this was going to Russia and drawing the muzhiks.[4] [INTERRUPTION FOR DOORBELL] Would you like a Coke?

JJ The social observation thing and the social commitment in your work, is this anything like Ben Shahn?[5] I mean, do you have a political attitude, or is it simply the attitude of an explorer looking at the folly and the whimsy of the world?

ss If you want, this last part that you said it's better. But *political*, let's leave it that way. You don't have enough tape there for my answer.

JJ Yes. But do you have strong political views?

ss No, not in the sense of wanting to do something about them through my – my constant saying is that what I am doing is political par excellence, and that anybody who wants me to be didactic and explicit would like me to lose my time. This in general is the bother that people on the outside – art history, committees, trustees, countless busybodies – want the artist to participate in directly and this is the wrongest thing possible because we are not educators, not directly. We are educators in a higher, much more important way. So we should be left alone as much as possible, except that some sort of remorse comes and occasionally we participate. We do things, but it's in the end a natural thing that comes over people, like [LEO] Tolstoy's desire to be a preacher only and stop writing, yet he wrote all sorts of nonsense while he was trying to be a do-gooder. I don't think we should be do-gooders so much.

JJ Do you think this is a shortcoming in, say, Ben Shahn's work?

ss Not a shortcoming. It's his nature, it's his climate, and if he does it naturally, he should do it. Another artist who lived and could function only out of a spirit of revenge was George Grosz. As soon as the object of his anger was taken away and he tried to dedicate himself to beauty, he was not happy. So good intentions do not lead to anything good. But some people have in their nature to work and be happy with good intentions. That's what Shahn is doing.

[THEY AGREE TO BRING THE CONVERSATION TO AN END.]

ss Now will you give me a script of this thing?

[THE TAPE IS TURNED OFF, BUT WHEN IT'S ON AGAIN THEY
BEGIN DISCUSSING MISTRANSCRIPTION. STEINBERG GIVES AN
EXAMPLE OF A MISREPORTING OF SOMETHING HE SAID.]

JJ What sort of misunderstandings?

ss Things that were vulgar, like the translation of Jugendstil[6] into Ugo
Stille,[7] a friend of ours, a journalist. I was saying that the great
father and grandfather of the art nouveau, and Jugendstil, was the
smoke of the cigarette. That was a great influence. They were great
observers of these forms. And of course nature and japonaiserie,
and so on, but it turns out that the grandfather of the art nouveau
was Ugo Stille, this Italian journalist! It was a translation of
Jugendstil. A complete nonsense. So it has to be remade and during
the process of remaking, of correcting the errors, I changed my
mind and I have maybe a better idea, so it ends that I rewrite it.

JJ Well, I will make a transcript of this, but it may not be immediately.

ss You can eliminate all sorts of nonsense.

JJ You would like me to cut out all the hesitation?

ss Sure, it has to be, all the errors of expression; it should be simplified.

JJ One of the extraordinary things I've discovered doing this is that
there is an unbelievable gap between the actual experience of
listening to someone talk to you whom you look at and you see
their expression, and so on, and the cold word on the page. I was
talking to someone the other day and I was fascinated, he seemed
charming and interesting. Yesterday I tried to transcribe about five
minutes of the talk, and after crossing out nearly three minutes
which were false starts and hesitations and qualifications, which he
afterwards dropped, what he said in the end was nothing at all. It
had all vanished and yet watching him try to find his way through
the idea really was interesting, and it also communicated a lot, too.

ss Sure, this is the great gap between the spoken word and the written
one. The spoken word is reality. It's like if I look at a magnificent
landscape, I'm taken by it. That's the spoken word. The written
word is like a drawing or a painting of the thing. So if you admired
this landscape, if you were taken in by that speech, you'd discount

all sorts of things like the temperature around you, the light, your wellbeing, the influence of your digestion, what your eyes said – this other world of the written one has to be a very different one.

JJ Perhaps a great deal is lost in the way of thought – or, is thought the right word? – ideas somehow, simply because we tend to communicate in terms of writing when we treat an idea seriously, and so much is said in conversation by real people, as you say, the real landscape.[8] I was talking to Ad Reinhardt the other day. His statements on paper seem to be severe, dogmatic, logical and absurd, stark. But when you talk to him, he is gentle, thoughtful, persuasive. It's quite a different experience to read what he said, almost an opposite experience – it's not like reading him at all. It's like talking to a priest, where the writing is like talking to a scientist.

SS That's a perfect description of Reinhardt. He's both. He's a professor; he is accustomed to speaking. This is a different race of people, the ones who translate, who edit in their mind, and transform the spoken word into the written word, because they have made a certain order in their head. This is the case with people who lecture and teach, or with writers who note. But in general, talking to people at random, the speech – it's like a continuous fall from an abyss, from one branch to another, grabbing this and that, and one plunges into talk without having more than a suspicion of an idea. It's not at all like the speech of the specialist.

JJ Have you a preference for expressing your own ideas outside of your drawings? I mean do you find that given three days to talk about something you really feel you come to say what you mean?

SS I think that speaking is of the nature of the theatre. Sometimes I perform my part well. And other times I don't perform it so well. I'm intimidated, or I get stuck, so it has to do with how I feel; it's not premeditated, it's an animalic thing this business of talking. Sometimes I am saying something with great pleasure and freedom and it's only because there is some pretty girl who is watching and I perform for her, sort of an act of seduction. Other times somebody puts the hex on me and nothing good comes out.

JJ Does this put the hex on you? This thing [THE TAPE RECORDER] ?

SS Not really, no. It's sort of mild. In general the machine puts the hex on me. I hear the tape and I hear those long pauses between brooding and thinking and figuring out what to say next ...

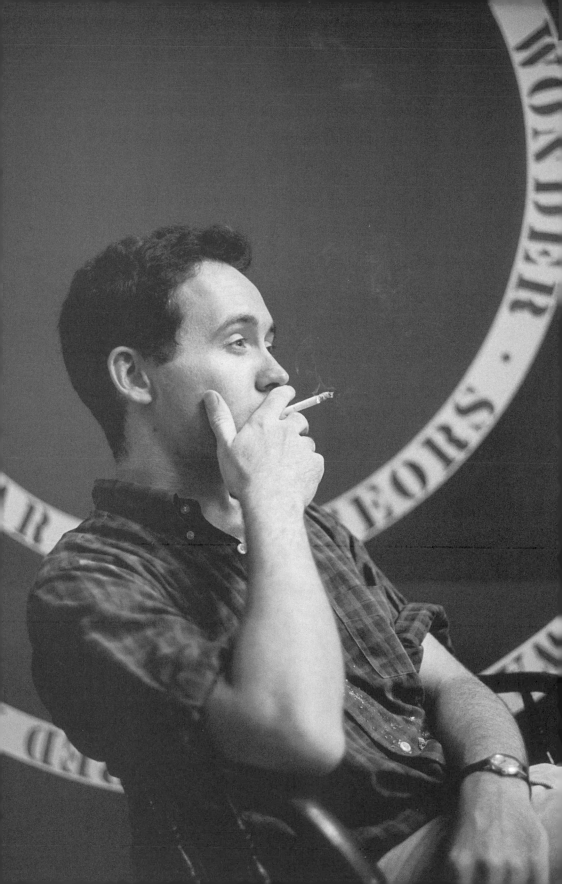

ROBERT INDIANA

Robert Indiana, who called himself a 'sign-painter' and an 'outsider', was regarded as a leading figure of the pop art movement, though he later said he didn't much like the term. Born as Robert Clark and raised by adoptive parents in Indiana, he took on the name of his state in 1958. He served in the US Air Force and studied in Chicago, Maine and Edinburgh. In the 1950s he moved to New York and lived in an artists' community in Coenties Slip on the southeasterly tip of Manhattan, where he collaborated with Andy Warhol on a silent film portrait called *Eat*, which showed Indiana eating a mushroom.

Indiana exhibited in group and solo shows in New York in the early 1960s. He became known for his assemblages with wooden beams ('herms' as he called them), his sculptures and paintings stencilled with words and numbers, sometimes incorporating literary and political references, and his sequence of paintings entitled *The American Dream*. He designed a six-metre *Eat* sign with flashing lights for the New York World Fair in 1964.

When he met Jones on the morning of 14 October 1965 (11.30am) in New York, Indiana had recently turned thirty-seven. It was just before the world encountered his iconic *LOVE* image, which first appeared on a Christmas card for the Museum of Modern Art, New York in 1965.

Indiana's voice was gravelly, and he had a habit of using his interviewer's name. Particularly, I suspect, when he disagreed with him.

JJ I'll try and ask specific questions so that you will have something to bite on, but what I'd like you to talk about is how your work relates to the European tradition or, you know, in your case, how it doesn't. What are the characteristics which you associate with the European tradition, which you reject? Can do?

RI That's a pretty big bite. I suppose one of the things that I feel sets my work apart is a matter of, maybe what you would call 'painterliness', in that I've never felt myself to be a painterly painter. Of course, if I am it's of a style which I feel is not very common to the European manner. Otherwise as far as the long picture goes, I suppose everybody falls into some kind of relation with art, but the immediate thing is where I don't feel any link at all. And that it's completely broken. And this is probably because of my age and my experience in Europe and New York, in that all those things which were exciting about European painting had pretty well subsided and pretty well died by the time I came of age myself.

JJ But you also said earlier on that you didn't belong to the abstract expressionist thing.

RI That's just age and circumstance. Because when I came to New York all those involved in the abstract expressionist circle were older, they had been here longer, they had had actual contact with the Europeans during the war. I had nothing of this at all.

JJ Some artists visit Europe and come back with some of the attitudes that European artists and painters have brushed off on them. You don't feel that you were touched in this way?

RI Well, that was circumstance, too. First of all I was in Europe mainly to finish out a formal educational programme. I was at the

University of Edinburgh finishing up academic work for a degree from the Art Institute in Chicago and there wasn't any very good reason for doing that except it was just a thing to be done. A fiscal thing enabled me to have a year in Europe, which I couldn't have had otherwise. I came into contact with almost no artists. In Edinburgh I studied for a short time at the art college, but there didn't really seem to be very much going on there at that time, and even in London, it was just at the tail end of the kitchen sink, and that certainly wasn't a terribly exciting time in London either.[1]

JJ Tell me about the American Dream.[2] I don't know what it is.

RI The American Dream?

JJ Mmhmm. The phrase that they use.

RI Well, it seems to be a kind of obsessive thing in this country because everybody is always talking about it, mainly on radio and television, so that it's a cliché, but it's a cliché which seems to affect everybody. Everybody feels there is this American Dream and it's always the business of the land of opportunity, where the poor man can become a millionaire and so forth. It's basically a materialistic business and I suppose when I paint the American Dream what I'm doing is reacting to that materialism and the lack of any real value to what everybody is so proud of in this country.

JJ So your paintings then do represent this kind of ironic comment or direct criticism. [PHONE RINGS] Could you talk a little bit about the words which you use? Isolated words: 'eat', for example, recurs.

RI Well, most of this aspect of [THE AMERICAN] *Dream* paintings, John, this is from my own private experience. However, knowing that it's shared by everyone else in America. 'Eat' is an obvious comment on the materialism. In my own life, it's autobiographical. My mother used to work in restaurants and had her own restaurants, and somehow, growing up in Indiana, eating just seemed to be one of the most important activities. There didn't seem to be very much more, and there's a kind of obsession about it. And then again this comes into the American Dream, the preoccupation with our standard of living and how we're continually made aware of how fortunate we are, and how rich we are and how many good things there are to eat, even when you're poor and so on. The other words, like 'die' – I was raised part of my life as a Christian Scientist and there's this, in this religion

and other aspects of the American character, this preoccupation with death in a different kind of way. And 'hug' and 'err' are a little bit more personal, just my own ideas about preoccupations in American life. This erotic and this romantic business is so exaggerated in America. And 'err' just refers, I suppose, to the Puritan situation and that is: we are so sure that we never make mistakes in this country and everything that America does is always right. And this is just, again, I suppose what you call an ironic comment on the situation.

JJ Yes. Don't you feel there is a kind of paradox in your conscious non-European Americanness and the fact that your paintings do attack the American way of life, the American Dream attitudes? This is an exaggeration, but you assert your Americanness, your name 'Indiana' is taken –

RI Taken from the state that I was born and raised in. I don't know, John, in relation to the European concept, why no one in Europe – given such a richer artistic background and so many more painters – why something like this never transpired there, but obviously it didn't. And therefore if one's going to make an original contribution, it's apt to *be* original.

I would much prefer to pursue what I'm doing than to hark back to something that has preoccupied the Europeans. I mean, there are Americans of course who studied in Europe and particularly Paris, and some of these are my own friends, and in their work you can see influences from the French, but I never did and I'm very happy that my work is not concerned with those things.

JJ Yes. What I mean is that the paradox resides in the fact that you are happy that your work isn't concerned with those things and yet at the same time it is a withdrawal from an American situation.

RI A withdrawal? I thought it was an engagement.

JJ Yes, perhaps that is true, but it's an engagement in a hostile sense.

RI No, I don't mean it to be hostile. I only mean it to be illuminating or instructive. I'm not antisocial. I hope that I would be pro-social. I mean, of course an artist withdraws because he has to, otherwise he wouldn't be able to get any work done. But I'm not against society; I'm really for society. And all my comments would be to make society realise what it's up to in a passive way. I'm

not a crusader and I don't take part in barricades and street demonstrations. I hope that it would only be effected through my work.

JJ Yes. Well, the criticism of society that is effected through your work, is this the raison d'être of your work? Do you paint your pictures as criticisms of societies, or do you feel that there are other issues in painting (before you said you weren't a painterly painter) other painterly values which take precedence over this social comment?

RI Well, what I feel my work entertains – and it's an asset – is a visual situation. I wouldn't call it a painterly situation, but I would certainly hope it is a visual situation, and visual things to me are the exciting things, and it's not necessarily paint on canvas. I've made murals that I haven't even touched myself, I've merely arrived at the concept. This to me is what excites me about art, and not the act of putting paint to canvas. And of course that's what separates me, I think, from the European tradition – I'm not saying necessarily the English, but the continental at least has always been this sensual delight of applying and touching and feeling and sculpting, and moulding, and this preoccupation with touch. It just doesn't mean very much to me at all. Maybe this is part of my Americanness.

JJ Yes. Well, I don't want to argue you into a corner – this isn't a cross-examination – but it does seem to me that just this studio and the collection of things you have in the other room, reveal an extreme sensibility towards objects, for want of a better word, of beauty. All these things which you collect are delightful formally and plastically, and this doesn't seem to tie up with what you're saying.

RI Your original question here wasn't answered, John, and that is the raison d'être. I'm not painting day by day with the thought that I'm transforming society because I know I'm not and I know no painter ever has, and the possibility is about as minimal as any possibility could get. But I'm very concerned that my paintings are – I suppose the ideal would be a fifty-fifty, the message is fifty, and the form is the other fifty. Sometimes I suppose, if I fail, the one gets a little heavier than the other, but first of all, beauty is not an ugly word as far as I'm concerned. I do like to make beautiful things and when I've done a painting, I think of it as beautiful, not anything else.

JJ Someone said to me the other day – it was [ROY] Lichtenstein; he was talking about those cartoons of his and he said that some of

the jokes last six minutes maybe, but there should be something more in the painting. This is really rather like what you're saying I suppose, that while the things are sometimes social comment, for you they stand or fall on some other formal level.

RI I don't have that lack of faith in my message, though, John. Lichtenstein lifts extremely amusing and provocative things directly from cartoons and I think I have more faith in them perhaps than he does because I don't think they last just six minutes. I've been laughing at some of his things for several years. Every time I see them I'm amused and I think maybe he's more of a poet than he realises himself. But I certainly think of myself as a poet; I do write poetry and I don't feel that my paintings are so topical or so to-the-minute that they have a duration that way. Once in a while, like with the *Confederacy* paintings, the series that I'm working on now – well, all right so it is topical, but it's a topic which is probably going to last for another century or two.[3] That's one of mankind's greatest burdens and one of his biggest problems – so why not talk about it?

JJ Over and beyond the single words that you use in your paintings, 'eat', 'die' and so on, that we spoke of, there are also these whole sentences or quotations.

RI Sometimes they're quotations. More often than not. But then like the *Alabama* that you're looking at, that's my own –

JJ That's your own statement?

RI Yes.

JJ For me it's obscure. 'Just as in the anatomy of man every nation must have its hind part'; are you saying that this state always lags behind the attitudes of the time?

RI No, I'm saying much more than that. I'm saying it's the shame of our country.[4]

JJ Well, that is what I meant really.

RI Not that I have any personal preferences over human anatomy, but given that that's the typical human reaction people are less proud of their backsides than they are of their front sides.

JJ Another thing you've spoken about in the past which interests me is the source of your symbols and images. The stars and circles and so on I believe you said derived from boats?

RI No, they don't derive from boats at all, John, they were *reinforced* by
 boats in that in my eight years on Coenties Slip⁵ all I'd have to do is
 look out my studio window and there'd be a tugboat going by with
 a star on it. But then of course you see these things on any street.
 All you have to do is look out the window of your car, or your
 studio or your house and there are signs. We're surrounded by signs.

 I was in Europe and of course you have lots of signs there, but I
 never felt that you were as inundated by them as we are. My whole
 life I remember signs. This is an influence that – how could one
 escape it? I have chosen to use it and other artists choose to reject it.

JJ It seems natural somehow because you've been surrounded by these
 signs all your life.

RI No, everybody else has been surrounded by them and everyone
 else has deigned to reject them, and I deign to use them, that's
 all. And this again is like what you call European tradition. Why
 in the world, you know, you have to scrape pretty hard even in
 the twentieth century to find a European painter who feels free
 to paint an automobile. And, you know, you've just seen *Mother
 and Father*, and an automobile is a glorious thing to paint. What's
 wrong with the European painter; what kind of thing is this that
 he rejects things which are around him, so violently?

JJ I remember a very odd conversation that I saw reported, I think
 it was [THE CRITIC] David Sylvester talking to Jasper Johns, but
 I'm not sure, in which Jasper Johns was asked, 'Do you use the
 stencilled letters because you prefer them to letters of any other
 kind?' He replied, 'Yes, obviously.' But the questioner asked,
 'Do you use them because those are the only ones that are
 available? Would you prefer to design a stencilled letter of your
 own?' 'No, I use them because they are the ones that are available.'
 And the questioner was still not satisfied, this wasn't quite what
 he meant, and he said, 'Do you use the stencilled letters because
 you like them, or is it just that they come that way?' Jasper Johns
 replied, not very helpfully, 'I like them because they come that way.'
 Now do you feel this? Do you see what I mean?

RI Yes, I know that interview that you're referring to –

JJ I hope I got it right.

RI Very close, John. I do happen to feel the same way. I came on these stencils probably in the same way that he did, and that is that in this old waterfront studio there they were, lying on the floor, and it took a year or two to think about them and begin to use them and, of course, Jasper Johns probably did set the first example. But how could you help but – again it's like this automobile, if one is going to react to what is around one, how could you be in any proximity to these things without one day picking them up and using them? I saw Henry Moore dedicate his sculpture at the Lincoln Center and the programme following it on television, and how this whole thing came about just because Henry Moore found a bone, you know. The artist is always doing this. I don't find bones, I found stencils, and since I don't want to be in that particular tradition, I reject bones and I accept stencils.

JJ In the two paintings of a mother, *A Mother is a Mother…*

RI This is a reference to [GERTRUDE] Stein. I happen to feel that Stein is probably the greatest literary figure America has ever produced. And I could spend my whole life just painting Stein paintings. That's how the title came about from the 'a rose is a rose'[6] business.

JJ Yes. Could you say more about that, about Stein in your paintings?

RI Well, I just happen to like her. I feel that she's made the most original contribution that this country has ever made in literature. And I never hesitate to link myself with, shall we say, compatriots. I did this with [CHARLES] Demuth[7] in my *Fifth American Dream*. I mean he's dead and, of course, I never knew the man, and he might not even enjoy what I did. But I feel a kinship of spirit, and I feel this with Stein. Always then the question comes up about the literary aspect of my painting and I don't want to be a literary painter, but then the things I use are so brief and so pithy that I never feel that I run that risk myself.

JJ The *Mother and Father* pictures, this is a very personal thing, too?

RI They are. I consider it as a single painting; it's a diptych. And they're taken from family snapshots, altered, of course. And it occurred to me one day that artists frequently paint their mother; they almost never paint their father. I don't know any artist that's managed to paint both mother and father. So I decided to do it.

JJ The baring of the mother's breast is understandable especially over such a statement as *A Mother is a Mother*, but the barefooted father?

RI Well, the painting – if you notice the license plate – the snapshots were actually taken I think in 1924, but the date was moved up to '27. I was probably conceived right around Christmas time. The idea is that this is conception night. And, I've said this before, I have the fantasy that I might possibly have been conceived in the back seat of a Model A Ford. I'm sure then that I would be the first painter ever arrived at by this circumstance. And how American can you possibly get?

JJ Hence father's bare feet.

RI Well, more or less. Sure. And besides he was a kind of stuffy person and that's not the way he'd want to be depicted.

JJ Can you tell me something about these – what would you call them – these wooden painted constructions?

RI I suppose construction is the handiest designation. Assemblage is possible, too. They were the beginning of my use of words.

JJ They preceded the paintings?

RI Oh yes. I didn't have very much money and, you know, everything in New York was a matter of size and back in the '50s if you weren't doing big canvases you might as well just have not been painting at all. So the idea of doing small canvases just seemed to be dead, and since I didn't have money for large canvases I scrounged around, and these buildings were being torn down on the waterfront and there in the rubble were these beautiful crossbeams. So I brought them into my studio and they became immediate references to the Greek herm figure. They started out being just white gesso on wood, and there still exist one or two of those, but I wasn't happy with that and they became polychrome, and then I still didn't feel that they were fulfilled, so words started to appear on them. And that preceded using words on canvases.

JJ I didn't know this. It just shows one's research is always a bit sloppy.

RI They helped launch my own activity in New York because just at that time the Museum of Modern Art was planning its assemblage show and just about everybody in New York had come to objects;

all the younger people were making objects of one kind or another. It was just in the air, just as the use of words was also in the air.

JJ How profound for you is this herm symbol? Is this something that matters about Greek things?

RI No, no. It's just that when I looked at them, that's what they were. It doesn't have any great meaning.

JJ I like them very much. But they're enigmatic.

RI Well, they're signposts. And that's in a way what the herma was used for, too, and of course all of my paintings are signs.

JJ You've taken a 'two' theme, as it were, on one of them: on another a 'three' theme, and on another a 'six'. Is that just an arbitrary thing which provides the formal basis for the thing that really matters?

RI That's about all it is.

JJ And in the case of 'chief' –

RI Many of the constructions not only refer to, but I even conceive them in relation to, a painting. And 'chief' refers to a painting based on [THE POET HENRY] Longfellow's [SONG OF] *Hiawatha*. I enumerated some of the Indian tribes and the colour, the design, everything else is in relation to that painting.

JJ Just to go back a bit, there was something you said in the other room that I'd really like to have down. There was an extremely beautiful stencil you have there; you said that you really liked the form of the stencils but Jasper Johns distorts and deforms them.

RI Yes, I was referring to his use of them. There was a brief period, of course, when he didn't, but in most of his work he uses the hard-edge stencils and then transforms them into a kind of abstract expressionistic handling, which would be against my own nature, that's all. And I've never quite understood why he insists upon that.

JJ Do you think this is kind of self-conscious painterliness?

RI Well, as I said about the whole abstract expressionist movement in New York, I never felt related to it and I suppose he did, that's all.

I was always an outsider and I hadn't in any way found myself at the time when all of those people were very conscious of each other and were influencing each other right and left.

JJ Earlier you said that you thought of yourself as a poet, and at the same time that you didn't really want to be regarded as someone in whose paintings the literary content was dominant. In what sense are you a poetic painter? Though that's a rather crude phrase.

RI No, no, it's not exactly, John. It just so happens that that aspect of my work is less. I have done a few paintings, not very many, and one that I referred to, *The Calumet* taken directly out of [HIAWATHA BY] Longfellow.[8] I've used lines directly out of [WALT] Whitman and out of [HERMAN] Melville. Those people have made my most literary paintings. I haven't done one of those paintings for a long time. The whole concept now is so remote, a thing of the past, no one would even want to consider this kind of painting. And I don't for the bulk of my work. But maybe out of a little bit of perversity, or just the feeling that there is nothing which is beneath contempt, I'll do one or two now and then.

JJ Something like the attitude which Larry Rivers expressed about choosing [TO PAINT] *Washington Crossing the Delaware* because he thought it would be anathema to the art scene.

RI Sure. Sure.

JJ In these earlier assemblage things, they are sort of found and then helped objects, you might say?

RI Very much found, yes.

JJ One aspect of the more recent work which I saw in the other room is a new sort of subjectivity – the question of your parents and that side of it. Do you think your work is moving towards statements that are more personal, almost in the autobiographical sense?

RI No, I don't think my work is moving in that direction, but I think I would always like to feel free to do a painting of such a topic whenever I felt like it. *Mother and Father* of course is not the only painting that has dealt with a subject in any realistic sense. *Leaves* which is there, was my last painting that I started on Coenties Slip, and that is an actual projection of one of my plants. I've done a *Red Sails* painting which refers to a popular song that I knew in my childhood. And every now and then I'm struck by – the word, the image, the association. And if the image is teasing or provocative enough, it'll be an image instead of a symbol. I feel that I should have the freedom to glide back and forth between those two.

JJ So many of the words in all periods of your work seem to be packed with associations.

RI Usually a tremendous number of associations. This is most true of 'eat'. 'Eat' was the last word that my mother spoke before she died. Eat was an obsession throughout my whole life. My mother loved to cook. She felt that was her chief asset in life was her culinary abilities. The family's livelihood came from restaurants. Eat signs here in New York, they're very rare, but in the Midwest eat signs are all over the landscape. It's like a first commandment.

JJ Recently I saw an English writer called Malcolm Muggeridge say on television that the four watchwords in America were 'eat', 'gas' and 'drugs', and one other I've forgotten, which as he entered every small town were displayed prominently. Magic words at the entrance to the town.

RI Yes. I have made a gas painting. 'Drugs' [ARE] a little more difficult, maybe one day I'll tackle that, too. But back to your original subject, John, somehow you don't feel this in Europe, and I don't know why in America things are so much on the surface. Maybe one day, with the Johnsons and so forth, all those things will be removed from the American scene. But I doubt it, it's going to take a long time.

JJ How do you mean?

RI Oh, I'm just joking about the [JOHNSONS'] highway beautification programme,⁹ John, plus maybe the triumph of good taste. I mean, Park Avenue is an example of what a city is like without signs, and that gets to be very European.

JJ Do you like it?

RI I think we could have both. But I don't like the idea that 42nd Street should be turned into a Park Avenue with trees and grass.

JJ Yes. You used a word then which reminded me of something I did want to ask you. It's held by many painters that art dies when it becomes tasteful, that in a sense every revolution, every new generation coming along rejects the past because it has become too tasteful and introduces a new, almost vulgar element into their work. Someone standing outside not talking to you might say that this is an element of your painting, that you selected what previous generations would have regarded as beneath contempt, too vulgar, street signs and so on. You introduced this into your work and gave

painting a new vitality, as has in fact often been the case in the past – the introduction of, in inverted commas, 'a vulgar' element.

RI But this is nothing that I have done, John, because Stuart Davis was doing this forty years ago you see.[10] So I'm afraid I didn't have anything to do with that. He did it much better than I did.

JJ Yes, but he did it also in the context of a kind of tasteful cubism, you might say, which –

RI He did it in the context of cubism, and not necessarily tasteful cubism, because I find some of his things not so tasteful. So I'm working in a two-dimensional, flat, strictly sign-painting technique, but I don't think I felt that I was being vulgar or that I was introducing a subject matter which was going to shock anyone. I thought that by this time these things were perfectly acceptable language. I'm interested in communication. Once in a while I'll do a painting that's fairly strong, but I don't think of shocking people. My paintings are too stylised, they're too finished. How could you think that I might think I'd be shocking somebody?

JJ Shocking is not quite the right word. I meant simply material, which wouldn't fit in with the general view of what was a tasteful and suitable subject for a painting. You've explained this. I mean a gasoline station sign is simply not art for a lot of people, or would not have been some time ago. Painting an automobile is exactly the same thing. Some things are just not suitable material for art.

RI But I think that we've pretty well arrived at the – I think everyone knows now that there is nothing which couldn't be art if it's handled, shall we say, by an artist.

JJ Yes. You said something about communication, that you felt you wanted to communicate things. How do you feel about the concept of art for art's sake, that art somehow is not too much concerned with communication?

RI First of all, art for art's sake: I think art is always for art's sake. That just comes first. The artist is always talking to himself first, he's talking to art, he's talking to all the artists who ever lived, and then he's talking to someone else. I think the communication, although I like to put stress on it, I think it automatically comes second. It's never really first. And the person who really is putting communication first – he's in advertising or he's something else.

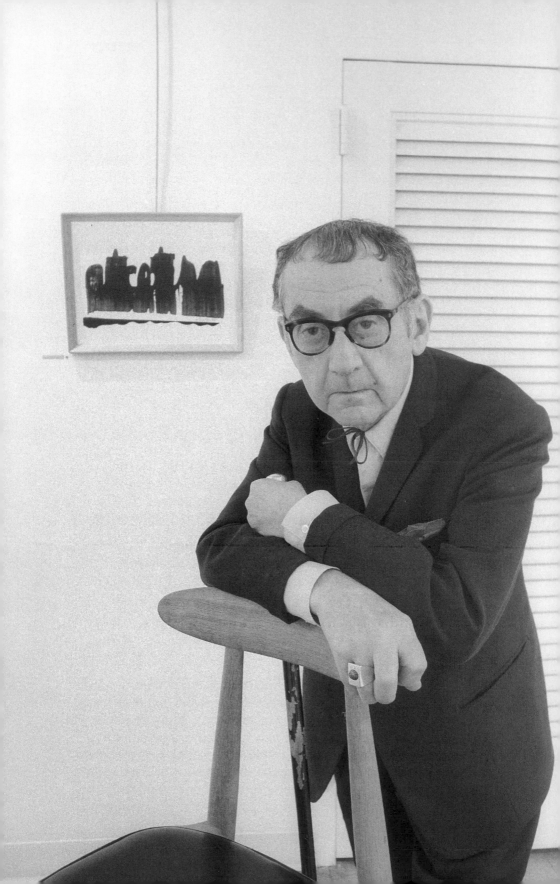

MAN RAY

This interview took place on 15 October 1965 (4.30pm) at the Cordier & Ekstrom Gallery at 978 Madison Avenue in New York, which showed the work of Man Ray and his lifelong friend Marcel Duchamp.

A tailor's son, born Emmanuel Radnitzky in Philadelphia and brought up from the age of seven in Brooklyn, Man Ray worked as a commercial artist, but had his first solo show in 1915. He worked during his career in all the following media: painting, drawing, sculpture, collage, readymades, film, assemblage, kinetic art and notably photography (including dada-influenced images he called Rayographs). His work showed the influence of both dada and surrealism, and also of African art. He collaborated with, among others, Duchamp and Lee Miller, who had been his assistant.

The experimentalism of American art of the mid twentieth century was partly his legacy.

At the time of this interview, when Man Ray was seventy-five, he was mostly based in Paris, where he had lived from 1921 to 1940, before being forced to leave in wartime, and to which he returned in 1946, after six years in Los Angeles.

His accent had more to do with Brooklyn than with Paris. And he had a habit of saying 'you see' significantly more than appears in this edited text.

There is a photograph of Man Ray and Marcel Duchamp playing chess in 1966 on the tables in Washington Square in Greenwich Village, just minutes away from the Joneses' apartment.

JJ You must have some views about the relationship between what people are doing today in America and the sort of things you were doing in the '20s. Do you feel that there is a strong connection?

MR Oh, a very close connection. Not only what was done before, but what was done a thousand or two thousand years ago as well. You see nothing can be done, whether you call it new, whether it appears new, unless something went before it. Impressionism, the [CLAUDE] Monet school, came from [GUSTAVE] Courbet, the Barbizon school [OF REALIST PAINTING], [ADOLPHE] Monticelli,[1] [ÉDOUARD] Manet. We just carried it a step further. The post-impressionists came after the impressionists. The cubists from the post-impressionists. The expressionists came from the cubists. And then from that came dadaism, and from dadaism came surrealism, which composed the same people in fact. To me I can't understand how they can imagine that anything can ever be really new in art. Nothing is new. I was looking at a book today of old Egyptian art from 2000 BC and, why there are some things in some of those paintings, bas reliefs, that look like Victor Brauner's paintings, and I've always said that Victor Brauner relies on antiquity for his source of inspiration.[2] And so many others ... [PABLO] Picasso relies on the primitives. They keep up the tradition of so-called primitive art. Art is never primitive, nor is it modern.

JJ Do you feel that in the things that you were doing many years ago and in the things that you do today, you reflected certain values which have now been cast off by some?

MR No, not at all. On the contrary. At first when I got out of the art schools I had a very thorough training in drawing, painting and even in the more mechanical arts of architecture, engineering and

even type designing. I did every kind of graphic art at that time when I decided to paint. And then I decided to throw all that away. And I didn't regret that I spent so many years at school not getting much out of it, but if I hadn't gone, I would have thought I had missed something, you see. Have you read my book, my *Self-Portrait*,[3] that I published here?

JJ No. You published in the States?

MR Yes. In 1963. It came out in England, Andre Deutsch brought it out in London last year.

JJ Is that when you were in London?

MR Yes. In November of '64. I had a little exhibition at some insignificant gallery that Deutsch had arranged, hoping it would help the publicity of the book, you see, but on the contrary I think it hurt it, and the book never sold very well in England. I never expected it would.

JJ I never even heard of it.

MR But I have described everything. You'll find all my opinions in that book because I speak of all my adventures and happenings in relation to my work, all my activities – drawing, painting, movies, photography, objects – I speak of everything. And I was limited to 500 pages. I could have written 5,000 and taken five years. But I did 500 pages in a year, and that was quite a feat amongst other things that I was doing at the same time. But I think I declare in that pretty clearly my attitude about art in relation to others.

JJ Yes. Well, I shall get hold of that.

MR The youngsters are very nice with me, they tell me, 'Ah, you were the first one.' They give me credit, 'You were the first one to do this, you were the first one to do that.' And, oh, what can I say? I say, 'I'm very flattered that you say it, but you never say it in public really. You say it to me. And let me advise you one thing, never be the first one, always be the last one.' [LAUGHS]

JJ A lot of the things you did in photography were later taken up by commercial photographers and used in advertising.

MR Yes-s. Yes.

JJ You were an innovator in that field.

MR Yes, but those things that I did which were called innovations
 in photography were alongside, parallel to, my more commercial
 work. What I call commercial work is working for others, trying to
 satisfy them. It was a sort of a cure for me as a misunderstood and
 neglected and even threatened artist at the time.

JJ How threatened?

MR Well, with my works in New York between 1915 and 1920 – my
 exhibitions – why, I was so violently attacked. One man came in
 one day and asked for a photograph of one of my paintings which
 was inspired by cubism, except that the images are flat (the painting
 is now on exhibition at the Metropolitan as American art). He got
 the photograph from the gallery and it soon appeared in a book
 he'd written on art in which he says alongside this reproduction,
 'I do not know who the painter is who painted this picture, but
 looking at it carefully I decided this man is a sexual pervert, a dope
 fiend, and has all the tendencies to commit a crime.' Just like that.
 He was very careful not to mention my name so I couldn't sue
 him [LAUGHS]. Well, that was the attitude at the time. My dealer
 also just didn't know what I was up to after my earliest things –
 landscapes and still life very much influenced by [PAUL] Cézanne.
 I admitted that I'd been influenced, too, like all the young ones. It's
 become the fad now. I mean since the artist was thrown on his own
 in the industrial revolution of the nineteenth century, to choose his
 own subject, his own source of inspiration, since he no longer was
 working exclusively for the church and the nobility. So we were
 free. Free to starve even.

 To my mind the artist is always an innovator, not only in the sense
 that he uses a new technique or a new source of inspiration, but
 because he is the leader. He is the one that throws the headlights
 on the road to follow and the others must sooner or later follow
 him no matter what he does. If somebody objects I would say,
 'Well, why don't you do what you think should be done?' As I said
 to my dealer once in New York before 1920, when he said, 'I cannot
 sell your things, nobody wants them, I don't understand them,
 I don't know how to talk about them. Why don't you paint those
 nice still lifes and landscapes you used to?' I said, 'Look, if you
 know what will sell, why don't you paint the pictures and let me sell
 them? I think we'll make out much better.'

 When they ask me, 'Can you show us your most recent work?

What have you been doing?' I reply, 'I have never in my life painted a recent picture.' I take up old themes. And I began to try to branch out and violate every possible rule in photography, which now we are doing in painting.

JJ Yes. You speak of the difficulty of selling things and the freedom to starve, but many of the young painters who paint in a way which seems to derive from your influence are extraordinarily successful.

MR And get much more than I do for my things. I'm not on the market, as one collector said. I say 'perhaps if you buy me, I'll be on the market.' That's all it takes.

JJ That is all it takes.

MR But I'm all for these youngsters. It may be a flash in the pan, it may last five or ten years at the most, you know, but wonderful. I think of all the stupid and useless things that are put on the market by which men make millions. These fellows who do something that is absolutely harmless to our society and can make a living by it, I say more power to them, I envy them. I have no feeling of competition or envy in any other sense. And I never attack or criticise, having suffered myself from so much criticism and attacks.

JJ Do you think criticism is a good thing?

MR I'm against critics. I once started off a lecture by saying, 'All critics should be assassinated.' I say the critics have always been wrong. If they were really objective –

JJ They gave you a hard time, did they?

MR Oh, yes. And one said to me, the most sympathetic of them in the old days in America, Nick McBride was his name,⁴ we used to meet at parties or gatherings at people's houses who had begun to collect a little bit of this modern painting. He didn't say anything really nasty, but he made a joke out of it, and he said to me, 'You know our newspaper is a very conservative paper, most of our art advertising comes from the most conservative galleries, Knoedler and people like that, and I have to write what is the policy of my paper. Don't read what I write. Just take out your yardstick and measure how much space I've given you and be satisfied accordingly.' That's the American idea of publicity, you see. I worked a great deal for publicity agencies, first as a draughtsman.

I also went out on location once and painted those billboards that serve now as pop art things. Recently I was interviewed in Paris by the *Herald Tribune* on my opinion of pop art. But they made a mistake. The printer had spelled pop 'pup', pup art. They stopped the press after a hundred copies had been printed and the editor sent me a copy with apologies. But I say this is a very valuable piece now. I would have left it. In fact I would have started with the alphabet – pap art, pep art, pip art, pop art and pup art, let's have it all through the thing. Names never imposed on me, names can never hurt me, as we say when we're fighting with each other as kids.

JJ So on the whole then you think that what's being done today is a kind of extension of what happened before?

MR Oh yes, it's a healthy sequel, and the attempt to really find new sources of inspiration, as we did thirty years ago when our dadaism was converted to surrealism. Dadaism was purely negative, destructive, but it was a clearing of the ground for something more constructive to come. And in surrealism the same poets and writers – it was a literary movement primarily – began to seek definite new sources of inspiration, like automatic writing and painting, the dream, the subconscious, chance, all these elements which were not taken as a fitting subject for creative work by previous schools.

JJ When I asked you earlier on if you had suffered a lot at the hands of the critics I meant do you think that you went through any kind of real physical hardship during those days?

MR Well, I had to work for a living, do something else. I didn't have that arrogance that many youngsters have that they think that the world owes them a living. It owes them a living, of course it does, but you can't collect it. Even with the government they owe you, but you can't collect. But they manage to collect because they're much better organised for it. I was a bit of an anarchist in my young days. And I knew some poets and painters who were anarchists in spirit.

JJ Well, dadaism was an anarchic movement.

MR Yes, very. But it was also clearing the field because it sort of melted in with the surrealist movement, since they were the same people. And many things that I'd done previously and had been exhibited

under the auspices of the dadaists were also exhibited years later with the surrealists.

JJ Yes. Someone said to me the other day that if the dadaists had known how their work was going to be taken up and finally enshrined in galleries and museums they wouldn't have done the same thing, because this was opposite to their intention.

MR Exactly. We never thought of selling our things. I used to give my things away. If somebody liked it and said, 'Oh, I wish I could buy that if I had the money.' 'Oh, you really like it? Take it.' I gave all my earlier things away of the dada period. A few remained and now they've all entered into collections. But I can go to extremes and put it in a nice frame and exhibit it as a work of art and it is art. It's the idea of the readymade you put your finger on.[5] Like that framed piece of cloth. Did you read the text underneath it?

JJ No, I haven't been around the gallery.

MR It's an excerpt from a letter I received from a university where the president asked me to make a donation to raise a fund. Even if it's something I take out of the wastepaper basket. So I took out that old paint rag from the wastepaper basket and framed it, and I didn't send it to her because I'm sure it wouldn't fetch the price there at an auction that it will here.

JJ Don't you think this is something of a tragedy that the anarchic element in dada was really against the whole system of galleries and so on, and now you've been caught up in it.

MR But we don't care. We didn't do it.

JJ No. I see, yes.

MR I'm not responsible. If I'd become a dealer and tried to cash in on it, or dadaists or surrealists, but there was always these clever-minded people with this business tendency who knew how they could exploit a thing. My advertising agencies used to tell me we have a product to sell that the public doesn't need and doesn't want. You've got to help us sell it – with my photographs or with my drawings. I didn't do much drawing for advertising, I hated it. But with photography it was very easy because all I had to do was to press a button, whether I photographed a potato or the most beautiful face in the world, you know, I had to go through the same motions.

Taking a photograph is an intellectual activity. If you make one little miscalculation you don't get it, but if you make a miscalculation in painting it may add to the quality for a lot of people. I'm not saying this cynically, you know, I really mean it. Like the dripping and the drooling school. Well, the old masters did that too, you know. Or it happened by accident sometimes. Once I saw a Vermeer painting where he had changed his mind about a figure in the canvas and painted it over. But through the years it came through like a ghost walking across. I thought it was wonderful, but it was condemned by the critics and the art historians as a man who didn't know his technique well enough.

One painter was painting with cans of paint he bought at the corner paint shop, you know, with a brush in each one so he could paint fast on a big canvas, and the dealer who came in said the painting was very strong, powerful, but he looked at the cans and said, 'Is this what you paint with?'. And the painter said, 'Yes. Why?' 'Well, are your paintings permanent ...' 'Oh,' he said, 'that's not my affair, that's your affair.' That's a comeback to the dealers who think they have a right to dictate to the painters sometimes.

JJ You don't think that art should necessarily be permanent art objects? Do you feel that the artist has a kind of obligation, if he sells something?

MR None whatsoever. To me the ideal painting would be a painting that would disappear with my death. I have no interest in posterity or the perpetuation of my works. I wrote my book so I would never have to speak of the past again. I want to live only in the present.

JJ Yes. Now I'm forcing you to talk about it again. That's not fair.

MR Yes, it's not fair, but I think I learned that lesson in advertising, that repetition is very effective.

JJ Yes. Tell me, the dada movement did have as part of its purpose a kind of attempt to overthrow old values and old social attitudes?

MR Yes, it was primarily a political movement you might say. It broke during the First World War. In America I was all by myself in 1914 when I began to say I will use materials that are not used in art, because – oh, I'd probably seen one or two drawings of Picasso at the old Stieglitz gallery,[6] with a bit of newspaper pasted on very timidly, or reproductions of the *Calligrammes* of [GUILLAUME]

Apollinaire,[7] you see. My first wife was French and she read to me [ARTHUR] Rimbaud, and the *Chants de Maldoror*,[8] ten years before the surrealists adopted it as their textbook. It was a whole new world for me and I began to go absolutely wild with materials and paints and everything. I violated all the rules, which I continued later in photography, too. But that became my second nature.

JJ Don't you think that it's sad that having been accepted by the galleries is an indication that the revolution or the protest that you were involved in didn't succeed?

MR Not at all. I don't agree with you there. As I told you before, it wasn't our fault that they were accepted. It wasn't our intention that they should be accepted.

JJ What I mean is that you were attacking certain social things …

MR Yes, but people like that, too. The daily newspapers are full of catastrophes and murders and tragedies, and they live on that, because people like that. I suppose some psychiatrist would say it's because you are not involved in it. But our whole existence is based on terrible tragedies, man doing harm to mankind. In addition to all the terrible things that nature does to us, you know.

And speaking of the artists who are making a lot of money now, I'm all for it. I think that every human being the world over has the right to a living automatically, whether he deserves it or not, whether he works for it or not, like an animal or a plant.

JJ But it was just this kind of social change that you were hoping to bring about surely with dadaism?

MR No. I think it was a lot of cynicism. We didn't think that we could do anything. Any more than the Pope with all his preaching of peace will not advance the cause of peace one iota, or the politicians' pretentions that they will advance the cause of peace. I don't believe in it. I think human nature wants war, wants strife, wants murder and bloodshed. Human nature has always been that way. And the outbreaks that occur from time to time is a satisfying of this desire. And I can do nothing about it, just go my own way, as if I'm living on the top of a volcano that will explode some day.

JJ And then in 1915 and 1920, did you feel that your art might do something about it by overthrowing …?

MR Not at all. No, I was proud of the idea that the art for art's sake, you know, should be absolutely useless and preach no cause. It was an evasion, and I thought that an evasion is just as legitimate as a constructive effort.

I'm against competition and the reason I went back to my painting entirely, or this kind of creative work, is because I imagined it was still one of the few activities where the element of competition didn't enter, where things were just by the personality who created them, and the greater the difference between one thing and another the more valuable, like the differences in the colour of skin, you know, the difference in races, that they're interesting, more amusing. Otherwise it would be a very monotonous world if everybody had the same aesthetic standards. So therefore I say we must each emphasise the personality.

JJ Are there any young painters in America today whom you are particularly fond of?

MR No. I'm not even fond of myself.

JJ No, but I mean you know there must be some painters that you like rather than others.

MR No.

JJ Or dislike more than others.

MR I don't dislike them. I'm indifferent. I say to them when I go to exhibitions once in a while, especially if they're people I know (otherwise I don't go), I do it because I still have a social instinct. And if I don't go, especially in Europe, they notice it right away, 'Oh, you haven't come to my opening.'

JJ I do remember your appearing on television in England and I seem to remember you saying that you thought that some of the things that are being done today, in a sense, were no advance on anything that had been done before, and that you regretted this.

MR I would never had said a thing like that.

JJ No? Well then I misunderstood.

MR Because I've said very definitely there is no progress in art. Our only justification today is that we are different. That's the only thing and that is a question of personality, and of our time.

Now they say, aren't you interested in the old masters anymore? Oh, I've spent hours looking at them, studying them, especially the portraits which I was interested in. I was interested in human faces. That's why I took up photography. And I decided never to paint anything that I could photograph. Now, if I see a face that interests me I can sit down and paint a portrait of that face, but I prefer using the camera – like a writer would prefer using a typewriter to writing by hand.

JJ Yes. Do you do much photography now?

MR No. I've given it up professionally, over twenty years.

JJ When did you last make movies?

MR Oh, that was in the '20s in the silent days, just about when the sound came in. Then I didn't want to go on with it. And I didn't want to become a moviemaker anyhow because also it's one of the activities that's sort of a banking operation, I realised. You can make a painting that doesn't involve any special sacrifice or outlay of capital, but doing a movie is a lot of work and money, and nobody could guarantee me the distribution of my films. I've seen hundreds of films by youngsters, but they never get anywhere with them – and very interesting.

In the best films I've ever seen there are ten minutes that interest me, and in the worst films I've seen – what people call the worst films – there are ten minutes that are equally interesting, which the director had no intention probably of putting over, and which nobody is conscious of because I have my own standards of selection.

And I generally choose my movie theatres with the most comfortable seats, so I can fall asleep. In Hollywood, when I'd be invited to previews of films, I had a special pair of prisms to go on my glasses and by turning them slightly I turn these black-and-white films into technicolour and abstract. So I would not be bored or fall asleep impolitely before my hosts. Maybe I'm too sophisticated. I've done too many things in my life, and I feel that I owe nothing to anybody to our society, and if I can disappear, I want to be anonymous and comfortable. Very selfish.

I've talked to students that way too, in lectures. 'How do you become famous, how do you become rich?' [THEY WOULD ASK].

There again I say, 'I'm only here as your art instructor, not your economic advisor.' I suffered myself all my youth, and I got a job working downtown, amongst the skyscrapers, for editors illustrating textbooks, and atlases, anything – maps, anatomy, machinery, I could draw anything, you know. And I made a few dollars every week and painted in every spare moment, because it was a passion with me. Like playing tennis or golf or chess, you know.

JJ Suppose you had not been successful, suppose you really had been anonymous and just comfortable, do you think it would have been quite the same thing?

MR Oh, not thirty years ago, but now it would now, I'm aiming for that.

JJ So success now means very little to you?

MR It means nothing at all to me.

JJ But thirty years ago?

MR About thirty years ago when I was at the height of my photographic career, because I was making lots of money and living very comfortably in France, I wanted to have a fling. Which I did, you see. And nearly killed myself in the process with eating and drinking and fast driving.

JJ You were interested in cars?

MR Oh, I used to be fascinated. I designed bodies for cars in the old days for friends who would buy the chassis. In those days, around the late '20s, you'd buy the chassis then take it to the custom-body builder. And I designed streamlined bodies for them. Of course, it was also considered absolutely mad, you see, eccentric. I drove cars at 80 miles an hour in France; there were no speed limits on the road, you know. I was interested in everything, in clothes, in food …

JJ There is a tendency among some young painters now to feel it necessary to go as far out as possible, to try everything once and maybe twice and fifty times. Do you think this is a good idea or have you changed your views about this?

MR Well, you know, I've got hundreds of projects filed away in portfolios, ideas for paintings and objects which I shall never realise. It's enough that I realise five or ten per cent of them, enough to keep me in social contact. Probably it's this social contact

that I still enjoy. I like to be with people and talk with them and discuss things, see their reactions, even if they seem to be stupid to me or tactless. They're more often tactless than stupid, you know.

JJ Were you pointing at me then?[9]

MR Well, it won't show on there, don't worry. Is your voice recorded too on there?

JJ Just vaguely.

MR Yes. But I always – I try to enjoy myself. My motives in painting are very simple: the pursuit of liberty and the pursuit of pleasure.

JJ Yes. Your work is hedonistic, pleasure-seeking then really?

MR Yes, of course, it's pleasure with a certain amount of technical experience, which I use to the utmost now. I've even gone back to using some of my academic training, anatomy or perspective. I showed some very realistic paintings in Paris and my friends [SAID], 'Why do you do a thing like that? It's not your idea.' I said I did it because I was not supposed to do it. I'm sure that many of these modern painters would love to do a thing like that now and then. *They do not dare.* I *dare.*

JJ Yes. Do you ever meet any of the old crowd now – Duchamp?

MR Duchamp is my oldest friend. He just came back from Paris today.

JJ Really?

MR I talked to him on the phone.

JJ Is he likely to be about New York? Do you think he'd talk to me?

MR Oh, you better be careful. He's four, three years older than I am.

JJ Yes. Does he seem very old to you now?

MR No. I spent two months in Spain this summer with him, you know, we were together in Cadaqués.[10] Did nothing. We just sat around and played a game of chess once in a while, *which leaves no material traces.* He found the ideal solution: not to paint anymore, and still uses his mind. And leaves no material traces. That's what I would like to do, too, but I still … I'm a bit naive.

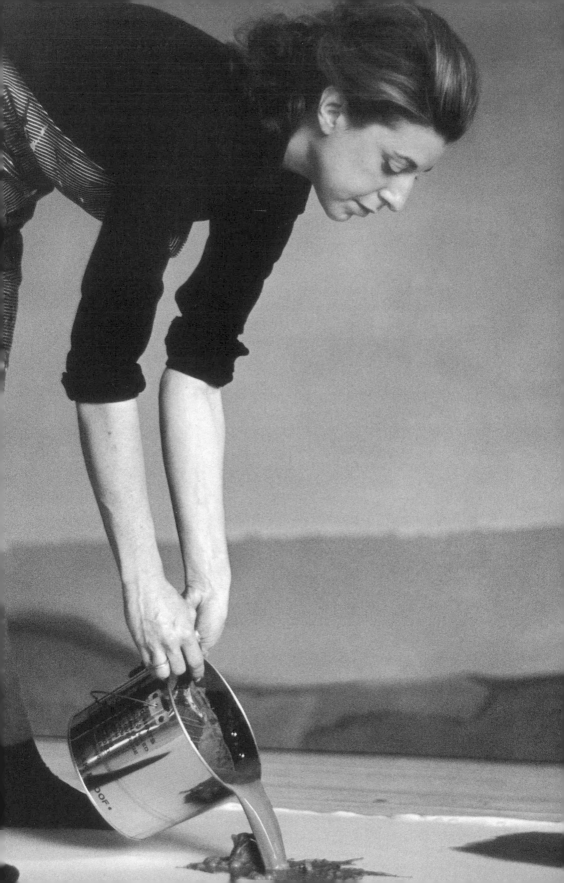

HELEN FRANKENTHALER

This interview took place in Helen Frankenthaler's studio at 173 East 83rd Street, New York, on the afternoon of 24 October 1965 (4.30pm). Frankenthaler, already at the forefront of second generation American abstract expressionists, was thirty-six.

Frankenthaler grew up in New York, and was a graduate of Bennington College in Vermont. She first had a painting chosen for a group show in 1950 (at the age of twenty-one), and her breakthrough painting in 1952 was *Mountains and Sea*, in which she pioneered a 'soak-stain' technique, pouring thinned paint onto unprimed canvas on the floor. In 1959 she won first prize in the Paris Biennial.

Influenced by Hans Hofmann, with whom she studied privately, and by Paul Cézanne's watercolours, she used fields of translucent colour, and had moved beyond the expressionist indulgence of the personal. At the time of this interview she was about to represent the US among a group of painters in the 1966 Venice Biennale.

The audio recording of this interview reveals a warmth to her voice and a New Yorker's tone of amusement (coming through, for instance, when she compares the elements of abstract expressionism to the elements of cuisine), and confidence, even when admitting difficulties in her work.

JJ In the interview you gave the other day you were talking about acrylic paint and you used the phrase that 'it [ACRYLIC PAINT] fought off a tendency to painterliness' in your work. What exactly did you mean by painterliness in this context?

HF Well, I think that in painterly painting one is immediately aware of how the paint is put on, and what the wrist and the brush did with it, and for me painterly painting means all the things that one connects with cuisine – brush, medium, stroke, dabs – and I think more and more one sees that as a veil to get rid of. Acrylic paints enable one to get through some of those veils. The result is often very cold and without feeling in a certain way. But I would rather cope with the lack of sentiment than a rich, scumbled, surface.

JJ One might well imagine a hard-edge painter saying something of this kind, but in your paintings there is unquestionably an interest in the effects of paint running, and paint running together, and nuances that derive from this. This isn't a contradiction?

HF I think with every medium you get it to work for *you* the way your sensibility is organised. I have used tube pigment oil paints and treated them in a way like acrylics. Mixing with turpentine and pouring it on unsized, unprimed duck,¹ so that in effect it's no different from my using acrylic paint. Except that acrylics are brighter and tougher, and are much more modern in a way. But they take less time. They look more harsh, they're more immediate, but I use acrylic paints the way I might use oils, so that I can get a blurred edge or a soaked-in stain, but less of it. I want less of it, I think.

JJ When you use these stains and these edges, are they a surprise to you as you're working, or do you work for them in the painting?

Do you have an idea in your mind that by putting these two edges together you'll achieve a certain effect, and you work towards that effect? Or do you accept or reject the effect as it comes out?

HF It depends. I think more and more I've been trying to get rid of that beautiful edge just because – and I use beautiful in a very loaded way – because it's gotten too easy for me. And while I can do pictures that seem billowy, muted, [WITH] blurred edges, now I want a much tougher, more resilient, resistant, bright surface. You see I don't think the alternative to blurred edge is hard-edge – and I think that's the problem, that if you get rid of the blurriness or scumbledness, or bleeding quality that the alternative is not razor-sharp, geometric shapes against each other. In other words, I sometimes will do a picture that looks quite – hard-edge isn't the word – but quite defined, and then it suddenly looks very sort of machine-made or inhuman to me, and I will allow to creep in or to remain some little spot that has just my wrist and nuance in it. But not, hopefully, in a schmaltzy way, but in a way that this makes it my experience and not just one of 100,000 pictures by X or Y. And I think that's the real problem at this moment, especially for a second – call it second-generation – New York painter, that in a way there's still a real tradition of abstract expressionism and all the temptations and nostalgia involved, and yet a real drive going ahead toward something else. But the something else is a real contradiction to what this generation came out of, the second generation. In other words, it is machinery and billboards, and sort of anonymous in a way, whereas the other was personal, sentimental, trademarked, individual. And that is a real struggle and it comes out aesthetically really in [THE QUESTION]: are you going to use your wrist or not?

JJ Ad Reinhardt, whom I was talking to the other day, said that, as he's often said, that art is quite separate from life and that the human concerns of every day have no place in painting, that painting comes from painting, and that the moment you begin to paint something which is kind of personal and subjective, the moment this becomes an important feature of your work, then in a sense you deny art itself. This is no longer art, this is therapy, I think is the word he uses, a kind of self-indulgence anyway. Now, in what you're saying just now, you implied, by saying you leave in a certain part which makes it human or rather it avoids it being inhuman, and like tens of thousands of other paintings by X,

[THAT] you obviously don't share Ad Reinhardt's view of this? And I say this because in a way your painting *is* a kind of art for art's sake painting – but not within his definition. Is that answerable?

HF Well, I would agree with Ad that art is art and you don't bring life and your personal syndrome into it consciously, but I think every body of work, all the paintings of a man are very much like the man and his life dilemmas, or his style. In other words, there are men who are tricky and mysterious, and some who are spontaneous, and some who are gloomy and depressed, and some who are tight and withdrawn, and some who are loose and expansive or repetitive, and I think over the years – if you know some artists very well – over decades they do paint their own personal life drama. For example, if I look over a year's work and I feel there are so many pictures that look this way to me and so many that look that way to me and that there might not be a consistent strain or push or conviction, one way or the other, very often I find that that's happened in the year, in the days themselves, that I've been confused or in conflict about my attitude towards this, that, or the other.

JJ Yes. Things other than painting?

HF Yeah. And I think when I did those pictures that look very explosive and spontaneous and what I call sort of 'up and out toward the edges', that at that time I was just that. Now I didn't feel consciously 'this is the person I am and I'm going to melt that into what I'm doing.' It was nothing but purely making a picture, and you don't make a joyful picture if you're joyful, or a sad picture if you're sad, but this other thing seeps in, I think.

JJ Do you think this is a test for you, in retrospect, of the success or failure of your paintings? I mean, are you pleased to find that the picture is very much you in a way, that it does reveal you?

HF I have little feeling about that. No, I …

JJ Because Reinhardt would say that that was just the very thing that would depress him about his pictures.

HF That it would reveal him? But I think Reinhardt's pictures are very much like Reinhardt.

JJ Yes, that's true. He does say this himself, how utterly personal they become. But that nevertheless he struggles to remove the signature.

HF Well, he does that with himself.

[MACHINE TURNED OFF]

HF Well, I think more and more people see a form that they belong in and try to fight through that rather than say: given the vocabulary and the context, how can I get to my particular essence and put it down? In other words, is it going to be a block, a stripe, a face, nothing, shaped, shapeless? And I think one of the most *wonderful* feelings is when you get after *terrible* struggle something that clicks and you know that, given the arena you've set for yourself – I don't mean the world stage, but your vocabulary/history/way of saying things – that you are on to something that only *you* can and must follow, and then making pictures is not a problem. Making pictures is a problem when you're half looking over your shoulder and wondering: does this look like *you* and will it fit the rules? And that is hell, and usually produces very dead work or *tour de force* work. And there's lots of that.

JJ I think when you go through a period of obsessive painting, when you work day in and every day regularly, that this drops off after a bit, if you really get deeply involved in it.

HF The what drops off?

JJ This sense of looking over your shoulder and asking yourself the question: is it me or does it obey the rules?

HF Yes. Yes.

JJ I mean this is a characteristic of work at the beginning of a bout of work and then it seems to pass, to drop away; becoming more deeply involved in the work and you forget that you're watching yourself or obeying rules.

HF I also think that there's a certain magic that happens once or twice, rarely three times in a real artist's life that involves a breakthrough, and it's at those moments that you hit on something that you yourself have never seen before or thought about that is suddenly in front of your eyes, and you seize on it and pick it up and drive it and maybe nobody else has seen anything like it before.

JJ You mean something of yours, too?

HF Yes. But then one goes through years of imitating one's own discovery and then things can get very tired and restless and you

sort of cast about, but the thing is to push your mind and arms so far that it will take you to unknown territories. For example, a year ago I wouldn't have had any of the thoughts that are lurking now in the left side of my brain about a shaped canvas. I wasn't against it, but it had no interest for me. I thought it wasn't, quote, 'painting'; that there seemed no reason for it, that pictures could be beautiful and original and advanced, abstract, etc., without being shaped, that that seemed an excuse. Now suddenly, and this really comes after talking to students of mine who are very lively and milk my brain, I suddenly feel, yes, maybe that's a logical solution or a step. In other words, it could possibly lead me some place, though I haven't tried it. But I find just in the way I turn my stretchers around, or I will do a picture and then cut one half of it out of the canvas surface and throw the other half away, that I'm rearranging edges and corners, and the colours in certain diminishing shapes do things in relation to colours and shapes that are square on all sides. This whole thing is beginning to really bug me. And I don't know if it'll wind up in anything that has to do with much more than carpentry, but what I'm saying is I would rather go astray for a little while on an idea like that, that seems sort of way out to me and may be impossible and one I would judge severely really, than dwell on what for me is *deja vu*, and not because one has to be the avant-garde but because …

JJ Be yourself.

HF Exactly.

JJ In the interview you talked about cubism and the importance of cubism for you, but oddly enough the turn this conversation is taking is much more like the sort of thing surrealists were concerned with. I don't mean the Max Ernst image thing,[2] but the concern about unconscious forces, automatic writing and so on. This seems to be related to what you're saying. Have you any feelings about the surrealists in that area of their exploration?

HF I do, except I really didn't mean shaped canvases in any image way.

JJ Well, I was jumping a paragraph back to when you were talking about paintings – and how you come across them, you discover something on the canvas which you then push and take – you said three or four times in a person's life this magic thing happens – something on the canvas which is a surprise and delight to you

when you take it on. This is very much like the sort of thing the surrealists were prescribing, that state of mind.

HF Yes. Well, there are two ways of doing this. One can throw a shape on a canvas and then play it from there. Or, which is more what I'm involved in right now, one can think a long time about painting before painting, and I don't mean a good painting comes out of ideas, but one can think: what about the edge? What has been done about edges, and what hasn't been done about edges, and what do I want to try today? Should I flood in a blue in the lower left-hand corner and see what happens then to the lower right-hand corner? Now that's quite different from saying jump in and take it from there. And I think in either case what you do with it makes either a successful or unsuccessful picture. I mean, no matter what it is.

JJ But before you're painting and during the actual painting there is a lot of this cerebration, is there? Do you think a lot about it?

HF Right now I'm thinking too much about it, I think and in the wrong way. I have a lot of problems about it right now. And for the first time I really don't like to paint and I used to love it. And I'm told that's age. I think more and more it isn't a matter of making one beautiful picture out of four or five beautiful pictures, but getting really to have an engagement with it, a whole fix.

JJ To become addicted.

HF Yes. So that in a sense it's all part of an idea. And in that interview at one point I did say something about each individual picture was an issue, and now more and more I think it's an individual body of work. I'm not saying that's good, but I think that is the development. And the real switch or change from ten years ago is that the whole scheme and context is very different, that you don't do one terrific picture, that it's much more of an all-over thing.

[GAP. LOST SECTION OF TAPE. THE CHANGE OF SUBJECT SEEMS TO BE ABOUT THE SOPHISTICATEDNESS OF THE YOUNGER GENERATION.]

HF I think what I meant there by worldliness was that at a much earlier age men and women today have such a range of experience and are so knowing about so many things – but I think this is always the case looking back at yourself and then looking at

people that are fifteen or twenty or twenty-five now – that they
take things for granted that you had to struggle for. So that if I go
to Bennington,[3] say, and see a senior show, it is so knowing and
professional and gallery-wise and hip that, in a way, they're missing
a certain beautiful, ugly, stumbling, growing, blind, depth thing, and
it looks very Madison Avenue. Now this isn't true with the best of
them but generally, and I think – just the way my fifteen-year-old
nephew can do advanced science or physics or whatever, and takes
for granted things that I might have been taught at fifteen – that
problems of understanding cubism are really, God, old stuff. It's
assimilated, osmosised or irrelevant, and you just take it from there.
But also I mean worldliness in a whole set of values, and speed
and things that are shocking are not shocking. And I don't know if
that's bad or not. And I think it's especially obvious, or an issue – it
isn't an issue for me – well yes, it is really, but [FOR] people in their
thirties, who were part of an avant-garde in the Fifties, who have
half a foot in coping with the present avant-garde, there is a real
contradiction in values and strokes, and that has to do with life
and painting, I think.

JJ When you say that the development of a painter is a kind of slow
growth, a personal, rather quiet thing, [ARE YOU SAYING] that the
involvement that the younger people show is a kind of distraction
from what you think it's really all about, something they have to
do, not exactly painfully, but rather painstakingly? And that they
are too much interested in so many things that they don't have time
to submit to this necessary period of development?

HF And you mean this shouldn't affect your own work?

JJ Well, you were talking about the worldliness outside. In a sense
there's this frantic awareness of everything and also there's,
I suppose, perhaps among the ninety per cent bad people, that
they want to get in on the art racket rather fast.[4] Success is an
important feature for them, and exhibitions and the whole art
racket fills their minds, and this denies the possibility of them
finding themselves in a painterly way?

HF I don't know, I think maybe it's a whole new context and that it
shouldn't be *judged* and when this was first apparent on the scene,
I thought 'how disgusting'. Now I think given the vocabulary and
rhythm of the whole thing maybe, you know, maybe they *should*
all be showing right away fast, and showing that work. And they

have no sense of this isn't right or traditional. And I think it's another lingo that one shouldn't judge. I mean you might not be sympathetic to the work or the individual, but it's another style. It's the way – I don't think ballroom dancing is the froog, but there it is and it's not to be denied.

JJ You said that you were tired really of what you know you can do well. Do you ever have the strong desire, as I think [PABLO] Picasso from time to time says he has done this, [OF] purposely working against the very things that he cares about? Do you feel that you need some kind of violent change of attitude?

HF Yes, I do, and often I sort of flay about wondering if I should move my studio or get rid of all the materials I've been using, or something radical, either do sculpture for a while or not paint for a while, or go back to doing landscape watercolours. But it is a real problem and I know the only way to get out of it is to work, that the more one broods about it the more one gets into the problem and away from a solution –

JJ Yes.

HF That if you're really concerned with it you transcend it somehow in your way.

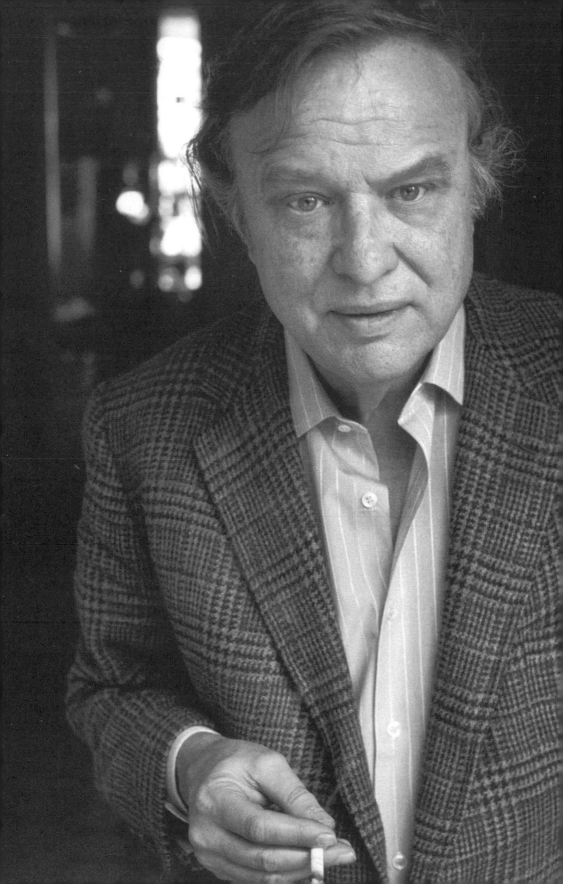

ROBERT MOTHERWELL

This interview took place on the afternoon of 25 October 1965 (4.30pm) at 173 East 94th Street. It was eleven blocks away from and one day after the interview with Robert Motherwell's third wife Helen Frankenthaler.

Born in Washington, Robert Motherwell grew up in California, with frail health, and studied philosophy at Stanford and then for a Harvard doctorate, before studying art at Columbia and, in the 1950s, teaching painting at Hunter College in New York and Black Mountain College in North Carolina. His first one-man show was at Peggy Guggenheim's Art of This Century gallery in 1944 and, with other abstract expressionists, he helped to found the New York School. Free association, or automatism, was a creative principle behind his work.

In 1964 he had created a mural-sized painting called *Dublin 1916, with Black and Tan*, inspired by Pablo Picasso's *Guernica* 1937. And at the time of the interview, when he was fifty, he had recently completed a series of 600 paintings on Japanese rice paper, *Lyric Suite*, which came to an end with the death of his friend, artist David Smith, in April 1965. That same year, in October, Motherwell had a major retrospective at the Museum of Modern Art in New York.

Throughout the interview Motherwell was articulate, unhesitating, and slightly didactic; all characteristics of someone accustomed to lecturing.

JJ David Sylvester interviewed an American painter who said up to about 1940 Americans had had a very strong inferiority complex about European art and felt that they were country cousins to it. And at that time many of the painters, having now met some of the Europeans and seeing that they weren't supermen, decided that they could go it alone; that if the Europeans could do it, then they could do it. His actual words were, 'We decided to make things and we didn't care if they weren't art. We hoped they would become art but the important thing was that they expressed ourselves and that they were our own.' Would you like to make an observation about that?

RM Yes. I think the observation is true, but I think it needs considerable elaboration and qualification. It's also true, as an aside, that there is such a thing that's generally called abstract expressionism but in the end it consists of ten or however many men there are, and within the general order of it there are considerable individual differences and histories. Which is to say – the statement you quote, I think, is a conclusion. That has a long history. Certainly in the past, ever since [JAMES ABBOTT MCNEILL] Whistler, if not before, many Americans have gone to Paris, as artists have from all over the Western world during its heyday, and I imagine the common American experience was, in the case of earlier painters who were the most sympathetic to Parisian painting, to pick up what they could, and, most often, to have the sense nevertheless that they did it in an inferior or second-rate way. And I would imagine in most cases, after their return to this country, sooner or later [THEY WENT ON] to drop it. Whether you're speaking of Max Weber[1], who was in Paris in the cubist days, or the Mexican [DIEGO] Rivera[2] or John Marin,[3] and so on.

I would say that in my estimate perhaps the first American who genuinely became in his way an equal rather than an imitation of the French enterprise was Alexander Calder,[4] who was before the abstract generation, but who, in spending perhaps half his mature working life in France, could legitimately be called a Franco-American artist. Now my own history is entirely different from any of my colleagues. I would think that I was the most Francophile with the exception of a singular trio that I'll speak about presently: John Graham,[5] Bill de Kooning and Arshile Gorky, all themselves born in Europe, who all came to America as grown men.

I think there's much more talent in the world everywhere than is ever realised and in my personal opinion the reason Americans on the whole in the earlier part of the century failed to master in quotes 'the French thing', it was not out of a lack of talent, but for two reasons. The first is that America has throughout the century been the most highly industrialised country in the world, (or perhaps half the century England was, or Germany), but what America conspicuously lacks is an artisan class. And certainly there's a great deal of the French enterprise, of the European enterprise, that is based in deep artisanship of a kind that almost cannot exist here.

But there's another consideration that I think is one of the few insights I had as a very young man in my adolescence, when I first saw a [HENRI] Matisse in California, who was the first great twentieth-century painter whom I fell in love with and who to my mind is still the greatest painter of the century. What was immediately apparent to me was that Matisse wasn't just a great artisan, or just a great painter, or just a great draughtsman, but he obviously was working in some context of ideas, of sky or land, of literature, of habits, etc. And I undertook for myself the somewhat quixotic enterprise, since I'm no linguist, of teaching myself French culture from Baudelaire to the surrealists. And once one understands what [ARTHUR] Rimbaud stands for to a Frenchman, or what [CHARLES] Baudelaire does or the whole relationship with the bourgeois class, then if one has technical facility and comes into contact with living French artists of real quality, the jump is not impossible. Or to put it in reverse, I would say that most of the people who failed or had to abandon the enterprise didn't cultivate themselves enough. And by cultivation I don't mean something highly intellectual in university degrees. I mean in the sense that

one cultivates the ground. To get French art, one had to cultivate France, that aspect of France which for a century was the most adventurous and international enterprise in modern art. Do I make myself clear?

JJ Yes.

RM And though I'm an internationalist at heart, I think one has to take the differences between countries seriously. You know, the drama of the English sky is bound to affect any Englishman. In the same way the fact that we're not essentially artisans meant that in the transference of an emotional abstraction to this soil it was bound to be tougher, more brutal, more barbaric, with less finesse, with many of the qualities that one actually uses to describe abstract expressionism. Which I think have nothing to do with aesthetic principles, but with the fact that it was made by Americans.

Now the exception is the trio of Graham and Gorky and de Kooning who were all European-bred, who all had that marvellous craftsman aspect. Certainly Gorky is as fine an artisan as [JOAN] Miró, or Picasso for that matter. But it is also obvious in the case of Graham, that he was not an abstract expressionist. It's also my belief that Gorky wasn't either, that when Gorky matured he ended completely without qualification the surrealist camp, and French histories of the surrealist movement now quite properly end with Gorky. De Kooning has both. I mean, he is both the great artisan that Gorky was, but he is also involved in the American violence and brutality and anger, in my opinion.

When I first came to New York, I came straight out of seven or eight years of university study with practically no art-school experience or professional experience. When I encountered many of my now eminent colleagues, who were to become abstract expressionists, as I was, I was very taken aback with their hostility to Europe. But you must remember that New York is a kind of Istanbul; it's a great crossing place, a great bazaar, and most of the people with whom I became very friendly were native New Yorkers, which meant in most cases the sons of immigrants, in perhaps half the cases, Jewish, and with savage feelings toward what Europe had done to their ancestors. And as the few people in the United States in those days – perhaps fifty altogether – who were involved in modern art, were treated as nothing in relation to the great masters of the École de Paris, [THEY] naturally felt a certain resentment

that if a thing were to be the real McCoy it had to be imported.
So New York had at the beginning, very roughly and crudely,
a relationship with Paris a little bit, I imagine, as Dublin does
with London.

JJ Are you Irish? Celtic?

RM Half Irish and half Scotch, but from some generations back in both
cases. My great-great-grandmother, whom I saw die when I was
twelve, left Ireland in the Great Hunger in 1846 as a young woman,
and cursed Queen Victoria every night before she went to bed till
the day she died [LAUGHS]. But, you know, whaddaya say – I didn't
grow up in violent Irish partisanship. On the contrary –

JJ Still the Great Hunger was very real to them.

RM Oh yes.

JJ All of us would have cursed Queen Victoria if we'd been there.

RM I think. It's one of those sad things in history.

JJ Sorry, I didn't mean to sidetrack you on that.

RM So then to go back to your original quote –

JJ May I take one? [CIGARETTE]

RM Please do. It is that when the European artists were here during
the war we saw them at first hand and realised that they were great
artists, but that they were also men, and that we were men, and that
conceivably we could try to be great artists –

JJ I take it that you had a special kind of sympathy for them, because
of your determined effort to understand or identify with French
culture, rather more than your colleagues?

RM That's true. One of the natural assumptions would be that since
there were perhaps twenty greatly celebrated Parisian artists here
during the war, there was a great deal of intercourse between them
and American artists. And actually it was very standoffish. Most of
the Americans were diffident or even hostile. And the Europeans on
the other hand were a bit helpless in that many of them didn't speak
English, and Americans, as you know, are no linguists at all, so that
if the European couldn't speak English it was very unlikely that the
American would be able to speak French. Also the Europeans were
a little bit isolated, partly because they were much more celebrated

than we were and we felt a little bit modest about getting close to them in general. Partly because the Museum of Modern Art and the Guggenheim and people like that were instrumental in bringing them here and they immediately moved, so to speak, socially in the *haut monde*, where we were all in Greenwich Village, which, as you know, is the Soho, I think, of New York.

JJ This is where I live now – and I understand exactly what you mean by everybody being *haut monde* except me.⁶

RM And another circumstance which again tends to be forgotten is that these were great modern artists, but by the time they'd all come, France had fallen and the Free French were the symbolic and the actual crusade against everything that was happening. So the modern European artists here tended to be taken up in American Francophile circles, which are relatively small and narrow and moved with different personnel from personnel that the American artists would normally encounter.

JJ And would that Francophile group in America tend to – this is a very strong word – despise American art as such?

RM Um, yes-s, or certainly not feel very active about going out and finding American artists and bringing them together. And it's also true that the most celebrated American artists at that particular time in general tended to be the most chauvinist, you know, such as Thomas Benton⁷ and [THE REALIST PAINTER] Edward Hopper, and so on. In many ways to American regional artists what could be more threatening than to have a stack of famous modern European artists come? And then also it was split by schools, you know. There were certain young American artists whose hero was Mondrian, and who wouldn't look at a surrealist. And there were others whose heroes were the surrealists and wouldn't look at [FERNAND] Léger, and so on. So actually very few of the American artists were very deeply involved in the Europeans. I was one of the exceptions. Later on, toward the end of the war, Gorky was, [ISAMU] Noguchi was, who is a Japanese-American. And he was having a difficult time because, of course, we were at war with Japan then, and so he naturally felt sympathetic to exiles.

And the person who was the greatest go-between because of his temperament, which is proselyting and because he spoke English extremely well, having an American wife at that time, and because

he was very young – he was still in his twenties – was [ROBERTO] Matta.[8] I would say the key figure – in his youth, in his ebullience, in his openness, in his energy – was Matta. And I think the Americans who were closest to him were myself and [WILLIAM] Baziotes[9] in the beginning, and maybe a year or two later Gorky very strongly, and David Hare to some extent, Noguchi, and then Wifredo Lam[10] who is a Cuban – and Matta of course was a Chilean – and an Englishman, who had been an officer in the Royal Navy, was against the war, and so settled in America, named Gordon Onslow Ford [THE SURREALIST AND ABSTRACT ARTIST].

JJ One of the controversies which sprang up later [WAS] the attitude of Clement Greenberg that abstract expressionism somehow is an extension of cubist principles. And the other view that it is a logical extension of surrealist attitudes. How do you feel about this?

RM Surrealism happens to be very disliked in America by the best painters and therefore I've stood up for its importance more than I normally would. I think the truth is that both positions are correct and it's not a contradiction. But I think Miró is the absolute European equivalent to what the Americans did. And the cubist part was all aesthetic: a real belief in the picture plane in a flat space, insisting on pictorial and not illusionist means. And there's no question that all of us preferred cubist pictures to any surrealist pictures. On the other hand, Greenberg, whom I admire the most by far of the critics of that period, nevertheless in my opinion regrettably had a temperamental revulsion, almost, against surrealism that I think blinded him to the importance of surrealist automatism, or 'doodling'.

JJ Yes.

RM Let me add just one more thing, while I think of it. In 1942 Sidney Janis came to see me,[11] the dealer, because he was writing a book called either 'abstract and surrealist artists' or 'surrealist and abstract art in America', and had spent a year travelling all over America finding any artist he could who conceivably would fit in one or the other of the categories. And I think in the end he found in all of America eighty or ninety artists. And didn't in fact publish the book, which is an interesting document of the period. And I remember his remarking that, to his astonishment, if you took all the people who were interested in these two areas throughout America, the widest influence he found was not Picasso, but

Paul Klee. Klee was extremely well-known in America in the '40s. There were two *excellent* German dealers who were refugees – J. B. Neumann[12] and Karl Nierendorf – both of whom had hundreds of them. And the Guggenheim Museum also had fifty or sixty on exhibit. Peggy Guggenheim had a dozen in her gallery. The Museum of Modern Art had however many it has. So that in New York one constantly saw lots of Paul Klees and of course, he fits the recipe we're talking about perfectly. There were probably more Klees visible in New York City than any place in the world in the '40s; and he interested everybody, and like Miró is one of the real bridges – which is to say he respected the cubist sense of the picture and had the surrealist automatism.

I think there's something else that's very important say to an audience overseas. And that is the extraordinary advantage Americans have had, ironically, in seeing contemporary European art. For years there was much more of it, perhaps still is, in the United States, available to anybody to see. I often think if London or Paris or Rome or Vienna had an institution like the Museum of Modern Art how it would have changed the whole scene, and so maybe the most important single influence on the renaissance, or the birth maybe, of modern American international art was not a painter at all, but a scholar, Alfred Barr.[13]

JJ Yes. I think that's very true. And [RELATES TO] my experience as a student. I was an art student from 1942 to '44 and then had to go into the army, and after I got out, three and a half years later, was a student again. And during those war years there was nothing to see because even if there had been collections they were all underground. Students during that period relied entirely on reproductions, and even those were scarce because book publication was cut down to a minimum. It was a very strange time and I think that had much more influence on the '50s than people think. Because many of the people that had been students then had had a very strange grounding in art.

RM I'm sure of it. Another great advantage we had here in New York City is with the enormous manpower of the United States. They were extremely strict, on both physical and psychological grounds, especially in the beginning, on who they took into the armed services. And without exception all the abstract expressionists were rejected, so that in those crucial years between 1940 and 1945

we were absolutely free to develop and to work and to realise ourselves; nearly all our contemporaries in Europe were involved in the war effort.

JJ It was exactly the reverse in England. The artist was the first to go because he wasn't serving any military purpose.

RM Well, here they were more afraid of artists. [LAUGHTER]

JJ You spoke of the violence of American art and the brutality, and yet an odd paradox it seems to me is that European painters have always valued the constant reintroduction of vulgarity into their work, some violent denial of anything that seemed to be becoming too precious, too tame, too tasteful, too acceptable and okay. It's almost a maxim of European painting that every generation somebody has to do something violently unlike the previous period because it had become too acceptable. It's a way of keeping art alive. It's like life itself. You can't really have any fun unless you do something which most people think is vulgar.

That was too much out of my head. What I was going to say was that in American painting if you think of, say, [JACKSON] Pollock and [MARK] Rothko, their paintings are tasteful to the point of being exquisite –

RM But it didn't seem so at all at the time. I remember going with Tomlin[14] to help hang a Rothko show in the early '50s and Tomlin had a classical cubist background and I remember Tomlin turning to me and saying, 'My God, Bob, this is not painting at all.' And you can't imagine how those great Pollocks that look so lyrical and beautiful now, how barbaric they looked, at the moment.

JJ There was a similar reaction in Europe: is it art?

RM And I remember when Baziotes and I in 1944 had our first shows at Peggy Guggenheim (I think mine in October and his in November), and we were both frightened and green and I helped him hang his show and I remember his turning white at a certain moment and saying, 'Bob, if you think this show is a mistake, that it's really not painting, I'd rather take it down right now than go through …' and my patting him on the back and saying, 'Come on, it's wonderful,' but really in my heart I was just as doubtful as he was.

JJ That is a marvellous story.

RM And look how beautiful, serene, bourgeois, impressionist paintings look to us now. And when they first appeared most people wondered is this painting at all, let alone is it good? And we had the same history. And I still get hit that way, as you know.

JJ Well, I don't know. You do, do you?

RM Oh yes. The *New York Times* reviewed my show in terms that it will be a red letter day for New York culture when it's taken down, it's such a disgrace.

JJ Really?

RM Oh yes, at great length.

JJ Who was the critic?

RM John Canaday is his name.[15]

JJ That's a bit depressing for you.

RM Well, it doesn't matter.

JJ At first everybody in Europe had pretty much the same reaction that you describe, of feeling that these things were so violent that perhaps they weren't art. But now they have come to see them as being lyrical and so on, as you said. But the people who admired the pop art revolution – if it is in fact a revolution – often justified their admiration in just those terms, that this was a vulgar new vitality coming to the thing that wrenched it away from becoming so tasteful that disappeared into a cloud of nuance.

RM Yes, but I don't agree with you that Pollock and Rothko are tasteful. To use a crude comparison, I would say that Rothkos could be compared in their rough-hewn quality to Stonehenge. And I think it's impossible to say that Stonehenge is tasteful. And I don't think impressionist pictures, serene as they are, are tasteful. Though I don't know exactly what taste is.

 Pop art, I think, is vulgar; I think is meant to be. And there are people who find vulgarity beautiful and maybe rightly, I don't know.

JJ As an art student [I THOUGHT]: after Mondrian what do you do next except go on trying to refine something which now seems to have been refined almost to its essence? I wonder if there isn't a similar feeling among young painters in New York confronted by abstract expressionism, which sits heavily on their backs – they

have to find themselves in a context where there's this immense
blast, this explosion behind them. There must be painters in Europe
still who are trying to get out from under Picasso's shadow.

RM Oh, I'm sure of it.

JJ And the only way they can do this is by some violent wrench and
something that's absolutely anathema to the art of their predecessors.

RM That's one way to do it, but it's not the only alternative. It seems to
me that the way to properly do it is what we ourselves did, which is
to forget the look of things, of the works of art that you admire and
to work by principles. I think the student process is: the student
falls in love with X or Y's work and tries to make them, and a very
skilful student can do it well (I've had students make beautiful
Matisses or Dufys [RAOUL, THE FRENCH FAUVIST PAINTER] or
Rothkos or Mondrians), but when one begins to mature, one drops
the look of what one admires and tries to grasp the inner principles
of it. So in the case of Matisse, a great deal of his beauty depends
on quantities of colour in relationship to each other – obviously
as he grows older, becoming more and more intense in hue. One
drops the look of a Matisse and begins to think in terms of using
the proper quantities of colour in the intensest degree of hue
that one can. Then one can go off on one's own and one doesn't
have to kill or contradict Matisse in order to go on. And if my
generation did anything, I think we stopped imitating Europe and
began to use parallel principles in our own way. And that's the real
transformation.

Since you're interested in the American experience I think one of
the most interesting things to talk about – and which I was late to
come to – was the enormous increase in scale, in actual physical
format. Others of my colleagues understood much sooner than
I did that a change in size of the same picture has a tremendously
different effect.

JJ Yes. When you say you came late to this, those large paintings of
yours – which are the ones most reproduced in England – large,
black sort of oval ... are not recent works, are they?

RM That particular theme has been a recurrent preoccupation with
me ever since I invented it, though [IT] amounts to perhaps five
per cent of my work. But it is a theme I've returned to over nearly
fifteen years. And the first one was the size of a magazine page.

I made one a couple of years ago that is twenty-two feet long
[6.7 m], and the difference is staggering.

JJ When you say you invented it, how did you come to make these
particular forms?

RM I think, as we've said earlier, all my painting life I've been interested
in automatism and particularly in what we call, unfortunately,
'doodling', but on a large scale. In the late 1940s Harold Rosenberg,
the critic, and I were editing a cultural magazine called *Possibilities*.[16]
(Unfortunately only one issue appeared because while we were in
the midst of the second issue one of the co-publishers was killed in
a transatlantic plane accident and the capital ceased to exist for it.)
But Harold contributed a savage, barbaric, Rimbaudian poem, and
we thought that we would like to have it more, in quotes, 'French' –
finely done, and so on, so we decided that I would write his poem
in my calligraphy and decorate it, put things around it.

JJ The French did this in *Verve*, didn't they?[17]

RM Yes. And in *Minotaure* and so on.[18] We knew it was going to be
reproduced in black and white, but my doodling was really quite
unsuccessful and I began to blot it out and, as you know, when
you're stuck or struggling with a picture your mind half-consciously
reaches for this or that. In blotting out the doodle I made a
strong, straight, thick black line and a strong oval. I remembered
somewhere reading [ABOUT] how beautifully Picasso is able to
contrast curvilinear forms with straight lines and thought: why
don't I make the doodle that's going with this poem a variation
on curves and straights? On one level it was as simple as that.
Nevertheless there's no doubt that there's something hypnotic
about that image that I stumbled on that day that is beyond
the aesthetic.

Later on, much later on, years later, some people noticed that they
could be regarded as phallic pictures and I made several deliberately
more phallic, others more geometric and the most anti-association
I could. An extraordinary thing was the aesthetic effect didn't differ
one bit. The emotional weight was identical.

JJ Do you think why it is meaningful may have something to do
with human physical rhythms or the structure of the human body?

That there might be anything in the theory that the form of art is an echo of some form in the human spectator that he recognises sympathetically?

RM I think it's possible – I think it's deeper than what's obvious and it has something to do with the human but also something to do with architecture. A psychoanalyst I play poker with sent me from Greece one summer a photograph of three Greek columns with the pediment across the top that had been taken at twilight, black against a twilight whiteness, and it looked very much like my pictures. Often Jungian terms are used in reference to my pictures – something archetypical about them. But if so it is by chance, though I must say by a most fortunate chance.

JJ It would be a paradox if it were true because you are an extraordinarily cerebral person.

RM Well, they say that. Greenberg one day said, 'I don't know what they talk about when they say you're so intellectual, you obviously do everything by intuition and have no facility at all.' And I think both remarks are absolutely true.

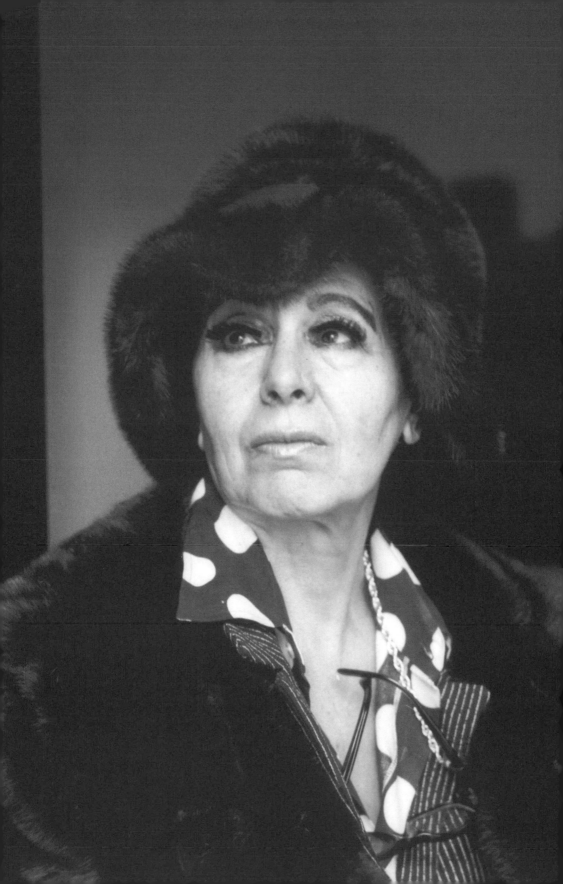

LOUISE NEVELSON

Louise Nevelson was interviewed on 7 December 1965 (10.30am) at
28 Spring Street, in Lower Manhattan. Jones was shown in by Nevelson's
assistant, Diana, and offered coffee. Nevelson made an entrance in a beige
patterned housecoat, which occasionally fell away to reveal a black-lace-
trimmed, flowered slip. In his notebook Jones noted that she had 'a slash
of green' on each eyelid and a 'little rouged mouth'. She was sixty-six.

She offered Jones a drink (at 10.30am). He declined, claiming a heavy
night before. She confessed she liked to drink alone and in the mornings,
and occasionally, when a 'drinking day' was due, all day. 'It relaxes me.'

Nevelson spoke deliberately, at a stately pace and with emphasis. She
tended to start sentences with the word 'Now' (more often than appears
in this edit).

Born Leah Berliawsky, in what is now Kiev in Ukraine, Louise Nevelson
came to the US at the age of four, learned English at school and spoke
Yiddish at home.

Known by the 1960s for her monumental, monochromatic, wooden
wall pieces and outdoor sculptures, she first exhibited in group shows in
the 1930s. Nevelson had been working with found objects (including a
shoeshine box exhibited at the Museum of Modern Art in New York in
the 1940s), and with stone, bronze, plaster, terracotta and in lithographs,
as well as with wood. In the 1950s she travelled to Latin America and,
inspired by the Mayan ruins she saw there, changed the scale of her work
from human to monumental.

Although at stages in her career she knew real hardship, by 1965 she was
a critical and commercial success. She had been on the cover of *Life*
magazine in 1958, showcased in the Venice Biennale in 1962, and in 1964
she produced works for the Israel Museum in Jerusalem, under the title
Homage to the Six Million I and *II*, in tribute to victims of the Holocaust.

LN I went to Germany, to Munich, to study with Hans Hofmann [AT
 HIS SCHOOL OF FINE ART] in 1931. I wasn't as happy in Munich as
 maybe other students, for many reasons that we won't go into at
 this moment. The following year, in 1932, Mr Hofmann came to
 America and I went back with him for a little while. You see the
 history in America is not all Americana. Now I'm not denying
 that our big boys – I call our big boys [MARK] Rothko, [WILLEM]
 de Kooning, [FRANZ] Kline etc. – are entitled to their place, and
 more than their place, because they're wonderful artists, wonderful
 human beings, did a marvellous job, gifted men. Nevertheless
 I will not accept that they are 'just' American. I feel that they are
 universal, you see. I brought out Mr Hofmann for another reason
 and that is that he wasn't an American; he brought his principles
 on creativity from Europe, because of the Second World War, and
 he established himself in New York. His influence as a teacher
 was very important. So the land was shifted, you see. As I said
 I don't think that these men have gotten more recognition than
 they deserve. I think their prices are not too much, because when
 you have men of that calibre, no price is too much. There's a lot of
 money around, but there are not a lot of artists of that quality.

 To go back to your original question, I feel that American art, as we
 call it, is not totally American. Creativity has always gone through
 the ages, and if you want to define it with a straight line, you can.
 It's a continuity. But the essence of what we have done is local.

JJ Did you ever feel affinity to any special European movement? For
 example, cubism or by the teaching of Hofmann, or surrealism, or
 any of those ideas? Did you ever feel affiliated to them in any way?

LN I feel affiliated to all of them.

JJ I just thought that maybe at some time or another, [PABLO] Picasso might have seemed to you more important in your own work, more *like* your own work, than, say Max Ernst, or vice versa.

LN I have already put in print that I feel directly [LIKE] a descendant of cubism. About Max Ernst: in some strange way, not in his figurative things or in his literary things and thinking, but the fantasy of the surrealists has touched me, and I like that part of it. But I took out of these things what I felt belonged to me and I understood.

JJ Which is what every artist does in a tradition, isn't it? They find something that they can work from.

LN I think cubism was the most important statement made in the twentieth century.

JJ Can you tell me what it was like during the Forties? Have you any reminiscences about the influence of people coming from Europe, Paris closing down, and the mood here – in relation to your work?

LN Well, I can recall, naturally, my own private world sort of collapsed about the same time the world collapsed, so I had two calamities and so it was, what you'd say, pretty bad. Now we had in America the WPA. Roosevelt introduced it and I think it was a very wise move on his part, instead of letting men go to pot, he gave them things to do. Preceding that, under the Hoover administration, people were selling apples on streets. The artist was in a particularly bad spot, and I guess he couldn't have been in a worse [ONE] anywhere in the world, at any time in history. So by the government's move, material was given to us, plus a little amount of money at least to pay for survival. And at that time, that's where some of these artists at least had a little freedom, including me.

JJ Were you dependent on the WPA?

LN Yes. At that time. And therefore you got down to the very basic essences of what life was, what you wanted. Now the people I mentioned, among others, like the de Koonings, the Klines, the Rothkos, and so forth, were all on that project. And the stark, austere way the artist had to live – life was so complex and difficult that naturally some had to come up shining. It made one feel a great determination, a fight.

JJ Did you ever feel when you were working under the WPA project some obligation to make art for social ends? Because the

impression I get is that after the help artists got from the WPA, some felt an obligation to serve society, to make some social comment about the situation in America. And then Kline and the people you mentioned seemed to turn to – abstraction, I suppose, is really the word – away from art serving society. I wondered if you personally ever went through a period of feeling that you were obliged to make art that was about the social situation?

LN Not for a second. Never entertained the idea for one second.

JJ You think it's foreign to the nature of art to serve something?

LN I think an artist truly wouldn't entertain that idea. Now I know in history [FRANCISCO] Goya and these people did that, but as far as my own consciousness is concerned, art is another place. It's removed. If I wanted to say something on the other, I would say it in words. I would never prostitute art for that purpose.

JJ As I was coming here, down the street, I had the feeling that I was walking in an enormous piece of sculpture by Nevelson. All the shopfronts had these little alcoves. And there were things in them, arranged in a rather ragged kind of way, not so orderly as your things, but the city seemed to be an enormous Nevelson sculpture. Do you think that your work derives from the street, or is it just a coincidence that these large reliefs resemble the facades of the city?

LN If you read some of my titles you'd know that I am glorifying New York City, which is a symbol of all cities. As a matter of fact, the subway, the big black iron things, or when you look across to New Jersey and see the boats and the big buildings, and the black docks – those are the keys to my work. And the dawn and the dusk. And that's why I don't have to go anywhere: I just look out of my window. And I've tried to say this before, by titles and so on – that I sit in one spot and I really am glorifying this city.

It's like a mirror you look into. And another thing – this may sound confusing, but I'm not making anything. I'm not making sculpture, I'm not making painting, I don't want to make anything. I just am trying to reveal something that encompasses a whole universe as we understand it. I sit somewhere, and there's a lot of air around me. A person can be right up close to me, there's still a lot of air around me. That is my cushion and that is my protection. Now I couldn't live without people. I love people. And yet I'm really removed from everybody. I don't know why, but it makes me comfortable to live

like this. I don't want to use the word work, I don't want to use the word sculpture – I'm not making anything, I am revealing a life of consciousness, and I am aware every minute of revealing that there are billions of people on earth [WHO] work hard just to survive – and that is their choice. From childhood I chose another thing and I was willing to pay the price. When I say I chose it, I mean exactly that. Never for a moment has it dawned on me to do anything else, and therefore the price is really not too high.

JJ It was worth it.

LN For me, it was necessary, according to my life. You see, here's what I'm trying to say: I didn't want what some people value. That doesn't mean that I dismiss their way of life, but for me I didn't want it. And at this point in my life, if I will be blessed to have the rest of it, I am just beginning. I have freed myself of so many things to come to this place. Now I was blessed with a great amount of energy and, as I say, the load was heavy, but somehow I carried it. It wasn't easy. It would be misleading to say that. Every day was difficult. I could use words like 'challenge'. I don't like words like that. They don't belong to my way of thinking. I didn't want any challenges. I wanted to create a world for myself where I would be comfortable. For me that environment was life and death. It was utterly impossible for me to live without it. I could not live in other people's environments. I consciously and subconsciously and super-consciously demanded for myself an environment. That doesn't mean having furniture and a beautiful sofa and the right lights. I think that is vulgarity. That is kind of a status thing, good taste and money and things. Nothing like that. That doesn't mean I wouldn't like to have a palace on Park Avenue. I could still enjoy that. But I wouldn't give it the facade of what they think it stands for.

JJ When you talk about the environment that you've chosen, are you talking about the whole way of life that you chose to lead?

LN Not at all. The visual environment.

JJ And the things that you did, these things are all part of making your environment?

LN Yes. To make my own world and take as little of the other.

JJ Do you physically construct these things all yourself now, or do you have somebody working for you?

LN Well, it's impossible to construct anything yourself by the nature of the work. Now in the beginning – you referred to the [WPA] project days – well, I recognised that it takes a lot of money to create and I was going to create, period. So I began finding the material, naturally – on the streets – boxes and old furniture and all – and I was using the principles of art and my eye was satisfied. But to answer your question, I don't use blueprints. I don't use maquettes. I work directly. Each piece is put in. If I composed this and didn't nail it, they would shake. So every piece I have made I compose, but I have to have somebody else to do the hammering. As I go on, I compose. There are no preconceived ideas on any piece. But I would like to be on record that there isn't a piece up till now that I didn't stand and compose before it ever left my studio.

JJ Did you as a woman find it difficult to live the life of an artist? Was it ever a handicap, do you think?

LN Well, I would have found life hard anyway. I found life hard, I found friendship hard, I found survival hard. I found the horrible things that people create to put on our backs and on our fingers and all hard. I found the whole world hard. But I think I was born an artist and that has given me my courage and conviction. People used to say one is gifted, and it's become a little old-fashioned, but I think artists are born. Take that young Russian ballet dancer;[1] now he is equipped to dance. You can't say that he wasn't born with the right proportions, the right rhythms and the right mentality and the right gifts. And that makes him, I think, a genius. Nobody, with the greatest amount of effort, could transfer themselves into this – this is born, like a diamond or a rock is created in the earth. I feel that great artists are born and it gives them their conviction, and they'll go through fire and water and all the elements to express this, to live with it. It is their life, life itself is that.

JJ For you there isn't a rift between life and art – living your life has been to live art. But then in another sense you do feel that there is a life which other people live, and the life of the artist is another kind of life. So that you do make a distinction between life and art.

LN I make a distinction not between life and art. Art is life. I make a distinction between life and society. You see there is the difference. Life in its consciousness – and most of the time let's assume that we are conscious – is creation. If you walk across the street or if you

take a cup of coffee and your hand touches the cup and you takc it, that's art. That's livingness, the essence of aliveness, the essence of livingness. It's all art. I think it was Picasso that said that art begins where life ends, and I say for myself that art is life and life is art.

JJ Can you tell me something about your background in New England? You came from Russia when you were very young.

LN Yes, my family came to New England from Russia when I was about four and a half. We came in April, and in September we had to go to school. Naturally the transition from Russia and its culture to New England, which was very rural and while the land was free, the culture fenced you in ... you were a *foreigner*.

JJ Did your parents have difficulty in adjusting, too?

LN Oh yes. My mother I don't think ever, practically, went into anyone's home. She became quite a recluse. And when she went down Main Street, they considered her the most beautiful woman in the city. But she would take months to make that performance. She used rouge and make up and very fancy clothes – shc ncvcr just went downtown – and then she walked slowly and moved slowly and saw that it was quite a parade.

JJ And your father, what work did he do?

LN Well, he had to learn the language and he went into several things and he was unhappy, and would have not stayed, but there was no alternative. IIe had these children, they entered school. You see, there were three of us that were born in Russia and my youngest sister born in America. Their dream was to come to New York and they never quite made it. So he learnt about real estate. His father was in the lumber business in Russia and he already had an uncle that was an artist and he an uncle that had the highest position of our race in Russia, so there was a conflict and a frustration. Nevertheless, he felt that we were in a new world and we had to have every advantage, and he saw that the girls should have the same opportunities as men – women should – and he made everything possible on that level. So, anyway, we adjusted, and whether we were foreigners or not they were handsome and they had four children, and we all had white, straight teeth that belonged to us and we all had good eyes and no one wore glasses – and we all could outrun anyone around us and wrap 'em up in

circles. Consequently, whether they liked it or not, there we were, big as life. Somehow we adjusted. But I will say even now that I don't think, as much as everybody tried, there is not an equality. I don't say that on a social level. I think it's deeper than that.

So I came to New York when I was rather young and I'd go home, where my brother's in the hotel business, every so often, but I didn't stay more than a day or two, because that's enough for me.

JJ Do you think that this experience of coming from one culture to a different one, was at all influential in your becoming an artist?

LN Well, I said earlier that I think artists are born with the right equipment. Nevertheless, I will say that the environment pushes you right where you belong.

JJ Yes. You said that possibly if you had come to New York instead of going to New England, things might have been different?

LN I think they might have been different, yes.

JJ You found here a community of refugees or ex-pats; or people that had come from Russia?

LN Yes, there would have been a wider scope and I wouldn't have felt so fenced in. Now if you say objectively, 'Oh, you were out in the woods and you were in a small place and you had all the freedoms in the world' – yes, but your behaviours were fenced in. A small town is not suited to certain mentalities.

JJ Do you think that your mother's tendency to be a recluse is something that you have, too?

LN Not in the same way. She was a recluse from society. I'm not a recluse. I made up my mind that I was a free human being. A free human being meant to me that my total time belonged to me. If a department store had offered me a million dollars a year because I was rather good at designing and things and said, 'You give us two hours a day per year, we'll give you a million dollars', I would have said no, because in principle that was not what I wanted. I wanted total time. I don't recognise twenty four hours a day. I recognise eternity in that time, and I would not cut it, nor would I prostitute the mind to cut it. It would be like surgery. I consider my total life as one thing, one consciousness. It might have been broken up here and there, for other reasons, but not because I sold it.

JJ Did you go to an art school in America before you went to [STUDY UNDER] Hofmann?

LN Yes.

JJ Where was that?

LN Well, I'm going to lead up to it. I went to school from the time I was five, graduated high school in my city in Maine, with honours – not that I was so brilliant, but it was important to me, and I never stopped studying – elocution and dance and comparative religion. I came out of there and came to New York – by that time I'd got married[2] – and I went right on – there was never a year that I stopped. I studied privately with art teachers. Then I went to the Art Students League for a few years and then I made my big break, in my domestic life and in my creative life, and I went to Hofmann in Germany. I've had a lot of schooling, actually. I never did what the teachers told me, but they always seemed to like what I did.

I made a great sacrifice when I went to Germany. I left my son in America. It was life and death. I couldn't live without art and I wanted to really get into the meat of it. Consequently when I went to Germany I went with great problems, too, and it didn't satisfy me, so I only stayed about four months. There were very few times I even saw Hofmann. So I don't feel his contribution was very much, for me. But I think [WHEN] he came to America his approach to his students was quite a different matter.

He had a small private school in Europe and almost all American students, but when he came here he opened a school and it was his survival, and the school was bigger. I think his coming to another land gave him a great insight, and I think he became a finer teacher.

JJ Did you attend his school in America?

LN For a little while. Hofmann and I were not student and teacher. He knows it. But I in retrospect understand what he's done for the American students and for American history, even if I don't feel that I was a participant. And I'm willing to say that it was me – I was too rugged and too individual for that kind of an environment. But I think what he had to say was very important. And I admit I was touched; everyone that went to his school was touched and he did give us something. But I wasn't ready to take that something. And, of course I never studied sculpture anyway,

with anybody. I wanted art in its essence. I wanted creation. I didn't want to know how to make a thing. I could make a thing. I don't even use tools, so to speak today – I'm an amateur when it comes to that. I use scissors – would anyone think of cutting wood with scissors? When I want to bend a piece of wood I put it in the bathtub and put [IT UNDER THE] water and slowly bend it. I never knew that people do that. I mean you find ways of doing what you want to say. And so I'm certainly not very mechanical, actually. But where the real creation comes, I'm right there, and it suits me fine.

JJ After you went to the Hofmann School you were still living in New York?

LN Oh yes.

JJ Were you part of any groups that exhibited? And did you know any of the other European artists that came here? During the war, when [ANDRÉ] Breton and Ernst and these people where about in New York, did you have anything to do with them?

LN No.

JJ But you were familiar with the sort of things they were doing.

LN Yes. I'm not very happy about it.

JJ Tell me about that.

LN Well, I was using forms at that time … and I have an exhibition and records to prove what I'm saying, and I don't think they were up to it. I don't want to be quoted as a forerunner; but I do resent the fact that by their not having eyes to see, they deprived me of survival. And so I can't laud them and think they're great – I don't think they are. I'll go further than that. I was in Peggy Guggenheim's [1943] exhibition of *31 Women*, and I was recognised as a modern artist, because I was the only artist that was showing with Nierendorf[3] in New York, which was the first gallery of New York at that time. Now if he took me, as a woman and the only American as such, the museum people of America, the art critics in America, the people that are really leeches on artists, should have recognised it. I will not forgive them and I am fighting a battle. Now they say, 'Well, what does that bitch want? She has everything she wants – she's famous through the world, she's selling her things' – well, I'm doing all this in spite of them, not because of them.

JJ I see. Apart from the *31 Women* show – did you show frequently in New York in the Forties?

LN Yes, I did. I had my first one-man show with Nierendorf in 1941 and every year thereafter. I showed a circus show in 1943.

JJ What was that like?

LN Well, they [THE WORKS] were pretty much like what I'm doing now. They were old furniture, they had movement. I had electricity where the eyes – I put electric lights in and they were moving, and life-size. I used broken mirrors and furniture on the heads. In some ways it may have been more exciting. It belonged to youth – it was exuberant – but naturally, my work must correspond to my age and I don't think that I want to be at a certain age what they call an adolescent. I recognise age as important to me, because every day I am bringing my consciousness with me. The history of my living is tied up with it now, in the images, the insight. I've paid for that and that's my heritage.

When I had my circus show at the Norlyst [GALLERY],[4] I also had a drawing show at Nierendorf. The circus show was so revolutionary I thought that these names that you mention – Breton and all these – would have recognised and communicated. Well, they were blind, and therefore they remain blind as far as I'm concerned. The first wall that I put in the Museum of Modern Art – was put in sort of gently – let's say soft-pedalled in. Now it took a man like [JEAN] Arp – he was in the Museum of Modern Art – a big dinner was given to him. I was invited to come because my installation was the same day as his installation, but I was never introduced to him. Why I wasn't I'll never know. Mr. Arp looked at the work and he said, 'This is America and I will write a poem to this artist. She is really the granddaughter of' – who does these things in Germany?

JJ [KURT] Schwitters.

LN Schwitters. Now you may not believe it, but my art history is a little negligent, so consequently I didn't know who Schwitters was, but I accepted it and Mr Arp, being the great artist he is, did go back to his country and did write a poem and had it published, and I still have never met this man. You understand why I like the Europeans? And before I had my work there [GEORGES] Mathieu[5] came to America and to the house and he saw a small black box with a door, and he said, 'I will not go back to Europe without this

box. I want to buy this box.' And I said, 'Lovely,' and he took it back to Europe. Naturally when our people from America went to look for artists in Europe he said, 'But you have this artist in America.' And so I really think that it was the Europeans that forced the hands in America, not the Americans whose nose I was under.

Then [PIERRE] Soulages[6] came to the house and he says, 'My, what a revelation', and he went back to Europe and he sang the praises, so you can see how enthusiastic I am about the European artists, because it wasn't the American museum people or artists, that said anything to my knowledge. I have said time and again my life has its spot of anger and people say, 'Well, how angry can you get when you've had all this?' I can't erase what I've lived. It was too deep. Every time I was hurt on this level it was like a psychic operation and I never got over it. I'm sorry, I wished I could. It still hurts.

JJ Where do you get all your bits and pieces of furniture?

LN Found them on the streets of New York. You see when we were very young we always heard that there's gold in the streets of America. So I put it to use.

JJ There really was for you [LAUGHS].

LN And I painted it gold.

JJ That's marvellous.

LN I am fighting – even now. I don't know why, because I could have had an easier life, I'm sure, if I wanted. But I think I wanted it as I understood it.

JJ In a way the hardness of it gave you a strength to do it. You push against it and it makes you stronger.

LN Probably. Yes. I must admit that because of my environment in Maine and all I was an extremely shy person. And basically it is ambivalent, because the shyer I am, the bolder I am. It's two-edged.

JJ Yes. I think I feel that.

LN Well, there you are. So you can see. And basically I don't think I might have been shy if it hadn't been because I was brought from Russia to this small town. I might have, in another environment, not been so shy or withdrawn, but the whole atmosphere at home and country lent itself to that pattern. So I struck out in a bold way.

JJ It all contributes.

LN It all contributes.

I was going to say, I taught and I must say that I had some very fine results. I never thought in my wildest dreams that I would ever teach. Now when I'd get into class, I would speak to the group, certainly no more than a few minutes, and then they would go to work. I didn't teach as such, but I would be there. I'd walk, I'd push a little or pull a little, and I would do that as if I was making, really creating a work of art at that moment. So I saw great results, and I was overwhelmed, and one day when I came to class I said, 'This class is doing very well, and I would like to hear from the students, because really I wasn't teaching as such,' and they all said that there was an atmosphere created and in this atmosphere – it wasn't only the teacher but the people – these were adults – were getting from each other kind of a rhythm, a wavelength. In other words, the room was kind of hepped for this thing. And so I loved it, actually – it was a communication on a creative level, you see. But after about four or five years, I got a little bit tired of it.

JJ Strangely demanding, isn't it?

LN Oh, very demanding. Really the next day I couldn't do a thing. And so I recognised that I'd given this as much as I could, and I resigned.

Years ago, the thing that might satisfy me, I'd go hunting for some visual object that would appease me, like a musician would want to hear sound. And on Third Avenue – that was our poorer antiques section – I saw a paddle that you row boats with. And it was very slender and to my way of thinking, it was something special.

And I went in and I asked the price and they said something like $300. And as I was walking I saw a piece of thin wood that came off a box lying on the street and somehow I identified the proportions and I took it home, and then I was going to make my own paddles, you see. And I can really say that there were only probably four notes that I ran into that created my world. Now we say Beethoven had an octave of eight notes, not including the half notes, and he built all his symphonies. And in the end I'm only going to have one note, and one note will be enough.

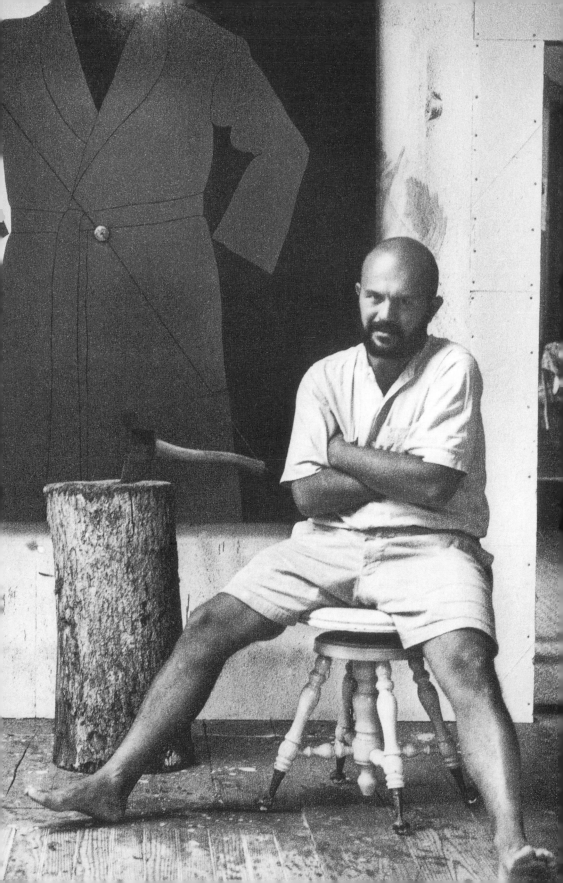

JIM DINE

The interview took place on 6 January 1966, at 50, East 11th Street, New York. Jim Dine was thirty, but was already feted as a pop artist, because of his use of everyday objects, such as tools and a bathroom sink, attached to his canvases. He was included in the influential 1962 show at the Pasadena Art Museum, *New Painting of Common Objects*, with Roy Lichtenstein, Andy Warhol and Ed Ruscha, among others.

Dine also used the gestural quality of abstract expressionism in his painting, but tended to distance himself from schools and labels. His work was autobiographical, with the quality of stream-of-consciousness.

He was particularly known for assemblage and happenings, some of which took place at the Judson Gallery in New York, which he founded with Claes Oldenburg and Allan Kaprow in 1958, such as the happening *The Smiling Workman* 1959 and an installation with found objects and street debris, *The House* 1960. Dine was also known for his *Car Crash* 1960, a four-person happening in which Dine appeared as a car, dressed in silver, and the actor Pat Muschinski (Claes Oldenburg's wife) read cacophonous concrete poetry scripted by Dine.

The use of a bathrobe as a self-portrait, which began in 1964, became a recurrent device.

In 1966, he was a guest lecturer at Yale, and an artist-in-residence at Oberlin College, Ohio.

During his interview with Jones, Dine spoke fast, energetically and informally.

(His sets for the 1966 Actors' Company production of 'A Midsummer Night's Dream' in San Francisco, with their heart motifs, went on to be celebrated.)

JJ Someone coming to your work freshly, especially some of the paintings with objects attached to them, would probably see it in relationship to the surrealists and the dadaists.

JD Well, I think obviously there's a connection. I come out of somewhere. I live in America 1965, but that doesn't mean that I don't know what went on before. And I am, of course, very aware. I don't consider myself a surrealist or dadaist. But I feel like a great receptacle for all the ideas, all kinds of art. I like everything. I'm certainly not interested in dada as a protest; that side of it doesn't interest me, only historically. And I don't like the surrealist, naive Freudian thing, because I know enough, having been analysed myself – it's quite a naive, childish approach.

JJ It's pseudo-science.

JD Yeah. Absolutely phony in its science. I'm more interested really in objects. In the key objects of a movement … Such as the Picasso *Glass of Absinthe*. A very important object – to me. Certain Duchamp things. Rather than a whole life. There are so many shitty Picassos; I don't like most of them. But I recently saw some Matisses I was knocked out by. I don't like all Matisses, but I love the satin – what do you call them? Made for priests to wear.

JJ The robes, the vestments –

JD Yeah, beautiful. Beautiful collages. God. The whole thing makes me think about wearing art. Makes me also think how important the object is. I'm knocked out by Matisse robes, a Picasso absinthe glass – how about a toaster? I'm not sure that it's because it's art it makes any difference to me. I mean certain tools like vices – wrenches, you call them spanners …

JJ We call them wrenches, too – the big ones.

JD Oh, the big ones are wrenches? Things like that seem to me just as prime an object as what I talked about.

JJ I couldn't agree more. I think they're beautiful.

JD I collect old tools. They're very beautiful and they make a lot of sense. You can't really get better than certain old tools – and in America there's the biggest tool manufacturer: Stanley.

JJ We have them in England, the same firm.

JD Yes? You can't beat a Stanley wooden-handled screwdriver. There's just no way to improve it. In fact, the only new tool I've ever seen that makes any sense, as opposed to say a small adjustment of a nineteenth-century [ONE], is a Stanley tool like a plane they call the sureform, do you know that?

JJ Surform.

JD It's beautiful. Fabulous tool – what an invention.

JJ Yeah, a lot of sculptors use them in England.

JD Yeah? I just started using one too – I'm just amazed by it.

JJ You can change the blades, too.

JD Yeah, absolutely. I have it for a rotary too. For my drill.

JJ In some of the works you've made you've included a tool.

JD Oh, lots of times. You know, the hell with the Picasso things, you can't beat an axe. By God, all the implications of an axe – an axe is as universal and as basic as a nose.

JJ But when you put them into your work there's more to it than simply calling attention to it.

JD Of course. There is the element of celebration. Of the fact it's a beautiful object; I want you to like it. But also it has its metaphorical content. ... Although I am anti-people who try to read things in – castration, etc. – obvious things.

JJ Is this the sort of thing that came up in your analysis [JOKING TONE]?

JD No [LAUGHS]. That's not what I think analysis is about. That's the kind of surrealist phony science. What the axe means is – it's about

chopping wood, and it's also about all kinds of chopping, both figuratively and literally – emotional chopping. I like to think about what I do as a kind of nourishment. That my art is a nourishment for myself, hopefully for others, although that doesn't come into it. There's enough going on about myself that I can talk about it for the rest of my life. It's like a voyage, a long trip. In fact, I just made a painting called *The Trip*, because it's about that. And you know, the high you get on marijuana is called 'The Trip'. I like that.

JJ You've stopped doing happenings. Have you anything to say about that?

JD I don't want to say things about other people, that's the only thing. I stopped doing them because I'm not a writer and I feel many times other people's performances are cop-outs about their own plastic art, and I don't want that to be the case.

I'm going to San Francisco because I'm going to design a set for 'Midsummer Night's Dream', and the costumes, and I like that idea better at this point because it means I can dictate the production. And it's much more total, particularly with something like 'Midsummer Night's Dream', rather than a contemporary piece.

JJ Who's performing it?

JD The Actors' Workshop in San Francisco, which is a very good repertory theatre. A friend of mine runs it and we've been talking about this for years. And it's an anonymous object – it's like a wrench, you know, or an axe, 'Midsummer Night's Dream'. It's in the vernacular. It's not like doing something avant-garde, that's not tested. It's a vehicle for yourself. That's what I like about it. And this guy I'm doing it with will be open to that idea, I know.

JJ And this you prefer to the happenings?

JD Well, I don't know, but I have the feeling I will. The thing I liked best about the happenings, for myself, was that I like to act. That's such a dead-end street [LAUGHING]. But I think in another life I would rather have been an actor. Well, you don't get applause and laughter from paintings. I mean, immediately [STILL LAUGHING].

JJ When you say laughter, I read somewhere that you didn't like the idea of people regarding you as the man who made funny happenings.

JD Well, you read that in Michael Kirby's book on happenings. What
 I said was they wanted to categorise it – as funny happenings.
 Whereas I said that people laughed at them many times not
 because they were funny, but out of embarrassment for themselves.
 Out of not knowing what else. Like people laughing when they're
 nervous – kids laughing at nudes, you know, in museums. Although
 I do believe there's an element of humour.

JJ Did you feel about the happenings when you were doing them, that
 you were revealing a great deal about yourself?

JD Yes, I did.

JJ And this is embarrassing.

JD Absolutely. I didn't do any for a long time, then I did one in '65 at
 the Theater Rally. Which everybody hated and I knew they would,
 because I used personal exposure as a medium. It didn't give them
 all the kind of expressionist volts that they were getting in the old
 days and it wasn't that kind of theatre.

 I think there is humour in my work, though. I believe in it as a very
 forceful expression.

JJ One of the themes that's come up over and over again with
 people I've interviewed has been the relationship of art to life, and
 someone like [ALLAN] Kaprow, for example, talks about trying to
 make his happenings get closer and closer to the everyday.

JD I'm not interested in that. Then you just live an artistic life. That's
 okay too. But I'm more interested in living a very ordinary middle-
 class life and then making a kind of special madness in my studio.
 Because I think there is a difference.

JJ When you began to make art, how did you feel in relationship to
 the giants of the American scene, the abstract expressionists? Did
 you have a strong reaction against that?

JD Oh no, I love them. I didn't think there was a bad one. It's just that
 I made something different. I didn't paint like them. I certainly
 came out of them, though – my teachers. Not literally, but – you
 know –

JJ But quite definitely your work doesn't subscribe to their values.

JD I don't think so. No.

JJ It's quite different.

JD Absolutely.

JJ Who were your teachers?

JD Oh, just in Ohio, some nameless people that were meaningless,
 for the most part. It was really seeing art magazines ... [THEY] were
 my teachers.

JJ Did you do much in the way of art training?

JD No. I went to college and took an art degree, but that was
 meaningless too, because they had never had anybody who wanted
 to be a painter before. So they just left me alone. And it was no
 adjustment to come here, you know. I was just working by
 myself always.

JJ Did you grow up in Ohio?

JD Yes, I'm from Cincinnati.

JJ What sort of things did you do when you were first working?
 How did they differ from what you do now?

JD Well, I think there's always been a thread of the same thing going
 through one's work. It's just obvious, if you are that sort of person.
 In college I taught myself how to draw sort of like an old master
 – but I also made very unusual constructions which I was thrown
 out of school for, finally, out of graduate school. And they destroyed
 them – the students.

 They were quite related to Rauschenbergs, and I'm told early
 [JASPER] Johns – [ROBERT] Rauschenberg told me this when he
 saw pictures of them. Yet I had no knowledge of those people
 – I hadn't seen them. It was just something in the air. And [HE
 COMPLAINS ABOUT THE QUALITY OF MATCHES HE IS TRYING
 UNSUCCESSFULLY TO STRIKE] I came to New York and started to
 work and Claes [OLDENBURG] and I showed together things that
 were sort of expressionist objects. And we met Kaprow and made
 the happenings. But there was a thread of abstract expressionism
 and German expressionism. Then I went off by myself for a
 year, and I made things which I thought were very spare and
 constrained, which is another side of me – but humorous too –
 there was that element in them, too. I had a big eight foot by four
 foot [2.4 × 1.2-m] painting – it was all black and heavily encrusted

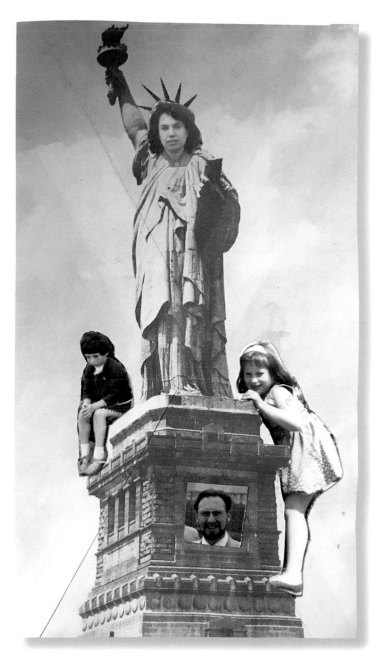

1. Card to send to friends from the US made by John Jones. Printed envelope and collage of photos, with the face of Gaby Jones as Liberty; Nicolette Jones, seated; Rachel Jones, climbing; John Jones on the plinth.

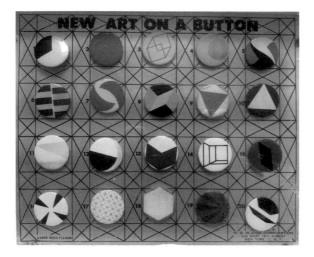

2. New Art on a Button collection of pop art badges by Dean Fleming. Manufactured by N. G. Slater Corporation, 220 West 19th Street, New York. A gift to John Jones.

3. Ephemera (clockwise from top left): John Jones's library card as Visiting Professor at NYU. Flier for screening of underground films including Warhol's *Kiss*, October 1965. John Jones's membership card for The American Federation of Arts valid October 1965–October 1966.

4. Robert Indiana *Under the Bowery Moon* 1966.Coloured pencil
19.8 × 54.6. Signed for John and Gaby Jones.

5. Louise Nevelson
Nude 1965
Pencil on paper
28.8 × 22.2
Signed 'Xmas 1965
to John Jones.
Good Wishes L.N.'

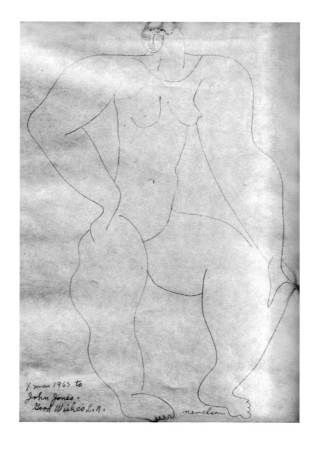

6. Roy Lichtenstein
Brushstroke 1965
Screenprint on paper
72.4 × 56.5

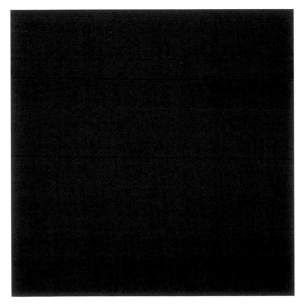

7. Ad Reinhardt
*Abstract Painting
No. 5* 1962
Oil paint on canvas
152.4 × 152.4

8. Claes Oldenburg
Floor Burger 1962
Acrylic paint on
canvas filled with
foam rubber and
cardboard boxes
132.1 × 213.4

9. Saul Steinberg
Dancing Couple 1965
Graphite, coloured
pencil on paper,
49.5 × 36.8

10. Robert Indiana
USA 666, the 6th American Dream
1964–6
Oil paint on canvas
266.7 × 266.7

11. Man Ray *Chess Set* 1962–6
Anodised copper chess pieces with polished and enamelled brass chess board inlaid in a wooden presentation case. Cast in an edition of 50

12. Helen Frankenthaler *Floe IV* 1965
Acrylic paint on canvas 142.2 × 149.9

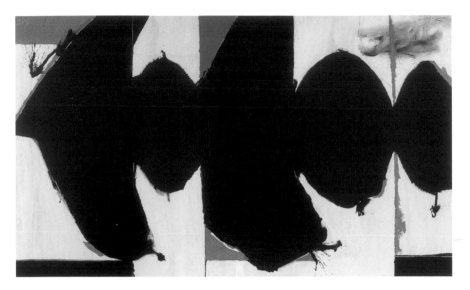

13. Robert Motherwell *Elegy to the Spanish Republic, 108* 1965–7
Oil paint on canvas 208.2 × 351.1

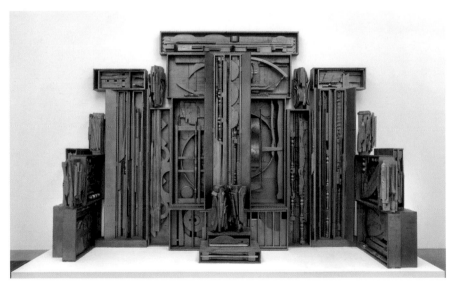

14. Louise Nevelson *An American Tribute to the British People* 1960–4
Painted wood 311 × 442.4 × 92

15. Jim Dine *Tool Box 1* 1966
From the series *Tool Box*
Screenprint on paper 60.5 × 47.5

16. Robert Rauschenberg *Bed* 1955
Oil paint and pencil on pillow, quilt and sheet
on wood supports 191.1 × 80 × 20.3

17. Marcel Duchamp
In Advance of the Broken Arm 1964
(Fourth version, after lost original of November 1915)
Wood and galvanised-iron snow shovel. H. 132

18. Louise Bourgeois
Lair 1962
Plaster 35.6 × 40.6 × 40.6

19. Grace Hartigan *Reisterstown Mall* 1965
Oil paint on canvas 203.2 × 259.1

20. Yoko Ono *Bag Piece* 1964
Performed by the artist during *Perpetual Fluxfest*,
Cinematheque, New York, 27 June 1965.
Gelatin silver print 19 × 19. Photo by George Maciunas

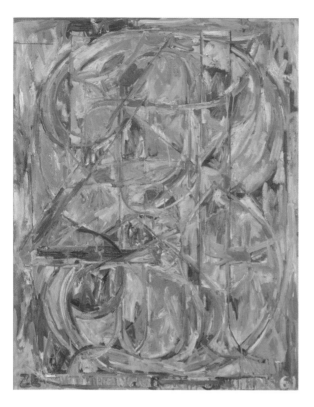

21. Jasper Johns
0 through 9 1961
Oil paint on canvas
137.2 × 104.8

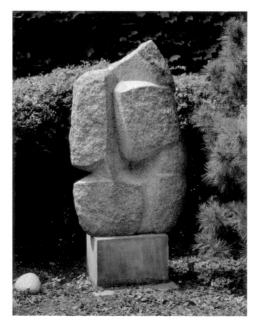

22. Isamu Noguchi
Indian Dancer 1965–6
Granite 153 × 87.9 ×
44.1

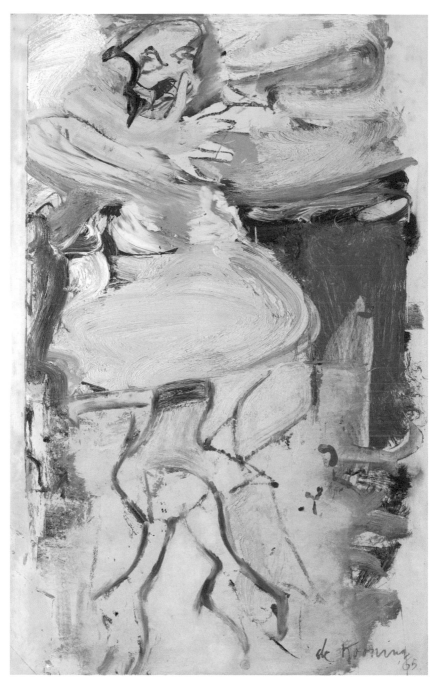

23. Willem de Kooning *Woman, Hand Before Face* 1965
Oil paint on paper on board 91.4 × 58.4

24. Ed Ruscha *Annie,*
Poured from Maple
Syrup 1966
Oil paint on canvas
139.7 × 149.9

25. Lee Krasner *Gaea* 1966
Oil paint on canvas 175.3 × 318.8

and shiny, with a little, little red stripe in the middle, called
The Legion of Honor. Then I made the first two palettes and then
ties and shoes and all that, and from there I made a lot of
tool paintings. And since they all come from the same place –
a hardware store, I mean – I found bathroom objects and started
bathroom things, and went back to palettes and made a whole
series about being an artist. And through this there are other
themes running through, like colour charts, rainbows. And then
I went into self-portraits. I made those red robes, which were
self-portraits. They were at the show at Janis [GALLERY],[1] a year ago
last November. With the axe and things. And from there the show
in England, at Fraser's.[2] And from there I went to the sculptures
I made, with the hammers, at the last pop show at Janis, and I've
made other sculptures since. And now I'm doing other things.

JJ I wondered if you could talk about any kind of change of attitude
that may have occurred.

JD Oh, yes, I had a change of attitude in the sense that I know a little
bit more about what I'm doing. Very little more, but at least I have
an idea that I have certain powers now, as I grow. And, sometimes
I have a little inkling –

JJ In those earlier expressionist things you were feeling your way,
were you?

JD That's right. I just did them. They were sort of instinctive. And
now I have more muscles, you know. Now I've found objects that
I just find in working, like a bottle of ink top or pencil shavings, or
something that I can use as a component of a whole idea I want to
make. I like being able to pick a thing up here and pick something
up there and – out of all this crap comes something.

JJ When you talk about putting it together – someone like, for
example, Tom Wesselmann, talks about the placing of things
and he's very much concerned with the formal aspect of his
compositions; and is in fact a little bit upset if people read into the
work meanings that have to do with the nature of the object. They
see a Coca Cola bottle as a comment on American society. He's
much more concerned with the actual placing and the rightness …

JD He may be, but he's choosing the objects, so he must be aware
that people will say things like that. Why doesn't he use, you know,
a bottle of cough medicine?

JJ The point is, do you assemble things in any kind of classic or academic sense of composing them?

JD Well, I compose. I think of myself as a composer, as the final glue. I'm the one that puts it together, but I like to think not in the academic sense, because I think my ideas about composing are certainly different than Matisse or something like that. No, I do it my own way. I feel my way about – you see I believe everything works, in a way. And I believe you don't have to smear paint on everything to make it relate back to the canvas. And you don't have to goosh it up with little squiggles of paint all over it, or whatever. I think that objects stand by themselves: they have a certain inner strength. I mean, nobody questions you wearing glasses not made of skin. They just sit there and it looks, you know, perfectly natural. And I believe that things work that way – things are independent.

JJ I just wondered – you see, Wesselmann, he's got a kind of classic desire that the whole thing should balance –

JD Yeah, but anything does anyway.

JJ Well, it's a classic sort of idea.

JD It's a sort of another way of living, too, isn't it? I mean, I don't live that way either. I live with a pile of papers. I'm like a Collyer. You know what the Collyer brothers are, who they were?³ They were two hermits …

JJ Oh yes, I do.

JD … that were found in New York City dead, with newspaper piled around them. Well, I live like that. It irritates the hell out of my wife. I mean, we redo our apartment, we repaint the walls and change everything around and get everything new again, and the place still looks like a shit house after two days, because I'm like a rat – you know, I bring everything with me – all these little clippings. I'm not interested in order.

JJ And your painting's like this. You're not interested in order for its own sake?

JD Right. Because that is my order, this sort of confusion.

JJ Can you talk a bit about this 'Midsummer Night's Dream' project?

JD No, I couldn't because I don't know. I don't fly, so I'm taking the train out and – and I'm going to make my drawings on the train. It takes so goddamn long.

JJ How long does it take?

JD Well, you take a train to Chicago. You leave at six o'clock at night and then you get there in Chicago at nine in the morning, then you wait till six the next night – which is okay. I want to see Chicago anyway. From six the next night. Then the next day. Then the following noon you're in San Francisco. So it's really not so bad, I guess. The trains are supposed to be very good out of Chicago to the west. They have sort of domes on, so you can see.

JJ Well, I was thinking of doing that just for that reason, because I'd like to see that.

JD Yeah, well I'm told that they illuminate the landscape at night in those domes – as you're going by there's floodlights on things. I'm very excited about going.

JJ So the abstract expressionists, in their work, seem to contain two aspects of European art. One was the cubist thing, the importance of the surface and the arrangement of things on that flat surface. But the other thing is this element of surrealism, where they work themselves into a state of mind with the direct gesture coming from somewhere deep in themselves.

JD Yes, but that's only a few abstract expressionists. Surely [MARK] Rothko doesn't do that.

JJ No, Rothko doesn't. But then I hardly regard him as an abstract expressionist. In that sense.

JD The direct gesture is the best of what I learnt from them. Because even if you don't make the gesture physically, what it's really about is impulse, about marginal thoughts. It's about trusting. Which I like. It's the thing I try to talk about in my teaching. You must trust what happens, even if you don't control it. For instance, particularly with beginning students, the best thing of theirs that they do is their palette. It's absolutely sensational because it's worked over, it's naive, it just is so pretty. They're usually appalled when I say that, but it is about trusting. That's the thing that I

learned from the abstract expressionists most – you trust your track, so that if you make a mistake it might be the best thing possible.

JJ Well, this does in a sense relate to this surrealist idea.

JD I guess so, sure. Via abstract expressionism, though.

JJ Of course.

JD Because I think the automatic things that the surrealists did were very ugly. Even the things like *Exquisite Corpse* – you know, the collective drawings. I think they're terrible. And I think the imagery is so terrible. It's phony mad art.

JJ Yes. There was, however, this seed in it of the abstract expressionist thing, which I agree with you about.

JD Well, I think abstract expressionism's the wrong word. I think it should have been abstract automatism, or something like that.

JJ You were saying about teaching: this is something you actually like doing. It helps your work, you say?

JD Well, because I'm only thirty years old and most of my peers are older, it makes me feel young. Which I am, and which one needs reminding about in New York, because suddenly my generation has had a success, so that you have to deal with adult business, adult things. And I like being challenged by people who have no stake financially in anything. Or political. They're just eager to challenge for their own egos or their own interest or curiosity, and I like that because those are pure questions and you can't bullshit students. That's the best part of it.

JJ You don't find that when you come to discuss ideas with them this is exhausting, that it inhibits you actually making things yourself?

JD Oh no. If it's exhausting it's only physically, and that doesn't inhibit me from making anything.

JJ I meant that somehow you dissipate the idea in discussing it.

JD No. I've heard that from teachers too, that their ideas were dissipated by teaching. I don't think so, because – let me think why I don't believe that – because if you have an idea that's strong enough, and it's worth painting, I don't think anyone can dissipate it. I don't see how it can be dissipated. In fact it's almost a good way of editing – teaching. You know, you get rid of a lot of the chaff.

JJ I think it isn't always quite so easy as that. My experience is that sometimes you have something burning in your mind; it isn't quite clearly formulated and yet you start talking about it to students, and in no time you've kind of verbalised it all away, or they're busy doing it and somehow it hardly seems to be worth starting it up. You tire yourself of an idea.

JD Well, I just haven't found that. I've heard that though, from so many people.

JJ Rauschenberg the other day was saying that he found after six weeks there was just nothing left. He'd used all the energy that he would use to work and all the ideas.

JD I've found it, as I say, almost uplifting. It brought me out of myself. So that one didn't think about the little things that bug you each day, that maybe keep you from working. You see people just wanting to hear from you – so it's a bit like a mission.

JJ When you talk about bringing you out of yourself, do you have bouts of being a hermit?

JD Oh yes. I really need to repair myself. I need to get away. In fact, going to San Francisco is a kind of repairing.

JJ Yes. So it doesn't have to be isolation, just a change of scene.

JD Oh no, I don't want isolation. I need people. No, a change of scene is what I like.

JJ Do you spend a lot of time with artists now?

JD No, none at all hardly. I find that most of us have nothing to say to each other and those that do spend time with each other may have no one else – and I have a lot else going for me. I've a rather rich family life and my friends are not artists. New York has gotten to be not terribly – nice. In that way it's not easy to be friends with other artists. I'm sure it's about New York, because the English artists I know – I have no better friend, I consider, than [R. B.] Kitaj. It's a take on life that one gets here. It's a bit Madison Avenue.

JJ There was a time, with The Club and the period of [JACKSON] Pollock and [THE SCULPTOR PHILIP] Pavia and [WILLEM] de Kooning, when the artists definitely felt they needed to be with each other quite a lot.

JD They had to be with each other. They had nobody else. They had
 no recognition. They had no families. Most of them were from the
 Depression, and many of them didn't marry. The bar life was
 a social life for them – plus they weren't terribly sure about what
 they were doing.

JJ Yes. That kind of a group thing was their security? To do what they
 wanted to do.

JD Yes, absolutely. I'm not terribly sure about what I'm doing, but,
 there are enough people I care about who are sure about what I'm
 doing. That it makes it okay.

JJ I suppose there was a period when you first came to New York
 when it was important to be among other people?

JD Yes, of course. Absolutely. I mean my relationship with Claes in
 1959 and '60 is as important to me, and I'm sure important to him –
 as anything I have.

JJ I suppose it may have something to do with the success with you.

JD Oh it does. I'm sure. As basic and as petty – it's about not wanting
 other people to see your ideas. Because things happen so quickly –

JJ Oh, I didn't quite mean it like that. That's another aspect of it.
 No, I meant that being successful you achieve a certain kind of
 confidence and security about the way you make something and
 you don't need to surround yourself with other people that are in
 the same boat.

JD Oh, absolutely. Sure. But one of the problems that comes in is,
 for me anyway, being the first generation that's had this happen
 to them, one doesn't know how to deal with it so well. You have
 to sort of go back into yourself, repair yourself, figure out what it
 all means.

JJ There's always the anxiety that it's all gonna come to an end
 somehow.

JD Oh, it's not really an anxiety, it's a reality. Because I know that most
 of my paintings aren't bought for the right reasons. They don't know
 what they've got. They buy them for financial investment, which is
 the dumbest idea in the world. They buy them for social prestige,

whatever that means. It has its constructive elements, because I then try and make things much more difficult, in a perverse way, maybe – but I'm interested in toughness in art. In a barrier between people and the thing, that they have to get through, that one person in a million will understand. I'm interested in making it as nasty as possible at times, because I think that's the way things are.

JJ Larry Rivers said that he painted *Washington Crossing the Delaware* because it would be anathema on the art scene – just the very thing that everybody would hate.

JD Oh, yeah, but that's about show business. That's not about what I'm talking about.

JJ Yes, but still that sort of thing did motivate some of the artists. I remember Lichtenstein making some statement about how easy it was to sell things; and he was desperately fishing round for something that people wouldn't like and commercial art was one thing that everybody in the art scene despised – and he did that, but they didn't hate that either. Are you ever motivated by a desire to do something which they simply will not have?

JD Well, many of my things people will not have – the best things, as far I'm concerned – just won't sell. But I'm so productive, I make enough things, that I get along okay. But the paintings I like the best for the most part have never sold. They're too difficult. I was very pleased that Oberlin Museum bought a very difficult one. But that's who should buy it, you know, what the hell.

JJ The situation in New York is rather different now from what one tended to think of as the inevitable life of the artist. The young had to go through a period of self-examination, which they did in isolation. A kind of apprenticeship.

JD Right.

JJ And certainly when I was student, this was very much the idea. But here you have to do all that self-examination in the full glare of public success.

JD That's right.

JJ Does this worry you at all? Do you feel that you might easily be seduced by the ease –

JD No, because I never really have any ease about things, unlike some of the other peers of mine. Because, as I say, my things are misunderstood, and also not many people know that they don't understand them. I don't play a political game, and I'm in no school really. I'm linked as a pop artist, but I'm not that – it's just because I'm their age or something, and I was in the scene at the same time. Or I used certain popular imagery at one time. No, I never worry about being seduced by any of that, because I'm still persona non grata in so many political camps, and that it's okay with me.

JJ I'm surprised to hear that.

JD It's painful at times, but I like it. Ultimately it gives me so much more time to do everything I want to do.

Pop artists are persuaded most of the time by certain dealers that what they've just done is a masterpiece – every time. It just isn't true. It isn't the most important thing that's going on in the world. They're not taking this fantastic chance. They're not riding around in outer space, for instance.⁴ So what the hell does that mean? It really irritates me, because it's all crap. How many masterpieces can you make in a lifetime, for Christ's sake? One of the reasons I retreated from the early fame I had – with *Life* magazine and all these things – is that I felt like I was becoming a star and that they were interested in seeing me and not my paintings. One has to grow up a bit.

I do know people who have done very important paintings at times and who suddenly cop out with an easy image or beautiful surface or something – suddenly these things are their best works and they're seduced by it. And their best works still remain unsold, you know. But this crap goes on.

But success: I'm not confident – it's a possibility that tomorrow I won't have any money. But I am confident about not making a compromise. Because what I do is what I like to do best. And if I stop doing that there's no point.

JJ This is the saving grace of this situation, really, that they don't expect you to go on doing the same thing over and over again. They just want you to do what the hell you like. This must be unique in the history of art.

JD Well, except that they *do* expect you to go on doing the same thing over and over again. That's one of the reasons I'm persona non grata – I keep changing. Well, that's part of my strength, for me. That's how I grow – I change, and people will say, 'Well, we were just getting used to your ties and now you're in the bathroom.' Well, tough shit, you know. Too bad for them. If they can't make the switch, that's not my business. It's not my problem really.

JJ Have you started making things for your show in November?

JD Oh, yeah. I'm going to show all my sculpture that I made. Most of it's done. I haven't finished a couple of pieces. And I have many new drawings and collages and about seven, eight paintings done for it.

JJ And some of these prints perhaps –

JD No, I won't show any prints.

JJ Where will they be published – the ones that you're going over to England to do?

JD Prater[5] will print them. They'll be published there with Alecto[6].

JJ Probably here, too.

JD Oh yeah, absolutely. That's part of the thing.

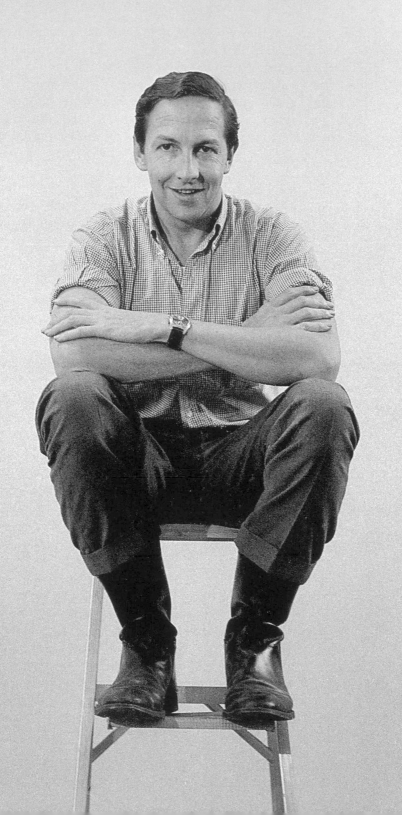

ROBERT RAUSCHENBERG

Milton Ernest 'Robert' Rauschenberg was born in Texas. His father had German and Cherokee ancestry and his mother was of Dutch descent. His parents were fundamentalist Christians. Rauschenberg dropped out of his pharmacology studies (not knowing then that he was dyslexic), was drafted into the US Navy in 1944, and served as a hospital technician. After the war he studied at the Kansas City Art Institute, at the Académie Julian in Paris and at Black Mountain College in North Carolina. He moved away from the strict discipline of the teacher he had sought there, Josef Albers, and associated with John Cage, Cy Twombly and Jasper Johns.

Rauschenberg travelled to Italy with Twombly, where a critic suggested he throw the work he had just exhibited in the Arno river. He did exactly that with the unsold pieces.

He was a dada-influenced precursor of the pop artists, known for his *Combines* (1954–64), incorporating everyday objects into his work and blurring the distinction between painting and sculpture.

He was also a conceptual artist. In 1962 he submitted to Paris's Galerie Iris Clert, which had sent out an open invitation for portraits of the gallery owner Clert, a telegram that read: 'This is a portrait of Iris Clert if I say so.'

He received the International Grand Prize in Painting at the 32nd Venice Biennale in 1964.

(In his work *Soundings* in 1968, which came out of his collaboration with the electrical engineer Billy Klüver, he created a light installation that responded to ambient sound.)

This interview took place in New York on 13 January 1966. Rauschenberg was forty. He spoke slowly and deliberately, in a friendly tone.

JJ Do you feel your work is an extension of any particular trend?

RR Very often I'm accused of coming out of, say, [KURT] Schwitters, or some periods of [PABLO] Picasso, in the use of materials. Like those Picasso things that were done either before I was born or just a couple of years later – with rubber gloves and sand and sticks,' and early Schwitters, too. If someone dislikes my work, then it's usually an accusation, and if they like it it's like they want me to be more comfortable and they're throwing on another blanket because it's cold out. But I wasn't very well educated about painting and a lot of these things I discovered after I had acknowledged, by the work, a natural sort of affinity with materials and ideas. Often I was really surprised when I found that for years people had been thinking along those lines. So, I've not consciously patterned any aesthetic.

I think that the ideas that were going on in Europe at that time have to be acknowledged, as one's family is – and I don't really have a strong family sense. I think those ideas have had certain repercussions. Those works having been done is the climate that I grew up in – and you don't have to go to art books or museums for that, because the look of the world has already changed. Art has a greater and more complicated and immediate influence, I think, than scholars are willing to acknowledge. There's always someone around who doesn't get written about, who sees something being done, and tells someone else – the first thing you know, it's changed the layout of a magazine or the shape of some object.

So the influence is unavoidable, just like the weather. I've only been influenced in the most open, general way. There's another kind of artist that does have a kind of obsession where he develops a line of thinking and isn't susceptible to the weather but lives in a kind of

controlled environment, who might be able to honestly draw some concrete comfort in the fact that this artist rather than that artist was doing the valid work of that time. But by the time it's gotten to me, it doesn't even matter who was right or who was wrong.

JJ I understand that business about reacting to climate and mood without any specific moment of which you can say, 'Well, at this moment I was suddenly aware of the work of somebody and this changed my attitude.' I think there are painters who see somebody's work for the first time and from then their life is different, not only their work. I was really seeking some revelation of that kind – perhaps the first time you saw something you realised was for you.

RR Oh, I think there are a few examples like that, but the ones that I can think of are not the European painters, but, say, Barney Newman and Rothko. Both have affected me greatly. I remember an extremely strong physical reaction to [MARK] Rothko's paintings when I first saw them. He had a show of very large, hot paintings at Betty Parsons' [GALLERY] and they just filled this whole room and it was a unique experience, the intensity of the conversion of a neutral architectural space by pure colour. I remember feeling very hot and feverish. And when I first saw Newman's show I went into the john and threw up, because there was the intensity of a single line on a canvas, done in the scale that it was done, and realising that this was not the side of some old building where there was the imprint of a beam or something, that this was man-made, was sort of overwhelming.

JJ That's interesting, that extreme physical reaction to a work. One other way people seem to form their own way of working is not by recognising in the works of the past something they feel sympathy for, but having a strong reaction against something. I think some young American painters found that the abstract expressionist thing weighed very heavily on their shoulders and that they were motivated by a strong desire to get out from under this. Did you ever have any such feeling?

RR I had. There was a kind of talk around the function of particular colours and ways of putting on paint, attributing all kinds of social and political interpretations to the material and the way that it was used, and shapes, that I found improper for myself.

JJ Can you think of instances?

RR Well, I think that a particular kind of red doesn't know that it represents blood – and there are too many other red things. It just wouldn't work for me. I couldn't see that in it. You find it in all the criticism of that period, too – if these paintings were viewed at another time or without the criticism, that information really wouldn't be in there. I think abstract expressionism has that built-in flaw. Whereas other kinds of expressionism, you can see that a face has a tortured expression, so you can read the intention of the artist.

JJ Ad Reinhardt had something to say when I was talking to him the other day about how deplorable it was that they should describe the Motherwell paintings as being dinosaurs rising from the primal mud, or bull's testicles hanging on the bull ring fence, or something.

RR Yes, that's ridiculous. My interest in their work was the variety of techniques of putting on paint and the sense of scale that was fresh to me. For years a large painting meant that that was a masterpiece or an important painting, and that's a hangover from the European idea of buying paintings by the metre or centimetre. That wouldn't work here. Sometimes a smaller picture is much more valuable than a large picture. Everybody's imagery has a built-in scale now.

About that earlier business of having the very strong reaction to exhibits that I'd gone to – I never felt that I wanted to go home and do that. It was more like, say, if it's a very cold, snowy day and you go to the [NEW YORK] Botanical Garden and find yourself in the room where everything is green and it's hot and the leaves are enormous and water is dripping everywhere, it's just a completely changed environment, and I think that disorientation is a very important aspect to living. Maybe only because our natural tendency is to cut ourselves off, or to develop habits how not to be upset. I've always been attracted to these things; I've gotten just as much out of exhibitions that I thought were really lousy – where you leave sure that that was unnecessary, or you saw nothing there that you hadn't seen a thousand times before. So I think you can use anything.

JJ When you first painted the bed which caused such a scandal – I've heard you say that it was a question really of not having any other kind of material to paint on at the time. Is that right?

RR Right. That painting is accepted as a gesture, probably in dada tradition, or updated dada, and it evolved so undramatically that for

years I was embarrassed that I hadn't gotten up one day and said, 'I've got a great idea here.' Do you want me to say what happened?

JJ Sure.

RR I had next to no money and for years had been literally dependent on what I could just find to work on – things like sheets. I have a painting that you can't tell unless you look at the back that it's done on an enormous beach towel – the front surface completely hides the fact. The only thing that tells it is the corners keep pulling upon the edges of things that are pasted on it [LAUGHING], because it can't get a grip on that surface very well. But I built a stretcher out of the wood I could get, and it was summer – I didn't need that quilt and I thought it already had a pattern established and I had been working, when I went from all-black to all-white, [TO] black-and-white newspaper print as my ground, so that there'd already be something going on before I even started painting. When I tried to go into colour, I started using funny papers,[2] and this need that even my first stroke be in relationship to something that was already there – the pattern of the quilt worked fine in that way. So I painted and painted, and nothing seemed to be happening, and I realised that the quilt as an image was so strong that in order to neutralise the quilt, to let it be anything other than a quilt with paint on it, I had to also include the pillow. And the more it looked like a bed, well then, the freer I was of the image of it.

JJ A paradox.

RR Yeah, well, it was … a quilt on a wall is much more an arbitrary idea than a bed on a wall.

JJ This business of using the materials to hand. Did some of your constructions simply grow out of shortage of materials, so you went and found things you could use, or did you have a strong preconception that you were going to make a kind of *assemblage*, and then go out and find things that might be useful for it?

RR I enjoyed the fact that I didn't know what my materials would be from day to day, and there was a real adventure about just knowing that you need something in order to make something out of, and just looking around and seeing what there was.

JJ You used to mooch around the rubbish tips?

RR Yeah – not a lot. My interest wasn't so much in rubbish as it was in – just availability. I've had to explain in the early pictures my affinity with old material – used. Sentimentalists say that the old material has more experience, has a life of its own. That's true up to a certain point, but my work was not about the re-creation or the exploitation of that kind of romantic notion. It just happens that people rarely throw out new things – but when they did, if I found them, I was just as happy to use that.

We were talking about the abstract expressionists and about my difficulty with – not the paintings themselves, so much as with what they were supposed to be about. And I never really could build myself up to believe that colours fought back, which was a popular idea. And materials – well, say if you use a coffee cup – a coffee cup has a certain meaning. And so does paint, and one colour is different from another colour in its connotations.

JJ They all have different identities, you mean?

RR Right. But these are physical properties and – I think they're to be recognised, but not worked with as an illustrator would work with them. I'm not being so clear about that.

I think if you're going to work symbolically with materials, you'd better really have an open mind about it, rather than an immediate association with green as grass and cool. That's not very interesting, because the green is mostly green and if it's thick paint, it's thick green. It's just a literal, pseudo-scientific kind of information that these materials have a supposed dramatic quality based on the limitations of a particular ideology that's going on at that moment.

Cubism looks like cubism. I'm not sure that abstract expressionism looks like abstract expressionism. One could paint exactly the same kind of painting with a completely different idea. Whereas I don't think that you can paint a cubistic picture without implying the inherent qualities and suggestions that cubism as a movement had.

JJ What you're saying is that the peripheral associations seemed to you a mistake. Your interest lay in the material for its own sake, not an association which an illustrator might employ or a storyteller.

RR Right. Yes.

JJ So that green is not a symbol for hope, or for the qualities you associate with grass. It is green.

RR I don't think that the idea of hope being a part of a painting is any more interesting than green being part of a painting. And it seems to me that that's quite dangerous, to be working sort of second-handedly with your materials.

My going out and finding what there was around to make pictures out of – I don't think it's interesting not having materials, or not very much money to buy things with – I think that was a good, realistic adjustment to my situation. But if I hadn't been so interested in trying to avoid being misled by having an artistic idea about the meaning of a painting, I would have found other materials. I would have gotten hold of more traditional material to work with. Just as now the materials I use – it coincides with the fact that I can afford them now. Silkscreen, the way I used it, was a very expensive process, and the last large work I've done, which is the remote-control radio sculpture in five parts, has, I think, about $12,000 worth of radio equipment in it.

JJ Tell me more about this.

RR Well, [I] had made another radio piece, years ago, with only three radios, and with one set of controls, just a tuning knob and a volume knob. And the radios were geared so that they didn't play parallel. The sound was always changing so that it would be impossible for them to go along with each other. And that was a small version of what I wanted to do after I saw the limitations [OF] that piece – and it turned out to be sculpture. It was going to be painting, but when I realised that sound can fill space very plastically – I wanted to take advantage of that, and so the pieces are all on wheels. They're remote-controlled, so that you're not restricted by where you happen to have your outlets. That piece didn't begin as an expensive idea or a way of spending money, but I needed those things and I think that if I had needed something other than what the streets would provide, there wouldn't have been any question about my arranging my life in such a way that I could have had that. In fact, during this period that I was working with what was simply available, I did a series of gold-leaf collages. Because I seriously wondered if I had some sort of psychological affection for junk. I don't trust myself one bit – nearly all of the changes that have taken place in my work have been as much as anything else a conscious checking on my own activities. When I did black-and-white paintings I was completely satisfied with

the fact that white was enough, or that black was enough, but then I had to turn against myself and arbitrarily move into colour to make sure that I wasn't taking advantage of a disillusioned point of view. Because it's you that you've got to keep your eye on. You're dangerous to yourself because you know all of your own weaknesses; you've got that conscious and that subconscious, and they're very tricky. And the older you get, the more experience you have in tricking yourself. Ad Reinhardt – I met him on the street after one show; I'm a great admirer of his, and I thought he was complimenting me – he said, 'You had some very good paintings in that last show.' I said 'Thank you,' as one would quickly want to sop up a compliment [LAUGHS]. And he said, 'Yes, well, there's nothing we can do about it I guess, but you can't help but get better.'

JJ Classic Reinhardt.

RR That's beautiful, and it's absolutely true, and as the years go on it gets harder, I think, for anyone to walk over to one's attitudes and pull the chain and flush 'em down the toilet. There's a natural desire to want to be loved and appreciated, and understanding and appreciation are really the beginning of the destruction of the work.

JJ When you spoke about moving on to other things to get yourself out of the habit of tricking yourself, somebody told me – or did I read it in the paper? – that you proposed to give up painting.

RR Yes. You read it in the paper and that was a scandalous misquote. The article began with 'Rauschenberg says "I'm through with painting,"' and nothing like that was ever said. It made a good scandalous story. And they had it first, because they made it up.

JJ That's a real scoop. [BOTH LAUGH]

RR As first as you can get. What actually happened was that the interview was supposed to be about the *Dante* drawings, and as the interviewer was leaving, he said, 'What are you working on now?' and I said, 'I'm about to move into a new space and what I want to do I can't do here because there's too much light, and I want to work in the dark.' I know this sounds quite 'Oh, tell me more about that,' but it's like the bed story – it's not a radical departure.

Painters for hundreds of years have been investigating the different aspects of light. I think there are nuances in darkness and near-darkness, and if you accept darkness as the field of activity, then you

can violate that by use of light. And I'm hung up now on wanting the viewer to accept some of the responsibility for what he sees, not by amount of attention, as it's been for years, but taking advantage simply of his physical presence in the vicinity of the work. I don't know how that's going to work out, but I do know I've been thinking about it for years. I was riding along in the car one night in San Francisco and I realised how difficult it was to look out into the darkness, and how when you looked one time you saw one thing and if you looked a little longer you saw something entirely different – so it was just a revelation. But I had been preparing myself for it – I mean, I don't think it was a mystic experience. It's just like all of a sudden something pops up that you've been working at for a long time. And so the interviewer said, 'What kind of painting will it be that you're working on?' and I said, 'I don't think it will it be painting … I think it's probably constructions.'

JJ Yes, tell me about those.

RR It occurred to me to work with things like wind and water and plants – and I don't know what's going to happen there. Through my involvement with the dance, this week I'm going out to Bell Laboratories and there's going to be a group of concerts in Stockholm sponsored by the Technology Museum, and we've been given scientists to work with. It's just extraordinary. We're already starting to work. Like our first meeting with all the PhDs – don't think I'm not scared [LAUGHING] – it's going to be tomorrow.

First I was intimidated by the fact that I was working with scientists, and I was told last night that one of the first questions a scientist asked was, 'How will we talk to these artists?' [LAUGHS] And I told Billy Klüver,³ who's arranging this, that he should have told them that everything we said was very important; that we spoke nothing but poetry [LAUGHS LONGER].

JJ It doesn't help you to know that they're scared too, does it, really?

RR A little, yes.

JJ It's a bit like when you're afraid of snakes – people tell you they're really more afraid of you.⁴

RR Isn't that comforting? [BOTH LAUGH] About the piece – I would like the work to be so sensitive that it would not only be your own presence and the path that you picked, that would trigger what you

would see, but say, if it was raining out, or if a telephone rings, if a truck goes past – that that would also influence what you would see.

JJ Humidity and sound affecting the light. That's interesting.

RR Right, yes. And your own presence. If you were to call someone over across the room to show them something at a very close range, the act of their crossing the room or your calling them – would destroy what it was you wanted them to see.

But this is the story about giving up painting. I wasn't painting when I made paintings, necessarily. I mean, it wasn't that I think painting is such a great idea. In fact, I'm against people thinking that it's a great idea. It may be a lousy idea. Most often if you think about what there is to do, a painting is very low on the list. But I happen to love it and recognise that that's one of my things.

JJ Is this departure one of those self-shocks that you administer from time to time to stop you getting …

RR It is. Yes.

JJ But it hasn't anything specifically to do with the dance?

RR No, but part of my interest in the dance is – it's not that I want to be a ballerina, but it's what they call the performing arts and it doesn't hang around to be rejudged, as opposed to a painting which very quickly gets to be a piece of furniture, which can be treated in a way that I think is very separate from the intentions and involvements while making it. The first luxury that I afforded myself when I started selling paintings was to send all the old work that I had in the studio to a warehouse. One sensed a responsibility to what one had done until it really got out on its own. And it gets to be a deterrent to having new ideas. There's a kind of resistance to wanting to deal with new elements because you don't want to make that painting that you did three months ago a liar. But once it gets out of sight, it's like working in a hospital, and once it's not one of your patients, well then, you can concentrate on your new sickness.

JJ There's one thing that seems to have come up in several of the interviews – the relationship of art and life. For some, particularly the people that have been doing the happenings, and particularly [ALLAN] Kaprow I'd say, the distinction between art and life is practically non-existent. It's a question of how you direct your attention more than a difference in quality. And for others, like

Reinhardt for example, art and life are as separate as they could possibly be – life is over here and art is what is not life. These conflicting attitudes keep cropping up. You said at one time that you worked in that area between art and life – I wasn't sure I understood what this meant.

RR Well, that's the quote about the gap[5] – I shudder every time I see the word now [SMILING] –

JJ Have you had it thrown back at you many times?

RR Yeah. I hadn't realised that it was such a provocative remark.

I paint the things I do the way I paint them almost as a way of existing without being an artist. It's only coincidental that they're recognised by the art world. Socially, politically, they exist in the art world. But you can't make art – even the people who think they can make art can't make art. What's art is a temporary value placed on a few objects – wall-coverings, if it's paintings. Neither can you act consciously to just live and make something about that; there's a hole in between these two impossibilities – and there are no directions about how one should proceed there.

JJ Do you like the idea of art being a kind of game that adults play? Where you go away from the everyday business of your obligations to family and teaching, and go off into a corner and make up things.

RR I don't like the idea of play. It implies an escape. Sometimes I work on a piece just like I don't really like washing dishes. And in order to live with myself I've got to wash the dishes – and I've got to paint, even though I don't feel like doing it because I know in the doing it that that's the only possibility for something to happen.

JJ Perhaps this is the same thing as the idea of the professional whose business it is each day to make things. I know a sculptor in England who used to say that he got up every morning and went to his studio and started work at nine and worked right through the day and there were many days when he had to make a very strong effort of will to do this, but nevertheless that is what his job was – he was a 'professional sculptor'. And the days that he went in when he forced himself to work were just as profitable, often, as the days when he had an absolutely raging idea and he couldn't get to the studio fast enough. It all was for him a necessity of the profession he'd chosen. But this is not quite the same thing, I think.

RR No, it's not. I rather think of working as making anything I damn
 well please – whether it's dance, lithographs, sculpture – as just
 a part of doing all these other things that one does. I like thinking
 of working as an artist as, not an obsession, but a choice. I would
 not be embarrassed if tomorrow I decided that what I want to do
 is learn how to drive a truck. If I was a truck driver, I would get
 involved with my truck, so that it's all a positive activity, whether
 you're working on a flat or you're zooming down the highway.

JJ Someone said to me the other day, something I thought was rather
 nice – and may be rather a romantic idea, but I'd like to know
 what you think about it. He said that the artist's function is to
 demonstrate to the rest of the world what it is like to be free, so
 that other people, bent under pressures of prejudice, habit, money-
 seeking, conventions, social pressures, all these sorts of things, could
 see that it was possible for human beings to really do whatever
 they liked. And that this obligation had nothing to do with the
 greatness of the artist or his failure as an artist – he might be
 a good or a bad one. This idea is tremendously attractive, although
 sometimes I think personally it doesn't quite fit the experience.

RR That's a misconception, really. That's a romantic view of being an
 artist. Like somebody else goes out and earns the bread and the
 artist is an intellectual bum.

JJ Yes. Except that it is true that we're very lucky in some ways.
 I mean, I look around at other people and think that although
 often their work is very exciting for them, nevertheless I often feel
 this marvellous sensation, you get up in the morning and really the
 day's your own. It's not exactly true, but more so –

RR And you have to make it. You really do have to make it. I wake up
 in the morning and –

JJ You've got to design your day.

RR – and I've got to make all the decisions myself.

JJ Yes. But this is the responsibility of freedom, and I think there's
 something in what this guy said.

RR Right. When it gets exaggerated, though – when it gets to be – like
 artists, are just –

JJ Butterflies.

RR Yeah. Just throw themselves around blindly.

JJ I remember a painting master of mine once told me that – one day he was drawing and a fellow came and looked over his shoulder and said, 'If I could draw like that, I'd never do another day's work.' And this kind of sums up this attitude. That the artist doesn't work at all, he just makes these marks and that's it. This is not quite the same thing as demonstrating one's freedom.

RR There may be something like being an explorer about being an artist. And I sometimes think that that's what I'd like to do. Except that explorers are usually looking for a particular place.

JJ It may be that some artists also, without knowing, are seeking something about themselves, too.

RR I went to Yale a couple of years ago – I hate lecturing and teaching, because there's a kind of freedom that I have to give up in order to be right, on the day. I had no prepared lecture – because I can't afford to really make up my mind. But it gets to be very difficult to examine anything without trying to come to some kind of conclusion, and a concluding doesn't really happen to anything. That's one of those philosophical ideas that – like progress – is an antidote to the chaos. I don't know what things mean. It's not so much that my work is to remind one of that as it is – and this may be the only thing I'm pure about – my own carrying out of what I believe is true. If you really pressed the idea of one thing truly being better than something else, I'd just walk right on by. Because I can't believe it, and yet built into our language it's unavoidable to not have a sense of differences based on some moral judgement.

I've been necessarily opposed to protest-type movements and critical viewpoints, because the only way you can be the critic is by not assuming that you're responsible. Protest movements do the same thing. I know that there's a certain power, or influence, or force that uniting achieves. All I am against is some sort of massed generality. In order for two people, really, to agree on something, I think there's already been a compromise or a misunderstanding involved.

JJ This relates to an idea that I've had and that is the moment I'm sure I've got the answer to something, then I know I'm wrong about it.

RR Right. And you are as wrong as you are sure. It just follows.
[BOTH LAUGH]

MARCEL DUCHAMP

One of the most significant artists of the twentieth century, Marcel Duchamp was associated in his early life with the cubists, and, from 1916, with the dadaists. He came to New York from France in 1915, already a celebrity. In 1917, for a show organised by the Society of Independent Artists, he first exhibited his 'readymade' entitled *Fountain*, a urinal signed 'R. Mutt', since recognised as a landmark artwork.

Duchamp turned his back on 'painterly' work and 'retinalism'[1] and engendered a conceptual art of ideas. He was (until 1944) a co-editor of the surrealist magazine *VVV* and advised Peggy Guggenheim on her collection of modern art, even after he gave up art for chess. His 'discovery' by Robert Rauschenberg and Jasper Johns led to the mid-century renaissance of conceptual art, and the birth of pop art. In 1966 an important retrospective of Duchamp's work was held at Tate.

Duchamp's last work of art was made secretly and revealed in 1966, twenty-five years after he had apparently ceased to be a practising artist.

This interview took place on 15 February 1966, at 28 West 10th Street, Duchamp's New York home, five doors down from the Marshall Chess Club (and former home of the crime writer Dashiell Hammett). Duchamp was seventy-eight.

In the recording of the interview, Duchamp's French accent is overlaid with an American one. Though his voice is evidently an old man's voice, it still has fullness and depth.

MD First, you want to know if the American contingent really separated itself from the European influences. There are, as you know, the artist and the people who talk about art, and when the artist is an active artist, it's all very nice and always valid. But when the artist begins to theoretise about or explain why he is, and decides why the Americans are so different from the rest of the world in art, it is a little dubious, it's complacent. The roots are the same as anywhere; they came from the beginning of the century, and when the group of exiles came in 1940, at the time of the war, everyone here acknowledges the very great influence that [ANDRÉ] Breton and his group had on what has been called abstract expressionism since.

JJ There is a paradox here, because many of the abstract expressionists to whom I've talked had a strong resentment towards Breton and the things that he stood for.

MD Yes, but you see, they may be the new ones, the young ones, but the men like [ARSHILE] Gorky, were really launched by Breton, who really found in him something that people had never seen before, even himself. This group at the same time had been in the WPA, the group that the government had formed to help the artists, at $30 a month – which was very difficult. Plus [THE] production of the artists [WAS] given to fill up the garrets of the government in Washington. The number of paintings that were given and unmade at that time is appalling. It was for three, five, ten years, I think.

JJ Ten years at least. Many of the paintings have disappeared, but some have survived. There were public auctions, I believe, and some people bought them – there were a few Jackson Pollocks ... But, it was really in the area of ideas that there was this kind of hostility, I think – to Breton and others. I don't know if you know Philip

Pavia but he was the organiser of The Club on Tenth Street. He had an almost paranoid hostility to anything to do with surrealism, and yet the paradox is his work springs entirely from this whole Breton concept of working without preconception.

MD Anyway Breton is sort of an entity more than a reality, in a way. I mean, his influence was through words and through attitudes. Of course, I don't know what Mr Pavia was meaning to say. Breton and his group were with people like Gorky and [WILLEM] de Kooning and [ROBERT] Motherwell, who all liked Breton very much because he has something very happening in his attitude. Anyway, the influence was maybe only the point of departure for them finding themselves, and they did find themselves, and by finding themselves they completely departed from Breton's influence, as all influences go.

JJ I read somewhere that you feel that your influence has been exaggerated here.

MD Yes, it's exaggerated, because in my opinion it doesn't count very much, because it's a negative influence. They all have their own channel to go by and keep to. Yes, if you want to say there is some similarity between what I may have done and what the new crop does – people like Rauschenberg, for whom I feel a very great friendship. That's the human element that comes in. And also you know that this century is so curious because at first in 1909, '10, '11, we have a group of non-figurative painters. Then comes cubism and dada and surrealism, and all of a sudden another jump to non-figurativism you saw in '40, which is abstract expressionism. There is a certain correlation between 1940/42 abstract expressionists and [WASSILY] Kandinsky and all these people, even if it is not patterned. But it's there, you can feel it; the idea is very similar. The same with dada and with pop, and so forth. So this is a characteristic of our century, that we go by jumps of two. There is first one fire lit and then stop again and [IT] comes back, forty years later. And as far as being completely separated or divorced from any influence [IT] is really a little silly, because we are so much in it, that we don't see that influence if it exists. It could very well be, but you will find it twenty years or after. When you analyse it with a sort of *recule*² you see the correlation, the continuity.

It's already found, probably in perspicacious minds, but not the minds of the artists themselves.

JJ When I was speaking about *your* influence, the area in which it has been most apparent, when I've been talking to painters, is the concept that the work of art is not something to be appreciated simply with the senses, but provokes thought in some way, and in itself it may be an object of no interest, may have no sensual appeal.

MD That's true. I hope they have understood that part, which is conceptualism, as opposed to sensualism, meaning that I always have exerted my horror against retinalism, and I feel the whole century from impressionism on is completely retinal – everything counts that is on the retina and nothing else, it doesn't go through the retina to grey matter of any kind. So that's been *my* conception and I don't care whether it's right or not: it's my attitude.

JJ It's been a force at work, unquestionably.

MD So that's that. And as far as conceptualism could be defined, the thing which is on the canvas, or in the sculpture, should really go beyond the retina and wake up thoughts that are not analysable.

JJ Another thing that keeps on coming up when I talk to painters here, and where there is real division – and of course this is not to take in to account your observation that whatever they think they are doing is quite separate from what is really happening: there is a strong division between the painters who think that art is an activity which is different from all other human activities and has nothing to do with life, and there are other people who are very concerned to bring the two together. It seems to me that one of your influences has been in the second field,[3] where the distinction between art and life has been made most clear.

MD Yes, you can really live your art. It's not so much a profession or an activity to make a living by, or anything like that – that's the characteristic of the great artists of the past. In our epoch, in our century, we judge the past essentially according to our norms, which are completely retinal. You look at Michelangelo and even Cimabue with our retinal eye, and in fifty or a hundred years when things have changed, then you look at Mr Cimabue in an entirely different way. In other words, every artist of the past is completely changed according to the norms of the day, and those norms change every century. It seems that the art of the past is made according to the period you live in, and there is nothing to hold on[TO]; it is a fluid thing that is completely gratuitous, in my opinion.

JJ You said something like this in England; you were talking about the impossibility of defining art.

MD Yes, because of that. It's really a commodity of the mind, just like wheat or steel, and just according to whatever the Wall Street quotation of the morning is.

JJ There is a tendency among artists to seek some constant.

MD They don't even know they are applying their constant to that period, and forget that their grandfathers had a different way … and their grandsons will have another way of looking at it. I have no respect for the artists' generalisations or theoretisations. Words are the enemy of the artist. He should shut up, once and for all.

JJ And yet again, there is the paradox that all the talking does in fact provoke ideas and these provoke actions …

MD Yes. I am the enemy of the word, even in writers. I think the form of communication is a complete lure. We never say anything when we exchange things for communication. We say completely general things, which mean nothing except, 'Give me some coffee.' Language is a form of not communicating.

JJ It's both a barrier and a bridge.

MD It's unfortunately a simplification of life which is much more complicated and would have much more flowers to offer if we didn't have language.

JJ I don't feel so extreme about this. I know that words are deceptive and inadequate, but we have so few ways of communicating …

MD But we do communicate all the time without knowing it, without expressing it. Lovers communicate and don't speak too much … It's not so obvious in other exchanges. Unfortunately, I think artists have generally no facility to talk or to use language, even in its limitations. I mean, they are too much … illiterates because they don't want to be otherwise. They may have been to college – that doesn't mean a thing, as far as saying something interesting.

JJ Well, there certainly are some painters who don't seem to be able to begin until they have thought their way to some conclusion. Do you know Ad Reinhart here?

MD Yes, I don't know him very well.

JJ He tries to define art in terms of negatives; he says what it is not.
He does this to the extent that anything you can name is not art.

MD Elimination.

JJ But the point is that he arrives at nothing ...

MD No. Because there isn't anything to arrive at. It's just like mercury, it
slips in your fingers. It defies language, because it's a language itself.
It's a language because people do it, and people look at it.

JJ Yes, but then what is it that makes art different from anything else
which people do and other people look at?

MD Because it's a completely gratuitous act. Basically, it shouldn't make
money. A thing that really is doodling with life, making a doodle,
and then the other fellow looks at your doodle. That's what it
comes to in the end. But society has made it differently, introducing
the money value to it, and that you can't help, and you have to go
with it. It doesn't change the nature of the thing itself, as being a
gratuitous gesture, I mean, a thing that just doesn't have to be made
and yet is being made. It's not essential to life. People say that art is
essential. It is not. For the majority of people it isn't necessary at all.
It's only a decision of a group, a minority, to say let's have art ... It's
a game, too, just like the introduction of the occupation of leisure.

JJ You wouldn't grant it the value of being a kind of demonstration of
freedom – of what it's like to do just what you want?

MD Oh, yes. It would be wonderful in an ideal society, but we integrate
art in our society, which is a completely ridiculous mixture. No, it
would be perfectly natural, but society is so stupid. You have to be
born; nobody asks to be born, and you're not only born, you have
to make a living. It should be given [TO] you. You shouldn't have to
work. And then if you don't work, it's not easy not to work, either,
because the heritage of so many generations who have worked to
make a living, you can't take it out of your make-up. It would be
another education to educate the new generations not to work.

JJ A sculptor said to me that it was the artist's obligation to do
whatever he likes, and that this is the artist's primary function, that
he must do something which is useless, which has no justification.

MD That's true, but it always ends by selling your pictures, don't forget,
and if you don't, you are a miserable thing living under the bridges.

It's a little unrealistic to consider … It's true in essence, but never true in reality.

JJ The interesting thing for him was the case of Andy Warhol, whom he says may not be an artist at all in any other sense, but in that sense he is, and he really seems to do whatever he likes.

MD Yes he's marvellous to do just whatever he liked.

JJ The paradox is that he is immediately accepted; society recognises him as a man who demonstrates freedom – they pay him for it.

MD It's possible today in America for that integration of the artist. Warhol is not the only one; you cannot shock the public today, the buying public even. And they buy any shock. Shock is for sale.

JJ The situation here must be unique.

MD It is unique, because there is no limit to the acceptance. The only shocking thing today is the Russian paintings. They paint as people painted in the 1850s, very naturalistic and anecdotal. They do that now, as they did always, but for us who have been beyond and away from that, when we see it today, it's shocking to see the young girl at the window on the Red Square, seeing the parade of the soldiers.

JJ It makes people angry.

MD That's the only shocking thing, because today if you saw these paintings on Madison Avenue, the buying public would be shocked and wouldn't buy – which is the essence of revolution, at least in the beginning of the century.

JJ Do you think that art should always be shocking?

MD No, but it just happens to be that way, because life goes on. In other words, in 1920 people don't do what they do in '30, or in '40. Everything changes every ten years, and art follows the crowd, the idea. It changes because new individuals produce something, but it is not shocking. It's just different. The word 'shock' is useful, but it means simply 'difference'. The difference between 1920 and 1930.

JJ The abstract expressionists in the Forties seemed to be quite wild men, violent, [BUT] now their work is almost tasteful and charming.

MD Sure. Fauvism was seven or eight years, from 1900 to 1907, when [GEORGES] Braque turned from fauve to cubism. Then cubism was six, seven years again, and then dada two or three years,

four years, and then surrealism, which covers literature, it covers philosophy. It's not essentially a movement of painting. Well it goes on. It's like a department store of ideas. Nevertheless, I'm sympathetic to it. Then abstract expressionism, twenty years, it's already a long affair. Then comes the pops and ops, and that will be another series of five, ten, twelve years, fifteen years, maybe more, and then, somebody will appear with another idea that the public will swallow, will like, and so on. I think it's purely normal. Nevertheless, it's not like the state of affairs when art was depending on the king or the prince, or the emperor's decisions. It seems that since [GUSTAVE] Courbet an artist doesn't do what the prince wants him to do, he does something and the prince says, 'I don't like it,' or 'I like it' and 'I'll take it', and the artist says to the commander, to the buyer: 'Take it, or leave it,' which is a great thing. The artists produce, and the buyer comes and accepts … he doesn't change or force the artist to go a certain way.

JJ Now, of course, he takes it every time.

MD He sees that there is nothing else to do. He wants to buy at all costs.

JJ Incredible really. Coming from England, I'm very conscious of this here. There is a similar situation in Europe, but here it's much more magnified. Art has become a commodity and the money which is involved in it! Yet in a way we always hoped for just this situation.

MD Yes, artists died in misery, and now they don't any more. At least some, but they never had a chance to make money, those poor things, because they were lured like the mosquitoes to the light.

[BREAK IN TAPE]

MD … this is just another profession – instead of selling beans, you sell canvases. So, when the artist works he knows that somebody will come and buy it, and he can't help making it with that *arrière pensée* [ULTERIOR MOTIVE]. He will tell me that he never thinks of the selling of each brushstroke. That I wouldn't believe, because I'm an artist myself, so I know the ropes of the profession.

JJ At the same time, in a situation where everything is acceptable, the artist in fact doesn't have to think about the buyer …

MD No, but the state of affairs is such that you don't have to think of it, and it's in your muscle, it's so acquired and … Well, just like life in America is different from life in Africa, but you don't think about

life in America when you are in America, you just live the life and your muscles act accordingly, without making a statement every morning about it.

JJ What you are saying is that the money is a pernicious influence anyway. That's a rather frightening thought.

MD It has made the complete integration of art a commodity. It could be on Wall Street – has been, or more or less – on the big board. They have been producing little leaflets every week giving you the list of the artists and their quotations. That's going up – you can buy a Renoir this year for more than a Cézanne. It is the disappearance of the religiousness of art, when Cimabue or Fra Angelico was not an artist, he was a servant of God. In fact, he was an artisan. The title of artist only dates back to one, two hundred years. The nobility of the title of an 'artist' is just like being baron or a prince nowadays. In my opinion. It is the end of God, the end of art, the end of everything. Maybe it's good, maybe it's bad, I don't care.

JJ But in a way you have worked towards a kind of destruction …

MD Maybe I have, without knowing even. I would never write about these things. I am forced to talk with you, but I am sorry to have my name attached to these things, because it's a profession of faith, and I don't believe in professions of faith of any kind.

JJ Now art is constantly questioned, examined. People have a negative anti-art attitude. They continue to make things, somehow believing that art itself is not worthwhile, it is a useless activity. What I meant was that in a sense you have contributed to this latter …

MD Yes, I probably have, but it was not conscious. That race after a definition of art is something like those optical illusions, like mirage – that's the best word to explain what we mean.

JJ And you have spoken of it as being a drug …

MD Yes, because it has taken the shape of a drug. Anything can take the shape of a drug; anything that you make a passion of, that you hunger for. Art is one, in my opinion. It's a habit-forming drug. As far as the public is concerned, if you show long enough the same thing, and call it art loud enough so that they hear it, they don't see it as art to begin with, but then the public becomes in the habit of seeing it being called art and finally they say, 'it is art.' They put their stamp on it, the public stamp, and that's done. That's habit-forming.

JJ Then it is art.

MD It is art, because it has decided to be.

JJ When you spoke about it being habit-forming, I thought you were talking about the artist, about his compulsion to make.

MD Well, it's a combination of the two: the artist makes, and the public accepts, and the combination of the two makes it a final reality – or passing reality at least.

JJ Have you in mind your readymades, when you make those observations?

MD I don't know. My readymades were done without pushing the limitations of the artist. After all, when you make a painting you use a brush. You never made that brush. You use paints in a tube. You never made those tubes; they are manufactured. You combine all these manufactured objects and sign the painting, but really what has been in the process is all these manufactured things finally getting a little thing. You don't see the manufacturing part of it, but it's there all along. So, probably when I decided to have those readymades, it was to completely accept the manufacturing, or indeed, the non-responsible hand of the artist, to see what happened when you had the choice and the signature was sufficient.

JJ Someone was telling me a story about you the other day: you had said when you made the *Bottle Rack* and the snow shovel,⁺ you selected these objects because you thought that never would anyone regard them as having any aesthetic interest at all.

MD Yeah, of course, yes, that was the difficulty.

JJ And then afterwards people did as you said. They began to call it art … Oh thank you. How kind. [OFFERED A CIGAR]

MD Do you smoke? This is a Manilla.

 That's why art is such a mirage, an illusion. And there is something, also, in the making of the work of art, which was a direction towards the conceptualism of the idea – instead of making something retinal. The choice of these objects was a difficult thing, because I could really choose twenty objects an hour if I wanted, and call them readymades. But then I had to refrain from it, to restrain myself in the decisions, and make it more difficult to accept. In the beginning it was not so difficult because it was new,

but if I had gone on with it, today I would be at the head of 1000 readymades for sale. It would be a complete destruction of the idea. The difficulty was to stop, not to go on. In other words, it's a thing of a short duration, it couldn't be done on and on.

JJ People talk of your abandoning painting and other things, including readymades, in favour of chess, as a gesture, was this?

MD No. It has nothing to do with it. It just happened that when I was fourteen or thirteen I began to like chess the way people like baseball or bridge, and it has probably had more attraction for me because, being born a French Cartesian, it satisfied part of my intellectual activities. But as far as making it more than a game, no.

JJ It was not a gesture about art?

MD No, never. It has nothing to do with it. It happened to be convenient not to have to paint to live; I could play a game of chess instead. With all the ideas we've been talking about – the dubiousness about art and the mirage of it – if you begin to comprehend this, you have to fill your time. Instead of being tempted to do more paintings, you should be tempted to do less paintings and play more chess.

JJ Your intellectual concerns seem to have been your contribution to art, and yet it strikes me, reading what you've said and what people said about you, you were probably a very sensual man, and there is another kind of paradox. In fact, you are a mass of paradoxes, really.

MD Yes, because you see, I never believed in the sensuality of art. Sensuality, sensualness, is purely a department of life where art doesn't come in, except occasionally as a makeshift. It's one thing, and art is another thing; art is a mirage, and sensuality is a reality.

JJ Don't you feel that in, say, [HENRI] Matisse they come together eventually?

MD Yes. They excuse the mirage. Sensuality gives a raison d'être to that mirage, gives a form of reality to it, where we are taken in. But the main thing is sensuality, not the mirage of art in my opinion.

JJ But does it put Matisse outside of art in a way?

MD Yes, all of them. [THEY LAUGH] It's just a trick. The people buy the sensuality stunt, and then it happens that some do it better than others, are called better artists than the others.

JJ Sensuality does inform your work, or rather you always seem to find equivalents for it, or parodies …

MD Yes, I did use sensuality a lot because it is an excuse to, well, pretend to be an artist, if you want, if you have the thought in the back of your mind that it's all wrong, futile.

JJ Has a sense of futility in your life been very strong and depressing?

MD No, not depressing. As far as my own life is concerned, I really enjoy doing nothing. I am a lazy bum, and want to die that way, if I can. It's difficult; it's not quoted on the big board in Wall Street, laziness, yet, but it should be. [THEY LAUGH.] At the time of the anarchists in 1885, there was this man who wrote a book called *The Right to Laziness*. Why should you have to work to live? You should be entitled to be lazy and live at the same time. The book itself is not very interesting, but the title is enough,

JJ You say that art is due to a futile mirage. Does it not in fact reflect life in this way?

MD Yes. But it could be a *paradis terrestre* [HEAVEN ON EARTH], a paradise again if there was no original sin. The original sin is money more than the apple.

 [BREAK AND THEN THEY ARE TALKING ABOUT CIGARS]

MD About the only ones I can find in New York. They have been replaced by Cuban.

JJ I usually make my own cigarettes, I roll them.

MD Do you remember before the Cuban Affair, they sold Cuban tobacco for the pipe here? Which is like the French tobacco, but even a little better. Oh, you weren't here. I used to smoke a pipe, with Cuban tobacco made here, or twice as expensive if you had it imported. Probably you could roll cigarettes with it, sure.

JJ I find most of the pipe tobaccos too coarse.

MD I don't like the English tobacco either for pipes.

JJ There is one English tobacco that I have become attached to. I think you find something you like. It's a little bit like art, you know.

MD [LAUGHS]. It's completely illusory. It's another mirage.

JJ It's like being a wine connoisseur.

MD Yes, the same thing. Absolutely. Artificial.

JJ People have a preference, but can't tell the difference in the dark.

MD In the dark you don't even know if you have smoke in your mouth. Unless it becomes acrid. It bites your tongue, in other words.

[RESUMING]

MD The death of a work of art. That's been an amusing idea, that a work of art supposedly made today will live about forty, fifty, sixty years and no more, because the pigment dies, or at least the freshness, especially in the case of an impressionistic painting. It's only living when it's still fresh and it goes down very quickly; in twenty years it becomes very dark because our pigments are not good enough. You might say that if you use marble in sculpture, it doesn't change, and yet there's a change, and also the change is not so much in the thing itself as it is in the people, who twenty years later are not the same, and their eyes are not the same, the act of looking is different. We don't believe in that. We go on looking at a Raphael. The painting has been dead so long ago. We look at it, and we remake it to our taste, in our terms.

JJ This is a depressing thought. Because the implication is that one should strive to make works of art which are fleeting, because you should go along with the nature of it. But eventually this produces art which is like [THE DANCER VASLAV] Nijinsky leaping the Paris opera stage once.

MD And gone. It's very unconsoling.

JJ It seems to amuse you to find things that are not consoling.

MD In my rational way of thinking, then they come in as proofs that we are advancing.

JJ Truth is always better than a lie.

MD Truth, that is another thing I don't want to talk about. It's an awful stupidity – it's another art, it's a mirage. I don't believe in the word truth. We invent something, and believe in it by way of habit. It's a stupid word. All these words like 'truth' and 'God', 'cause', 'effect' and so on, which are the terminology of Cartesianism or logics, are nice to use, but when you come to believe in it, or believe to the [EXTENT] of giving your life for it, I can't accept it, I can't go along.

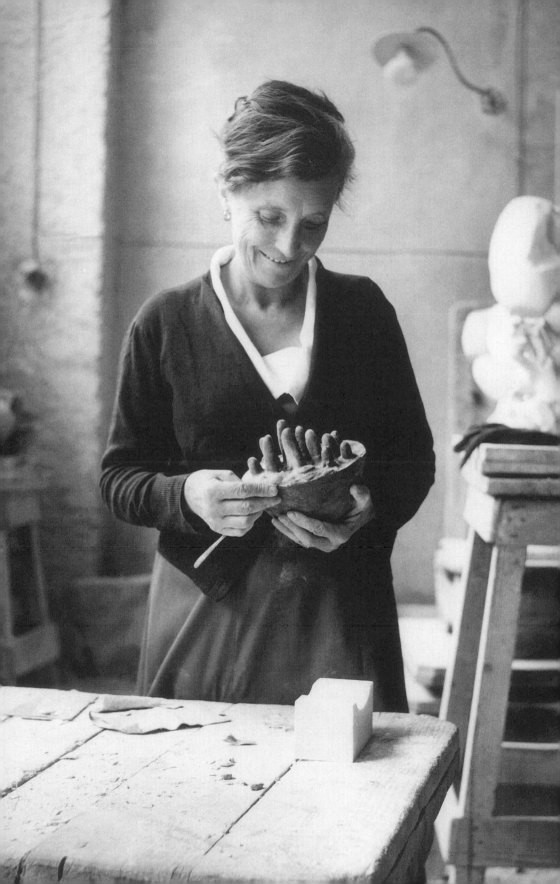

LOUISE BOURGEOIS

Born in Paris to parents who repaired and sold antique tapestries, Louise Bourgeois studied maths until 1932, when, after the death of her mother, she turned to art. Fernand Léger pointed her towards sculpture. She came to the US in 1938, and had her first solo show in New York in 1945. She exhibited with the abstract expressionists in several shows at the Peridot Gallery in New York in the late 1940s and into the 1950s.

In 1956 she opened the shop Erasumus Books and Prints, which she ran for three years, and became a US citizen in 1957.

In 1960 she began to use plastic, latex and rubber in her work, which was formerly made of wood (including driftwood), and in 1964 she had her first solo show in eleven years, at the Stable Gallery in New York. Although primarily a sculptor, Bourgeois was also a prolific painter and printmaker.

She had been in psychoanalysis since 1952, after the death of her father.

In 1966 she exhibited as part of the *Eccentric Abstraction* show at the Fischbach Gallery in New York.

This interview took place on 12 March 1966, at 347 West 20th Street, where Bourgeois and her husband Robert Goldwater moved from 18th Street in 1962 (and where she lived and worked for the rest of her life). Bourgeois was fifty-four.

She spoke fluently to Jones and with a French accent and a certain emphatic conviction.

LB I will start my story by saying that in 1932 [THREE-SECOND PAUSE] my mother died and [TWO-SECOND PAUSE, SIGH] I was ready to move away from the house [SIGH]. ·

JJ Was that in Paris?

LB Yes. We lived in a large, pleasant home right outside of Paris in the Vallée de la Bièvre,[1] which is [A] small river which had a great part in my upbringing, and she had contracted Spanish grippe – influenza – and died of the consequences some twenty years later.[2] We were a closely knit family and suddenly it broke apart.[SIGH] In a good French fashion my father was full of women, and when the mother disappeared we were thrown against a rather turbulent life of his own, that upset me so much that I said I would either marry an Englishman, or anybody who would take me out of the country. I was then working at the Louvre. In rather bad English I explained the beauties of Rubens to Australians and lots of nice people.

JJ Were you an art historian?

LB No, I was an artist. I was at Académie Julian,[3] and at the Grande-Chaumière[4] I was a kind of a monitor – I took care of the studios. We were well paid at the Louvre, and to make a living I was at the Louvre in the morning. This is where I met an American student who was working on primitive [ART] – the influence of – it was his PhD thesis and he was doing the round of the *Musee de L'Homme* and so on, and I met him there and he said, 'If you want me I will carry you to America', and I said 'Good'. So this is how I came.[5]

JJ You were a practising artist when you came to America?

LB Yes, I had already left the Beaux-Arts. The best studio at the time was the Académie Ranson,[6] where a very good man was teaching –

[ROGER] Bissière.[7] He was excellent – if an unvocal and inarticulate teacher. He had a way of communicating the essential of teaching.

JJ Do you remember any of your contemporaries?

LB Well, it was the period of Étienne Martin.[8] [FRANÇOIS] Stahly[9] was younger, but Martin was the best really, the most sensitive artist. I was a student, but I worked with [ROBERT] Vlerick,[10] who was a very good man, and [THE SCULPTOR CHARLES] Despiau. Despiau was harder, and very detached, but Vlerick was a very good teacher and they were both unsuccessful yet.

JJ So, then you came to America. Did you work here?

LB I didn't work economically. No, we had enough income – Robert [GOLDWATER] was teaching, and he was eager for me to go on. The second day I came to America I went to a man called [VACLAV] Vytlacil,[11] who was a [HANS] Hofmann[12] disciple, working very much in the cubist tradition. He was a painter. And he was an excellent teacher – a theorician.

JJ How long was it before you showed your work?

LB It was about four years.

JJ When the war came and people came over, the refugees, did you know many of them?

LB I knew many of them because lots of them were French. And they stayed together, more or less. We had a neighbour and friend who was Varian Fry[13] – Varian is still around. He did this avant-garde writing. Later on he had a breakdown – he disappeared even though he is still alive.[14] But he was very important at the time, because as a Quaker in Marseilles he provided all these people with false passports and got them here. He saved dozens of lives. And about, I would say, two dozen, not more, settled in New York and then of course we saw them, mostly at Varian's house. [JACQUES] Lipchitz[15] was already irascible, and [MARCEL] Duchamp was prima-donna-ish. In view of the development of American painting, I would say that *the* most important person was [ROBERTO] Matta.[16] He had a fantastic energy. Matta had the friendship of [ARSHILE] Gorky, and Gorky was the hinge, you see – the Americans understood Gorky. I met [ANDRÉ] Breton at the OWI,[17] the radio programme of French language, where, as you know, he broadcast, made a living there for many years.

JJ The art scene when you arrived here must have been a bit depressing after Paris, or was it not?

LB I didn't find it so because I was a good fifteen or twenty years younger than those people. Having come as a young girl to get married, I was not in the same age bracket, but I found it a privilege to know these people. As a student I never compared myself with them. Also I must say that, coming from the same corner of the world, I was not over-impressed. I had the attitude of a student.

JJ Were the students in Paris hostile or sympathetic to surrealism, or moving towards some other kind of painting?

LB Well, the centre of the surrealist activity was on the rue de Seine. I used to live at 18 rue de Seine, which was the old building of Raymond Duncan[18] – who was a pest. Anyway, across the street from me there was the orthopedist, and right downstairs Breton, the big surrealist, had several shows. So there was a continual knowledge on the part of the students of the surrealistic activities.

JJ I've heard from American painters that there was a certain hostility towards surrealist attitudes, particularly because they felt it was a literary movement and didn't have much to do with painting. You must have felt differently about it, having seen the other side of it.

LB Yes, I did, because in that famous show in the late Thirties that Breton had at Raymond Duncan, at lunchtime I would stop there and ask to stay a long time in the show and I was struck by the absolute beauty of the objects. It was very pure and completely dissociated from the verbal aspect of the surrealists that has been a reproach to them. From the start they knew a beautiful form when they saw one in the common object – in objects that you see in the street, in mechanical objects, *objects trouves*, in accidents – everything was there in that show.

JJ To come on to New York, who were the American painters that you got to know?

LB Well, I showed with Bill de Kooning, in 1944 at the Bertha Schaefer Gallery.[19] He was totally unknown.

JJ What was his painting like then?

LB A portrait of a woman – he had then his colourist gift – his famous pink was there.

JJ He never worked in the social realist vein that was the tendency?

LB No. This was a straight portrait and he had other portraits at
the time. His pencil portraits were very Ingresque – he is a good
draughtsman. His line, though it is not a naturalistic line now, is
still very sensitive. That was very early, of course, this show.

I remember Bill, when we had dinner at a Greek restaurant – The
Parthenon, The Athenian or something – and he ordered these big
Greek fishes open in the middle of the table. I have never forgotten
it because he was very generous. He would give it to the others.

JJ He was very poor then?

LB Oh, he was completely destitute.

JJ Later you came to know many of the American painters well?

LB Yes. Well, I had become an American and stayed here – most of
these people left. The late Thirties and the early Forties for me is
the determinant period because of the fantastic loneliness that
followed my rash leaving home and this is really the core of my
work. It was a loneliness that I could not explain since I was very
happy and very grateful. I must have missed something very much
because I started doing a sculpture that was made of people. They
were my height – about 5½ ft [1.6 m] – very slender figures, one
of which Alfred Barr[20] bought. I would crowd the room with these
figures – I still have some of them here – and I would feel better.
Maybe it is a poor motivation, but this is the origin of my work.
They kept me warm, and in exchange I worked on them eternally.
I still work on those figures of the time – I never destroy them.

JJ Did Robert's interest in the primitive inform your work at all?

LB No, a great deal of primitive work is frontal and a need for human
relations was anything but. I remember in 18th Street we lived in
a very old house where the proportion of the rooms was beautiful
– and these figures I was referring to were placed as in a ballet on
a stage, and it was anything but frontal – it was the opposite. You
could circulate round them. And then Erick Hawkins,[21] the ballet
master, came to see this show and from then we made a ballet set.

JJ Obviously the relationship between the way the figures stood
was important.

LB Oh terribly important.

JJ They were grouped.

LB That's right. And in the Peridot Gallery,²² where this piece called
 Figure Endormi was bought, the room was also extremely fine and
 one was in the centre and they evolved in *relation* to each other.
 This relation to human being, to brother, sister that I suddenly had
 lost (I never regretted it, I'm not complaining), but I felt it when
 I didn't have it any more and it was re-created in rooms.

JJ When you talk about these sculptures growing out of a personal
 state of mind, out of a loneliness, a perhaps unconscious sense
 of loss – from an aesthetic point of view, do they have any
 antecedents? Did you feel you were part of a movement, or a set of
 current ideas?

LB Well, John, it may be the very wrong thing to say that I did not
 belong to any movements, but the fact is that it is true. I think that
 what I was taught in France is a need for ferocious independence.
 And you cannot be ferociously independent and follow others.
 Even today I have things to say, and if I cannot say them the way
 I want to say them, I will go into another profession.

JJ During the Forties then you began to do these figures. What came
 next? You still worked on them, you say, but how did they grow?

LB I discovered that these families of figures had never been done
 before. I discovered I was saying something that was my own. Now
 I *know* that it could be better done – but this is not what gives me
 a kick. What I find important is to say something my own way. So
 today, over twenty years later, I am still making groups of figures
 that have become much more bending. The character of the figures
 have changed, but they are still by twos and threes, and they are still
 very close to our human problems.

JJ Was there a specific relationship between these figures?

LB They represented a threat of breaking – of separation. By putting
 together figures or human beings in certain relations, you assured
 yourself that that it would not be broken, that if it were broken
 there was a continuity in another similar relationship springing up
 in another group. I'm still haunted today with this problem.

JJ Would you say that, whilst this is the source of your sculpture from
 a very personal point of view – this [is] not the thing which you
 expect the spectator to enjoy?

LB No. You cannot expect people to see through, to read you. They may be not even interested – they want to read something of themselves in it. What is very strange is that even though the origin of the work is so personal, it is actually very – *décanté*[23] – it is very abstract.

JJ So essentially it was a formal relationship, linked to a psychological relationship?

LB Yes. But it's a very formal relationship, definitely.

JJ Essentially this is what sculpture is for you.

LB Yes. Sculpture is a relation of planes and volumes and directions.

JJ It is not necessarily a current view, but it has been expressed by some artists, that these formal concerns are outmoded. There's a tendency to make art for quite other reasons than formal ones.

LB Yes, of course, this is a present day concern.

JJ But for you this is not the case. The language of sculpture is constant. Formal concerns are the basis of sculpture, though you may have very strong personal motives for making the things.

LB We put in our work things that *we* can discover maybe ten years later or never, but we are not conscious of those things at the time. What is important in these slender figures that I have is rather the direction. In the past you might say that they were unbending, they were rigid – today the angle of all these pieces is very important. Whether they lean towards each other gives their character.

JJ Do you think this reflects a change, a relaxing now after those lonely years?

LB Well, it reflects a good many failures really. This is the only thing that makes you change.

JJ That's an interesting observation. A *bon mot*. [BOTH LAUGH] What was your contact with the abstract expressionists? Did they affect your work in any way?

LB Well, I knew the abstract expressionists before they were abstract expressionists. I saw them regularly before The Club at Hayter's.[24]

JJ Did you know Hayter?

LB Yes, and I was fond of him.

JJ Did you do any prints?

LB Yes, I made a good many prints and they were an exact reflection of my sculpture. I used to work with a burin,[25] you know, directly in the plate, and you wouldn't know that I was connected with Hayter by the style of my work, which is very simple and very linear.

JJ Drypoint?

LB No, it is gouging.

JJ You were an early member of The Club and knew people who attended. Can you remember what sort of things happened?

LB Yes, everybody came to The Club, and what can be said in its favour is that it was needed. It filled a role. There were two aspects of The Club: the formal one – some people wanted lectures, adult education – this kind of foolishness [MUTTERED]. But others wanted a meeting place for the artists that would replace the cafes of Baudelaire and that tradition of freedom, of coming and going within a group and just having the right to sit there and be with. The two movements were present in The Club. From the beginning.

JJ There was an element of loneliness, too, which motivated this?

LB Oh, yes. It still exists – because of the geography of New York.

JJ So who did you know in The Club?

LB Bill [DE KOONING] was important. He would sit saying nothing and listen to a good deal, and he's a very patient person, and then he would suddenly become terribly irritable and talk his mind. At that point his accent was all right – you *could* understand what he said – and he was very cutting and would stand for no nonsense when accuracy was concerned. It is very amusing that he has become the soul of this New York School, and when people want to make him the all-American boy, he says 'Godammit, I'm *still* a foreigner.'

JJ Do you remember any of the discussions? Were they fruitful?

LB Yes, they were fruitful. The verbal aspect doesn't interest me too much. I would say again what I say about the surrealists, forgetting what they said, the fact remains that the work was beautiful.

JJ I think it's interesting that the atmosphere of The Club was not very clear, there wasn't a clearly defined programme. It wasn't until Harold Rosenberg[26] wrote it down twenty years later that the

abstract expressionists were able to say what they were doing.
He gave them words to express what it was about.

LB Yes. But there were two or three significant promoters at first. The
Magazine of Art published de Kooning. And all the famous names
of today started at the Peridot gallery – Jim Brooks,[27] [PHILIP]
Guston,[28] [ARTHUR] Drexler and myself were at the Peridot in
the late Forties or early Fifties. Then suddenly we were with Egan
[GALLERY],[29] and I don't know why. Egan did a lot for us, and
I think [REUBEN] Nakian[30] and myself were the only sculptors.
Nakian being of an older generation and a very fine artist.

JJ On the whole, the principles of abstract expressionism – action
painting and this kind of thing – didn't touch you at all, did they?

LB I would say that for me Franz Kline was the most talented man.

JJ But I mean you as a sculptor.

LB It did in a way. For instance, the freedom of Matta – this offhand
manner, I admired terribly much. This idea that you don't have to do
the best finishing and finicking. The breadth of vision impressed me.

JJ Did you find a change in your work as a result of this awareness?

LB No, but I found a certain confidence. That I didn't have to finish it.

JJ Do you have any observations about the current scene now?

LB I know it is different in Europe. There is a speed of evolution in
this country. First of all the galleries push you to work too fast and
the artists have a feeling that if they don't show every year they are
going to lose something. In fact, there is nothing to lose. But you
are pushed – will you be ready in May? June? There is another kind
of pressure, which is what success does in this country. A gallery
will always give you a show – it's a trial period – then you are on for
three weeks. If you do not strike success then, off you go. You will
never be heard again. And if you strike success this is your downfall.
Suddenly you find yourself with a family of offspring. They come
and dissect your work – how is it done? And they do it better.
[LAUGHTER] This bothers me. I think it is an upsetting element.

They learn too fast. For something that could mature for many
years, you know, and grow – and maybe disintegrate, and re-come
out in a different form. And there are other characteristics of the
American scene which are Chicago-gangster intimidation.

JJ How do you mean?

LB There is intimidation on the one hand, and the fact that you will
 never find anybody who will criticise, give an adverse opinion. You
 meet with no success and you are buried without a word, or you
 meet with success and nobody will criticise. So criticism, which can
 be very mild – which can be an *epigram* – it disappears completely.

JJ Do you feel this affects you and your work very much?

LB Personally, no. But it gives a climate of unsaid brutality. It is a
 gangster's, mafia world. Nothing is ever said that is important. It is
 very carefully unsaid. There can be intimidation by silence.

JJ Are any young artists working in New York today whose work you
 find intriguing?

LB I would say the whole pop generation – I find them very creative.

JJ How do you react to the idea that American art is a new definition
 of art? You must have encountered some who talk as if their work
 had shed French painting, French sculpture, all the values.

LB Yes, I feel that there is something unique in America. In Europe,
 they are awfully tired. There it is a law of diminishing return.

JJ The cult here of the original all the time –

LB We have the pop and we have the hop, and in three weeks we
 have something else. But you have to say: whatever I do, I have an
 absolute belief in what I do.

JJ Are you sustained by a sense of belonging to a kind of tradition, to
 the family of sculptors? I feel as a European a certain sustaining
 security out of feeling part of something much larger, that goes
 back a long time. You think that you understand what [PAUL]
 Cézanne was doing and that he might understand what you are
 doing. That sense of security – does this mean anything to you?

LB Well, what would keep me going is the feeling that the work we do
 is needed. As soon as it is art, this family of followers surges out of
 the ground. It is exasperating, but it means that everything that is
 new is watched and suddenly it is not in vain.

JJ What is sculpture for really?

LB Sculpture is a process by which you become aware of finer relations.

JJ Both for the maker and the spectator?

LB Yes. And of course the relations are blunt at the beginning and they become finer and more durable, and the search for relations is infinite. You never get tired of working on sculpture.

JJ Do you think it has any utility outside itself?

LB It seems to, because the mass media is clamouring for material.

JJ I saw Dwight Macdonald[31] at an exhibition opening and he asked me what I was doing. I talked about contemporary American art, and then I mentioned the Forties and he said, 'Oh, but the Forties, that was so long ago. There's nothing contemporary about that.'

 I don't feel like this. For me the Forties are very recent. It may have something to do with the war, of course. It impresses itself very strongly on one's mind in Europe, so that all through the Fifties you feel that the war has just ended. Even in the Sixties now I have a sense it was only yesterday – the blackout and the rations and being a soldier. But here it isn't the same feeling at all. [THE PAINTER AND SCULPTOR] George Segal[32] said to me, '1946 is like another century.' All gone.

LB Well, there is the necessary adaptability that you have to show. You had a lot of artists at a very young stage who survived through two shows. Then they are satisfied, they made a little impression, they have no interest whatsoever in art, except that they wanted to be somebody, and you give them a number of shows like children, and then they settle down. Well, they still have to have their two first shows. So what did they do? The artists rented a store, created a gallery, ran it themselves. And it is still done. You invite people of approximately your interest and your level of integrity. They are usually in the Tenth Street district on the East [SIDE] and they mushroomed. There were dozens of them. And the artists who remained, move on towards the midtown.

JJ Are you thinking of people like [CLAES] Oldenburg, when they took the Ray Gun gallery?

LB Well, Oldenburg, yes. He did start that way. And of course this is the American initiative and is really admirable. In Europe they always count on somebody on the Faubourg St Honore to do something for them. The desire to please then …

JJ You were saying earlier on that they do have to work to please here.

LB Yes, later on. They have to achieve success. But you know here, you achieve success sometimes by insulting people, the opposite of pleasing. If you insult hard enough, then they notice you.

JJ [ROY] Lichtenstein said something like this. Larry Rivers, too. Rivers said that he painted *Washington Crossing the Delaware* because he thought it would be the one thing which would be anathema to the art scene.

LB Oh no, I can tell you how *Washington Crossing the Delaware* came to life. Once at The Club, Alfred Barr was invited – he came very often, because he wanted to be near the source of things. It was a very crowded evening and he was put on the spot and asked 'what should we paint?' And finally he said – and he really believes it – 'Why are you so personal, why don't you think back of the great American adventure, you know – *epopee*?'[33] And by golly, Rivers was the only one to catch on, and he produced an historical painting; it was not a joke at all. Later on he turned it into a joke, you know.

JJ But still the way he painted it showed that it wasn't just to shock. Afterwards he may say that he chose it to shock, but the way the picture is painted is a very serious business.

LB Certainly it is.

JJ Lichtenstein said something like this, too. He said that the art scene was such that you can hang a dirty paint rag on the wall and somebody would buy it, so he looked for something everybody hated – and that was commercial art. He said: 'But they didn't hate that enough.'

LB That's right. Well, this is where Duchamp comes in.

JJ Go on.

LB Well, I want to say that Larry Rivers was able to learn from a casual remark. He saw the seriousness of it, and those younger people have simply followed what Duchamp said thirty years ago. The anti-art – except that Duchamp meant it in a different way.

JJ He meant a kind of art of ideas, I think.

LB That's right. Duchamp is an intellectual.

JJ He tends to talk about *The Large Glass*[34] as being something which promotes thought rather than inspires physical reaction.

LB Yes. It would be interesting to investigate the teaching of Duchamp. How what he has said has been interpreted, and whether this is what he wanted. Because sometimes you say something and people understand the opposite. I see this in teaching – the most difficult thing is to communicate what you really mean.

JJ You didn't speak about these plaster works that you have in the other room. These are rather different from your families of figures.

LB It's a series of work which is a different trend. These are recoiling upon the self.

JJ They are still figures, then?

LB Very much so. And the difference is that they are completely ingrown and they are completely alone, by definition. They are called, *Lairs* – animal runs. Because if you are not on your toes in your relation with others and you have to survive, then you really need protection. It always revolves around this question of survival and security. Some of the lairs have one entrance and are caves, really. But other lairs have a second entrance which was an escape – all sorts of modulation on the art of escaping danger. Then in this train of thought about danger from inside or from outside, we came to the strange phenomena of pessimism and the concern with the not-thinking-about-death which is so specifically American. And that reminded me of the black period of the Forties, and the second show at the Peridot where the main piece was *The Blind Leading the Blind*. The only photograph I have of it is this. That piece was an inspiration to [FREDERICK] Kiesler.[35] It was about twelve or fourteen people walking behind each other, all united by the arms of one on the shoulders of the preceding one.

Later on that piece was completely black. Then the *Figure Endormis* were painted completely black. I referred to a former teacher of mine, Bissière; Bissière taught us the value of silence, the value of an absence and the value of black as a functioning element in a picture. And of course black is symbolic. This became a school in New York. Both the black and the *assemblage*. Now I don't know if you would consider a school of abstract expressionism in sculpture.

JJ Some of the sculptors talk about the ideas of abstract expressionism, but it seems to me as far as an actual technique is concerned, it's almost impossible to practise in sculpture. In painting it's easy to understand – a man standing before a canvas and attacking it in some way. The immediacy of it is the whole point.

LB It is never that immediate in sculpture, because it takes so long to put things together.

JJ Did you know Louise Nevelson?

LB Even though Louise is a good decade older than I am, we were friends. She was in a very different group, which was the social realists, the ACA group.[36] She is politically minded – which was the opposite of the American Abstract Artists. I like her bouncing strength – and she knew my work, and she was benevolent, you know. When Erick Hawkins asked me to do this ballet thing, she helped me put some ink on them. It happened at the Cherry Lane Theater and she came with slacks on and she painted the thing with Indian ink. I remember an incident where a piece was made of several layers of plank on top of each other and I said – everything I did was very personal – 'This is a wound, here.' And then we piled things upon it, either to alleviate the pain or hide it. Later on some other pieces were added, and it was all painted black. Then there was a kind of dove shape, to add a little red accent of hope to a very depressing-looking thing. She painted that. So we're on very friendly terms. Her work was completely different, as I said. She was definitely 'for the people, of the people'– and she's still that way.

JJ I think you were going to say a bit more about the lair sculptures.

LB The lair is really a twisted shape. You take more or less a figure – basically a vertical, symmetrical form, and out of the feeling that this person inspires you, you twist it. It is a relation of the passive. But I have never felt passive myself – the world is my oyster. When I see – as I saw in my childhood – the chickens – this man would come and twist their neck because we needed chicken for dinner. I have never felt like the chicken. I have felt the curse of the man who twists the neck and what he is going to have to cope with as emotions later. So that the twisting, which is a horrible feeling, has come over again in my sculpture. This is where the lairs come in – the lairs are twisted rods that are turned on themselves over and over again, where the executioner becomes the executed, and

you feel through the violence that has been done to a person, that it might be done to you. This is involved very much with emotions. This is the connection between the lairs and the standing figures.

JJ Are you very conscious of this when you make them?

LB Yes. I am very conscious at the time of the motivation, what I call the gestation period, which can last for two or three weeks sometimes longer, and then suddenly you will have this need to express yourself in a certain form. What is present during the gestation period is this feeling that you have to hold on to running horses, that you have to control yourself, and that you should not be angry at people – this brake that you put on your emotions, then suddenly it explodes in formal shapes. I'm not so young – I can say this has happened to me all my life and I have never hurt anybody. [LAUGHS].

JJ The lairs are both a figure and also some kind of animal's home. Is this a kind of maternal object?

LB No, it is not terribly maternal. It is a flight from the aggressive feeling that I feel. This is not terribly interesting, but I had a brother that I was very close [TO] – that has been represented over and over again, in double figures. This brother was unfortunate – he died a very pathetic death – and I was constantly told that I should be nice to him and – even though I was rather frail – I was constantly reminded that I could not talk brutally to him, and I could not do bad things to him, and when I was successful, to a small degree, I was always told, 'Now do not tell Pierre that you passed this exam. Do not tell Pierre that you were successful, that people liked you,' – all kinds of childish success. I have found this in [PHILOSOPHER] Jean-Paul Sartre, this rang a bell – when this desire to please, which is absolutely horrible, then gave rise to a desire to displease and attack people and tell them what you thought. But you should never do this because it would hurt. And, well, it was a repression.

JJ And now relate this to the sculpture.

LB I did not want to show what I felt and there were lots of chickens' necks being twisted – it was an aggressive and crude environment. I took care of my mother; she didn't take care of me. I was in a position to hurt and I did not want to, and I was not supposed to.

JJ Would you say sculpture has been for you some kind of therapy?

LB I don't know if I don't resent that a bit, the word therapy. I think really that teaching is a much better therapy. Because it involves so many different situations – mild and not mild.

 The pop art show. [SHOWING A PICTURE] This is a cement, and this is different pieces of wood – the black is ebony.

JJ When did you begin to work in plaster and cement?

LB I started to work in plaster because the shapes are so different. There is in wood a stiffness that doesn't come in in a poured material, such as plaster or wax. I have worked quite a bit in wax. Wax has a special character of its own – what you can do cannot be done with anything else. We have in America excellent wax as by-product of the oil industry, so you have very flexible and adaptable wax, quite black in colour. I prepare a Hydracolour floor, I pour it in and the wax gets to be an eighth of an inch. At this point I cut it in ribbons or squares, or in any geometrical shape, and then it is joined together – it reminds you of sheet metal work, and yet it is wax. I find this very pleasant. I must say that also I cannot touch metal, the touch of metal is disagreeable to me, so I would achieve this in wax without having to work in metal, which I find unfeminine.

JJ When you move to cement or wax, does your theme change?

LB Well, I find it much richer – instead of fighting the media, really the media is yours and you can allow yourself to be tender. And then the work that you do has that quality of tenderness.

JJ The blackness of these figures which you describe as having to do with death, did you expect the spectator to see this in them, or was it just that blackness gave the sculpture a sombre quality?

 When I was talking to [ROBERT] Rauschenberg, he was critical of abstract expressionist painters who were concerned with symbolism in their painting. You had to recognise that red had to do with blood, or green with grass. They tended, he said, to neglect the red for red's sake, or green for green's sake. He thought this was a weakness.

LB I don't think the problem appears, because when you use the black it expresses a desire to withdraw – but you are not conscious of it.

JJ You never consciously employed black as a gloomy symbol?

LB No. Not at all. If somebody had told me this at the time, probably
 it would have bothered me. I would probably have denied. And yet
 – the observer sees much more in your work than the artist.

JJ In the case of the use of black and white by the abstract
 expressionists, did it reflect a period of depression?

LB I know that Bill [DE KOONING] was a man quite driven, and he
 would accept readily the fact that – even though he wouldn't have
 at the time – when he painted the horrible women [IT] coincided
 with the visit of his mother. We knew it around him, but I don't
 think he was conscious of it. Franz Kline was a very depressed man
 – and when he painted his colours at the end of his life it's because
 he had a desire to break away from the black. It is interesting that
 Bill, when he came out with his beautiful colours, it was when he
 let himself paint the women. When these horrible creatures came
 out, then he was gentle again.

 [BREAK]

JJ You like that [WORK] that has many different levels?

LB This is where the richness comes from. It is the mainspring of real
 artistic production, because if you talk you say one thing at a time.
 But in a work of art, multiple meanings appear at different times.

JJ Really sculpture is this. It's never wholly one thing. With someone
 like Henry Moore, for example, some of the figures are landscapes.

LB Yes. I read about Henry Moore that he makes things very small and
 then enlarges them. This is a thing that I couldn't do.

JJ You don't make maquettes?

LB No, I never do. I start at the permanent, at the way the things will
 remain. I am not able to enlarge.

JJ Do you draw?

LB A great deal, yes. I draw landscapes.

JJ Do you ever draw directly from a landscape?

LB No, I would not.

JJ How many years is it since you have drawn from the figure, as you
 did as a student?

LB Well, at this point I have the use of the model in school and
I do make drawings to show the students how they have to turn
around the figure and give several views of the same movement,
and later on express the movement in one single view. One of the
exercises I give them is that we work in salt blocks – the salt that
you put in a field[37] – because it has a beautiful crystal whiteness.
It's very lovely. So we carve, and the goal is to make the finished
product look bigger than the original shape and this is achieved
by understanding movement. I demonstrate it with the figure to
express the turning of a torso or something, with lines. So I am very
fond of drawing. In this drawing, which is very much the human
figure, it expresses the fact that the person is a prisoner – unable to
move, the rigidity is complete – he is paralysed. This is the word,
paralysed by past. And I have lots of drawings downstairs where
the person is represented by one of these houses in New York,
these very narrow houses, very much like this, and then the person
is ossified when he is prisoner of the past, to the family house.
Then landscape was a fluid landscape, you see it is actually sand
dunes, sand quarries really, in the south of France. I lived there for
many years, because of the climate. My mother. We used to go to
Apremont,[38] way up in the mountains – it is very scary to go on that
road, because these roads were not made for cars, they were made
for donkeys, I suppose. And at the top of this Apremont there was
a house that stood on the chalky, fragile land, and the people had
dug caves in them, so much so that when the house was for sale
it was simply that it was in danger of disappearing in the ground
underneath, and this is what is represented there, this is the caves.

JJ Again there are caves and lairs.

LB That's right. In this particular case they represented a danger.

JJ Most of the things that you've said about the figures and the lairs,
and even these drawings are related to surrealism. They're about
psychological attitudes. The question of the natural man being
a prisoner of the past and, it's implied here, a prisoner of the city,
a prisoner of civilisation. And this does resemble a late dada or
surrealist drawing, to some extent.

LB Yes, you might say that the surrealists had this quality of detaching
themselves and making fun of themselves. And I detach myself
from my problems in the work. I'm not very good at being
objective. But the surrealists are very objective. Even in René

Crevel, one of my favourite artists. He was haunted by all these problems that we talk about and he did commit suicide, so he lost at his own game. And with the clarity he *seemed* to have, that intelligence is not enough to take care of your problems, you have to trust the animal in you.

JJ Most of the abstract expressionists here seem to be accident prone, depressed men, suicidal … Gorky committed suicide under terrible circumstances. De Kooning has for years been an alcoholic and very depressed – or manic perhaps: he has periods of excited gaiety. Kline, you said, was rather sad and ill, and drank a great deal. Pollock was another alcoholic and died in a car crash – not suicide in any legal sense, but in another psychological sense it is. All these people do seem to have a melancholy or self-destructive disposition. Perhaps I'm exaggerating it.

LB No. I don't know that it is particularly American. But I have seen a great many people from Germany coming here to teach and one very old man said, 'Well, of course, in Europe you are allowed to be an eccentric, even if you teach in a university, you can forget to shave and you don't have to watch your manners and so on. But here, you see, you are supposed to be good, you are supposed to conform and then this aggression is turned against yourself.' In Europe it wouldn't. Even if you read [THE PHILOSOPHER AND CULTURAL CRITIC SØREN] Kierkegaard, which *amazes* me, the revelations he makes about himself, the way he feels about people. He's not ashamed to be mad.

JJ Someone said to me that success spoiled de Kooning to some extent.

LB It did, I think so. Because all the guilt that he felt had an outlet when he could complain about his fate. But once the success came in, then the guilt had no outlet and it was turned against himself. What is more, he's very jealous and he's very concerned about his future image and – yes, I think all these things can be said. Because of his reputation, lots of people would have loved to analyse him. They thought that the material would be original. But he has turned against people who wanted to help him. But then this is the ransom – this real rage – if it is turned against the people who could help you, then the self is defenceless. He won't let any doctor come near him. On the other hand, he is always ready to help, if you ask him to do you a good turn, then he might talk to you.

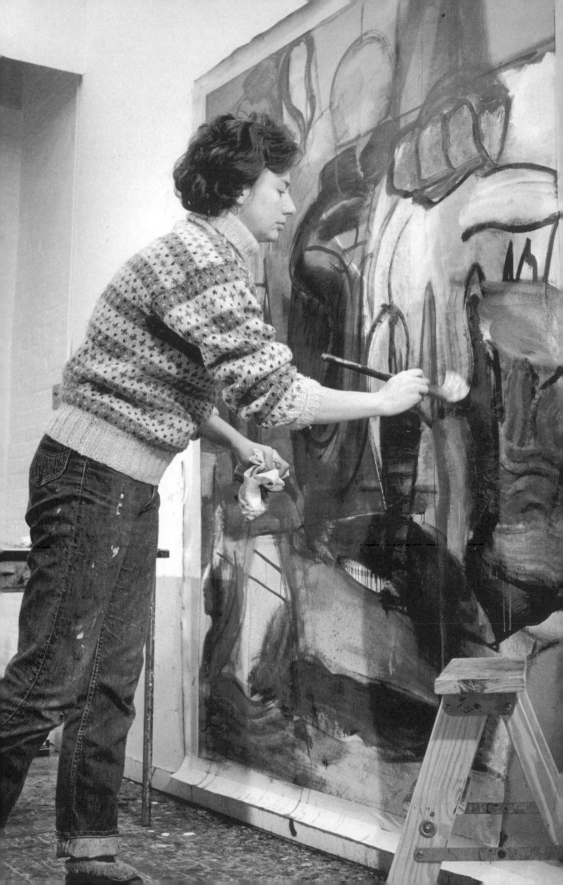

GRACE HARTIGAN

John Jones interviewed Grace Hartigan on 17 March 1966 in the rag factory she had made into a studio at 112 South Calvert Street, Baltimore, Maryland. She was forty-three, and the previous year had been appointed Director of the Hoffberger School of Painting in Maryland.

Born in New Jersey, with Irish heritage on her father's side, Hartigan was first married at nineteen. She painted in California for a while, and then studied mechanical drawing in New Jersey. She worked as a draughtsman in an aeroplane factory during the war to support herself and her son.

She began with figurative painting indebted to the classics, but in 1953 became the first 'second generation' abstract expressionist whose work was held in collection of the Museum of Modern Art in New York. She exhibited under the name George Hartigan until 1954, when she had a sold-out exhibition at the Tibor de Nagy Gallery in New York. She was included in the *12 Americans* show at the Museum of Modern Art in 1956, and in the museum's *New American Painting* exhibition which toured Europe in 1958–9. She was acclaimed in *Newsweek*, and in 1958 *Life* called her 'the most celebrated of the young American women painters'. From the 1950s her work made use of motifs and characters, and when she worked for a phase in watercolour collage she said 'the cry became a song'. But after 1962 her images, including one of Marilyn Monroe, were perceived as 'more anxious', reflecting the assassination of John F. Kennedy, and the rise of pop art, which she strongly opposed.

Hartigan's friends included Jackson Pollock, the de Koonings, Larry Rivers and Helen Frankenthaler.

GH In my student years I studied with a man called Isaac Lane Muse,[1]
 and he taught the school of Paris, so it was really [HENRI] Matisse,
 [GEORGES] Braque and [PABLO] Picasso, and fairly cubist-oriented.
 When I met, and saw the work of, Jackson Pollock I felt very
 fervently 'the Break', even if Jackson himself didn't feel that way.
 I did, and the other young people my age, like Alfred Leslie[2] and
 Bob Goodnough,[3] and Harry Jackson[4] and Helen Frankenthaler.
 We felt that this was completely American and new, and
 I remember a New Year's Eve Party – 1948 or 49 – we drank to
 the death of cubism. And the painting that you saw downstairs,
 The King is Dead: the king was Picasso.

JJ After the event, people like Clem Greenberg, however, found in
 Jackson Pollock all sorts of echoes of the Picasso tradition.

GH That I don't think was Pollock's intention at all. I think he was very
 interested in the idea of the automatic gesture and that, of course,
 relates to surrealism. But that never interested me, and really didn't
 interest Goodnough or Leslie. It did interest Frankenthaler. But
 I never used the automatic technique of drip. I never even used the
 accident, the automatic part. Everything was always brushed, so
 that I kept the control between the hand and the surface.

JJ Did you go as far as approaching the picture without any
 preconceived ideas about how it was going to be – which does
 grow out of the surrealist movement?

GH Well, it was more that the blank canvas was an approximation of
 life, and the action of the painting was to make something, or to
 be defeated by this act of the unknown. Now the trouble with all
 of that was that some people, like Pollock and [PHILIP] Guston[5]
 especially, made an entire personal form out of this. I found that

whenever I did that I came up with a very vigorous and interesting abstract expressionist painting. I tried it over and over again, but it didn't seem to lead into any personal vocabulary for me.

JJ And this is important for you?

GH Yes. I think creation has to do with the hope that you'll put something into the world that hasn't existed before.

JJ Ad Reinhardt's anxiety was that life should intrude on painting. You disagree?

GH It reminds me of one of my favourite things that [PIET] Mondrian said when he first saw a [YVES] Tanguy.⁶ He said, 'Oh that's very nice, but I like painting with a little more dirt in it, like mine.' I believe in getting the dirt of life into my work. Not that I don't respect Reinhardt's position and his work, but it's completely alien to mine.

JJ It's nice to have him around as a sort of sounding board.

GH Oh yes, and in a way there's nothing more romantic than such a classicist's posture. So he's real romantic.

I began painting in a very odd way. Around the beginning of the war, I was painting like an amateur – I was only out of high school a year or so – and I got a job as a mechanical draughtsman and went to engineering school, and was trained as a machine designer. I painted weekends and evenings, and began to study in New Jersey with Isaac Lane Muse, who, as I said, taught the school of Paris. He also taught drawing from the figure, but in his painting classes he taught an almost stylised approach to cubism and to Matisse. It was more decoration, actually, than spatial concept. Gradually painting took over, and he moved his studio to New York, and I moved to New York and continued to study with him, for about another year. Then I met Milton Avery,⁷ and became influenced by Milton's work, which is very odd now that he's kind of rediscovered, and [MARK] Rothko had always thought so highly of him. Around the time that I was still involved with Matisse and Braque and Picasso, Avery was the first real live artist I'd ever known. *Time* magazine made fun of an article by Clement Greenberg in *The Nation* which was the first time that anybody had written about David Smith⁸ and Jackson Pollock, and they incidentally reproduced the Pollock upside down. This was about 1947. It

aroused my curiosity. I'd never seen anything so peculiar as that Pollock. So I went and saw his show – the first drip things that he'd done. At the same time I began to meet some of the students who were studying at the Brooklyn Museum School and at NYU. NYU was a very lively place. Bill Baziotes' was there, [ROBERT] Iglehart,[10] Tony Smith,[11] and they rented for their students' use a place that came to be called Studio 35 on Eighth Street. Those students and I, and Harry Jackson, we became very close. We saw each other's work constantly and Pollock interested us very much. I finally came to meet Pollock through Sonja Sekula.[12] We were all living on the East Side. [JOHN] Cage[13] was in the building. She said that Pollock had just moved to the country and was depressed because none of the young people seemed to be interested in his work. So Harry Jackson and I went out to pay homage and he was absolutely delighted to be told that somebody young was involved with what he was doing. Studio 35 didn't last very long, but Leslie and Jackson and I organised an exhibition there, because *Life* magazine had just come out with an article on painters under thirty-five, and we thought it was so academic and horrible that we were going to show them what really … [ROBERT] De Niro[14] was in this show; De Niro in my mind was European, whereas the rest of us were tremendous rebels and involved with the new space.

JJ You were conscious of the Americanness.

GH Yes. Very, very violently so. It was almost a cause.

JJ That's why you painted *The King is Dead*, a kind of propaganda picture.

GH In a way, yes. I came to feel after a couple of years of working in this direction that I had no right to this form, that it wasn't my own. I hadn't discovered it, I had acquired it. The attitude of the old guard – abstract expressionists like Rothko, [BARNETT] Newman, [WILLEM] de Kooning, Pollock, [FRANZ] Kline – was not to make a new kind of space, or even to make an American work. I think in this struggle – this dialogue of life and death – they came out with a new painting form, but that was not their search and their intention. That was almost a by-product of the subject matter.

JJ What was this struggle?

GH Well, maybe historians will sometime figure this out. I think it had something to do with the war and being cut off from Europe.

America was in the war, but it wasn't in our laps. There was some sense of displacement and guilt, that we were sending our men over there to die, but we ourselves were really quite safe. And the artists of conscience, I think, felt that they would approximate the drama of life and death if they took the tremendous risk of destruction in their own work. Now this is just guessing. That might be too simple and too obvious an explanation.

JJ I heard that there was a certain amount of disillusionment on the part of artists involved with the extreme left-wing projects in the Thirties. When the Forties came, it all seemed hopeless.

GH That's possible. The thing is that my generation is, like [ROBERT] Motherwell said amusingly, 'We're apolitical, like cats.' [LAUGHS] Since I was in high school, when everybody had the good sense to be a communist, I never was involved with politics at all.

JJ One of the issues that's come up in these tapes is that many people working in New York felt the heavy hand of Europe on their backs. They felt in the Thirties that they were kind of country cousins to Europe, and that you couldn't be an artist until you'd been to Europe. And they very much wanted to have an art which wasn't so dependent. They had to get out from the shadow of Picasso and Matisse. And then the next, younger generation still found they had to get out of the shadow of abstract expressionism.

GH I think a tremendously powerful movement and tremendously powerful artists almost castrate the next generation, and my generation is in a hell of a mess. The people who are going to come out of it seem to be the people who are least involved with their predecessors. An artist like myself, who was terribly involved, is having an awful time finding the truth of my own way.

JJ This is exactly what I mean, getting out from under their influence.

GH The thing that is very hard for anyone to realise is the appalling desert that America was – and the New York scene was – as late as … well, I arrived in New York around 1945. There was nothing in any galleries but European art with the exception of people like [JOHN] Marin,[15] Max Weber,[16] Abraham Rattner,[17] Milton Avery, and they were shown during the war years because they couldn't get much European art over here. That really was not very exciting to the younger people. So until we discovered Pollock and de Kooning, we tended to go to people who were very alive, and it

was marvellous to see Matisse's newest things at the Pierre Matisse Gallery when the war was over, and to see those Picassos come.

JJ How about the influence of the surrealist refugees?

GH I think it affected the generation before mine. I didn't know any of these people, and I've never been attracted to surrealism at all, either in the look of the art or in the automatic approach to it. I think it probably did make a climate of seriousness that did affect [ARSHILE] Gorky, certainly, and Motherwell. But what was marvellous was to find right in your own lap work that had been going on.

JJ I get the feeling, jumping a bit, that your work is related to Matisse.

GH My earliest work was out of Matisse, certainly. Now it is Matisse with a tremendous American bite on it. I'm not doing what I hoped for – but then maybe no artist ever does.

JJ Unfortunately not.

GH What I would like is to make a whole art of metaphor. That is, I would like every form in it to exist on many levels, and to have a highly developed personal, formal and metaphorical vocabulary. The only artists that have done that satisfactorily, in my mind, have been [JOAN] Miró and Gorky, where each form – is it a plant, or is it a woman or is it a shoe? – exists in many possibilities, and that way it's like the art of, say, James Joyce,[18] where every phrase is sound, it is association, it is character, it exists on many levels. And that's what I would like to achieve. Matisse never really did that. I don't think he even wanted to – he was very much related to the visual world and he didn't make his forms, except in a few paintings, like *The Moroccans* [1915–16], exist on many levels, where you think perhaps they're plants, perhaps it's fruit, perhaps it's human beings, etc. He did that very rarely. This is what I'm primarily aiming at now.

JJ Claes Oldenburg also has this feeling that his work should not be read on any kind of level – pop or anything – but it has many levels and associations as well. Quite different from the way you're talking about it, but a similar desire to have twenty different interpretations.

GH Well, of course, with Oldenburg I just see a hamburger and that's all there is to it. Whereas I would like my forms to be a hamburger or sex, or the change of the moon or many, many different possibilities as well.

JJ It's odd you should choose these three examples, because that's exactly what he would say was in his hamburger – there is sex, there's also three discs like the moon, and also it's a very personal thing and a world that he's invented, and a kind of sculpture.

GH Well, that's very interesting that his point of view is similar to mine, whereas the work is so completely different. I don't know, we haven't met.

JJ [ROBERT] Rauschenberg said of abstract expressionist painting – particularly the kind that talks in terms of metaphor and symbol – a typical, enigmatic Rauschenberg phrase: 'the red doesn't know that it's supposed to be blood.'

GH [LAUGHS] But does blood know that it's supposed to be red? I have a very wonderful example of this very thing.

JJ Oh good.

GH Yes. When de Kooning did the [SERIES OF SIX PAINTINGS 1950–3] *Women* I had a long argument with Jim Fitzsimmons, who is an art critic and now editor of *Art International*. He took these paintings as a demonstration of de Kooning's hatred for women, and I argued their beauty, as well as their structure and the elimination of the concept of background – many formal things about them – but most of all I thought they were beautiful, gorgeous paintings, and he thought they were horrors, and violent attacks on the female. And, as an example, he pointed to one of these paintings that had gashes of alazarin crimson across the breast. He said, 'That's blood, he's stabbed her. It's a perfect example of what I mean.' So, I went to de Kooning and asked him if he intended to stab this woman, and de Kooning said, 'Blood? Jesus, I thought of them as rubies!' Red doesn't know whether it's blood or whether it's rubies.

JJ The only thing you're sure of is that it's –

GH That it's red. Yes, and it's paint.

 A question in relationship to the gesture of abstract expressionism is whether the drama is authentic or staged. And that question in 1952 set me into an investigation of the figure, the art of the past, Spanish art in particular, which I'd never investigated before. I was interested in the psychology, the revelation of the human in the way that [FRANCISCO] Goya revealed it, and in that grey black light. In the possibility of going on from it against the French

tradition, which is one of a completely different kind of light, and a completely different philosophy and approach to the human being and the human condition, and a much more luxurious and sensual one. I was interested in the more stark Spanish one. The paintings tended to look like German expressionism, much to my horror.

JJ On the whole one doesn't live a stark, bleak life and so, although one may feel oneself drawn to this kind of work, nevertheless to paint in this way often becomes melodramatic.

GH Yes, because you simply cannot approximate somebody else's life, and that's where someone like Bernard Buffet[19] is such a fraud, because he makes decoration out of something that is supposed to be stark and bare, and he lives in a château, painting in a bare studio. It's absolutely ridiculous.

JJ I agree.

GH It would seem that to be true and authentic and close to oneself is the easiest thing in the world, but actually it's one of the most difficult things, to really figure out where you are, where you come from and what is completely true.

JJ I think the aim is to use all your sophistication. But use it innocently, without affectation, without mannerism. It's very difficult.

GH The thing that for me has been helpful for the last year and a half is that, like an old Freudian, I look at the things that send me – scare me the most, the things that I criticise the most in my society – and I look at why I'm afraid, or what is it about them that scares me. And then I try to do something about it in painting, sort of explain to myself what it is.

JJ That's interesting.

GH It's almost like the old idea of exorcism. So that some of the themes that I've used come from – well, girlie magazines, a lot of the things that the pop people use, the American commercial world that is so all-consuming, so aggressive, so hostile to individual life and to feeling, living and the mass production idea.

JJ You felt girlie magazines epitomise this?

GH Well, girlie magazines are another thing. They are in a way a sell-out on female sexuality and sensuality. They're packaging the human woman and selling it in a certain way that I think is

horrendous. The thing that the pop people did is to use humour to displace the danger. I feel that's avoiding the issue. I think you have to go into the danger and come out with something that's a real triumph and not a comment – and that's the trouble with the camp element. It's avoiding putting yourself in danger and really trying to do something about it. It might be ludicrous to think that art is a way of overcoming the things that you hate in your society, but I think that I've [A] much better chance of doing it by making a work of art that's alive and marvellous and real, as against something that is cold and dead and vulgar and ugly and threatening, than you do by making something that's silly and funny about the whole thing. Or making social comment, which never worked out.

JJ Paradoxically every pop artist I've talked to has said that social comment is the furthest from his mind.

GH Oh, really? I wonder if they've always said that. I think they're in a spot, because you can't go on camping it up forever.

JJ Lichtenstein says he paints abstracts.

GH So does Andrew Wyeth [LAUGHS].[20] So let's draw our conclusions from that. My work is to be read as comment and a triumph over American modern life, and it's read as abstract art, and the pop artists' work is read as what I want my work to read as, and they think they're abstract. It's really very, very strange.

JJ It's interesting that you think your work is facing social issues.

GH I think so. Yes.

JJ Many painters will say 'This is what gets me going, involves me, makes me paint. But when the picture is finished, I think it unlikely that the spectator would see in the work any of these things.' Do you feel that?

GH I think that it's unlikely that the spectator would feel the philosophy, which is to use art as a power to triumph over the things that I find horrendous, say. In my most recent work the titles give clues to where the work came from. I think if they get an idea of something that's tremendously alive and vital, that's enough – and if they're fascinated or not, or moved or not – no, I want them to be moved. I won't say 'not' about that.

JJ You want them to be moved about these issues?

GH No, I want them to be moved by the painting. The fact that I need
to set this up for myself, I guess, could be called subjective, but if
the work at the end does move people – for instance, really looking
at Matisse changed my entire life. If one can change someone else's
life, they don't have to know what the sources were that made this
work come into existence.

JJ But you say the titles are important. This gives people a clue about
the social comment.

GH Well, gives them a clue to the source. It doesn't give them a clue to
whether or not this is something that I want to use art as a weapon
against. They can know that something is a shopping centre and
another thing has come from an assembly kit of putting a human
being together. Or that another one has to do with – oh, *Henderson,
the Rain King* (a novel of Saul Bellow's) [REFERRING TO HER WORK
THE RAIN KING OF 1965].

JJ Someone once said to me that a picture of, say, a bandaged
man in hospital, bearing the title 'Catholic Priest Beaten up by
Communist Workers' could be put beside the same picture with
the title 'Communist Beaten up by Fascist Troops' and – this is
an obvious example – the meaning of the picture is immediately
changed. Even within social realism, propaganda, there's an
ambiguity. When you say it's odd that pop art should be read as
social comment when they don't want their pictures to be seen this
way, while you *do* want your pictures to be seen this way, it's very
possible that someone coming to your pictures might see them, in
the richness and brilliance and vitality of the colours, as some kind
of celebration of the put-the-human-being-together kit or the
supermarket, or whatever it is.

GH Well, you're not far from what I'm really talking about. That the
essence of every single painting now is the insistence upon human
values and human feeling, and individuality over mass production
and anonymity. And that's the essence of the social concept. It's
not as specific as sex, or that we can assemble a human being from
a kit – that isn't it. And if the painting is read as just a triumphant
individual human expression, then that's good enough for me,
because I think that's what it's all about anyhow.

JJ This is a long way from a statement in *Time* magazine: you were quoted as saying, 'When I start a painting I begin with, let's say, a colour. No, let's say I just start.'

GH Well, that was a brief period and, if we're going to remember my old statements, I'm now more at – 'I'm interested in the vulgar and vital in American modern life, and the possibility of its transcendence into the beautiful.' Maybe in a few years we'll be back to the other statement.

JJ Did you ever attend Motherwell's [ART SCHOOL]?

GH That lasted only about a year, and I was in Mexico at the time. When I came back that loft, which became known as Studio 35, had been taken over by [THE SCULPTOR] Tony Smith and Hale Woodruff[21] and Iglehart of NYU, for their students to use as studios. They also continued with the idea of meetings and discussions, and I began to attend those.

JJ Do you remember any of the discussions?

GH I remember particularly an evening when de Kooning got up and said to the effect: 'I'll go along with you boys, but I'm not in your empty house. If I'm going to paint a man standing against a lamp post, I'm going to paint it if I want to.' In other words, he was presenting a very anti-Reinhardt approach. His idea was the art of excess and inclusion, rather than exclusion.

Studio 35 stopped then and there was a lapse of – I don't know – several months, and then The Club began, and I began going to it almost immediately. They let some of the younger people come even though we weren't members. That was a different group of people. The Club ended up a very de Kooning-oriented thing, and I think that certainly Newman, Rothko, [CLYFFORD] Still, Motherwell, were very non-interested in this. All the people around de Kooning were much more … well, Pollock's favourite way of putting de Kooning down was to call him a European. [LAUGHS]

JJ It still persists.

GH Yes. Would you like some more?

JJ No. I won't have another one. Can you remember much about your visits?

GH To what was called The Club? Oh, I remember a lot. As time goes
 on, you tend to think of the past as the good old days, and you
 forget the tremendous hostilities and furies and friend against
 friend that existed in that time. The greatest hostility that I met,
 because I was the first of the younger people to begin to investigate
 the figure again and everyone else was involved with abstraction,
 some of The Club members came up to me and said, 'If we were in
 Paris, we wouldn't let you in here – we keep figurative people out in
 Paris, you know – in our club we are all abstract.' I remember when
 [RICHARD] Diebenkorn first came to New York, around 1952 or 3,
 he said, 'Who are you?' – we were the same age – 'What are you all
 interested in?' I said, 'Well, I'm beginning to investigate the figure.'
 And he said, 'How reactionary can you be? We're interested in
 Rothko.' And Diebenkorn has turned out to be the real advocate of
 a figurative, almost [ÉDOUARD] Manet[-LIKE] kind of expression.

JJ Something of Matisse and [PIERRE] Bonnard, too.

GH Yes.

JJ I've noticed going round the openings that the figure is very badly
 treated in New York. I'm staggered at some of the shows that find
 their way on to the walls, because when we were students in our
 second year in that more academic atmosphere, we painted pictures
 like this all the time and they'd be dismissed as exercises.

GH The fact that now, after so much abstract work, someone can do the
 figure, no matter how badly, they take it as a new movement, or a
 new approach and it's absolutely ludicrous. And the worst approach
 to the figure that I've seen – and it really deserves the *salon* term
 – is to take the abstract expressionist brush and apply it to a
 traditionally spaced figure concept – and that's the new academy.

JJ That is dreadful.

GH There are a lot of students doing that, but there are even artists in
 New York, supposedly respected, who are doing that sort of thing.

JJ I don't talk to too many people who are interested in the figure.

GH It's something that interests me very, very much, and I think that
 we painters, no matter how we go away from it, are image-makers.
 And that is a haunting thing for every artist. Even Reinhardt: he
 renounces it forever, but his very anger in renouncing it shows the
 the attraction, the pull of this.

JJ Man in the long run is interested in himself and the figure, and the abstract expressionist thing, splendid as it was, in its hostility to the figurative posed a tremendous problem for everybody.

GH There's almost no way to go on from it. I *am* in sympathy with looking at image-making once more and in great dis-sympathy, if that's the word, with the solutions people have come up with, because there is no point in doing a lousy Manet or a lousy impressionist painting, or a lousy salon painting, and just because it's come after abstract expressionism to have it look as though it's new and relevant.

JJ Yes. Though maybe painters in New York, inheriting abstract expressionism, make a revolutionary gesture which says, 'If I'm going to deal with the figure, I'll start again at the point where art seemed to move away from it, and even if I do produce terrible pictures, possibly something will emerge from it.' The feeling that for a while it's necessary to paint bad Manets in your own education towards a new figuration.

GH Well, then there is the question of whether it's valuable to display your education in public. I mean, what an artist goes through – or an artist of seriousness – is anything he wants to experiment in, but to have it heralded as new and possibly relevant to other artists …

JJ Do you feel strongly about people showing too soon?

GH I don't feel too strongly about showing too soon. I feel quite strongly about showing too often. And the pressure of all of the machinery now of the art world is certainly greater than when I was younger. And it's increasing. The mass magazines are taking everyone up, and of course you're part of the Kleenex society – blow your nose and throw it away. Disposable art, disposable artists – and that has embittered many people.

JJ Do you find it a pressure on you personally?

GH It was at first and it was quite a blow. It took me a couple of years to get some kind of perspective and wisdom about it. Now I just think it's the condition that exists and probably will always exist. Because America has become a great cultural situation. I think it was true in Paris.

JJ I don't think it was quite so true. One of the built-in things in Europe was this idea that a painter didn't really have a one-man

show till he was about forty. If he did, he was a prodigy. You had to find your way through all the different attitudes until you had found yourself.

GH My God, in America you're a has-been when you're forty.

JJ Six months to go.[22]

GH But the amazing thing about that is you have all the possibilities for being a new find. You have possibly five more lives if you live into your eighties.

JJ That's true.

GH So it could be a great adventure.

JJ I didn't mean to ask you this, but it interests me very much. Have you any idea why all the abstract expressionists were so accident-prone – self-destructive?

GH I think that was the condition of facing the canvas as though it were a life-and-death situation.

JJ You think it grew out of the art?

GH I think that the art was the life and the life was the art, and that the dilemmas that were faced on the canvas were faced in life itself. And there was no separation between them; I won't put you down for being a European –

JJ I'm quite accustomed.

GH But this is very American, as far as I can see; that the art was not an object, a product, something that a talented, developed human being did, and then put his own personality in. It was a complete identification: you lived in the canvas and in life in absolutely similar ways. It was almost like bullfighting or something. Now that's not so true any more, but it was almost the essence of the abstract expressionists. Presenting life crises on the canvas.

JJ And yet in a form which it was very difficult for the spectator to read. It couldn't be seen as a life crisis in the painting.

GH No. And maybe it's not essential that it is read that way, but, having known these people so intimately, this is the way they worked and this was the way they lived. And for Jackson Pollock

to play Russian roulette with the car was to approximate the Russian roulette that he played on the canvas, and each one was an extension of the other.

JJ He was doing this when he was killed?

GH Yes, definitely. He was involved with a work block, to use a corny word, but that was really what it was, and he chose ways in life to try to break, to crash out, and the way that he had found in painting to crash out, was to take this spill, this chance, this throw – to throw it away it's like the *coup d'oeil*, the dice, hazard – the risk doesn't mean that you will win, you just have the chance of winning. But then, you don't realise this, you may lose. That, I think, was the essence of Pollock's life, especially towards the end.

JJ You think he was doing this in the car, too?

GH Mmhmm. Yes. I think he was acting out the drama in life itself.

JJ Playing chicken with himself.

GH Yes. With the hope that he would break through.

JJ I heard a talk the other day at the College Art Association which described Pollock's life up to the time when he began to be successful. He had a terribly tough life. I had no idea of the poverty that he went through in the Thirties.

GH Well, I didn't know Pollock until about 1948. Then it was still very tough. He had, when I met him, just exchanged a painting with Dan Miller, who was the grocery store man around the corner from him. Miller only took this painting because he liked Pollock so much; he couldn't understand the painting from beginning to end. A couple of years ago he said it was so valuable he just couldn't keep it any more; he had to sell it, it made him so nervous [LAUGHS]. And Pollock had just gotten some kind of a little grant, one quite unknown, nothing as grand as a Guggenheim. A Tiffany, I think. And of course he'd had Peggy Guggenheim's help, but she'd since gone back to Europe, so he was really hard pressed for money.

JJ But I think it was nothing like the early days. In the Thirties during the Depression, he and his brother lived in a cold water flat,[23] and they really didn't get enough money to live on. If one was working the other wasn't, and they used to steal things all the time to live. And he started to drink.

GH That's part of Pollock's life which I didn't know about, but I took
that as a condition of seriousness – the fact that you were going to
live on your work. Then you had to face the fact that you didn't sell
anything, so then what to do? And, to use our word, you scrounge.
You pick up a little job here and there – if you're lucky, sell
a drawing for $5. Your friends feed you, you live until the money
runs out – absolutely hand-to-mouth existence. And I lived that
way in the early years when I got my studio on the Lower East
Side in 1950, and through two years of living on stale bread, bacon
ends, broken matzos, oatmeal – if you were lucky, you had raisins.
Just a few people, like my dealer, John Myers, knew a few people
who had more money than we did, and then he would make them
give us dinners. I've supported myself all my life. And when I didn't
sell my work, I took odd jobs. I can give you a list of jobs that are
so ridiculous –

JJ What did you do?

GH Let's see, I ran a travel bureau three nights a week at the Savoy-
Plaza Hotel. I took moron jobs, which you can pick up in New
York – you join an employment agency and they pay you about
a dollar and a half an hour to stuff fillers into envelopes. You sit
there like a machine. I was a receptionist during registration at
an insurance school. I was an artist's model for a while. The best
job I had was editing market research interviews. New York is
a marvellous place because it's filled with these jobs that you can
pick up and as soon as you get $30 or $60 or so, enough for the rent
and a little paint and canvas, then you quit and work on your own
work, and then when the money runs out and it's really desperate
you just pick up one of these jobs again. And slowly the work began
to sell – and I wasn't proud – I sold big paintings for $50.

JJ Do you have a contract with a gallery?

GH Now I have a contract with Martha Jackson Gallery; she pays all
of my business expenses against sales.

JJ This is the European tradition.

GH Yes. She runs her gallery in more the European tradition. I try
to really do something that has not existed before, and make
something that's authentic, using not just necessarily the figure, and
to make a vocabulary that is exciting and alive, relevant and real.

JJ It's very difficult, but that's what makes it good.

GH Oh, yes. Well, it wouldn't be fun if it wasn't hard [LAUGHS].

JJ Do you have any other anecdotes about The Club?

GH Let's see. I can think of several things. Some of the younger people were invited to speak at The Club one evening. It was, I think, Joan Mitchell, Alfred Leslie and myself on the panel – there were a couple of other people – maybe Goodnough. And Alfred Leslie made the statement that he invented art, and Charlie Egan got up and rushed over to punch him. I remember that very well.

JJ My god, how they cared about it, didn't they?

GH Oh, it was crucial. Another evening incensed me terribly. I, and a lot of others, thought that even though we would be violently opposed to each other, the outsiders were enemies and the outsiders especially were critics. And I remember an evening with [ROBERT] Goldwater,²⁴ Jim Fitzsimmons, Alfred Barr, I think, and Jim Soby²⁵ – a panel of the establishment. And I got up and attacked them for deadheadedness, reactionary thoughts, you know – no life, and all of the things that you can attack critics for.

JJ Louise Bourgeois recalls an evening when Alfred Barr was on a panel and Larry Rivers asked him: 'What do you think we should paint?' And Barr said, 'I think you ought to look at early American painting,' and all the old historical stuff that was absolutely anathema. And she says that Larry painted *Washington Crossing the Delaware*: he was the one that got the message and he had a go at it.

GH I'm not sure that that's the reason why Larry painted the *Washington Crossing the Delaware*. I think the element of humour and camp, so to speak, was always in Larry's mind, and he was always considering what was most outrageous, so it was kind of dada of him. To paint his mother-in-law nude is outrageous. No, I think this was part of Larry's whole psychology, and always was.

JJ That may have been just why he picked it up. It isn't a contradiction entirely. He was disposed in this way anyway.

GH Yes, I think so. Definitely.

 I found a few crucial moments in other artists – like two crucial things that Pollock said to me. One was to throw away the artist's

handbook – that traditional one. And then, quite contrary to the surrealist automatic idea, he said that, for a developed artist there's no such thing as an accident. From de Kooning, I remembered seeing him work on a painting – it might have been *Attic* [1949] because that was the time when I knew him, and I thought the painting was fantastic, but the thing that I couldn't understand was in this beginning-to-be really very excitingly worked out abstract painting – at the very top was a completely realistically painted skylight. I quite timidly asked him why that was there and he said, 'Oh, that's going to go. That's how I know where everything is.' And that was terribly fascinating to me, because it completely removed the design idea from abstract painting, and it made it a living presence; that everything in that painting was a drama, like action in a room, personages, events, everything taking place, and he was scaling everything in this drama, in relationship to something that was quite realistic, that was still in the room, and then at the end that realism would leave the room.

JJ This is just the reverse of a story about [GUSTAVE] Courbet. One day Courbet was painting in the forest and a passer-by looked over his shoulder and said, 'What's that brown patch in the corner?' and he said, 'I don't know.' And days later he met this acquaintance again and said, 'You asked me about that brown patch in the corner of the painting. It turned out to be a bundle of twigs.'

GH [LAUGHS] Really, that is fascinating, because it is completely the reverse. It is also the reverse of – who was it that threw the sponge on the wall for his students to draw from – Leonardo? Yes. So here is a very abstract artist who is using elements of complete realism and then making them vanish, whereas completely realistic artists use automatic and associative approaches, to make realism.

JJ That's very nice.

GH Yes, it is.

JJ I wouldn't have thought this before I came to America, but looking at abstract expressionist paintings, one of the things that struck me is that when these guys came on the scene they were all tough guys, and their work was this grand, violent, explosive gesture; and yet now, when you go and see their paintings, they're sort of sweet, they're gentle, pastelly, extraordinarily harmless.

GH Well, as far as Pollock's work is concerned, I read the drip period
 as lyricism, from the beginning – always. I wouldn't get confused
 between Pollock's personal behaviour – especially when he was
 drunk. When he was sober, he was quite a gentle, feeling man.
 I think some of his work is terribly explosive, like these early,
 almost-Picasso-but-surrealist, images, and some of the black-and-
 white things are ferocious, and some are very gentle and lyrical.
 I read de Kooning's earlier work as quite classical. The violence
 I saw in the *Women* is still there, but they also have, as I argued with
 Jim Fitzsimmons, a beauty to them, and I always saw that. I think
 that one of the values of having artist's eyes is that you see things
 as they are done, for what they are, and don't need that time lapse.

JJ Do you feel that the aim of your paintings is some kind of
 orderliness?

GH I think it has to be, otherwise it's really madness. One hopes for
 a new kind of order, and de Kooning took the risk of madness in
 going totally into chaos, but out of that chaos came certain kinds of
 order. And I think that Pollock went into chaos and came out with
 an order that is almost Mozart, it's so light and clear.

 What I was trying to do when I was facing again – in the late
 1950s and around 1960 – the blank canvas was to plunge into that
 whiteness as though it were a living situation, and come up with
 something that would astonish me. And I didn't [LAUGHS].

 So, here we are again, you know – once more unto the breach, dear
 friends. Let's try the old image-making. And perhaps I won't come
 up with anything this time either – but I think I'm on to something
 a bit new in the approach.

 [BREAK]

GH Everything I've been through in relationship to my dreams
 has been a semi-disaster. To my hopes, to the possibility of
 astonishment. I've never been sufficiently astonished. In a way,
 that drives me on.

JJ This is a requirement of your work, is it, that you should
 astonish yourself?

GH Yes. I think I want that tremendous surprise, the gasp.

JJ As a woman in painting, do you find that's a problem, or not?

GH Well, if there's a problem around, I'll take it on. There are so many aspects of this, it's awfully hard to know where to begin. I think one of the things that made women not be as active creatively as men, in spite of innate talent, is that a woman from the time she's born really is told how to please, to lure in a way – that's part of her education. Whereas the nature of creative work is really to dare and to aggress, and to take the chance of whether it pleases or not – it's what you have to do and you do it. And that's against most feminine psychology, I think.

JJ Do you think it was easier for a woman in America, to assume this daring?

GH I don't know, because I've never really lived in Europe, I've just travelled there. The woman intellectual in Europe certainly has traditionally, even in the old nineteenth-century salon days, been given a tremendous voice and role, and women who have written – I know a great deal about Virginia Woolf – certainly couldn't have been more marvellous and original, creative. I know this problem – the thing about being a woman – plagued her, and the kind of prejudice that she had I haven't really personally encountered in relationship to my work. That is, it's never been put down for a woman's work. I don't know really what a woman's work looks like – but it's always been said that it doesn't look like a woman's work. I think, hopefully, in the future there will be artists, and some of them will be men and some of them will be women, and then in their personal lives they can pursue their roles as men and women as fully as one can.

I don't think of being a woman as a passive situation. I think that a woman is a very active, alive creature in her way, and a man is a very active and alive creature in his way.

I remember a remark of Bob Goodnough's from years ago, when he saw a painting of mine that he thought was pretty something. He said, 'Good God, imagine being married to a woman who could paint better than you could.' I think that is a masculine attitude.

During the war I was a mechanical draughtsman, and I was one of the few women who was kept on draughting after the war, and that had nothing to do with man or woman, that had to do with the fact

that I did a very good job. It doesn't matter what the conditions are, what work is good – that's all. We're left with that.

JJ What are your standards of measuring this?

GH Well, artists – we have our standards – our ways of deciding between ourselves. It's a continual shuffling process. In the shuffling it seems that of the abstract expressionist time it was men, and of the generation after it, the women who are spoken of the most turn out to be Helen Frankenthaler, Joan Mitchell and myself. Now after that, there are many other young women. Certainly the younger women seem to be going more into construction, like Lee Bontacu and Marisol, the two that I think of right away. Of course Louise Nevelson is older, but then she never was involved with the abstract expressionists. Her thing's her own. And at the end, whether it's man or woman, it's the artist's work that turns out to be relevant or not relevant.

JJ I'm now playing the role of the kind of interviewer who isn't a painter. When you talk about how all these painters together can tell whether it's good or bad, what do you mean by this?

GH Well, I think the question that you ask is, 'Is it real? Is it alive? Does it mean anything?' And there's no way to explain the answers that you give to yourself for these things. There's no way to make a formula, no way to package it, to bottle it. And I think that's how art survives. It's through the decisions of artists, over and over again, thrashing everything out. I believe in artists, and if artists didn't agree that that was art, it wouldn't be art any more.

JJ If social comment is not apparent to the spectator, what is the point of art – what does it do?

GH Well, it makes you understand what it's like to be alive.

JJ You don't think that this should be worked out in life?

GH Life is so fleeting, art is one of the ways you can have the concentration of it at the time you're looking at something, or reading something, or listening to something that another human being has done. They have sort of crystallised human experience, put it there for you, available to you. And life itself is so dispersed. It's more than life. It's superlife. It's like taking all of life and making a wonderful capsule of it, so you can have a life experience

that is not necessarily your own, but is a human experience and more than that. It takes hope into account and triumph in a way that life itself might not. One can live a whole life without really experiencing triumph very often, but in art you can experience triumph.

JJ You mean as a maker of art, or as someone who looks at it?

GH Both. As an artist – you know – one looks as well as makes.

JJ Is that something that transcends everyday experiences for the public?

GH Well, I really don't know about the public. They're such a big mass to think about.

JJ As an artist, do you care what they think?

GH Well, I paint for myself and one wonderful stranger.

JJ Who's that person?

GH I don't know. That's the mystery, you see. I know it's not just me. It's someone terribly discerning who doesn't have to be an artist. It's a dialogue, really. There's another person there – another personage or presence – and that's the canvas. The thing that you're making as it begins to appear. You're making it for your own sake and the inner dialogue that's being carried on. Someone said once that when you begin the painting the whole world is in your studio, and then as the painting goes on it becomes you and it, and then at the end you leave.

I don't think I'm very different from other human beings and I'm – you know – every person. What I think I have is some kind of ability to put life down in a form that can be captured, just for that time, and hopefully it will have something to do with other times and will say something about what it was like to be alive, once life has gone from me and from our time. Often when I look at the art of the past – I've been looking at some reproductions of Etruscan art – I get overwhelmingly moved by these artists telling me what life was like then – not just life in terms of that kind of civilisation, that daily life, but the essence of life. I'm moved by the feeling of the human beings that lived and this sense of life coming from these works. It gives me a richness and reassurance of the values of making this transient thing, as tangible and as real as you can.

JJ You feel that because the Etruscans move you so much, then you can do things now which may move future generations?

GH I can only hope, yes. It makes me feel that life isn't as transitory as it seems to be, because I always feel as though I'm living on quicksand and it's slipping out from under my feet, and I can never capture it. It's never really there. Minutes go and hours go, and days go and years go, and where is it all? It's nowhere, except that in that time that you've lived, if you have put it down somewhere, made a record, you feel that you've had it, you've captured.

JJ In that way your painting is a kind a diary?

GH I suppose so. I hope that it's not just a personal diary, but a human document that will be relevant to other people. But there's no guarantee of that. Historians recount events, but they don't get inside the events. The painting and literature and music are the human events.

JJ How do you relate this to your grandfather, who's a blacksmith in Cork?

GH Oh, I just think that it's marvellous that I have that kind of vitality as a heritage. I'm very grateful for it [LAUGHS]. I don't think he was bothered with these things, and probably it's a good thing most people aren't. But since I am so concerned with the fleetingness of time, I wonder how other people live who have no way of putting it down. Of course in many ways people do – they make gardens and write diaries, and knit.

JJ You don't think these are evasions?

GH No, I think it's an attempt to stop time, to hold it, to make something that is more than the fleetingness of life.

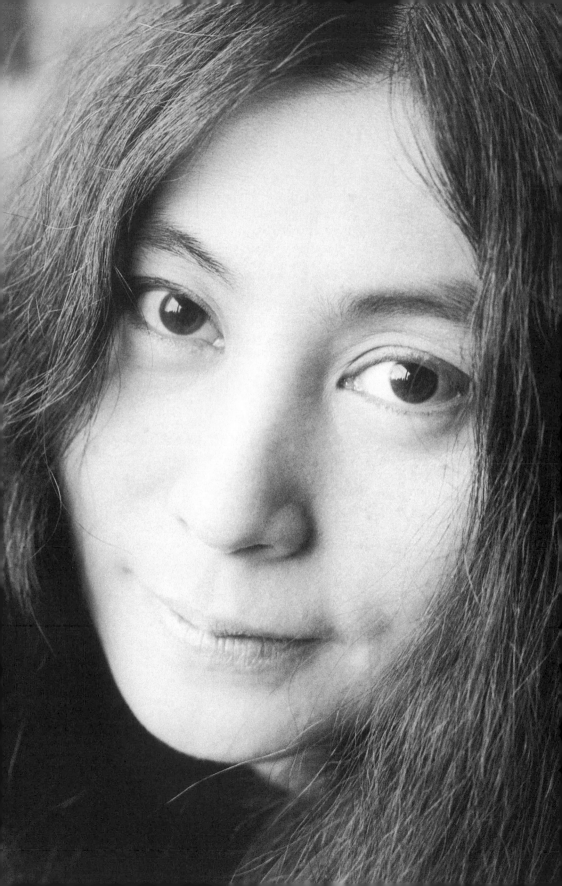

YOKO ONO

John Jones interviewed Yoko Ono on the morning of 11 April 1966 (10.30am) at her apartment at 1 West 100 Street. She was thirty-three.

Ono was born in Japan, and spent time in both the US and Japan. She experienced the war in Japan, and hunger.

In 1961, Ono and La Monte Young curated the *Chambers Street Loft Series*, which was an early compilation of radical music, dance, plays and constructions. Ono had a show of her *Instruction Paintings* at George Maciunas's AG Gallery in New York, in July 1961, where she was also instrumental in the development of Fluxus, with her ideas of participation and conceptualism.

In 1962, in Japan, she exhibited her instructions, this time, only with words, without the use of images. Ono also sold 'future mornings' on rooftops. On 4 July 1964, she published *Grapefruit*, a significant event. That same month, she performed *Cut Piece* in Kyoto.

In 1965, she performed new works at Carnegie Recital Hall, including *Bag Piece*, *Strip Tease for Three* and *Cut Piece*. In 1966, she did a *Do It Yourself Dance Festival*, which was also published in the *Fluxus Newspaper*. In February, she had a screening with other Fluxus artists of *Film No. 4*, and other films. In March, she participated in *The Stone* at the Judson Gallery in New York.

Later that same year, after Jones's return from the US, Ono went to England where she took part in the *Destruction In Art Symposium* in London, had a show at the Indica Gallery, and gave other concerts and performances, including a lecture/demonstration at Leeds Art College. In Leeds she and her family stayed with the Jones family in their home.

JJ In this room there's so much echo ... Tell me if you think your work has any relationship with dada, or any of the European movements?

YO Well, I don't know ... I wasn't very conscious of that because I started as a music composer and I was just writing school music. And I read many books of philosophy, but I wasn't too interested in [THE] art world. I liked painting and I did paint myself but I wasn't learned particularly in that field, and also I had a dislike of being an intellectual. Poetry I read, not so much about art, so I really didn't know of the existence of dada. That sounds almost impossible because most Japanese artists do know, and I'm sure that they were influenced by it. But the way I started was that I got very upset about the poems I was writing. They didn't work out well. And also I wasn't composing anything that I thought was great, and so, for about two or three years, I wasn't creative. (Anything that I write in poetry it came out something like Nakahara Chūya¹ – a Japanese poet who writes symbolic poems.) And while I was not doing anything I was about to go insane. And just to prevent [ME] from going insane – and this sounds sort of dramatic but I really meant it – I used to do silly things like lighting a match and just watch it until it goes off, and so on, and these acts became very necessary for me. I wonder if you read my book *Grapefruit*?

JJ I didn't know you had a book.

YO Oh no, really? Well, if you read that you would understand all my compositions are a very simple form of something close to Haiku. So many people think that it's just a book of Zen poetry, but it's a book of instructions. Those instructions became necessary from a very personal reason, and then later I discovered that the kind of thing that I do, people will say 'Oh, that's been done in the

1920s.' And then I got very interested in the dada movement and also Marcel Duchamp. But still I wouldn't claim that I know very much about his work, because I didn't make any special effort to read, except that I come across people talking about it; I can't help it, because this is *the* place you hear about him and you hear about dada. But I really believe that my thing, if anything, is connected strongly with classic Japanese art and concept and Zen Buddhism.

JJ When did you come over from Japan?

YO I came in 1953, stayed until 1962, and then came back again in 1964.

JJ Where were you educated?

YO I was educated in Japan until I was eighteen. That gives away my age [LAUGHS]. But anyway. And I went to a university there[2] for about a half a year, and then came here, and I went to college here for three years and I quit.

JJ What college?

YO Sarah Lawrence College in Bronxville; it's a liberal arts school.

JJ You trained as a musician?

YO In Sarah Lawrence? Well, it's a liberal arts school and you can just take anything. It's actually like a high-class – not even high-class – finishing school. I didn't enjoy the atmosphere too much, but one thing that was nice was that you can do whatever you want to do.

JJ But when you said that you were a composer …

YO Well, mainly in Japan.

JJ Did you have a Western music training, or a Japanese music training? I imagine they are different?

YO Yes, but Japan is a very Westernised country, and my father was a very good pianist, in fact brilliant, I thought, and he had a debut concert, very good reviews, and had to go back to the old family trade. So he wanted his first daughter – or son, rather – to become a pianist. So even when I was three or even before that, he would just go on trying to move my hands. He was very interested in making me become a pianist. So I was trained since I was about four. I had training in piano and Western composition training, and my first piece was played maybe when I was five or six, and then it so happens that I was a very lousy pianist [LAUGHS]. Around the

time I was twelve or thirteen, and I was never interested in Western music. I hated Beethoven, Bach and so on at that time, and so I would always try to escape from lessons. What I liked the most was to write poems and read books and paint.

JJ How did you come to speak English so well and so soon?

YO Well, my parents were going back and forth to Japan and Europe and America, so when I was very young I would come with them. Another thing was there was a brief moment when I had an English tutor, before the war. During the war, it was very bad, you know, you couldn't even speak about English. I hated English. It's so strange you know, all these things that I hate gradually became part of my life.

JJ When you talk about the relationship with Zen Buddhism and Japanese forms of poetry, would you say these are the things you really do in your work?

YO Well, instead of making a great effort, I try to be as lazy as I can be, and that's led into my own form. And I believe that everybody should be lazy, because if not, they become hypocritical. And if they don't try to be unique, they are still unique. You know, just having your face. So it seems that because I am so lazy, I ended up being very Japanese. But the Japanese Japanese, you know, would not consider my pieces so Japanese. They don't really like my pieces, I don't think, because they're very Westernised people and they believe in logical thinking. And they don't think my things are logical enough.

JJ Your work does have a sort of anti-logical element in it. It has this in common with dada. Is it an attack on reason?

YO No, I wouldn't say, because 'anti' means that you're very conscious about that logic. Logic doesn't interest me. So I have no interest in going against it either.

JJ Did you meet Cage here?

YO Oh, [JOHN] Cage. Yes, 1956 or '57.

JJ And did he have some influence on you? Or did you find sympathy with what he was doing?

YO You see, because I'm a Japanese, I think I have a different view of it. Many people are influenced by him and in most cases because the

people who are influenced are Western, they are influenced by his Oriental flavour, the Oriental philosophy behind it. But we've come from the Orient, so there's no reason why I should be influenced by that.

JJ You felt a sympathy, though, for what he was doing?

YO No.

JJ What I'm really looking for is other people in the same area of ideas with whom you feel a certain sympathy and whose work is not unlike your own. Do you find Cage to be one of these people?

YO I want to be very exact and that's why it's very difficult for me to say yes or no. Because 'no' is the first answer that came to my mind, but 'no' is not exact. Let me put it this way, to a very Oriental mind I would think he's very Western, so I find him very alien from me. To the Western mind, he might suggest something exotic in his philosophy, but I think there are two kinds of people; one who is influenced by the Oriental side, and the other who's influenced purely by this chance operation thing, which is not exactly Oriental.

JJ You mentioned Zen. Were you brought up to be familiar with Zen beliefs?

YO No, my father is a Christian, my mother is a Christian, my sister is a Catholic, and so it wasn't a very Zen atmosphere.

JJ Do you have a religion?

YO No.

JJ You were going to say something about your relationship with Zen.

YO Oh. Yes, well I became very interested in Zen when I was about fourteen and I went to Zen temples.

JJ Did you have instruction?

YO No, I was too young to understand Zen. Theoretically, I was very interested in it, but when I went to the temple and saw the monks I was not impressed. Because the younger monks, or their disciples, are very humble, beautiful people, but the older monks, the ones that are supposedly enlightened (when I think of it now, probably they were enlightened, and that's why they were acting that way) they were acting as if they were just any regular person who is greedy and so on. And in those days I was very disillusioned.

JJ You wanted them to be more different from everyday.

YO Yes

JJ Tell me about the first events you did when you came here. Or did you begin in Japan, after your music phase – this unhappy time in your life when you were striking matches? When did you begin to make these public or publish anything, or perform?

YO I didn't do it in Japan. I used to do it in when I was in Sarah Lawrence. Make it public is not exactly the word, but I wrote the instructions.

JJ That's in the book.

YO That's in the book, yes.

JJ And when did you begin to produce events and pieces?

YO 1959, or something like that.

JJ Tell me about them.

YO Oh, those were the things that I did in the loft and I had a loft in Chambers Street.

JJ Were you painting then?

YO Yes, I was painting too, but did you hear anything about the Chambers Street loft?

JJ No, I want you to tell me about it.

YO Oh, yes, good. Well, I had a loft then and this loft I got specifically for this purpose: I wanted to give a series of concerts there and give the place as an opportunity to artists that don't have opportunities. And we had a series of concerts there and the people that were connected then with the series were John Cage, David Tudor,[3] Merce Cunningham, La Monte Young,[4] Bob Morris,[5] just everybody that you can think of, who is now doing major works in this field. James Waring[6] … and they all came into my loft and I think most of the people who are working now actively in New York had their debut there, Yvonne Rainer,[7] and those people. It was a very exciting series, and La Monte Young and I were doing it together, but we were constantly having difference of opinions. You know, La Monte is a very tough person; I'm very tough, too. So finally it ended after twelve or thirteen concerts.

JJ What sort of things did you do?

YO In those days, the kind of thing that I did for my pieces, or interpretation of other people's pieces, was just walking around and throwing beans. I would have a bag of beans and just throw beans among the audience.

JJ Did this kind of performance derive directly from things like striking matches?

YO Yes, yes.

JJ Had you, before this became public, started to do this kind of thing in private?

YO Yes.

JJ When you were alone, you might, for example, have thrown beans about?

YO That particular thing I didn't, but for instance, you know, this *Bag Piece* here was derived from those days. Actually, I was so shy. I was a different person, you can't imagine, but I was so shy, that when, somebody comes to visit me, I was very nervous. And I was married then to another person, a composer,[8] and say somebody visits us, I would immediately run out and go to a flick, or stay in the stairway or something, and hide, so that I wouldn't be seen. And wait there until the person goes home, and that's not because I don't like him, because I like him. After that I would just ask my husband how it went. And finally I started to become interested in hiding in a closet or something when people come, and then I made a bag, and when people would come I would hide myself in the bag, and I'd be present but I wouldn't really, you know, during the discussion.

JJ And so the first things were spreading beans and after this …

YO The mask thing was before that and also there's another piece that's in there, that was a necklace piece: you're supposed to throw all your jewellery in the pond and that instruction I did, actually threw all my jewellery in the pond, by going on a boat in the middle of the pond and throw[ING]. Also to give presents to people that are very dear to you but has no meaning to the person, which I did. In other words, whenever you buy a present you don't buy anything that is dear to them, intentionally you buy something that is dear to you – or not buy, but give something that's dear to you, instead.

JJ These were the early concerts. So how did it develop? What else did you do?

YO Well, a long time before that, in Sarah Lawrence I think, I had a piece that – it goes on and on and on – you're not supposed to play it for anybody; you have to go into a wood and hide and play just one tone, with the accompaniment of the birds singing. You know, that kind of thing.

So my things were very personal. Also before that, the poems of 1952, to be exact, that I wrote became very formalised. And I was irritated by that and so I dropped ink drops, so that some words will be hidden and so make a beat/offbeat kind of thing. I think one variation of that was put in *The Anthology*, a magazine published by Jackson Mac Low and La Monte Young, neo-dada people. You might be interested in that, I'll show you it.

Then I wrote the first homosexual opera, that has nothing to do with women. There's no women in it. Even the dancers, when they do that duet, you know, usually the man carries the woman, but a man carrying a man. The opera consisted of what you call overtones only, and no duets … there's no vocal singing

JJ Is there any music at all?

YO No music.

JJ How do you get overtones, then?

YO Overtones, yes. Well, I was interested in a sound that you don't intentionally create, but it's made by doing some act. In other words, if you fall, falling is your intention, but by falling there is sound created, though unexpectedly. And so all the sounds in that thing are just overtones in that sense.

JJ Were they planned, or were they all chance? Did you have a kind of script?

YO Oh, yes, and then the instructions were given to each person by word of mouth. That was another thing – if you see the *Grapefruit* book, you'll understand – most of my pieces I intended to make all word-of-mouth pieces. Anything will have to go on being delivered to people by word of mouth – and it changes, gradually, you know.

JJ In other words although the opera is written, it hasn't been published anywhere?

YO No, it's not published but it's been …

JJ … a word-of-mouth thing. But there must have been a written account of it at some time.

YO Yes, a long time later, after that opera was performed twice already. It's a very difficult piece and involves many people so you can't perform it so many times. One in the United States, and once in Japan. And after that, Tony [COX], my present husband, made an attempt at writing, explaining it, so there's a rough draft of that, I think.

JJ I read in a *Footnote* you went to Japan and performed one or two things – how were you received? With as much interest as here?

YO Yes, I think so, but I think that the interest was a different kind of interest. There I was a novelty. Here, you know, there were many talks about me, and it was always from [A] scandal point of view, and I didn't think that there was any serious attempt of understanding my pieces.

JJ This was performed in the loft, was it, the opera?

YO No, it was performed in Carnegie Hall, and that was actually the first large concert among this group of people.

JJ And was this the time when you became associated with Fluxus?[9]

YO Oh, that's another thing. But I'll tell you [ABOUT] my acquaintance with George Maciunas:[10] George came to one of the Chamber Street loft concerts and, suddenly I heard that a man who came to my concert got very interested in the loft kind of thing, and he's attempting to do the same thing in Uptown, and it's going to be a big thing, and he's got a lot of money and everyone was excited and there were some people who thought that my thing is going to be over, and he's using all the people that were in my series. And then I gave one of my calligraphy, a sketch, to Richard Maxfield,[11] for his birthday. I was in Richard Maxfield's living room, and George Maciunas happened to see it. He was very interested in having my show of calligraphy there, too. So I met him, and he didn't seem to be an evil person who's trying to take everything from me, you know. It was a beautiful gallery he had, Agnes Gallery on Madison Avenue,[12] and actually it turns out that he wasn't rich either, and he was going to go broke, and my painting show I think was the last show that he had there. While my show was on, we would meet

every day. I would be down here, and he said he's going to try to make some kind of group, and a magazine, and he wants to think of a good name. I suggested something like banana, apples and grapefruit, because you know grapefruit is my thing, and he said, 'Oh, no, there has to be something more dignified.' So the next day he says he's a decided on 'Fluxus'. Fluxus! And he showed me all these meanings of the word. I still thought, 'Well, a little bit too … pedantic.'

JJ What do you mean, that grapefruit is your thing?

YO Oh, because there was a poem that I wrote that was called 'Grapefruit': 'A Grapefruit in the World of Park',[13] and then a short story that I wrote with that same title, and then a music composition with that title, and those were played and performed over and over again, so grapefruit was my thing, I mean to other people.

JJ But how did it come to be your title of so many things in the first place? Was there anything special about grapefruit for you?

YO Well, grapefruit is a hybrid of orange and lemon.

JJ Is it? I didn't know.

YO Well, I don't know if it really is or not, but probably the reason why I never investigated the truth of it is because I'm afraid to discover it's not true, you know.[14] Anyway, I never investigate anything that I don't want to. But I did hear that it was a fact that grapefruit is a hybrid of lemon and orange and that fascinated me because it's nature, but nature that came after human effort, sort of a human touch, you know. And it's like the skyline … the skyline is like a borderline of human effort and nature and that fascinates me. And also, grapefruit is not a fruit that exists in Japan. It's a foreign fruit, to Japanese. You can eat grapefruit in Japan. But it suggests exoticism to me – something very light and nice. The colour of grapefruit is the colour of light; that's another thing I like.

And what I wanted to say before about the relationship between my work and its historical position: I think it's true that American art was influenced by European art after Jackson Pollock, and then they started to believe that something fantastic started to happen, something unique. But still it seems that there's definitely some influence of Europe now, neo-dada and so on. But there's another

major influence that you couldn't see before, in America, before the Second World War, that is the Oriental influence, and that's very definite.

JJ No question.

YO And I think that the mixture of those two is really what's happening.

JJ Yes.

YO The reason why I feel closer to Oriental culture – my work, that is – is because there really isn't much distance between Japan and any other country now, because the communication system has developed so much so that we've the same culture, and so our problems are the same – Vietnam and so on is our problem, too. So that our aggravation and tension and stress problems, are the same too. So, naturally, art that comes from your personal life, or social life, become very similar too, so that peculiar mixture of the dada and the Orient, you know, that's where it is, I think.

JJ And you embodied this?

YO Well, I couldn't say yes or no about that. I never thought of it from that point of view. Naturally as an artist I'm terribly egotistic and egocentric, but I felt that there was something unique about what I was doing, and then it occurred to me that 'Ah these things were happening in Zen Buddhism or in the days of warrior, in tea ceremony and so on, the spirit is the same.' So I went back to Japan with the hope that maybe they would understand my pieces more because they might understand my language which actually is derived from the classic Japanese spirit. But they didn't because their culture is Pepsi Cola and rock 'n' roll and if any artist would make it in Japan the critic would always say, 'He is the Jasper Johns of Japan', or 'Robert Rauschenberg of Japan', and you have to have a certain frame of reference, in the Western countries, otherwise you can't be considered an artist. It's not an exaggeration at all, at least in the avant-garde world. So that sounds very presumptuous, but I think the reason why they didn't like my work – well, some people did like it, but the people who didn't like my work – was because there was no frame of reference in the Western art world at the time. And also I think they don't need my kind of art. I think, for instance, the Sky-Machine. That is a machine with sky coming out. In New York, maybe we need it, but in Japan

they still need more machines that actually produce chocolate and things. So they're in a state that has not developed yet to a point of needing an abstract machine.

JJ Do you believe that most of the things you do are extracted from life? Do you change them very much?

YO … I'm always thinking of life as an aggravation. Because the minute you're born you're headed towards death. One leg is in the coffin already, and what you're trying to do is to accumulate all sorts of knowledge and things under the condition that it's going to just go, some time. And if you are sensitive at all you become very aggravated. So then you are sort of waiting for death, and between the time of being born and death it's not pleasant to go insane (maybe it is, I don't know), so you have to do something, and everyone's playing games. All you can do is to get up in the morning and eat and work and go to sleep, but you want to add something to it because life is otherwise dull or you become insane …

JJ You have time on your hands.

YO Right. So you add something like baseball, that's a game. You know, I don't consider art anything more than that. In other words, I think it's fine if you are satisfied with the rules of baseball. Art is not any better than that or any less. But if you're not interested in baseball and those rules wouldn't satisfy you then you start to create some other rules and games, and that's the way I look at my works. That they're additional acts that make life a little bit more endurable. And also, a little more serious aspect of it … say a criminal is sentenced to be hanged, and just before hanging someone says, 'Do you have any wish?' And he would say, 'Well, please, let me just have one cigarette.' Then he will smoke it and it might take ten minutes. (I don't know, I don't smoke.) But is he really interested in just postponing his death for ten minutes or does ten minutes mean anything to him? I think that ten minutes is not ten minutes to him, but it's the full experience of smoking and it's a completeness of experience, like a substitute of eternity. Which is not completeness in time, but completeness in space, which is eternity. And I am beginning to think that what we're trying to do is like that. That's a smoking event, by the way.

JJ Yes, and how!

YO And so, in other words when you do an event, it is like we're limited, physically and mentally, and in time especially, so that by having very many rich experiences that's the way to become larger and longer. And not only that but because the tension that's created from poverty leads to war, that would slow down by adding all sorts of variations. I'm asking people, instead of going to an office in a straight line, you know, do a somersault each corner of the streets. Now that would slow down the whole process of life, but the tension's released and it'll be a more peaceful world. And also people have a fuller life. Fulfillment does have a sort of tinge of morality aspect to it, but I'm not thinking of that at all: I'm thinking in terms of rules.

JJ Some of the things that you do, are as you've described, ways of enriching time, filling time and extending time.

YO Not enriching, extending.

JJ And making one's life larger and longer, but this is still entirely outside of the fundamental natural requirements, you know – eating, making love, sleeping and so on.

YO Right, right …

JJ Do you feel that your work ever intrudes into these areas at all?

YO Oh, eating …

JJ And sex … I mean, do you feel that somehow your work is an observation about these, or well, it's a ridiculous question really, but it seems to me there might be something to be said about the idea of art having to do with these fundamentals rather than having to do with all the time-filling aspects.

YO Well, yes, I think that's a good point. I think of them as variations of sex and sleep, and what was it, eating? Yes, in other words, you see, let's just take eating. We eat but our stomach is so small that it becomes full immediately, but our gluttony is still there. You can't make your stomach larger, but you can invent all sorts of imaginary food, and eat them. In other words, it's a kind of invention so that you can actually eat more than what your stomach can take, and that's why we mainly live in the imaginary world. It's an extension of that and all we're interested in is to sleep longer, eat more and to make love in many different variations.

I think whatever I can contribute is in the imaginary field, you know. Because I have a very limited body especially; for instance, as an artist I can't even stretch my own canvas. And also I'm lazy, and so that instead of going on a trip, which is unpleasant anyway because you have to cope with wind, and dust, and all sorts of things like that, I'd rather stay in a small room and just dream about it. And all my instructions came about from that. And I hate to make my hands dirty with paint and all that. I'm not one of those physical painters who love to just soak their hands in paint. So all my paintings are imaginary instructions, and my music is imaginary, too, so when you go into my concert you just hear your mind music.

I think that that has a lot to do with telepathy and so on. I think people are gradually getting more and more inclined to that field, of communicating without using physical effort, but mental effort. And paintings, I think, would all become imaginary or thinking paintings, and music would, too. That's why I don't really feel close to John Cage's music, and he himself said that he's very happy that something that is very different from his things [is] starting to happen, like I'm doing. He's very glad for that, but he doesn't understand it. That's what he said. When we had a concert together in Japan, and were very close because we went to all the concerts, all the towns and cities together, but his music really offends me because he's interested in this loud sound, you know, in a concert. I don't understand why because that distracts me from hearing the mind sound. In a completely opposite direction. Then he suggested maybe for my type of thing that I'd be interested in reading some books, Indian books, that he'd read, different positions in sexual intercourse and so on, but I don't really believe in reading books. I said, 'Oh, sure!' but I never read them.

JJ *The Kama Sutra*, I suspect.

YO Oh, really? I don't know. Well, he said it was very fascinating ...

JJ It always is, anything to do with sex.

YO At this kind of recital or concert, some of the people in the concert were very close to me and instead of giving instructions, I would suggest a certain state of mind which they can express by physical contact and so on. And that's why John said that I should read this. 'There's so many different forms of sexual behaviour' ... But

after that, because my pieces are all word-of-mouth pieces, my scores couldn't be exhibited in a score exhibition that took place at that time in Japan, and I was very upset, and John said, 'Well, you express your existence by not being there'; he thought that was nicer.

JJ Tell me what you contributed to Fluxus; the plastic box.

YO I think George is just putting me in because he doesn't consider me a faithful Fluxus person, and so the only time I have any association is because, for instance, the dance concert that I did, earlier this year, I didn't have the $15 to put an ad in and we decided that if Fluxus will take care of the ad, he said, 'It's all right.'

JJ When is your next performance?

YO Well, I'm planning to do the morning event again, as soon as possible.

JJ I have about six weeks left in New York and I want to go to one before …

YO Oh great, if you can come to the morning.

JJ As I seem always to miss the things you do, including the *Bag*, I missed this. Tell me about the *Bag*.

YO So, *Bag* is … I'm very enthusiastic about this; I think this will be one thing of mine that will be assimilated immediately into life. You know about the topless bathing suit and things; I think people are overexposed, and I think that they should rather seek for some dress that doesn't expose them, and *Bag* is actually a dress, clothing. In Japan, in [THE] old days they had tea-rooms where you can think, but in the Western world, there's nothing but material, and so I'm very interested in making spiritual clothing that you wear and you think inside. And you can wear it to a cocktail party or something, and it gives you a strange feeling, and the whole aspect of life changed. You see all the women and you see that their bosom is sticking out, but in a bag you can't see, and you can't even see if it's a woman or man, but then you would start to establish a different kind of subtle observation I think.

JJ But would you establish any relationship at all with those people? Would it be possible?

YO Yes, you would return to the subtle communication from a bag person to bag person.

JJ Is there a communication?

YO The bag is transparent. You can't be seen, but you can see other things.

JJ I didn't realise that.

YO Oh, I'm sorry. So it's a weird situation that you can't express yourself so much because you can't be seen, but you can see everything in the room. So it's almost like going back to the womb, but still maintaining your eyes; your eyes are still there.

JJ A womb with a view.

YO A womb with a view, yes.

JJ Sorry.

YO So it's a nice kind of communication and I feel quite comfortable in it.

JJ An accusation that might be brought against your work is that it is quite mad, [ONO LAUGHS AND AGREES] and that its origins are related to the symptoms of neurosis, that the things you do are an escape from reality, which you might fear to the point of being incapable of functioning satisfactorily in, in inverted commas, 'reality'. What do you think about this?

YO I think that if you think of my work as the only work, then you are mad, but then I can see that you would say that I am mad. But when I bring my work out into the world, I don't mean that that work should diminish other works. And it's just an addition, you know, so that if, for instance, I don't use any colours in my painting, but if everybody in the world would use that method of painting, and if there's no colour elsewhere, perhaps I might be tempted to use colour. In other words, I feel that the things that are already done are still existent, and they are very much part of me, and when I see other people's work, I don't think of them as other people's work, but I think of them as an extension of me. We're a part of everybody and everybody's part of us. If I were to try to cover the whole world with my painting, and just diminish others, then that's

madness, but adding something to it would not be madness because that means that the other things are me, too. Other things that you consider sane.

JJ Yes, but how far is your work a substitute for basic realities … an escape, a retreat?

YO I think I'm just going to repeat myself there, but when I bring out something, then this is not just a substitute of basic reality, but I still hold the basic reality as well, and it's just an addition to that. And so I'm not escaping from the basic reality, but after exhausting the basic reality rather, I still want more – you see, I'm a glutton. And so that it's just an addition.

And also instead of prying into whether I'm really sane or insane, I thought you were more interested in the basic question of art forms in general. Some art form is just an escape from life. For instance, watching a sculpture that is in front of you is like while you're watching it you're resting – in other words, you're not living, and that just serves as a rest object, a hindrance to your thinking, and your thinking has stopped, and you let the object take over you. Now, I'm not interested in that kind of art form. I think that kind of art form is represented, today, by op art and so forth, a form that gives you the effect like LSD, or like shooting narcotics, that you don't have to do anything, and that takes over you. It's a very definite effect it has on you. And that is a similar situation from reading *Readers' Digest* – you don't have to think, you just get the digested thing already. But in my art form, you can't be insane, you can't escape from life, because you will have to participate in it; you need to be somebody who does understand the basic realities in order to participate in it. You don't let the art form work on you but you have to work, you don't sit back. You have to be the important element in the artwork to create something, and creativity does actually require a lot of sanity, I think, don't you?

JJ Yes, I think so.

YO But I'm sure you're interested in one aspect of my personal life connected to this.

[JJ DEMURS].

YO It's quite all right.

I was in a mental institute once because I was very mentally strained at that point. I was in Japan, and I had hopes of being accepted and understood in Japan, as far as my work is concerned – more in Japan than in United States, which turned out to be not true. And there were so many tensions that I was in the middle of – complex human relationships and so on, and I don't know what the reason but I tried to commit suicide, and after, partly from my own will, I was in the mental hospital for about a month. And the reason why I bring that out is because at that time I was in the most limited condition that you can imagine, in a single room, and I was just sitting on a bed and a special nurse was taking care of me, and all my paintings became acutely imaginary. Instructures were things that I thought then. Those were the things that I discovered then, so to speak.

Instructure is a thing I made: it's objects that derive from instructions and, for instance, I think you can see it in that *Footnote*, but it's a kind of object that … claims that it's not complete as an object, but part of it has to be imagined. Let's say a statue of Venus is not complete but the head has to be imagined and you don't put the head on, that part has to be made by an acute imaginary effort or creative effort on the part of the observer.

JJ Do you find yourself more relaxed than you were in those days?

YO Not necessarily. I think that the fact that I had my baby at least I don't feel tempted to kill myself; whenever I think of it, I think of my child: she's too young and she needs care. But what I was going to say was that I strongly object to your definition about reality, and insanity and so on. Because I really feel that everybody's deformed in one way or another; there's no perfection – if you are perfect, then you are insane, and also you are deformed in that sense, and so that everybody is dealing with their own secret deformity, it's just a matter of degree.

Also, did you ever notice that when you are very, very ill, and very weak, you start to hear sounds that you would never notice; it's not delusion, sounds that actually exist, but that you don't notice usually because you're healthy and your mind is on something else. But because your mind is not on those things, you suddenly notice subtle sounds. And then you're widening the range of sound

perception. As an artist if you're interested at all in widening the range of artistic experience you become interested in an extremity like that. That doesn't mean you are ignoring the larger sounds; you're adding the small sounds. I am interested in sounds that were not experienced before, and visions that were not visioned before. You might think it is different, but it's going to be assimilated into life so that in ten years it's not going to be different, and other new things will be called insane. I was in a family where everything was very strict, very formal and polite and everything, and there's no way out, so that every three years or two years or something, I would go into this deep depression, where I can't stand people walking in the house, so everybody had to wear special slippers, and I would have many, many bandages on me, and I would be in a dark room, I would just stay in there, because I couldn't endure the sounds in the house. But I just thought, 'Oh, you're just having one of those depressions.' That was really because I didn't have any outlet: I had to be always nice and this kind of thing. I think that's what really helped me to find things that I wanted.

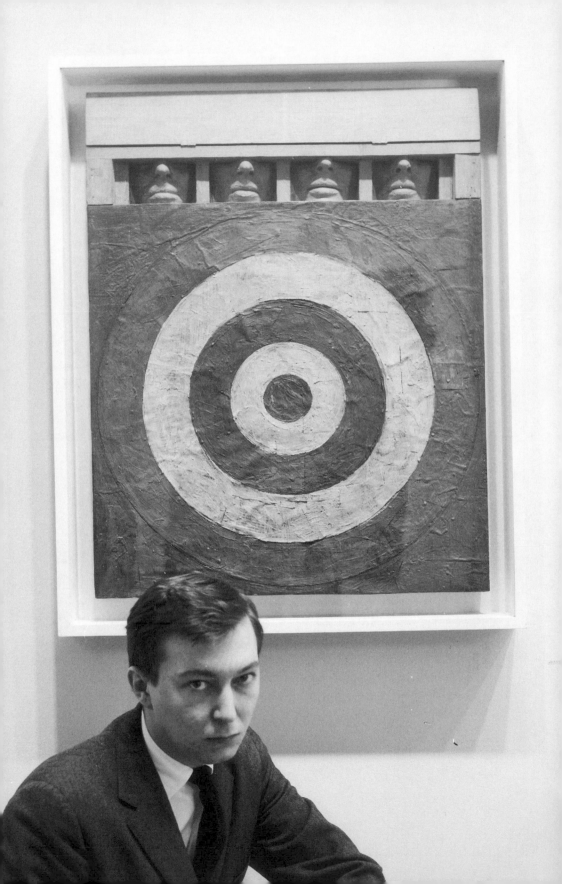

JASPER JOHNS

This interview took place on the morning of 13 April 1966 (11am) at Jasper Johns's studio at 340 Riverside Drive, near the corner with 106th Street, a grand address that was a marker of his success, although Johns was only thirty-five.

Johns grew up in Carolina in an environment without art, and his art education was minimal. But in 1954, when gallery owner Leo Castelli first saw his work (while at the studio of Robert Rauschenberg, with whom Johns was in a relationship), which already included his trademark flags, maps, targets, letters and numbers, he instantly gave him his first solo show. And Alfred Barr, director of the Museum of Modern Art in New York bought four pieces.

In 1960 Johns won the Vincent Van Volkmer Prize. In 1963 he set up the Foundation for Contemporary Arts with, among others, John Cage, and in 1964 he was commissioned to make a 2.7 × 2.1 m (9 × 7 ft) work to be placed in the Lincoln Center in New York. It was a grid of figures, entitled *Numbers*.

By using familiar symbols in his work, Johns reintroduced content to abstract expressionism, and was associated (at least by others) with both pop art and the neo-dada (here he was influenced by Marcel Duchamp). As well as painting, Johns also created sculptures and prints.

In the audio recording of this interview, Johns's voice is gentle and somewhat tentative, with a brief, staccato laugh. He sounds like the British actor Ben Whishaw, but with an American accent.

JAS. Well, I don't have any strong sense of what European painting is, or has been. I've very little training in art history.

JJ Put it in another way, do you think that your approach to painting would have been possible were it not that you had seen cubist pictures?

JAS. I don't know whether it would or not – I don't think it really matters. I did see some, but I've never had any static idea about what my own work was, so it's very hard for me to relate it to anything that I remember about other paintings.

JJ How did you come to paint? Where did you study?

JAS. I studied briefly at the University of South Carolina, in Columbia … I knew there was something called modern art, and I knew there was somebody called [PABLO] Picasso, and then there was somebody called [HENRI] Matisse, and then there was somebody called [GEORGES] Braque. I never saw a painting. I saw reproductions, but there was no museum there. The only paintings around were paintings of the ex-presidents of the university or something, hanging in the libraries. But certainly I was moved by some quality, I don't know what, in European modern painting, probably because it was a novelty more than anything else to me – it was not like the general things that I saw. But I didn't have any sense of ideas involved in it.

JJ And how did you come to be a painter?

JAS. I was always going to be an artist from childhood, and I think, since there was no art around, but I knew there was something called art, probably it had the quality of a fantasy. It was something which was not where I was and probably I wanted to be somewhere

else. [LAUGHTER] Fortunately once one has that kind of idea in painting, one has the opportunity to act out that fantasy. It doesn't have to remain a fantasy.

JJ You lived in Carolina?

JAS. Yes.

JJ When did you move?

JAS. In the late Forties, I guess. I came to New York.

JJ The sort of paintings you saw there and the scene, how did you react?

JAS. Well, I didn't move in the circle of people who were making art. I was quite outside that for a number of years, and I did see museum paintings – some – then I went into the army, I got out of the army and came back here.

JJ By that time abstract expressionism must have been all over the place.

JAS. It was all over. I was very unfamiliar with it. Well, I had seen [JACKSON] Pollock and I had seen [HANS] Hofmann, bits, nothing very strong, and previous to that I had seen [BARNETT] Newman at Betty Parsons [GALLERY]. When I saw the Newman show I admired the pictures very much, but I didn't see they could have any relationship to my life. It didn't occur to me that I might enter into that world. And I don't know what I thought, but I always thought that somehow I was going to be a painter. Certainly at that time it had no effect on my actions; I went right on with the kind of idiotic things I was doing.

JJ What were you doing?

JAS. Absolutely anything at all. The work had no particular quality. Then I wondered why I never became a painter, if that was what I was going to be [LAUGHS]. I decided I would have to take some steps to be one. So I tried to take an attitude toward my work and toward myself that whatever I did, that was it, and I would have to mean it. I don't know whether this attitude helped me to arrive at something or whether this idea simply accompanied the change in working. I don't know that one caused the other.

JJ Abstract expressionism was never a heavy weight on your back?

JAS. No, it was not, because I was not familiar with it.

JJ Not even later …

JAS. It was never presented to me in school, and I never knew much about it, and when I began working, certainly those painters' works were available to be seen in galleries and museums a bit; but I just saw the pictures every now and then. I never felt any resentment [LAUGHS] toward the strength of these painters. I did sense at the time I began painting [THAT] young people [WERE] using discoveries from abstract expressionist painting as a beginning for their own painting. Then there seemed to me no reason to imitate or to use those devices, since someone else was doing it so beautifully. I didn't resent it that they were doing it, I just didn't see any reason for me to do it if they were doing it.

JJ The problematic thing is how one comes to find one's own set of interests within painting, if one doesn't learn from other painting. Where does it come from?

JAS. Well, I think one learns from other painting, but I think certainly in my working, one of the things I did was to avoid things which resembled things that I knew. If I made a kind of stroke or configuration that reminded me of another painter, my tendency was to get rid of it because I decided that it was some unconscious kind of imitation, and I tried to avoid that. So that I simply took what was left, out of what I could do, once I had destroyed these elements. And I settled for that as being unavoidable, since the other things I could recognise and get rid of.

JJ You never had a feeling that their definition of art was a set of values which you had to either accept or reject?

JAS. No, because I had no idea of my own thing, my own feeling either. I assumed that painting was not removed from them, that it was very much a part of themselves. And then I thought that in my work, what I did should not be removed from me, it should not be what someone else was about.

JJ But the implication of this is that art is a wholly subjective thing that has no qualities which somehow make it painting. The artist has two functions: one is a responsibility to himself and to his own vision, and the other is to art itself.

JAS. Well, I don't believe that, because I don't believe art has any particular quality; I think it can be anything we want to make it. And certainly, it seems to me that we're constantly encountering things that make us question whether it is or isn't. Once we accept that it is, I can't see that there's any particular logic in that. I think the acceptance is subjective and the producing of this thing is largely subjective. I mean, even imitation is subjective. I can't see it's done for any good reason.

JJ Ad Reinhardt's extreme view is that art is, well, not anything else. But within this context there's a kind of academic belief that art has to be served by the artist, that he is not subjectively defining it all the time, rather that it has been defined once and for all, and he must keep himself out of it, and serve this definition.

JAS. Well, it seems to me clear that it has not been defined, otherwise why is it so lively? It's always slipping away, and doing all kinds of funny things; if it was simply a matter of serving something which existed then it should be a fairly simple matter to do that, you would simply gather information about what it is and then do whatever is required.

JJ There is one connection that flitted through my mind between your work and the kind of thing that was talked about by Barncy Newman and his colleagues, and that is this business about what they call the field, painting a picture which is not tied to some focal point or leading up to some point. And I once read a statement [OF YOURS] I think in *Time* magazine many years ago, that paintings should be looked at like a radiator. It seems to me that there is a link here between these two attitudes: the painting presents itself to you equally at all points.

Would you accept this similarity in attitudes between you and Newman?

JAS. I'd be happy to … [BOTH LAUGH]

JJ Or did you mean something quite different?

JAS. Well, I've not discussed this with Barney, so I'm not so clear on his terms, but if what you're talking about is what you said that every point in the picture is equally available, then I think that's a happy condition.

JJ Yes. There is a quality which is highly praised in your paintings all the time and I wondered – quite apart from accepting any praise that's coming – if for you it is a matter of importance? [DAVID] Sylvester is always talking about painterliness, the actual quality of the paint, which one associates with a certain kind of French painting. In fact, it's a quality some of the abstract expressionists felt it necessary to reject, an awareness of the actual painting materials. Sylvester is frequently loud in his praises of your handling of materials and I wondered if this is important to you, or whether you feel it is something which happens? People talk about your work as being painter's painting. Do you know what I'm talking about?

JAS. Yes, I know what you're talking about. I don't know what I think about it. Generally, I think, in my painting, there's suggested in the material how it was done. Sometimes the surface is broken up into strokes and you sense the hand touching the canvas, which is fine, but it is of no specific interest to me if that's the case. I think it is important to me that the painting conveys the way it was made – but then again, many paintings do that but would not be admired for it. I don't think I would object to that quality, but one develops habits, unfortunately, and sometimes one is preoccupied with other elements, and one area simply becomes a kind of habit.

JJ I think probably it has to do with the idea about truth to materials that sculptors used to talk about so much. You do certain things in marble and certain things in wood. And your work seems to be the sort of thing that people do in paint. It would seem to have a painterly touch – I can't really define it more clearly than that.

Is there anything in the story that you did something with a beer can just because somebody said that Castelli can sell anything?

JAS. Bill de Kooning said it. He didn't say it to me, it was reported to me that he said: 'that son of a bitch could give him a beer can, and he could sell it.' Or two beer cans – I forgot.

JJ Was this really what persuaded you?

JAS. Yes, well, at that time I was doing sculptures of lightbulbs and flashlights and things, and it seemed to me a perfect object, plus that I liked the idea that he had said this.

JJ Some people have a feeling that they had to shake up the art scene a little bit; people were accepting things too easily.

JAS. I've never much had the sense of presenting the public with anything.

JJ Or the art world …

JAS. One has the sense of one's own life and – that one is responding to things or not. I think one would like to shake oneself up by doing things; if that's conveyed publicly, then fine.

JJ But was there an element in the lightbulb sculpture and so on, of taking something from life and calling attention to it in the way that Duchamp's readymades, for example, did?

JAS. I don't know what Duchamp's idea was. I don't know whether it was a public idea or a private idea; for me, for a number of years I had wanted to make some sculptures and had never found any way to proceed, and it occurred to me that this was a way.

JJ What was there about it?

JAS. Well I suppose it related to my painting at that time, or a little bit earlier than the sculptures were done – the idea of a predefined form. The paintings had divided up a space on the surface and it seemed to me that these objects divided three-dimensional space in a predefined way, and that I should be able to work in that area, so I tried it.

JJ When you've spoken of this before – the targets' and the flags, you've mentioned – you've said that the design is taken care of and this leaves you free to get on with the fun of it, or the other element; it solves half the problem for you. What is the other area after that design has been taken care of? The flags and the targets, and I take it now the lightbulbs, have already established a form within which you work, but what was the work? If it wasn't this question of surface painterly quality, what was left for you to do?

JAS. [PAUSE] Well, I'm not certain. If you're given an area and it's broken up into units, one of the things left to do is cover the surface with paint and to fill in those areas. This activity then alters the quality of the divisions on the surface. I don't know what there is to see in my paintings, but certainly there's something to see other than the first divisions on which the painting is based.

JJ I just wondered what was the issue for you as you were making it, but I think you answered it.

JAS. [SOUNDS OF A CIGARETTE BEING LIT] Well, one issue for me was this idea that you have an image, then once you have seen an image there are other things to see. I used this example of the window, you can look at the window and you can look out and you can see the buildings and whatever, or you can look at the glass, or you can look at the screen behind the glass, or all of this. I think this question of what the thing is, and where it is, and what use you're going to put it to is brought up in those paintings. Certainly there's opportunity to see all kinds of things other than say, the flag, or whatever [PUFFS ON CIGARETTE]. The flag image too is available.

JJ In the paintings that have moved out a bit from the canvas, where you employ letters and so on, I'd really like you to talk just generally about what seems to you to be important about them. About the making of them.

JAS. Well, one thing that happens, say, in my painting with a brush on the canvas, one of the simple divisions becomes a brushstroke; one is faced with this idea of what is a unit within what you're doing. It's possible for something which doesn't have that quality at one time to take on that quality at another time. I mean, the mind makes certain adjustments and then sees differently. It interests me whether, say, a lot of brushstrokes make an image and whether an image can become a lot of brushstrokes. It interests me whether any object can operate in any way other than remaining an object.

JJ When, for example, you were hanging spoons and forks to a large painting, the issue is partly whether they become assimilated into it, or stay themselves.

JAS. Well, that, or whether their presence may alter response to some other area.

JJ That's really very beautiful, that painting [REFERRING TO A PAINTING ON THE WALL]. I hadn't seen that before.

JAS. It's curious because I painted it about a year ago and it was shown [IN] a couple of places and then I decided I wanted to do it again. I brought it back and I've changed the whole picture. I rarely do that. Once I finish, I'm through [LAUGHS].

JJ Yes, that's absolutely extraordinary [ABOUT PICTURE]. You don't ever consciously employ some kind of geometric system which is not immediately recognisable as a target or flag, or something?

I'm thinking here of the relative proportions of the length of the string with which the fork is held and the line which goes across to make that sweep of grey, whether these are intuitively arrived at, or a geometric system which you set up and then work on?

JAS. Well, it's largely intuitive, in this painting. Something which has occurred in a number of paintings is this kind of arc form, and generally it's been a radius, it's simply the length of the stick, from one end of the stick swirling round, and I decided to lengthen that so it had a different configuration.

JJ I mentioned before the use of letters and objects which come away from the canvas. Sometimes they read the names of colours – can you say something about that?

JAS. When I first used letters, they didn't make the names of colours, they made words. The first two paintings – one was called *Tango*, and one was called *The*. But then I made a couple of paintings where I put the names of colours on top of areas of colours, and I suppose a certain kind of simple-minded logic then made me want to take the colour names out of that relationship and use them as objects, more or less.

JJ Sometimes they match the actual colour of the letter – it matches the meaning of the word – sometimes they don't.

JAS. Yes. There's something about seeing and knowing that's involved. A lot of people have the idea that there's something that can be defined as pure visual experience, and I find myself always doubting that that's a possibility. Because it seems to me that from time to time my sense of pure vision has varied, and I imagine there are other processes at work.

JJ You have all the psychologists of perception on your side.

JAS. I do? I'm glad to hear that.

JJ In your painting do you often begin with a not very clear notion of what the issue is and find it later in the painting?.

JAS. This particular painting comes about because I had certain elements that I wanted to get together in a painting, and the problem is simply to put all those things in the space in some way. The painting will be the result of putting these things together, rather than anything else.

JJ Recently I noticed in some of your paintings a preoccupation with after-images and colour contrasts. How did this come about?

JAS. Well, I did one painting where that was of interest to me. It was a flag painted in its opposite colours and I did that when I was painting flags [LAUGHS]. I had seen in a book on photography a little image which was the flag in its opposite colours and you look at it for so many seconds and then you look at a white area and you see red, white and blue, and at that time I tried to make a collage based on this. And I don't know whether I worked too small or what, but it was a mess and I threw it away. And then about a year ago I was in Japan and I saw the work of a young Japanese artist who was doing what he called 'imitation art', and he'd seen lots of black-and-white reproductions of other people's work, and he set out to make those paintings for himself. And among them were some of my paintings, flags which were painted all in the wrong colours. And this reminded me of this thing I had tried to do and I decided to do it – I was working in Japan on something else so I made it when I got back here. And then this painting of the target, which is going to be treated that way, comes about actually because it's a commission; somebody wanted a painting, otherwise I wouldn't have done it. I mean they didn't ask for it to be this, but they wanted an image painting. And I thought it would be interesting to try that.

JJ It's funny, I came across a set of cigarette cards which were put out in the Twenties in England, about optical illusions. They contained a lot of the stuff which is now being done in op art, essentially the basic tricks the eye plays.

Let me just get two or three things straight: when you talk about seeing a painting like a radiator – that all-over thing – this was not a conscious rejection of the old academic idea of composition, of things building up to some focal point or leading the eye round the picture, till you come to some centre?

JAS. I don't think so. I think I got to that position through examining my own experience of looking at things; I'm not certain. I don't want to reject the possibility of any kind of influence, but I don't think any action of mine had that quality of overthrowing something.

JJ In the same vein, was there, in your choice of the flag, ever any social comment, any observation about the symbolic nature of the thing?

JAS. No.

JJ There was no gesture involved there …

JAS. No.

JJ … and beer cans, apart from the Castelli story, this was never a conscious attempt to use pop culture, in the sense that so many people have seen pop art as a conscious attempt to employ the everyday and, in a sense, vulgar, manifestations of American culture.

JAS. No, I think what one wants to do is to clarify and experiment with one's sense of seeing. And that gives opportunity for almost anything that I can think of [LAUGHS].

JJ It's intriguing that your real concern is basically to do with seeing.

JAS. Well, I would say seeing and knowing.

JJ Yes, perception of objects. It's a sort of tension between knowing and seeing which you explore, sometimes you see it and sometimes you know it.

JAS. Yes, I think so, and I think also that there's certain things we see which shift from the sense of seeing to the sense of knowing,

JJ Your work has been associated with pop art – do you feel any affiliation with that movement?

JAS. As a movement, no; in terms of some of the individual works, yes. The idea of a movement doesn't interest me. I think there's a great variety of ideas there, some of them interest me and some do not.

 The idea that these works group themselves into a kind of forceful attack or influence on the public eye, doesn't interest me. Some of the concerns with techniques and visual possibilities do interest me.

JJ Any particular work you have seen that is of special interest? Areas other people are exploring that you find intriguing?

JAS. Well, in a sense of relationship in my own work – I don't know because that's very fuzzy, but I just saw this show of [CLAES]

Oldenburg's which I thought was very impressive and quite outstanding. I don't feel so much related to it – my enjoyment is not so much that I'm related to it as it is that he's doing things I would not think to do.

JJ Is it important for you to keep yourself isolated from the others? I've talked to one or two painters who feel that it's very necessary somehow to get away from the group thing.

JAS. I don't think it matters. I'm not very close to many painters at the point of seeing them work or seeing works in progress, and there are just a few people that I talk with about work, but as far as an idea of that making any difference, I don't think it really matters. I think it's very nice to contact people on the level of ideas or methods or processes involved in work; it can be very helpful.

Maybe that's a possibility, but really what one wants is to do what one does [SOUND OF MATCHES] and to think what one thinks and to have one's experiences. The sense that others interfere with this, I think, is a little questionable. I know that it's very difficult for many people to have a strong sense of who or what they are, as separate from others [SHUTS MATCHBOX] but I don't know that it matters. I feel that I work in an area where many ideas are useful and now I would not cut myself off from the ideas of others.

JJ I heard John Cage talk about music, as containing certain ideas which followed after painting at one period: some of the changes that came about in musical composition were informed by experiments that artists were doing. But recently, in Baltimore, I heard him express the idea that now music had gone to a point at which it was up to the artist to catch up.

JAS. Oh, really? That's interesting.

JJ … and now music was leading. I wondered if that particular area of experiment and ideas was influential on you at all?

JAS. Well, I think John's ideas have influenced me in the sense that he's a friend of mine and one is always influenced by contact with whomever. Programmatically, I think not. I don't know whether music has the capacity or whether just John Cage has the capacity to plan a way of proceeding and then go about it, to accomplish certain things. I'm more ambiguous about what I want and what I think should be than he is, I believe.

JJ I guess it's unquestionable that there's been a similar set of interests among certain groups of painters – a kind of parody of planning which he does has certainly been a way some artists have proceeded in making their pictures, and I recognise a connection.

JAS. Yes. One thing that can happen is that someone like John can become a source of ideas, I mean he's fantastic, a kind of vault, and one goes to it to pull out these things it has in it. My relation with him hasn't been like that – I mean I value him tremendously, but I don't think I behave toward him in this way.

JJ In your account of your development as an artist and the work that you do now, there's a strong indication that you have to depend entirely upon yourself. I don't mean this in the sense of you being blind to other work going on, deaf to other people's observations, but a kind of self-sufficiency about the way you approach the whole thing, a lack of involvement with movements, with trends and ideas which several other people took up, and that Cage's statements are intriguing to you, but when you approach the painting you don't consciously approach it the way he might approach a musical composition. All the time in other words you seek a kind of isolation, a separateness from the rest. Inevitably you do make contact with other people and all this feeds your experience, but fundamentally you have been on your own. Do you feel this?

JAS. I can't say that exactly because I've had the good fortune to be close to a number of lively people, but in a close situation you don't have the sense of gathering information; it comes out of the experience of your life. That's true with Cage, I think, and true with Rauschenberg. Certainly I've been influenced very strongly, but I can't give the programme of influence.

I have had situations where people have said: 'Would you make a painting of this?' or, 'Why don't you make a painting of this?' and I've done it. But it's like you were given a subject – that's happened. I had someone who wanted me to make a painting for him; he said he would like a painting of a very large number; my dealer had said I probably wouldn't do it, and I said, 'Yes, I'll do it, what number?' and he gave me the number and I did it.

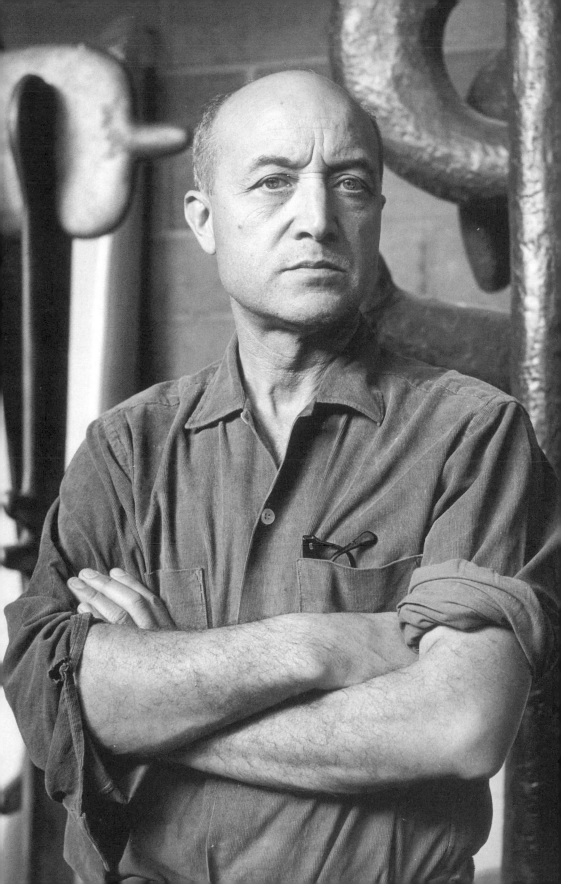

ISAMU NOGUCHI

The son of a Japanese poet and an American writer, who were estranged since his birth, Isamu Noguchi was known as 'Sam Gilmour' (using his mother's surname) in school. His studies and travels included a six-month apprenticeship with Constantin Brâncuși (1876–1957), learning about stone sculpture, in Paris; brush-painting with Qi Baishi (1864–1957) in Peking (now Beijing), and pottery with Uno Jinmatsu (1864–1937) in Kyoto.

Known as a landscape architect and for the satisfying shapes of his abstract stone sculptures, that fuse East and West, Noguchi worked in a wide range of media. Among his many achievements, he designed the first baby monitor ('Radio Nurse' in 1937), created the acclaimed bas-relief sculpture on the front of the Rockefeller Center in 1940, contributed designs to a hugely influential 1947 Herman Miller catalogue of mass-produced furniture, and created stage sets for Martha Graham's dance works, as well as a 1955 production of 'King Lear' starring John Gielgud.

He was elected to the American Academy of Arts and Letters in 1962.

This interview took place on Friday 13 May 1966, at 3138 10th Street, Queens, Long Island. Noguchi was sixty-one.

In the recording of the interview there is a trace of a Japanese accent in Noguchi's idiomatic American speech. He pieced his thoughts together with pauses and a liking for the phrase 'you know'.

IN To start with, I was born here, but was taken to Japan when I was two years old, and sent back here when I was thirteen to go to school, because my mother thought it would be better for me here. When I was seventeen, I had gotten through high school, I wanted to become an artist, and was sent to a sculptor.[1] But I didn't get along with him, gave up and started to do medicine. And after two years of that, by accident, I came into sculpture again.

JJ How, by accident?

IN I happened to go into a sort of a night school, a settlement school where they were doing sculptures and the director [ONORIO RUOTOLO] took a personal interest in me. I was nineteen, and when I was twenty-two I got the Guggenheim Fellowship, and went to Paris for two years and worked with Brâncuşi[2] for six months.

JJ Tell me about working with Brâncuşi.

IN Well, he taught me much that I already knew from Japan: the direct use of material and the respect of tools. I had had this experience in Japan, having been apprenticed to a carpenter there, by my mother. And so it was very close to me, and I appreciated it very much. I think this contact with Brâncuşi has remained with me strongly.

JJ Did his attitudes differ from the Japanese attitudes you had learned?

IN I say they don't differ. I think his attitudes derive very much from the peasant handcraft point of view. He believed in handwork to such an extent that he distrusted the machine. He thought that the marks of the tools, the evidence of tool working, and of the hand working on it, were of supreme importance. In 1939 when he came to this country, at the opening of the Museum of Modern Art, I had just completed a stainless-steel plaque which is on Radio

City [MUSIC HALL]. It's a great big affair, a casting of about nine tons of stainless steel. And he wanted to get his *Endless Column*³ cast in stainless, and we talked about the matter. And Sturgis Ingersoll,⁴ a friend and patron of his in Philadelphia, had the Budd Company⁵ which makes railroad trains of stainless [STEEL], figured out how to build it of sheet stainless. Brâncuşi took wild exception to this. He would have nothing to do with welded sculpture.

Last time I saw him was maybe a year before his death, and I was working at the UNESCO garden in Paris, and he was still adamant in objecting to stainless-steel welding.

My attitudes to sculpture were very much formed by Brâncuşi: I have a squeamishness when it comes to things which are pasted up and welded up, which go against the handcrafted thing. Of course, right now there is in the States a kind of a glorying in the 'no hand has touched it' attitude, which you can equate with manufacturing. They try to make a virtue out of a fault. Does it become a virtue, or is the new only possible upon the corpses of good taste?

JJ You still feel strongly that it is a fault? Or is it an open question in your mind?

IN It's difficult for me to say. One half of me says no, do not deny your values, and the other half says, to hell with values. I think that's one of the moot things that we have come up against in the art world. It has all to do with the population explosion, and with the facility that machinery brings, with the discovery that we can have instant Zen; that it's not only instant coffee, but instant tea, and instant art. Is it then better, I wonder? Is instant coffee better than a good old cup of espresso?

JJ This was an issue in England at one time, you know, the arts and craft movement. William Morris thought it was important to preserve hand-done things. But the Bauhaus moves towards the idea that you can employ the machine and still make tasteful objects.

IN Well the half of me which has espoused machine-produced things, you know, tables, chairs, lanterns or what have you⁶ – I have felt no reason why it shouldn't be mass-produced, and still be good, and why it shouldn't be made by machinery and to precise dimensions. I suppose my big influence in that direction comes from Buckminster Fuller.⁷ I've known him since 1929, when I did a head of him, and we have been good friends ever since. And he has been,

as he is for many people, the most marvellous teacher. He taught me to be what he calls 'an artist scientist'. And so that half of me is in conflict with the other half of me, which derives from Brâncuși.

JJ And from the carpenter in Japan?

IN And from the carpenter in Japan, and also I might say from the theatrical work I have done for Martha Graham, but there, there is a kind of coming together, because the interaction of art and environment is where these two things combine: that is, the scientific approach and the natural approach. And I have done gardens – an example of how things can work in all dimensions.

JJ After you had studied with Brâncuși, you came here. What happened after that?

IN Well, it was not a very good time of art. Just before the Depression, I managed to do a flock of heads, which was when I did Mr Fuller's head, and Martha Graham's head, in 1929, and I made enough money to get away. And I went off to the Orient, where I had wanted to go, and lived in Peking and in Japan. So when I came back here in 1932, it was in the midst of the Depression.

JJ Did you work as a sculptor in Japan?

IN Yes, I was making drawings and sculpture there. I had exhibitions when I came back here in 1932, but one didn't sell anything in those days, and having by then gone through two years of Guggenheim and two years' travelling around the world, and then not being [ABLE] to make a living … So I started doing heads for a living and this business sort of trapped me for a while, because it was the way to survive. This kept up until 1934 when I went off to Mexico.

JJ Did you feel that the heads were a sort of betrayal of some of the attitudes that you had collected from Brâncuși?

IN Yes, in a way, and on the other hand I felt it necessary for me to grow in whatever way I could, and to do abstractions would have been for me a possible cul-de-sac, because one becomes involved then with style and with manner. Although Sandy [ALEXANDER] Calder started doing abstractions after I did (I was doing them in 1927 and 1928, and he started doing them in 1931). And he used to think I was crazy. But we were great friends then. The point is that he was able to keep it up without really becoming effete; I don't think that his work has suffered to the extent that a lot of

abstractionists have, in becoming dry. And I can think of all kinds of people who have got caught in this thin sort of preciousness, and so I respect Sandy for this. However, whatever my capacities may have been, I was never able to test it because I distrusted myself, you see. And I distrusted the abstraction as such.

JJ So you came back and there was the Depression. Were you mixed up with the WPA?

IN No, I never managed to get on the WPA because the people who ran the WPA said 'you can make money doing heads so why should you get on the WPA?' I got angry and that's the reason I went to Mexico in 1935. I did a large wall down there, somewhat Communistic in intent, although I was not a Communist.[8]

JJ Were you strongly left wing …

IN Of course, everybody was. It was quite indecent not to be.

JJ How long were you there?

IN I came back to New York in 1937, of course the year of the Spanish [CIVIL] War, and everybody was involved with all kinds of protests.

JJ You didn't go there?

IN I didn't go there, no, but the temptation was there, and then there was the World Fair here, and I was doing something for that. But beyond that everybody was trying to find some way out of this rut we were all in. Since I wasn't in the WPA, I had to find some way of making a living – I was still doing heads. But I did win this competition for this thing on Radio City, and although I thought at that time that it was a kind of a backwash from what I did in Mexico, when I look at it today, it looks sort of pop-ish. As a matter of fact the pop movement is not too far removed from the Mexican movement, if you ask me.

JJ What happened to you when the war came? Did you meet any of the emigrés from Europe who came here?

IN Before the war I had done a number of playground studies, one of them *Play Mountain* in 1940. Nothing ever came of them, but I went west with [ARSHILE] Gorky in 1941 and we drove out there. I came back from rather disastrous experiences on the West Coast, where we became involved in the Nisei,[9] the Japanese-Americans and I felt emotionally obligated to go with them into exile, into

one of these camps, and so that's what I did in the early part of the war. And when I got out of that, and came to New York in 1942, I was lucky to find a small studio in the Village and I abandoned every pretence at being a social leader and became a sculptor. That's when I started to do a lot of experimental work using everything from plastics to paper, to bones and strings. There's one up in the corner there. I call that *Monument to Heroes.* That period I was doing things with lights and whatnot. All the kinds of things I see prevalent today, I was doing then. I was also doing some more work for Martha Graham, and I did furniture, and in 1946 I was included in an exhibition at the Museum of Modern Art, *Fourteen Americans.* Gorky was in that, too, and [SAUL] Steinberg, and other people. In the war years, all these people came over from Europe, the surrealists in particular.

JJ Did you meet any of them?

IN Oh yes, I knew them well. Breton, the whole entourage from Max Ernst to [ROBERTO] Matta ... I was never a surrealist, although I may have had an occasional sort of twinge of regret that I wasn't – or that I wasn't a Catholic, or that I wasn't this or that. My mother was kind of an agnostic and a sceptic, and I think I have retained that scepticism, and although I have occasionally had a sense that I had my social duties, I don't think I was ever a very good party-liner.

JJ Some of the American artists I have spoken to felt the surrealists stood for everything that they disliked. Others, of course, were very friendly with them, and sympathetic.

IN Well, I was not hostile to them. I felt that maybe they were a little hostile to me, but I had friends among them. I was friendly with David Hare, who, as you know, subsequently married Jacqueline Breton,[10] and although he might say that he wasn't a surrealist either, at least he was among them. And Matta I knew very well, and I introduced Gorky to [ANDRÉ] Breton, and then Gorky became a surrealist. I don't know whether he would say he wasn't a surrealist, but who is and who isn't? I don't think it really matters, but there was this great influence of the refugees from Europe. As a matter of fact, [FERNAND] Léger was here before the war. I did a head of him in Los Angeles in 1941, when I went there with Gorky.

JJ Quite apart from the social meeting, the ideas that they brought with them weren't new to you, were they?

IN No, because with my Paris background with Brâncuşi, there was
 nothing particularly new. The surrealists were in full swing in 1927,
 '28. I think there were a lot of people who wanted to be involved,
 maybe others who didn't. [JACKSON] Pollock, for instance, who at
 that time came to New York, and started painting, I don't know
 that he ever wanted to be a surrealist. Nor Bill de Kooning either.

JJ Gorky got a great deal of confidence from his contact with Breton,
 because Breton encouraged him – said in effect: 'what you're doing
 is alright, go on'.

IN Exactly. But Gorky's breaking out of his chrysalis of copying other
 people was when he was married, and he went to the country and
 discovered nature. We drove out together with his fiancée, and he
 was married shortly afterwards. So he must have started going to
 the country in 1942, and about 1943 or '44, he met Breton. He had
 already discovered this thing, these drawings. It was Breton who
 became terribly enthusiastic about them, and there's no question
 that it was because of Breton's encouragement that Gorky was able
 to break into this sacred circle. And Julian Levy, the gallery man,
 took up Gorky, and then they started this whole sort of mystical,
 tragic sequence of the growth and death of a tragic hero.

JJ Wasn't he at that time painting autobiographical pictures that had
 some extraordinary reference to his family, to his background?

IN I have heard that. [JOEL] Shapiro, for instance, says that it's all
 autobiographical. It could very well be. He had this painting of his
 mother and himself, which he had made from a photograph. For
 years he would drag it out every now and then, and contemplate
 it, and I suspect work on it a bit, but that was his autobiography:
 he, his mother, and his mysterious background, which we knew
 nothing about. We assumed he was Georgian. Recently, his nephew
 came to interview me and told me things that – although I had
 vaguely known – I was rather astonished to hear. I had met his
 sister and some of his family at his funeral, where I understood that
 he was an Armenian. Gorky was very careful about building up this
 mythic character, the name for instance, and he carefully hid his
 Armenian background – and his father he kept hidden all the time.

JJ His father was here?

IN Yes, his father was here, and in fact had come here before Gorky. His father died only a few months before Gorky died. But nobody knew anything about him. Very extraordinary.

JJ Gorky's influence was enormous among the other Americans here, wasn't it?

IN He was a great lover and appreciator of art. When I first knew him, we would meet in the gallery and he would talk at length about art, and his knowledge was so profound, and that was a great thing for all of us. I don't know about his influence since his death, but his influence at the time he was living was as a person, and as a person who loved art and understood it, and had this great eloquence.

JJ You went to the Eighth Street Club [THE CLUB], did you?

IN Yes, I went quite often, at the beginning and then I skipped some years, because I went away in 1950 round the world, took two years off and went everywhere. I had a Bollingen Fellowship and wanted to discover what sculpture in situ was like, and what the purposes might be. I said I wanted to write a book on leisure, and off I went.

JJ That's a cunning thing to do.

IN It's a very broad subject, it can include a lot.

JJ It was good to get a grant for it.

IN I still have to deliver the book. But they are very decent about it, and someday maybe I will write a book. But I went all through India and everywhere you can imagine where sculptors had left their marks. Before going, I had a show at the Egan Gallery, but I guess people weren't ready or weren't ready to buy. Anyway, I didn't sell anything, but I think it was one of the most beautiful shows I had. After this show, I just wanted to find out more about things.

JJ Your personal aesthetic was partly formed by contact with Brâncuşi, you've established this.

IN Partly Brancusi, partly Bucky Fuller, and partly my own.

JJ When you went round the world, did you find your attitude changing?

IN Yes, well, I went because I was, for one thing, very much disturbed by Gorky's death, and I felt that the artificiality of fame and fortune in New York left the artist in a precarious position. And

since I felt that sculpture, to really have some meaning other than immediate popularity or artistic kudos, you had to have a broader base, I wanted to see how sculptures were used and where it might help me. At that time we were all very conscious of the ending of history: with the atomic bomb our future was a question mark. Continuity of tradition did not mean anything when you might all be blown to hell next day. However, there was a possibility that you wouldn't be blown up, in which case, you might as well find out where you're going to go, and that's why I took this trip. I became fascinated by the use of sculpture in creating environment, and my trip ended up in Japan, and I became very much involved in doing gardens, because in a sense it's the ultimate objective of sculpture to create your environment. It's a three-dimensional thing; it's not hypothetical, a practical and non-theoretical thing.

JJ When you were here, what did you feel about Gorky and the others?

IN They were victims, and Pollock, for instance, was obviously a victim of unwarranted inflation. That is to say, he himself felt badly about it. He tried to escape from his own shadow, so to speak. Not only in the drinking, but in his painting, he was trying to escape from this load of responsibility which constrained him. My impression was, seeing him occasionally, and talking to him – and as you know, at the end he was trying to do some portrait-like things – he felt dissatisfied with people reading into his work, and he wanted to have his own justification and confidence. In the beginning, Jackson told me he could only paint when he was soused and listening to jazz, and then he had this sort of state of hyperconsciousness. Well, why not? But, the point was, he himself said: 'What did I do? And why did I do it? And should I have done it this way, or shouldn't I?', and it is natural that artists question themselves. When people praise artists, they begin to think that something must be wrong, and they take to drink or to disputation. I think that's what happened with Jackson and with Gorky, and with Kline.[11]

JJ When you went to The Club in those days, and met [FRANZ] Kline and Pollock and so on, was The Club an important moment in the development of American art, in your experience?

IN Actually from my experience, it was merely a social get-together, and as for the exchange of ideas, I would say that we just liked to hear ourselves talk, and say what we have always thought, and there

were no surprises. Everybody said what they were working at all the time, so it was kind of putting into words. Like I'm doing now …

JJ I think for a lot of people who were lonely, The Club had tremendous importance in their lives.

IN Well, you know, we don't have cafes here; it is the American equivalent of a cafe, but clubs have always existed in New York. The so-called Club that you refer to was a little bit better organised and had seats, whereas normally you held forth in the Waldorf Cafeteria, or the automat, or in some bar, like the Cedar bar … Wherever two artists get together – that's a club.

JJ So, when did you return from this world trip?

IN It was '51 or '52.

JJ You seem to have always had a capacity for finding a commission. There were heads and then a wall in Mexico.

IN But they were not all commissions. Take for instance the wall in Mexico: I worked eight months on it, I was paid $88. Do you call that a commission?

JJ Not really. But you were kept …

IN No, I wasn't kept, I borrowed $600 from the Guggenheim Fellowship foundation. That's how I got down there, and then I sold my car to get back. Some things look like commissions. Even jobs that I do here, they hardly pay. I have always been poor. Occasionally I do get some modest commission and my one sure way of making a living, previously, were heads.And there are two kinds: heads of friends, where you get no money, and the heads of people who have some money and who you might sting for, and you can hardly call that a commission, because you are the one who is sort of forcing yourself on them. But I don't think I have been fortunate with commissions. Except that some architects have had enough confidence in me to let me do things, like Gordon Bunshaft at Skidmore Merrill,[12] and I am grateful to have had the opportunity. Now, for instance, UNESCO: you might say that's a commission. Actually all the artists were paid $5,000 apiece for whatever we did, excepting some who got double that: [JOAN] Miró and I think [HENRY] Moore got $10,000. For that $5,000, I not only did the upper garden, but a lower garden much bigger, including two trips to Japan, and one year in Paris, and $5,000 doesn't even

pay for my trips to Japan. Things I do because I want to, look like commissions.

JJ For many people, the change from anonymity to celebrity was really quite violent. You were talking about the perils of celebrity earlier on: de Kooning and Jackson Pollock who suddenly found that they were international figures. Now in a way you have achieved this, too. How does it apply to you, this question of the hazards of celebrity? Your name is well known in schools of design and schools of architecture, and in the world of sculpture.

IN I think that in my case, if there is such a thing, it's merely been because I've been around an awful long while, still kicking, you see.

JJ Has it affected you?

IN I don't think that it produces any anxiety in me particularly. I think some things are dangerous at certain times of life, but are quite innocuous at another, and I would say that with Bill de Kooning too, he just doesn't take it seriously, so he could survive it. Whereas Jackson and Gorky were much younger when they died, they just couldn't take it quite as well. Jackson or David Smith for instance, who died more recently, I don't think that they enjoyed being celebrities; they just felt guilty and bad about the whole business.

JJ You've worked in all sorts of fields – worked with architects and done gardens. Did this seem to you to be an extension of sculpture?

IN Yes, I think anything is sculpture anyway, and I have felt that the possibilities of growth are enhanced by doing things.

JJ Accepting challenges …

IN Yeah, by doing it you discover that you're doing something new. And if you know everything, there is nothing to do. That's the beauty of every new job – it's a discovery,

JJ Are you working on a commission now?

IN The only thing I have in the way of a commission right now is a playground in Japan. And why am I doing it? Well, first they asked me to, and secondly it looks like it's the only one I'm ever likely to do, because although I've tried my damnedest since 1934 when I did my first playground design, I cannot seem to get it across here in New York. The last one, I worked for five years with Lewis Kahn, [THE ARCHITECT], and it's stuck now with an injunction

and we can't get it off the ground. So, my doing it in Japan is partly out of gripe. I just want to see something done along those lines. Anyways, it's a pleasure to do it there.

JJ Do you feel that sculpture is something like a playground really? Is it very close to your concept of the nature of art?

IN Well, playgrounds are just a figure of speech, so is a garden; you know, it's the world.

JJ Do you have any stories about your contacts in the Forties that stuck in the mind?

IN We'd meet up in the evening, nothing as organised as a club in those days. The Club came later. Then they got sort of up on their boxes and had to hear themselves orate a bit. I think [ROBERT] Motherwell had something to do with the attitude of quasi-academic awareness of art and art history, because he came upon the scene from the intellectualising side, which was new to us. As artists, we considered ourselves to be more or less non-intellectual, or maybe anti-intellectual, and this intellectual attitude to art, which incidentally is prominent today, is something we were very suspicious about.

JJ Are you still?

IN I think that it is not likely to lead to anything very profound in the arts. It's like a good filing cabinet; it organises things. However, the life of the artist, and his growth, can be stunted by intellectualism.

JJ Do you teach a lot?

IN No, I don't. I have no disciples, and it leaves me very free, but then I sort of have a hankering occasionally to be able to discuss things, or to pass on things, or to work with somebody. That's one reason I do work with other people in projects. I ought to teach, but I've gotten along so long without doing it, I'm embarrassed by the idea.

JJ Some people find it a strain, and that they exhaust their ideas.

IN I wouldn't. If I had the right kind of pupils, it would be marvellous.

JJ Do you value the skills of the hand? Would you like to teach people on that level?

IN No, I have no particular specialised skill. I can do almost anything, 'Jack of all trades' – if I have a job to do, then I find the machinery or the tool, or whatever it is that I need. I sometimes call upon the

skills of others: I go to a stone quarry, or to a metal shop. I don't really believe in art coming from craft. We can find machinery as we need it. And New York, for instance, is a giant machine. I can go and push a button over in Brooklyn, and something will happen. It's a terrific, and that's why I like New York, really.

JJ Do you have a hankering ever to live in Japan?

IN Yes, in Japan there are other buttons I can push, and that's the reason the world becomes a tool, and the whole damn thing is a tool. It's a wonderful thing.

JJ I wanted to ask you about some of the younger people who are now showing at the Jewish Museum, have you seen that show?[13]

Some of them, in the extreme, uncomplicated nature of their work, seemed to me to reflect some of the attitudes of Brâncuşi and even yourself. Do you feel sympathy for these young people?

IN Yes. Let me say I enjoyed the exhibition.

JJ Do you have reservations?

IN I have reservations, because of the removal of most of the work from the hand, and I wonder how far they can go. As a technician in a factory, yes; but as a personal artist there is a kind of an unreality about it, which I question as a sculptor. The thing that Brâncuşi questioned, I question. Because when a thing is so machine-made, it's not that it's perfect, because Brâncuşi questioned the perfectability of the machine. I remember after the war there was a flat stainless-steel mirror that he had gotten made in Germany. He said the Germans were wonderful; this grinding they did on this stainless-steel plate was a mirror finish, but it wasn't his. He had to do the whole thing over by hand. Now that is an example of what he felt had to go into the thing, the sweat of the brow – I have heard the word 'Baraka' employed, sort of human labour and affection.

JJ What language is Baraka?[14]

IN I think it's Arabic. It's a kind of a wearing of things which the machine in its rawness and hard edge does not give. You might say we've overcome that sort of squeamishness, but where does development occur, excepting in the long dialogue between the material and artist? If the thing is merely handed over as a design that somebody else turns out, the dialogue becomes ephemeral.

WILLEM DE KOONING

John Jones interviewed Willem de Kooning on 23 May 1966 in his large, glass-walled studio in East Hampton. De Kooning had built the room, with steel girders supporting the roof, near the house he moved to in 1963. At the time of the interview de Kooning was sixty-two.

Born in Rotterdam, de Kooning left school at the age of twelve for an apprenticeship, and studied fine art at evening classes. At twenty-two he came to the us as a stowaway on a British freighter, landed in Virginia, stayed at a Dutch Seamen's Home in New Jersey and worked as a house painter. In 1927 he came to Manhattan where he had a studio at West 44th Street. He spent 1928 at the Woodstock art colony, was employed by the Works Progress Administration (wpa) in 1935, married in 1943, separated in 1957 (later to reunite), and had fourteen solo shows between 1948 and 1966, including two in 1965.

De Kooning was influenced by Pablo Picasso, Jean Arp, Piet Mondrian, and Joan Miró as well as his friends Stuart Davis, Arshile Gorky and the Russian artist John Graham, and later Franz Kline (notably in his monochrome work). De Kooning became the leading light of the New York School of abstract expressionists (who moved on from cubism, surrealism and regionalism), was a founding member of The Club on Eighth Street, and by the 1960s was recognised as one of the world's most influential painters. Picasso's work came to be influenced by his.

His *Women* series in the 1950s was controversial: some thought it hostile towards women; others, including fellow artist Grace Hartigan, found it beautiful (see p.225).

De Kooning spoke with a youthful-sounding enthusiasm in a Dutch accent, his speech employing both small errors of language and informal, idiomatic Americanisms. At the request of the de Kooning estate, his interview is not edited, just curtailed for space.

WDK Well, like I said. Like when I came in America in 1926. Then after a little while I went around. And my friends in Europe you know, in Holland, they thought I must be out of my mind to want to go to America. For an artist, you go to Paris, a place like that. In those days, Berlin.

JJ Berlin they used to go to?

WDK Yes they used to go a lot to Berlin. In those days – and places like that. And so I didn't want to go to America for art. I mean, I wasn't interested much in art. I was, you know … I went to the Academy there. I was an accomplished student.

JJ You had a very academic training, did you?

WDK A very academic training. Yes. I went to school very early there.

JJ Where was that?

WDK In Rotterdam. And, you know, I started working when I was about twelve years old. In a shop. You get a lot of training there, you know. More than in the schools.

JJ What sort of work was that?

WDK Well it was a very fancy house-painting and decorating shop. With the name of Gidding. It's actually an English name, I think. Gidding?

JJ It could be.

WDK G-i-d-d-i-n-g. I know I see it in English. They were two brothers. One was like the contractor for the big jobs, and then the other one was the artist. And he was a very good artist. Jaap Gidding was his name. And so, I became an apprentice. And they had, oh lots of

artists working for them, you know, men – same thing as here. You have to make a living. They really wanted to paint but they had no money, so they had to work.

JJ Sure everybody did this.

WDK Yes. So I had a wonderful training that way in the shop. And Mr Gidding said that I ought go to the academy. So, in the wintertime there is a night school.

JJ Ah. That's before you went to the academy.

WDK Yes, then I went to the academy the same season. They were very concerned there in those days. I was still in the old-fashioned atmosphere where they train a young person good, you see?

JJ I had that, too.

WDK You had it too. And I think it's nice. I never regret it. And it has nothing to do with child labour at all. I mean, I think really it was like a trade school while you worked. You see? So I did that.

JJ And then you came to the States.

WDK Oh well, then I kind of grew up and I did all kinds of things, you know – commercial sign-painting and worked in a department store. And I used to get night jobs and things like that. And I thought that's what I'm going to do. And I think the best place is America. I wasn't really interested in becoming a painter. Among the youngsters it was a little old hat. It's [A] little bit like now the pop artists. They didn't want to be painters per se, you know what I mean?

JJ No, I understand.

WDK And so I came to. So I went to America. And my friends thought: you go to Paris … but I went to America. So then I was here a year or so and I started meeting other artists. Russian, a lot of Russian artists, all refugees. And I went to exhibitions. And they only had a few galleries.

JJ Were you painting then?

WDK I started to paint, in my free time. And I still have a picture upstairs of that period. 1928.

JJ Yeah.

WDK And so later I found out you could see so many things here you couldn't see in Europe. They had everybody here.

JJ What sort of things do you remember?

WDK There were only a few galleries …

JJ Julien Levy, or was that later?

WDK No, that was much later. But they had the Reinhardt Galleries, for instance, the Balzac Galleries and different galleries. I forget the names. But the Reinhardt mainly. The Dudensing Gallery. And gee, you could see terrific Picassos, [HENRI] Matisse and they had all kinds of other artists which now all seem forgotten. But I saw a terrific exhibition of Paul Klee which I found out you could never see in Paris. I didn't even consider him. [WASSILY] Kandinsky. So everything has a contradiction. This is an artless country. But you could see more art here.

Not much, not like now. But I mean, because, if you're interested, huh, you only have to see a few. So when they started The Museum of Modem Art that was in the same building where the Reinhardt Galleries was on the corner of 57th Street and Fifth Avenue. They rented an enormous floor. And that became The Museum of Modern Art. And they had a colossal exhibition of Matisse. I never saw anything like it. I saw a Matisse here. Matisse there. But a whole retrospective show: gee. It was: boy!

JJ I can imagine the impact of it.

WDK Yes. I walked in and walked out. I got so nervous. I never saw such colours. Now they're not so bright any more [LAUGHTER]. But at that time, geez. And I saw a wonderful show by the Mexican painter. [DIEGO] Rivera. And we liked those Mexican artists in those days. Anyhow, you could see a lot of things here. And then I met artists.

JJ Who were the fellows you met then, the artists that you hung around with? I was talking to George Morris. He was the president of the American Abstract Artists Society.

WDK That's right.

JJ In the Thirties. And you used to go to their meetings, I think. Or –

WDK Yes, but I didn't go. I didn't belong to that part.

JJ He told me you didn't belong.

WDK No. That was …

JJ But were those the fellows that you were meeting a lot?

WDK Yes. Harry Holtzman[1] started that school. Harry Holtzman. And he wanted to make a school, a school for ourselves. In other words, discussion, and what are we going to do. He was interested in the development of art, see, and not the exhibit, necessarily.

JJ Sure.

WDK And consider yourself already accomplished, you know what I mean?

JJ Yes, I know.

WDK And so I backed him up and I helped him, and out of his own money he rented the loft. And he got it all fixed up, and I helped him paint it. And then Balcomb Greene,[2] and Gorky and Ibram Lassaw,[3] and a lot of fellows, they came. And we had the first meeting, talking about how we could, you know, make some kind of a group. And a lot of us didn't feel kosher in the sense of we could make it look like, but it had no real meaning, or at least we thought so. So then of course there was also the revolutionary movement, going parallel. There were all the so-called painters who were devoted to …

JJ The American scene.

WDK Well, there was the American scene and also the idea of the communists. You know, there were a lot of fellow travellers and communists in those days.

JJ Most of the fellows had a very strong left-wing sympathy in those days.

WDK That's right. We were for the underdog. We used to split on the idea of not wanting to be proletarian artists, but we did come together to talk about it seriously, what could be in it for us. Not just to copy those other people. And Harry Holtzman had that in mind, too, probably just seeing what we ought to do, like, to have some more moral attitude. Like the word 'composition' had to have some kind of meaning. Composition is really a moral attitude. Otherwise, you're making a layout. You have to have some kind

of conviction about why you should, otherwise you become kind of a mannerist. And compose. That means you are really arranging things.

So, most of the artists weren't interested. He [HOLTZMAN] wanted to exhibit. And that's why they make the AAA: the American Abstract Artists. And then [ARSHILE] Gorky and myself and a few, we didn't want to do that, we weren't interested in that. The exhibit didn't mean much anyhow. So you come all together and exhibit and nobody sells. I was interested in selling a painting. I wasn't interested in exhibiting. So I kind of not went into this.

JJ You were close to Gorky in those days?

WDK Oh yes, very close.

JJ He was one of your best friends in those times?

WDK Oh yes.

JJ Who were the people you were with? Gorky was one.

WDK Well. I worked in this commercial place. The Eastman Brothers. They were decorators. And they did a lot of theatrical work. I did that. I designed theatrical shows.

JJ For the stage?

WDK Yes. Well, I could only do it under their supervision – in other words they were experts in the actual theatre. And they told me what to do. But I could do it, they couldn't do it, you see what I mean?

JJ Yes.

WDK But I couldn't have done it without them. So I even showed. I designed a whole show for Texas Guinan⁴ in 1927.

JJ Did you? [SURPRISED]

WDK *Padlocks of 1927.* I designed the whole show. But I didn't get no credit. And it wasn't coming to me because they really did it. But I came from Europe and I had, without me knowing it, different ideas and they exploited that – in a nice way. And so then I met different artists and one of them was Misha Reznikoff I met.⁵ And Anton Refregier.⁶ And they kind of took me into the Greenwich Village and made me meet other artists. And so through Misha

Reznikoff I met Gorky. And I almost had a fist fight with him. Oh, he was impossible. Whatever you say, he disagreed [LAUGHTER]. But I liked him anyhow. I thought he's really smarter than the other ones. But then we become very good friends you know. Very friendly. And I learned a lot from him.

JJ Was it just that he was always a difficult person to talk to?

WDK Oh, he –

JJ Or was it that you really disagreed with him on the fundamentals?

WDK Well, most of the time he was right, too. I mean he knew more so he couldn't stand it.

JJ They tell me he was a very well-informed character.

WDK Fantastic. I could never figure out why. Because in a very – I often know more about a ... with my training. And he's an Armenian. Went to school in Tiflis.⁷ Some school in Georgia. But he had a fantastic insight.

JJ Someone was telling me that for years they thought he was a Georgian and they didn't know he was Armenian at all ... it was only lately they found out he was an Armenian. I've forgotten who that was: Conrad Marca-Relli, or someone like that.

WDK Well. I mean, Armenians in America they kind of ... some of them. But I knew all the time he was Armenian all right.

JJ He was kind of a mysterious guy, too, though. Wasn't he? Secretive, so they tell me.

WDK About his background. Yes. He told very tall stories.

JJ How do you mean? What sort of things did he tell you?

WDK You know, like typical great stories about his father sitting on a horse, and being like great peasants, or wealthy landowners or something like that. Maybe there's something to it but I met his sister later and he made up a whole background for himself. [LAUGHING]. But nobody paid attention. Stuart Davis gave him the business. He was so smart, Stuart Davis.⁸ Oh boy. He talked out of the corner of his mouth like that [IMPRESSION].

JJ And he wouldn't let Gorky tell him these stories? He wouldn't take these stories you say – Stuart Davis?

WDK No, of course not. Stuart Davis even wrote about it that Gorky had a way of taking his jacket off when the party was going good. He would take this jacket off. Turn it around, inside out because it has the silk lining, you know. Somehow he looked like a real Tartar peasant. It changed the whole attitude. He was very inventive about those things. You know, turning a jacket around. Now, whoever did that? He turned the jacket around, he looked like, because this becomes like completely white maybe. You know what I mean? Like white silk or a cream-coloured silk. And he would make this fantastic – he was terrific in dancing, you know, like the Cossacks.

JJ He'd do the Russian dancing.

WDK I don't know if it was Cossack, but from that period. And Stuart Davis says he try to do that in other circles [LAUGHING]. He wasn't very impressed with it, you know what I mean? His group. And I didn't know them then, those characters like Pop Hart,⁹ Niles Spencer.¹⁰ I met later Niles Spencer. But Stuart Davis was a real fantastic guy.

JJ This loft you talked about that Holtzman put together, when did that happen? That must have been in the mid Thirties, wasn't it?

WDK Yes. I guess so. I forget the dates.

JJ And afterwards. You didn't join that crowd, but you were on the WPA,¹¹ were you?

WDK Oh yes. Yes.

JJ What was that like for you? Was it a good thing for you?

WDK Oh, it was wonderful for all of us.

JJ It was good.

WDK Oh yes. But I wasn't [A] citizen so I had to resign. So I didn't get much out of it – about a year and a half. For some people it went on for years, and most artists who ever amounted later on to anything in all different schools of art, were in the WPA. And I had … in the Depression I could get very good jobs commercially because they fired the, you know, the big shots, art directors. You used to have an art director make $300 a week and he told you what to do, you know. And so they fired those guys and they hired the one who was really doing the work. And raised his salary [LAUGHING]. I used to get more money because they fired the

other guy. I saved them an enormous amount of money. And they gave me $25 a week more maybe, you see me? When I found out about that art project I said, 'Gee. I have to get on that.' And I had to do all kind of things to change my background. Because I really wasn't in need. But I managed somehow to get on the –

JJ Just to get into the art project.

WDK Yeah. I wanted to get into the art project. You get $23.86 a week. And it wasn't bad, you know. And it was marvellous because everybody was – well, I mean it wasn't so nice that everybody was poor, but we had the higher rating. And that was because of the unions, the house-painters and decorators' union wouldn't allow anybody working for the Project Administration, with the Roosevelt business there, they wouldn't let them work below union rate. So we got the high rate from the union. It was $1.60 an hour or something. So we worked fifteen hours a week for the project.

JJ Some people tell me that although it was great having the money, it was a sad old grey time in American painting, and for them as individuals. Did you feel that? It wasn't a gay time for you, was it?

WDK Oh, I liked it very much.

JJ Oh, it was for you. Good.

WDK Well, Gorky liked it. Stuart Davis: he laughed somehow. I guess the good artists liked it, you know? Yes, because you had this … nothing to worry about. Right? It wasn't much but now it must be very difficult for the young people because everybody makes a fortune. Carpenters make $5, $6 an hour. So how can you compete? This time we were all in the … because of need. We weren't recognised as artists as much as we were on the home relief. The dole. But they do that much nicer here than in Europe, you know. They don't let you stand in line, and all that business.

JJ This is changing now too, in England. It used to be bad, but it's not so bad.

WDK I'm telling you. Yes, but they learn. But they take you good. I mean, you have to sign in and you're a person, you know.

JJ And what sort of things did you work on with WPA? Did you just produce paintings or did you work on murals?

WDK You had six weeks to make a painting, a certain size painting. And

Burgoyne Diller[12] who was a wonderful artist, who died, he was one of the supervisors. Harry Holtzman was a supervisor. He was always more interested in the theoretic part of it so he tried to serve as a supervisor to do us good. See? It was like more or less a free-for-all. And the right people used to get the right jobs because it had nothing to do with art per se, but like I said, as a means of support for which you worked. And the union made it so it was a decent wage. See? So the right people, since it was a new thing, the right people got the right jobs. Like Cahill, who became the head of it – Mr Cahill. He was very good All the people really liked art. So it worked out very good.

JJ You did a painting every six weeks. That was your work?

WDK Yeah. I made a very serious painting and I worked fifteen hours a week, but I worked maybe fifty hours a week because, what am I going to do?

JJ Sure. You did many more paintings than you were required to do.

WDK Yeah. But you only had to give one. Then I went. Diller wanted me to make a mural for a housing project.[13] But that never went through, but I worked on that. I made sketches.

JJ What was the one you mentioned just now that you worked on with Gorky?

WDK No, those were commercial jobs. That came later.

JJ And when did the WPA thing finish for you. What time?

WDK I forget the dates, but I got on a little later and then I had to resign. All of a sudden. Notice was put on that if you were no[T A] citizen you had to resign. And I went to my supervisors. And they were really my friends and I said, 'What am I going to do?' And they said, 'What do you mean? You're not a citizen?' And I said, 'No.' They said, 'Well. Who knows?' I said, 'Well. They say they have something on the bottom that if you lie, you're not doing so good.' You know that I mean? They said, 'Well, it's all up to you, Bill because it's crazy.' But what was so wonderful is, I remember in Holland, when something like that would come everybody would have to show his citizen papers. And then the few Germans left over, they kick them out, right? But here they do it the other way around, isn't that marvellous? I had to prove that I was not a citizen. They leave it up to you, this.

JJ Yes [LAUGHING]. That's great.

WDK Do you remember those lines? You're younger than I am but I remember seeing lines in Europe – always these people standing there. Early morning to late at night. To prove that they're all right. They came to Rotterdam. And here they did it the other way around; it's much better bookkeeping.

JJ In spite of the poverty, you were very happy to be in America, weren't you?

WDK Oh yes. I like it here, sure.

JJ Did you miss Holland much in those days?

WDK You're never poor here. You're without money and you're starving.

JJ You didn't want to go back to Holland in those early days?

WDK No.

JJ You made up your mind to stay?

WDK Oh sure.

JJ So you didn't ever actually do a mural project at all for the WPA?

WDK No, it didn't come off.

JJ But what do you think of the paintings you were doing in those days? What happened to those pictures you gave?

WDK Oh they got lost. They kind of cleaned them all out and some man on Canal Street bought them all by weight. Yes, an enormous amount of painting. Thousands of paintings. And when the artists found out about it, some of them went to this place and picked out their paintings and bought them back for $6. Or $8 or $10. The man made a good profit, but he didn't overcharge. Yes, that wasn't so nice that they cleaned [THEM] out. They didn't want to burn it [ALL] so they sold it to this guy.

JJ Junk dealers.

WDK Yeah.

JJ Or antique dealers.

WDK But it was bad that they didn't take care of it.

JJ The paintings you did then in those days … did you feel that they were important paintings for you? Or were you kind of learning? Or did you feel that it was just part of your growth in some way? Do you regret the loss of those pictures?

WDK No, no. There were some of them [THAT] were very nice. But no. I don't regret, no.

JJ But they were very different from the kind of thing you came to do later?

WDK Well, in those days we all changed so often. There were all those different, how can I say, conditions. Like a lot of the artists wanted to be like, painting, for the revolutionary forces. They were very much influenced by Diego Rivera and [JOSÉ CLEMENTE] Orozco.

JJ Did your work at that time have any social comment at all? Did you paint pictures about the poor?

WDK I did some, yeah. But it was always like painting.

JJ What did you do after you came off the project? How did you live?

WDK Oh yes, then I had to resign. On the whole I had a good experience because I found out I could actually live from this money. And I changed my attitude about – I decided to be an artist. So before, I would be known that they could hire me and I would do things, and I painted for my own. You know what I mean?

And then I find out that's the wrong attitude to take. Because you always know the people who give you jobs. And I wanted to know people who would buy a painting. So I said that I was an artist. And more or less secretly, I did odd jobs on the side. So I became known in a small crowd as an artist. And I always had kind of a good reputation underground. And then slowly people came and bought some pictures to help me. You know there are always a few people, they figure, 'Gee. This guy is really broke. Let's go and buy a painting'. And that was a much better attitude. So that was just a decision I took. It was the same condition but slowly on it changed.

Slowly on if you sell a painting to a man who is a collector, and he just wants to help you and he likes the picture, too, more or less, he has a friend and he says, 'Go and buy a painting,' and then before you know they like the painting, too.

JJ Did you have one or two people then that would regularly buy a picture? Sort of patrons?

WDK No. I had friends who helped me. Who pay the rent or something and then I gave them a painting. When it mounted up they took a painting instead.

JJ I see. That was the Thirties and then, I suppose, the war came.

WDK Then the war came and the project changed into more or less the war effort. So artists had to start learning how to make posters or all kind of sign-painting, or camouflage and things like that. But I had nothing to do with that, I was out.

JJ And by that time, some of the refugees were coming over here weren't they?

WDK Well. They came a little later. But there was one who came here very early.

JJ Who was that?

WDK That was Jean Hélion. And he came very in the beginning. He didn't want to have anything to do with this war business, you know. And he wrote to all his friends: 'You're fools: come to America.' But they wouldn't. And he tried so much. He was so devoted to Mondrian. He did everything to talk Mondrian into coming to America, but he wouldn't. And then the war really started. America got into the war, too. And the meantime, the Germans were attacking France, they went into France. You know people forget, but you know that the French were invaded through Germany. And all the newspapers that Germany is maybe not so hot. And I remember being very angry with my friends – not because I was for the Germans, but that they could be so stupid. I said, 'You must be out of your mind. They're going to give them such a shellacking. Because Germany. You know what I mean?

JJ Yes. Yes.

WDK Which they did.

JJ And they did, yes.

WDK But there was all the newspapers and the emotion was all –

JJ Optimism.

WDK That France was just walking – it sounded funny. I'm no military expert. But they weren't even fighting. They just walked into – you remember?

JJ I remember the Maginot Line. Like it was nothing.

WDK But then the Germans turned around after about six months, I think, or three months – they start really attacking and moved around and things like that.

JJ And then all the people came out of France.

WDK Then they …

JJ The painters.

WDK They came. And you know what Hélion did? He went back. He joined. Isn't that marvellous?

JJ Extraordinary.

WDK 'Vive la France! They can't do that to France,' he says.

JJ He went back.

WDK Yes. He signed up immediately.

JJ I didn't know that. I thought he stayed here.

WDK Yes. I like him for it. But, it's so crazy, isn't it? He went away long before: when they really got into France. He says, 'Now what is this?' And he went.

JJ So who else came at that time, who you knew afterward – when they started coming?

WDK Well, on the project, [FERNAND] Léger came here.

JJ Oh yes. Did you meet him?

WDK I worked for him.

JJ Ah. What did you do?

WDK Well, he was on the project, too. But he couldn't be really legitimately on the project because after all he's French citizen. But they had certain ways of inviting people, in a kind of leading capacity. And I think [FREDERICK] Kiesler, the architect, had it arranged with the project. Léger wanted to make large murals

here, even for nothing. You see? And he had in mind the French Line – it's after all French property. And if he could make the big murals in the French Line, like on the outside, between all the iron girders, he had that in mind he would like to do it for free. So he got on the project to do that. With this project in mind. You know, separate project in mind. For the French Line. But he had of course to get assistants to make it legitimate. Or, at least, that's the way they figured it. So they had six and I was one of them. And it was nice. We worked for Léger. And he was very …

JJ What happened to this big mural?

WDK The French Line didn't want it. They didn't want him and they didn't want us [LAUGHTER]. But we had a project, know what I mean? For us it made no difference. Because we got …

JJ So he didn't actually carry it out?

WDK No. But he made a lot of sketches, and he insisted that we all did our own sketch. We weren't helping him. And he gave us all a mural, a panel to do on he big – what do you call the, when you got into the place?

JJ The hall.

WDK The hall. Kind of, you know. And on the outside he was going to make the big murals, you see, but it didn't go through. But we were working quite a while on those things.

JJ How did you get on with him? What was he like?

WDK Well, he didn't speak English but we had Mercedes Matter.[14] She was our interpreter. And we had a good time with him. And it was a very good thing because he was wonderful, but still only a human being. And he was sitting at the same table making his designs – a little sketch – and laying on the floor and looking at it just like we did. And sometimes they were good and sometimes they weren't so good. But he was very surprised he could have gotten so many artists he couldn't get in France. Later on he wrote an article about it. He said actually abstract painting belonged to America. And I can see what he meant. Because when he saw Times Square and the skyscrapers, it's just like his paintings. You know that big city square he has? It looks just like Times Square.

JJ That's right.

WDK In those days. Now it's changed because it's more modern. But he could get so many artists here who understood him, much more than in France, you know.

JJ There was a certain hostility, wasn't there, among the Americans to the people that came? Some painters feeling that Europe was dominating as far as art was concerned. Do you remember this?

WDK Well, we weren't angry with the artists. But we did think that the Museum of Modern Art and museums ought to give us a chance, too. Which they later on did. Now they regret that they weren't paying attention. Know what I mean?

JJ Yeah.

WDK And sure we were peeved about that, that unless it came from Europe, you know. And they actually wrote that. And [ALFRED] Barr wrote in his book that abstract painting is dead: it doesn't belong to America. He was all for the regional art shows.[15] You know what I mean? So they weren't so bright those guys. But we weren't angry with the artists. We learned from them as well.

JJ Who else did you know among the refugees?

WDK Well, there was Max Ernst. He was a fabulous man.

JJ You liked him.

WDK Oh yes. He's marvellous. I know him very good, Max; we became friendly. They did a lot of good to Gorky. André Breton thought he was a terrific artist and they say, 'Why, you're a wonderful artist.' And that's the only time when Gorky started having a name here, not being – oh, he was very much respected, but in some mysterious way, you know, like some theoretician. A smart fellow. But they thought his work was wonderful. And they did him a lot of good, I think.

JJ They encouraged him.

WDK They encouraged him immensely.

JJ Gave him a lot of confidence.

WDK They encouraged him immensely and he went with Julien Levy.[16] And they thought he was wonderful, yeah. And so.

JJ I talked to Philip Pavia, who very much disliked the surrealists – or

rather, he disliked what he thought they stood for. He has this very strong hostility to what he calls the literariness of surrealism.

WDK Well. Philip is a wonderful guy, We have more fun with him. He's just wonderful. But I'm at odds with him, because he obviously keeps changing.

JJ Well, I wasn't wondering so much about him, but I was wondering about your reaction to the whole idea of surrealism.

WDK Well, you can't go by him. I'm telling you because –

JJ No no.

WDK You know like he's all angry with Zen, if somebody writes about Zen, and he's furious. He says, 'That lousy Zen'. You know, he has that voice. He says, 'Jesus, that Zen'. He says, 'They drive you crazy! Everything is Zen. You'd better be careful,' he says. I like him for it. But he talks so much about – I wasn't even interested, you know. Then a couple of months later he says, 'You know that Zen is not bad at all.' And he starts giving you books. He buys books for you, you know. You have to read Zen. Or you have to do this. And he keeps changing his mind. He hated abstract painting. He says. 'That lousy Pollock, he's like Sargent.' So furious, he was. They got so angry with Pollock. They were so angry when Clem Greenberg said that Pollock was a great artist. They flipped. Most of the artists. But you know what I know, and I told them, too. I said, 'Well I know you're very furious and you hate his work, but I'm sure that tonight when you go back to your studio, you'll hate your own work even more.' You know what I mean? And that was true. They all changed. He was a remarkable man. You see me?

But in the beginning, they were so angry with him. But such a marvellous thing, for Greenberg to say it. He's great. Or better or something. That somebody comes out with something, right? Make like a bang. And then everybody got angry. And they say he's crazy. But before you know it another guy says ...

JJ He was a big factor in changing –

WDK Sure.

JJ Giving Americans status and confidence.

WDK Sure. He was a wonderful artist.

ED RUSCHA

This interview took place at 9.30am on 27 July 1966, in Ed Ruscha's studio at 1024 ¾ North Western Avenue in Los Angeles, which he had moved into the previous year. Ruscha was twenty-nine. (Some years later the studio contained a motorcycle, a punchbag and cowboy hats – though we don't know if it already did.)

Born to a Catholic family in Nebraska, Ruscha grew up in Oklahoma City and then moved to Los Angeles, where he studied at the Chouinard Art Institute 1956–60. Influenced by Jasper Johns and Marcel Duchamp, he painted words and phrases between 1961 and 1964, was shown at the Ferus Gallery in Los Angeles, and was known for such pop-related paintings as *Sweetwater* 1959, *Large Trademark* 1962, *Wonder Bread* 1962 and *Standard Station* 1966, which he also produced as a silkscreen.

Ruscha's first two books of photographs (*Twentysix Gasoline Stations* and *Some Los Angeles Apartments*) displayed a deadpan aesthetic.

He had worked at the advertising agency Carson Roberts and at the time of the interview was working as a layout designer for *Artforum* magazine under the pseudonym 'Eddie Russia'.

His voice sounds youthful, and slightly languid in the audio recording of this interview. He says 'like' and 'you know' more than is apparent in this edited text.

JJ Do you feel your work is some kind of extension of surrealism or any European art movement of the beginning of the century?

ER Well, let's see, maybe we better start like this. In high school, I started taking commercial art courses and wanted to be a commercial artist. I had no interest in painting at all. And some of the work of the dadaists interested me while I was high school.

I came to art school very naturally and stayed in advertising for about three years. In my fourth year, I became interested in painting because I couldn't do what I wanted to in advertising. And so it was a matter of taking a language that I had learned in advertising and putting it into painting.

I think everything comes back to abstract art. I understand that. And figurative as the direction [is] that I may be taking, which is going to be highly figurative, abstract art is still the most important thing. To me in my life as an artist, abstract art has been the most important factor. I just look at the picture and no matter how literal it is I see the abstract possibilities in it, and there's really no distinction between the two. And the work of the dadaists influenced my way of thinking – most of all, I'd say, Kurt Schwitters. Now surrealism, I'd never been interested in that until recently, not to any great extent.

JJ In a way advertising has used a lot of dada techniques without them being specifically fine art attitudes. Tell me about when you decided to be a painter, what did you do? You just went off and started painting pictures?

ER Yeah, well I was an art director in an agency, and I knew it wouldn't work, and the people at this agency knew it wouldn't work and I just left. And then I started painting and I was very sure of myself as a painter. I don't know how or what made me get work. I didn't have a gallery at the time and the gallery situation makes things pretty comfortable, you know. It's a good thing to have.

JJ When you started painting how far did your work differ from the stuff that you had been doing in advertising? What essentially was the difference?

ER Well, the difference was that advertising had a motivation behind it. And when I started painting, my pictures had absolutely no motivation – or almost anti-motivation, you know. No communication at all. I had approached painting as though it were like telling a story, but it didn't communicate. Like I was doing pictures of words of towns that I had gone through in the United States and these were on large canvases and people looking at them wouldn't understand what the story was. But still the techniques, the tools, the visual things were from advertising.

JJ And what were the towns about?

ER Well, it was just personal memories, and I don't know how I'd go into my subconscious to explain, except that it was like, you might say, a diary. And it was the mystery of the words like Vicksburg and Sweetwater and towns like that, that I had gone through – a tour I made when I was in high school and I hitchhiked around the south. And I went through Macon, Georgia and all through the south. I just picked these towns and they had beautiful names to me, and I saw them typographically and I started thinking typographically. I was a printer's devil at one time and I'm familiar with typography, and yet the printed word just – lacked a vitality. I could print that word on a piece of paper, but it would lack vitality.

 And so I began to see the great mystery of painting, how a painting could make that thing be much better, much more than it is.

JJ That's interesting.

ER Did you see my *Annie* painting at the gallery that I just recently finished? With the drops and all that?

JJ I did see it.

ER Well, that picture originally came out of a design typeface. The
 word itself had a falling to it. It had a flowingness to it. And so
 I began approaching it like I take maple syrup and pour this out
 and into that shape, and I began to see how maple syrup would fall
 – and so, a picture on those grounds is just a breakthrough for me.
 From just straight typography, which I'm not that interested in.

JJ When you were doing these towns, the arrangement of the word
 on the canvas – you talked about it being abstract art. You expected
 it to function on that level as well as the fact that you could read
 what it says.

ER Yeah, the name of the town, it's legible, it's obvious, but the
 placement was very contrived or considered. And they were good
 exercises for me in working on large spaces. A printing space never
 gets much over that big [GESTURES A SIZE], so working on canvas
 was really an exciting thing.

JJ After the towns, what happened?

ER Well, I never did much with those paintings. I've still got a few of
 them back home. But after those, well, I left school and travelled
 around Europe for about a year and then came back here. And
 I started my first *Annie* painting. I didn't do any large painting in
 Europe; I did some smaller things – words I'd seen in Europe, like
 boulangerie and things like that.

 I did a lot of paintings like that and I was just really knocked out
 by the typography – art nouveau typography or modern typography,
 or contemporary typography. And before I left, I had planned on
 painting this *Annie* picture.

JJ You say you just chose a word out of the book of typography.
 It didn't have any special associations?

ER No, no it did, it did. It was from the comic strip book of the time
 and the typography moved me. There was just some beauty about
 that –

JJ In a sense these are the most familiar design objects that people
 encounter – a type.

ER Yeah. In a sense, I'm designing. Because I take elements and put
 them together in what I consider is the best way. But being a type
 designer, oh, what a boring thing that would be. Such rigid rules.

JJ You were saying about these things in Europe. If the word itself has only personal associations for you, what do you suppose there is in it for the spectator? Is it any different from a piece of a billboard?

ER No, it's not just a piece of a billboard.

JJ I mean, what is the difference, when you isolate one word?

ER Let me go back again, the billboard has a motivation behind it.

JJ Right.

ER And it's designed for that motivation. Now, my things are not designed for a spectator necessarily. Maybe my later work is better suited for a spectator. I don't know.

JJ Essentially, it's a completely irrational thing. It's unmotivated.

ER Yeah … I do commercial art, too, and I can cut one off and do the other, and I know when I have something I have to do. I can't face a blank canvas, just cannot do it. I have to have ideas, and ideas are rare. There are people in advertising that have much better ideas than painters do. It's because they have a different language, different tools, and they work with different things. And I probably think more like them but then I have the personal aspect that an advertising person can't have. They have to think about selling goods and the response and all that. And advertising on those grounds, just don't, they don't jive with me.

JJ The names which you picked up in Europe were partly associated with their interest as typefaces, but also they have some kind of association with you. There were those two aspects of it. What came afterwards? With a word like 'Won't' for example, what lies behind this?

ER I don't know. Maybe there is some mystery behind that. I dunno, … I'm not trying to be mysterious here. But I don't know why that word came out except that I worked very hard on the thing in the paint and I thought I'll never let that go. I hate it, I really hate it. But the word itself is from no particular source. Maybe it's something subconscious, subliminal … Maybe someone said 'won't' one day and I picked it up and somehow, I began working on drawings.

JJ Do you feel that this is a special word that has a special power?

ER No, not this word. I did a word called 'Smash'. And that picture was just bold, and I guess I liked it for that. Maybe that one picture is special in that way. And a word like 'Electric' is great, like that's a good word. And I did a word: 'honk'.

JJ Since you say that the whole business is essentially abstract, do you ever choose the word because you think the combination of letters makes for an interesting shape, like one is a square one, one is a round one –

ER No, no, never.

JJ It's not an arrangement of abstract shapes?

ER No. But it is abstract shapes, and I can see them as abstract shapes.

JJ But not selected for that reason?

ER No, no, not at all. That would be like designing for a spectator. That would be like saying, 'Look, what I'm doing … Here's a curve and a flat,' you know. It's not that at all.

JJ When you paint the letters with that kind of effect like the sky, there, why did you do that?

ER Well, I was trying to search for a new way of putting the word on. I just can't paint a word flat on a canvas any more. It has no interest to me, and I have to kind of push on and approach it some other way.

JJ Does the form of the word ever echo the meaning of the word?

ER Yeah, the 'Smash' word – that does, like the word is very big and you stand in front of it and it says 'Smash', and it is smash. But I don't paint my pictures that way. I'm not trying to illustrate words. The *Electric* painting – maybe it does because it's got a blending of colours. Those two pictures probably are the best example of that: words that look like themselves. I'm not interested in doing that either, particularly.

JJ This is a sort of game that [SAUL] Steinberg plays sometimes where you draw the word thin and the word itself is thin –

ER That doesn't interest me, because that's whimsy. Steinberg does it pretty well and there are some other people there that do things like that. Like you spell the word mistake and then you put the E backwards, right?

JJ Right, that's it. And yet, in the sense there is this kind of dada, irrational thing going on in your work and sometimes dada work was on the fringe of whimsy.

ER Yeah, see actually that kind of whimsy you're talking about – the word mistake, and the E backwards. That's very rational.

JJ Yes, it is.

ER Because it communicates. And my words don't communicate that way.

JJ And you prefer them to have this kind of irrational –

ER Well yeah, I guess maybe I strike the middle ground; I have a feeling about it when I put a word on canvas. I like the word 'automatic'. It really gets me. Maybe I see something like an IBM processor [MAKES A TICKING SOUND LIKE A MACHINE PRINTING]. But I'm not consciously trying to illustrate the word.

JJ You painted some birds, what was all that about? I haven't seen many of these incidentally –

ER Yeah, well, I'd like you to see them. They are all over at the gallery. And there are two in London, but they are the worst two. They really are. Let me put this coffee on.

JJ [AUDIO BREAK] The birds. You were about to tell me about some birds.

ER Yeah, I can't really tell you what was going on there except that I saw a new chance to use some colour. But they were three-dimensional objects illustrated on a canvas, and that's the first time I did that.

 Before that all my paintings were, oh, hard-edged, flat, and the surface and the figure were almost one, on the same plane. There were no illusions of depth, and the birds had these illusions.

JJ Some of them were just straight birds, and others were birds you messed about with a bit? In a surrealist way.

ER Yeah [LAUGHS].

JJ Wasn't there one where the bird had a pencil for a beak?

ER Yeah, right.

JJ Then the other birds had beaks and were just birds.

ER Yeah. I can't tie that down to anything else I did. I really can't.
 It was just a kind of freaky period that I went through. And with
 these books, too.

JJ Yeah, tell me about the books.

ER I'm not trying to make a work of art out of these books. Even
 [GEORGE] Wittenborn¹ says, 'What are these things about?' Until
 somebody comes along and says, 'Look, he's a painter.' So they sell
 books for me. But before that, they laughed and said, 'We can't
 sell these things'. And now they say, 'Oh, keep them coming.' So,
 it's a crazy part of that business world.

JJ But apart from that side of it, what is it for you?

ER I printed 700 of these books and I didn't know what I wanted to do
 with them. Maybe give some to my friends and maybe sell some
 to people if they were interested. And actually, if I sold enough of
 these books it could pay for what it cost me to print them.

JJ But why did you make them in the first place? What brought it on?

ER Well, I don't know. Maybe it's some notion I have about wanting to
 have a publication.

JJ But they are kind of banal, aren't they?

ER Well, I'm not after that.

JJ You're not seeking banality?

ER No, no I'm not. I think those gas stations are pretty –

JJ Yeah, but that's all.

ER And I didn't go out on the road to find a variety of gasoline
 stations, dilapidated ones, abandoned ones or anything like that,
 because I could have made an interesting logical book, but it's
 not logical.

JJ Is its point that it is kind of pointless?

ER Yeah. There could be 100 books on gasoline stations, all different.
 And there could be some that anyone can pick up and understand
 completely. You know if somebody wrote a foreword to it and said
 'Look at America'.

JJ Although people could have made a book about gasoline stations that had an obvious appeal, is the interest in these books the fact that they don't have any kind of appeal in that sense?

ER Maybe so.

JJ I'm asking really how purposeful this is on your part.

ER People can't go through there and flyspeck.[2] And find one picture and say, 'Well, this is not right,' you know. The books aren't really on that level. Some people misunderstand me. Artists say, 'I saw it, yeah, you put photographic art together. Oh well, what about Edward Weston[3] or someone like that?'

And it's just completely lost the idea, because some of these pictures were not taken by me, and it's unimportant whether these pictures were taken by me or not.

[BREAK]

But they are not throwaways. Definitely not throwaways. They have a very good binding element; they have a flat spine which I wanted. I don't try to put them together as cheaply as I can. I want people that are interested to take care of them. I've gone to the trouble to design some boxes and things like that. And I wanted them to be cared for, but by people who know that they are only caring for something that someone's put together for a pointless reason.

JJ They're books in every way except that they are not motivated in the way that books usually are, is that it? And they don't have any literary or any art purpose or they don't make a point.

ER No, I thought maybe now I could sell some of these things to people in gas stations –

JJ Well, if you did that would kind of defeat the purpose, wouldn't it?

ER Well, it would defeat the purpose and I thought: well, what difference does it make if it defeats the purpose? If I could sell some of these books, I can pay back what it cost me to make the book. And if they see something in it, fine. I show these books to so-called intellectuals and some of them are just downright irritated. I have shown them to gas station men before and that's okay. But the people that are so-called intellectuals are constantly looking for intellectual material and it's not there. But it's not some whimsical joke or some practical joke that I'm after, because

I care about those things. And I'm not necessarily saying, 'Hey, look everyone, these are pointless.' But I like the idea of a book and I've designed the format and I'll keep that format throughout my books. I just wanted to someday see a hell of a lot of books. [THEY LAUGH]

JJ Yeah, I think it's certainly something that appeals …

ER And it's really a sense of accomplishment.

JJ Well, alright. I guess it is [LAUGHS].

ER It's kind of a personal accomplishment, yeah. Like, art books bore me, they really do … but you're never going to see books that are, like, in this vein.

JJ You don't, that's true.

ER Some technical books are like this. Like some books on geology and land surveying, and things like that. And industrial hygiene books will have just pictures of smoke in the sky and different kind of soots and you know some of these really appeal to me. I go through technical books and there is a lot of good material.

 A whole book on different models of water pumps. And there is something there, somewhere in the middle, it's logical but it's not logical.

JJ That's it, I'm sure I understand. I feel it anyway that this is something. In a way there is an odd similarity between these books and a tendency among some young sculptors, now, the *Primary Structures*⁴ thing – there is in their work and certainly for the spectator a feeling that these objects are simply there without any kind of emotional tie-up. No associations. They can't be thought of as sculpture –

ER Well, no, I wouldn't say that. You couldn't parallel this with the *Primary Structures* – those people who do that kind of stuff, I think they are amused when they think they have said nothing.

JJ Somebody like Dan Flavin,⁵ for example, those light things. Wouldn't you say that essentially there is the same puzzling quality they have of not being anything but a neon tube?

ER No, I wouldn't say that. In the first place, that kind of work really just bores me to tears –

JJ But don't you think these have a boring element, too?

ER Well, maybe they are boring, but it's definitely a book. Their sculpture may not definitely be sculpture. You could mistake them in different surroundings. These books would never been mistaken as anything else but the book. And the photographs would never be mistaken for anything but photographs, and the words are spelled correctly and there is an order to it.

And there is a care taken to it. They take care in their work, too. But it's almost like they don't want to be called sculptors. They want their work to have this nothingness to it.

JJ Right.

ER They all think alike in that respect. About their work reaching nothingness, but that doesn't interest me. I really can't tie anything down. But I know how I feel about certain things.

The first book, *Twentysix Gasoline Stations*, I thought of the title before I even did the pictures. The title just made me do that book. I was driving along seeing all these gas stations about, gas stations, gas stations. How about twenty-six? And I thought of a title of a book, *Twentysix Gasoline Stations*, and that was it.

JJ Twenty-seven wouldn't have been any good?

ER I love titles – that's very important. You know this book on apartments? Some people say, 'Well, you know that's a pretty elegant book because you didn't go down the street and shoot any old apartments that are falling apart.' Well, that's not what I'm interested in. That's for fine arts photographers. For one reason or another I took pictures, and they all just happened to be pictures of apartments that are recently built.

And I think they are pretty, and they are ugly at the same time, and the title of the book: *Some Los Angeles Apartments* – the word 'Some' is *so* incorrect. Like no one would ever …

JJ So imprecise.

ER Yeah. 'Some' is dumb. The titles of my books have just taken on a quantitative thing, like 'Various', 'Some', 'Twentysix'.

JJ To go back to the word painting again, Robert Indiana finds the words that he selects packed with overtones, all sorts of

implications. 'Eat', 'hug', and so on. For him they are kind of key words to the American scene. The words you select don't have any such overtones?

ER No, no.

JJ Do you feel sympathy with the pop art thing?

ER Yeah, quite a bit because their art came out of advertising. And I went through [THE] same thing that Andy Warhol went through. I'd always heard of him because I was in advertising, and he did advertising work. And I was very surprised to see paintings by him.

JJ It seems to me that a certain element about the things he does reflects the same frame of mind that your books do.

ER I suppose some of the attitudes are kind of overlapping … The work of his I like best are probably those soup cans, but as I said we went through the same things, and he sees things quite a bit like I do. And it's like he went through rejecting a lot of things that we were taught about, which is a logical step.

A lot of things the pop artists have done are similar to what I've done: it's using the language of advertising in pictures. A lot of people hate pop art, and I think it's dead, personally, but so many things are going to come out of that that are good, really good.

JJ One thing always being said about the pop artists was that their work was social comment, although actually mostly when they talk they have no such interest.

ER I don't think so at all. Roy Lichtenstein's work I don't take as social comment.

JJ Some of them are very much concerned that their pictures should be seen as fine art. Lichtenstein specifically, and Tom Wesselmann, too. And he's [LICHTENSTEIN IS] very much against the idea that his work should be seen as some kind of observation on the culture that he lives in.

In the case of Andy Warhol there is this extraordinary indifference to the question of whether it is fine art or not. It isn't social comment, it isn't fine art, it isn't anything, and I seem to recognise in your attitude something of the same kind. You don't care whether your stuff's fine art or –

ER Uh, yeah, I do. Whether artists like to admit it or not, they are a
 member of a special family of creative people. And I have no great
 allegiance to any movement or anything like that, and there are no
 pinnacles to any great way of painting. But fine art has a dignity
 about it that will keep work presented well and protected, and
 those are very logical reasons for wanting my work presented as
 fine art. Otherwise people could kick it around like they would
 a billboard, and I don't want that.

 So, I guess you might say that I do think my work is important
 enough that I don't want it kicked around, and I don't want it
 destroyed and forgotten.

JJ But quite apart from what happens with the work itself, do you feel
 that it serves any of the qualities that people associate with fine art?
 Is it purposefully a contribution to the whole body of what people
 call fine art?

ER Well, yeah, sure it's a contribution.

JJ That involves recognition of fine art as having certain values, certain
 qualities which you hope to contribute to in some way or respect –

ER Well, yeah anyone knows that anytime that they get involved in a
 gallery arrangement, a museum arrangement, their work is going to
 be considered as a contribution whether they like it or not. I don't
 care how much Andy Warhol says that he doesn't care whether his
 work's fine art or not.

 Andy Warhol has the idea of giving your work to someone else and
 letting them do it. Well, it's not a bad idea. A lot of people think
 it's just so far out. It's not at all. My work's not like this. My books
 could be, and as I go along I'd like to have some kind of grant and
 be able to hire someone to just do the mechanical part of the book
 because it's a time-consuming thing and time is money, it really is.

 But when I do a painting, I can't hire anybody else to help me.
 I mean my paintings are done in a traditional way, oil on canvas,
 that's it.

JJ What do you suppose art's for? Why do people do it? Is it for
 the artist?

ER It really looks that way. And sometimes I'm amazed when I see
 how much respect people have for the artist. And even though

there are all kinds of bandwagons and trends, and people buying certain artists, I'm surprised to see that, above and beyond all that, people still have a feeling about what an artist might be doing.

I don't want to say I want to make my contribution, because I'm not that interested, but I want to invent some world of my own in this way.

JJ Who or what do you paint for; you?

ER Just for an accomplishment. I'd say that's pretty close to it.

JJ For yourself, essentially?

ER Yeah, I'd say I paint for myself. I want people to buy my work and –

JJ To buy it or to like it?

ER Well, I want people to like it. Now people work for funny reasons and my collectors don't understand work. It's like keeping up with the Joneses and collectors want to be pacesetter collectors, just like artists want to be pacesetter artists.

But I really don't care about that. The money angle of it is good and I'm really thankful. When an artist has to depend on his work for an income, then it's a dangerous thing, it really is. And I'm just glad I don't have to because I got expensive tastes and I like money, and I like what it can do, and I like good dinners and clothing, and that sort of thing. And I'd like to have nice cars and all that, and you just can't do it by painting. And if you could, it'd screw you up badly.

I'm really glad that I don't have to depend on selling the paintings because I don't sell that many paintings. But I do commercial art and I can get along that way. And I'm glad I don't have to teach because I wouldn't know what to tell anyone. I try to keep away from the art world. Not that many friends I have are artists.

JJ What are you going to do with the books?

ER I've done three so far. I'm working on my fourth now and I've got probably two or three other books that I know have to be done. I haven't taken pictures yet but I want them to have the appearance of a body of work. All having the same format. And sometimes the technical work is expensive and time-consuming and I want to get some kind of grant, or a publisher that must leave the final considerations up to me about my books. I can't approach

a publisher and say, 'I got an idea about a book' and they say, 'Well, change it around here a little bit and maybe we can sell it.' It's no use doing the book if that was going to happen. Collaborations are really bad in that respect. So that's why I need something like a grant. And I'm not approaching it as though I'm a photographer, because I'm not.

These pictures in these books are snapshots. But it's a total idea of putting a book together, editing and all that, and I'd like to get some kind of grant for that.

JJ Who do you have in mind?

ER Well, Harry Abrams.[6] Or maybe even a Guggenheim. Maybe Bill Copley,[7] or someone like that. That'd be very good.

LEE KRASNER

Lee Krasner was interviewed by John Jones on the morning of 24 August 1966 (11am), at 830 Fireplace Road, Springs, Long Island, the house on the bay in East Hampton where she had settled with her husband Jackson Pollock in 1945. Krasner was fifty-seven. Pollock had died in a car crash in August 1956 at the age of forty-four.

Born in New York, the fourth of five children in a Russian Jewish family, Krasner, who studied at the Woman's Art School, Cooper Union, at the National Academy of Design and the Art Students League, moved on from her academic training under the neo-cubist influence of Hans Hofmann, who became her teacher in 1937, and then left hard-edge abstraction behind when she saw the work of Jackson Pollock in 1942.

She worked as a mural assistant for Roosevelt's wartime Works Progress Administration (WPA), and made collages for the windows of nineteen department stores for the war effort.

She was part of the American Abstract Artists group and her work at a show at the Betty Parsons Gallery in 1950 (not her first) was all in black and white. It later evolved into colour fields and collages made with the canvas lying on the floor, using cut and then torn shapes and alluding to figures and landscapes, and later to plant forms. After Pollock's death she became an insomniac and her *Umber* series with muted colours was created in artificial light, working at night. In 1963 when she broke her right wrist she worked with her non-dominant left hand.

In 1965 her exhibition at the Whitechapel Gallery in London was critically well received as her influence and importance had begun to be recognised.

In the audio recording of the interview, Lee Krasner sounds like a New Yorker and has a strong, confident voice, and a habit of describing historical events in the present tense, as if reliving them.

JJ I think your work is a pretty pure product of what one might call the American revolution in painting. But this movement itself had antecedents in European movements. Do you feel your work is a step on from that base? What part of European painting do you feel any affinity with?

LK Well, it's a little difficult as a question posed in this form. My own feeling is that all art comes from art. The idea of Europe or America is a geographical boundary and produces, I think, more harm than good – chauvinism is one of the ugliest little heads that's reared sooner or later. So to try to go back to timing, where unquestionably the art was coming from Paris, or Europe, certainly, I was a product. I was aware of it. And then something starts to happen right here. It's as though a seed has moved from one area to the other. Let me say this: to see a [HENRI] Matisse show today will excite me as much as it did back there when I saw it.

JJ When did you first get the idea that you wanted to be a painter?

LK Well, that happened so long ago. I think at the time you leave elementary school – I was about thirteen years of age – you have to designate what you are going to do, to get in high school …

JJ Even then you knew?

LK It was art at that point. I've never been able to understand why it became that, to this date.

JJ Your parents were not the kind to encourage you?

LK Not the least, there was no symptom in my environment that I could put my finger on.

JJ Was there some hostility on the part of your parents?

LK Not in the slightest, they couldn't have cared less. So long as I didn't bother them too much, that was my business. That was all right, they never questioned it. I could have said anything.

JJ And at the high school, what sort of training did you get?

LK A severe, academic training at high school where I did not especially come out with flying colours. In fact, the only reason they passed me in art – this was said clearly to me by my art teacher (and I was majoring in art in high school) – was because I had done so well in my other subjects. It wasn't that there was any encouragement or environment, which mystifies me even more why I stayed with it. That lasts almost up to today, curiously enough.

JJ Really? You still wonder why you're engaged?

LK Well, I ceased wondering a long time ago about why I'm engaged. One can only wonder for a certain length of time. But in terms of outside encouragement, I'd say it's equally true today. But I don't question it. I just go about my business, I've long since accepted the idea that this is what I'm about [LAUGHS].

If I'd failed in my designated choice, art, I'd have had to stay on. The high school was a public school. My parents did not have enough money – when I said that they left me pretty much on my own, I didn't make unusual requests. I then went to a public school, the Woman's Art School, where you had to go in with a body of work, taking the sixty-five passing average, and I was accepted.

JJ Where was this?

LK On Cooper Square, New York City. At some point I moved into the National Academy [OF DESIGN] which seemed to be a little artier, more serious. From the academy comes a break and painting on my own, and then I go back into schooling and that's with Hans Hofmann, who has come to this country and is teaching cubism. So that the European link in that sense becomes Hans Hofmann. Hofmann, I understand, landed first on the West Coast, and then came to New York, and somewhere along the line I joined the class.

I'd been getting nos steadily with regard to my work. There was a man called Victor Perard in Cooper Union, who did favour my work, but didn't open any doors for me, except for the astonishing fact that he said something nice about it. And Hofmann would have been the one where, instead of a constant no: enthusiasm.

JJ Can you tell me about the way he taught?

LK At the time he, as an art teacher, was obviously swinging between Picasso and Matisse, so consequently criticism one week might bear heavily on the Picasso side, and perhaps the next week, or whenever he had his own turn of heart, it would move to a Matisse direction – colour would be the big emphasis. It was simple to understand that he was dealing with this for himself. Certainly that was a direct European continuity. I think he came in twice a week, and made the rounds from easel to easel and said what he had to say.

JJ What were you doing? Drawing the figure, drawing still life?

LK The school primarily had nothing except working from life: either model or still life. You would be drawing or painting from this.

JJ If he was having a week when he was interested in Matisse, he would talk to you about colour. When he was interested in cubism, what did he talk to you about? What did you understand by his cubist thinking?

LK What he was teaching in effect amounted to a violation of your flat canvas, creating three dimensions and then trying to bring it back to the flat plane again. And all your breaking up of planes, linear or in colour, was on the object in front of you, rigidly. You could have no freedom in that sense, you could not leave the object, no matter how far your fantasy was allowed to interpret; it was always geared to the model or the still life in front of you.

JJ At that time, was his influence mainly that you sensed his enthusiasm and vitality, or was it that he made sense? Because some people have suggested to me that often they really didn't understand what he was saying.

LK In effect, both these are true. His English was very poor, and often it didn't make sense, and in fact, many times, I'd have to wait till he'd left the room after I'd got the criticism and call a monitor up (there was always a monitor), and say, 'Would you mind explaining what he said to me?' Oh, yes, there were many such incidents. But then as he was teaching cubism, the principles of it, needless to say this was a very exciting, at the time, thing to dig one's teeth into. Remember my training up to then was academy.

JJ Just to go back one step – when you were talking about the academy training, this was drawing the antique cast, was it?

LK Cast, and then eventually promoted to life, the figure. That's the full traditional, with perspective, with anatomy, the full academy.

JJ I had this ... I know it. At that time, can you recall being particularly fond of any period of art?

LK One factor that occurs here, which is not to do with teaching, but has to do with experience, is that the Museum of Modern Art puts up its first exhibition [IN 1929], and I see for the first time, not through reproduction, my first Matisse, my first Picasso, etc., and this is what causes the revolution. I'm confronted with the live painting and this does do something quite basic.

JJ Was your immediate reaction to it enthusiastic?

LK I felt I'd found myself. This is what I've been looking for all my life. I mean I moved in. I'm sure I didn't know what it was about, but there was no question about the response, none. This is far more significant than anything I may have learnt, before or after, in terms of learning via a teacher, or reading, or looking at reproductions.

JJ Whilst still at the academy, you must have felt some sort of conflict between it and your sudden enthusiasms for these things.

LK That was made clear in the very next criticism. You know, the brushes were flung across the room by the instructor, and he ran out saying, 'I can't teach you anything.'

JJ Really?

LK Quite, and oh, no, that was brought sharply upfront: I'd done something awful, and it was apparent.

JJ You had begun to paint pictures under the influence of this stuff?

LK Well, let me put it this way. I never made a good academy student, so something was wrong with me all the time, although I was trying awfully hard to do what everybody else was doing. It just wouldn't come out right, and by the time there was this reaction, I couldn't care less. One of my instructors, Leon Kroll, who had just come into the academy and was received as though he were Picasso, just simply turned around and told me to go home and take a mental bath; that was his criticism, in a matter of a week from the time of seeing the show. That violent and instantaneous was the reaction. In other words, there was confirmation that some part of me was connected with things that were happening in the world,

that meant more to me than whatever it was in my surroundings. That was the real turning point, I'd say.

JJ Was that really the first time you had any glimmerings of what was happening in cubism?

LK That's right. I had read and seen, but nothing came through to me. It was in the presence of the paintings themselves that this happened, and I didn't know or try to find out what had happened, I simply acknowledged that something very basic had taken place.

JJ This was probably partly influential in your decision to go to Hofmann, was it?

LK I would say. Remember, Hofmann was a contemporary of Picasso's and Matisse's, and he had come from Europe.

JJ So after Hofmann …

LK Well, after Hofmann, I leave and start painting on my own, still very much in this realm, my own interpretation of it.

JJ Are we up to the WPA?

LK Oh, yes, we are in the WPA. I am on my own in my own studio and the next revolution that occurs was Pollock, for me. I meet Pollock,¹ see the work, due to an exhibition that we're both in at the McMillen Gallery. John Graham, who was a painter, arranged the show and selected, and I was informed that it would be American and French painters, and the French painters were these gods, and three unknown Americans, de Kooning, Pollock and myself. I knew [WILLEM] de Kooning, I did not know the name Pollock. I'd never heard it, or if I [HAD] heard it, it meant nothing to me …

JJ How did you come to know Bill de Kooning?

LK Oh, I'd known him for years. He lived in the area. There was a small nucleus of people working in the idiom that interested me – de Kooning was one of them. I was on 9th Street, at the time, and de Kooning had his lodge in 18th Street or some such thing, so that we knew and saw each other. And [ARSHILE] Gorky was part of this thing. It was a small body of artists then, and one saw them.

JJ Was Gorky, up to that point, an important influence? I understand he also gave lessons, but people paid attention to what he was doing and listened to what he had to say.

LK Yes, I'd say that was true, because they were very few people here that were doing anything close to what one felt identified with.

JJ So you had the show at McMillen, and you met Pollock, and his attitudes were also another revelation.

LK As revolutionary as the break Hofmann was from the academy, so was Pollock from Hofmann.

JJ Now, this is a difficult question, but can you say what it was about Pollock's paintings that was so much of a revelation for you – what was he doing that really made you think differently?

LK Well, it is a little difficult, but I remember again, just as I speak, seeing the first live paintings of the French school of painting and the effect it had. Again this happens to me in the presence of the first Pollocks I see, in his studio, when I call on him.

JJ You can't say specifically what there was about them?

LK No, but once more I feel that wheel has turned and one has to deal with it, and there's no question for me about it.

JJ What was he painting at that time? (I know his work quite well.)

LK Well, I would only be able to call a few of them by title, but in the studio, when I walk in, and see the work for the first time, on the wall is *The Magic Mirror*, *Birth*, the *Masked Image*, and others, but these I remember vividly.

JJ You were already in the WPA?

LK Oh yes.

JJ Tell me about that. Were you on the easel painting?

LK No, I don't think I was ever on the easel; I was on the mural, in the role of assistant. I found it gave me more leeway to do what I wanted to do. The ego of the artist being what it is, being sent in as an assistant, you just sort of sat around, because they wouldn't have you touch their work with a ten-foot pole, [BOTH LAUGH] and I felt I could function there, keep about what I'm about more clearly, part of the time. Later on, I did get into the position of having to execute huge murals that other artists had done. I made a deal with the supervisor that I would do this provided I would get my own abstract mural. They consented, [BUT THEN] the WPA. swung into a war service project so I never got my abstract mural.

JJ Who were you assistant to?

LK Oh, I never worked with the artists that did the job, because by the
time these jobs were given to me, the artists no longer were on the
project, but all sketches had been done, all the preliminary research,
like the history of navigation, 180 ft [55 M] of it, going up in some
school. So much time and energy had already been put into these
jobs that they simply needed execution, and I'd be given a group of
people to work with and in effect, I was supervising it.

JJ I asked you this because Bill de Kooning and Charles Maddox
were working with [FERNAND] Léger on a particular project which
came to New York – something to do with the French Line …

LK That's right, I remember when Léger was working here.

JJ Did you meet any of the Europeans that came over here?

LK Oh, I met Léger and I met [PIET] Mondrian, although he was not
on the Project; because I was a member of the American Abstract
Artists and we showed once a year, and invited both Mondrian and
Léger to exhibit with us and they accepted. Consequently I met
Mondrian. I was a great admirer of his work; I met Léger; so to
that extent I had contact with these two Europeans.

JJ When you talked about the Europeans earlier you said, 'these gods'.
Some people have talked about how when the artists appeared from
Europe something of their glamour disappeared. In the sense that
you recognised that they were ordinary human beings engaged on
painting, and they weren't such giants as they had seemed …

LK Yes.

JJ When you met Mondrian and Léger, did you have a sense
of disappointment?

LK No, I didn't have that sense of disappointment at all, with
Mondrian, anyway, thrilled.[2] I think I feel today as strongly about
a Mondrian as I did then, and on meeting the man, there was no
let-down, let me put it that way.

JJ The American Abstract Artists thing – they were dedicated and
almost you might say militant about abstraction … and I believe
that when they had their first meetings, both de Kooning and
Gorky declined to show with them.

JJ … and nobody seems much to know why. The suggestion is that both de Kooning and Gorky were still not sure about leaving the figurative behind, and the out-and-out principles of abstract art were not something they wanted to be completely committed to. Were you sure that abstract art, without any hint of figuration, was what you wanted to do by that time?

LK Well, you bring up some fantastically interesting points in that one question. It is true that Gorky and de Kooning would not join – I do not know why, but as you suggest it is because they are still interested in the figurative. Remember I am working abstractly now, but my abstraction stems from either a figure or a still life, so I find no conflict in this; I don't feel I have to leave something behind.

Around this time, I meet Pollock, and when I bring Hofmann up to meet Pollock and he's confronted for the first time with the work, Hofmann's reaction is in the form of several questions. One pertinent one is: 'You do not work from nature?', and Pollock's answer is, 'I am Nature.'

Now this, I think, is a key in terms of what you call American painting, and the cubist break. Because the cubists at all times have their nature in front of them. Hofmann says you cannot work by heart, you will repeat yourself, and that is when Pollock says, 'I am Nature.' Today it's only ten years since Pollock has died. We have a new rigid academy – *avant, avant, avant*, purer and more holy than thou. Once more it's back to when I was in the American Abstract Artists group, with the same rigidity, and once more one has to say [SPEAKS SLOWLY AND EMPHATICALLY] 'Get Out of My Way'.

JJ That's splendid. Now that bit about with Hofmann and Pollock is intriguing for me. I've suggested to some people that – I was going to say, abstract expressionism, but I mean Pollock – Pollock's work had, up to the point of the large drip canvases, been not far removed from Picasso, or let's say it was in that vein. Picasso was one of the people he must have looked at quite a bit.

LK Oh, considerably.

JJ Cubism was a very important movement for him.

LK He was extremely aware of it.

JJ But many people have talked to me as if cubism and surrealism are on two sides of a fence and some people came to cubism and some to surrealism. It always seemed to me that Pollock managed to combine both, and although he probably deplored the literary aspect of the surrealists (the dreams, storytelling), the principles of unconscious motivation were very close to him.

LK Extremely close. Exactly. He merged them. He was able to state what the surrealists had brought in, in painting terms, not in theory. To merge. And this was possibly projected as the one step that we call American – 'the Break'.

I loathe the slogan 'American painting' – it lumps anything and everything, and it depends on who's mentioning the Americans, so you have chauvinism instantly. That is not healthy in terms of an interest in art. That Pollock is an American painter can never be denied, but to use the phrase that will carry anything and everyone is a muddiness I tend not to be able to live comfortably with.

JJ Well, the truth is that, but for various reasons – the war, economics – Pollock might well have been working in Paris. The tradition is quite clear, it seems to me. It was a break, certainly, but that it happened in New York is a fact, too.

LK No one can deny this fact, but to make it a chauvinistic provincial phrase is shocking to me.

JJ (Can I cadge a cigarette, please?)

LK Please – do you mind those?

JJ (I usually roll my own, but I've run out … thank you.)

I want to talk to you about Pollock but also about your own work. I don't know how to put this without it sounding very journalistic – but do your paintings come out of a mood? Are they expressive of states of mind that you're in?

LK I do find that they're expressive of my state of mind. But one thing I've observed is the timing sequence, and they never necessarily gel.

JJ What about the timing sequence?

LK Well, let us say I can remember a painting I did at what I would have described [AS] possibly the saddest moment of my life; you'd be hard put, if I put that canvas in front of you today, to understand

it, even as I don't to this day. It's alive, joyous, full of optimism, and I've never been able to understand the timing sequence, because I do remember the state of mind I was in, consciously, at the time I painted the picture. Now I have dealt with this for myself, privately, at great length and have come up with no answer.

JJ Is it conceivable that the painting was an escape from the mood you were in? Does it express the world you went into to get away from it?

LK I doubt it. Well, it's possible. As I have no answer, anything is possible. I haven't resolved it; I am only aware that the conscious part of me was about as far away as you can get from what came through, so I only know that the time is not necessarily one and the same thing.

JJ No, the time of the painting and the mood.

LK If when you're doing your painting it is really coming through and not being willed. That's essential.

JJ Yes. In a sense this is a confirmation of the theory about it coming from unconscious sources. Your conscious mind may be depressed, but your unconscious may find very vital and lively things to say.

LK Right. And I don't think it has anything to do with escape in the slightest sense because there you'd have to be aware of what you were doing and what you were trying to escape from; and there was no such state of mind. I have no answer on it, I simply accept it.

JJ Yes. Do you find that some of your paintings have a mood which you would call gloomy?

LK Oh, yes. Oh surely.

JJ And does that sometimes come on occasions when you yourself feel very lively and bright?

LK Yes, but I can't quote it as a hard, fast rule either, so that it's a little elusive.

JJ So on the whole there doesn't seem to be an immediate connection between the mood of the painting and the mood you happen to be in when you paint it?

LK For me, that is absolutely true.

JJ Good, that's interesting. Now, moving away from this question of the subconscious, it's been suggested to me that when the war came and the WPA folded, many artists felt a certain political disillusionment, a disappointment, because many were progressively left-wing, and then the war came and they got tired of art in the service of their politics. So they tended to go into their studios and paint pictures which were more introspective, less related to social commitment. Some people see this as one of the seeds of the change, this turning inwards. Would you go along with this?

LK I, for one, didn't experience it that way, and – you mustn't misunderstand me, it wasn't that there wasn't an awareness of what was happening, and some kind of participation – but one felt that the canvas was not the vehicle by which you expressed or illustrated this phenomenon.

JJ Did you think on the whole, the Project was a good thing?

LK I would say, definitely it was good, if for no other reason it kept artists alive through an extremely difficult financial time. I keep that strongly in mind.

JJ What reservations would you have about the Project?

LK Reservations would be the usual red tape that sets in instantly on anything that is run on this scale wherever the work was allocated or for whoever. The principal of a high school could say what he wanted put up on the wall. I do not think art is democratic. I do not think that everybody can have their say on art. But by and large, the main issue is that, speaking for myself as well as [AN] awful lot of other artists, it was a way to stay alive and continue working, and that one must not overlook [LAUGHS].

JJ But you hold strongly that vast organisation of art is not possible?

LK It's outrageous; it's outrageous.

JJ Like the thing about a camel being a horse designed by a committee.

LK Exactly. In any other profession, let's say law, you don't have that freedom of saying I have my opinion, and can go about it. The arts are wide open. Everyone cannot say what is art. It is not democratic, it can never run in that large sense of democracy or representation in numbers. Unfortunately that is not the nature of it.

JJ What do you think art's for?

LK What do I think art is for? I'm sure I haven't got the answer to that.
I simply accept the fact that it is as old as man and part of man,
and goes through phases where it's holier than thou, down to where
it's everybody's cup of tea. So I say it's as big as life and here to stay,
and curiously enough civilisation is measured by its art.

JJ In the end do you do it for yourself? This can be misunderstood, but
in the long run, is the artist a selfish person or an obsessed person?

LK I don't want to speak about the artist because I speak about myself.
I dare not talk about 'the artist', per se. I would say 'selfish' would
be the last phrase I'd use to define it, as, to the extent the artist
finds, they give on an overwhelming scale, so 'selfish' would never
be my definition.

JJ I guess that for some artists, art is an almost holy mission, for
others it's much more of a personal thing they've got to get out
of their system and they really don't know what its utility is, what
value it has. I suspect from what you have said that you're rather
optimistic about the meaning of art, its value in the world.

LK The meaning of art? Extremely optimistic about it. I never question
it for a second, never have, and still don't, and I'm in a role that
takes a good deal of knocking, both as a painter, Lee Krasner, and
as the widow of Jackson Pollock.

JJ I really don't want to intrude on your private thoughts about
Pollock at all, but since he was such an important figure and you
were so close to him, I can't help wanting to know a little bit more
about him as a person. He always, I believe, drank a lot, did he not,
or is this something you don't want to talk about?

LK Oh, I don't mind speaking about it, you know, it's common
knowledge he drank. Let me say that in the time I was with
Pollock, he had the problem of drinking and [THERE WERE] all but,
I think, two years where he didn't drink. And it is equally true that
he never stopped, through the entire period I was with him, trying
to get assistance to break this thing. Never, for a second. And he
tried everything that could be tried. Unfortunately, he was stuck
with it, as the problem of alcoholism is still an unresolved problem,
so that medical science or psychiatric help, or religious help, has not
been able to give the answer to that one, but I think it's important

to know that he didn't accept it. Till the very end, at the time he died, he was still trying to do something about this.

JJ Were his drinking and his painting linked in any way, would you say, or were they just two separate aspects of him?

LK My own feeling is that they were not linked. He never went near the studio when he was drunk, or drinking. He would have his cycles of drinking either before he went into a painting phase, as he worked in cycles, or after he came out of them. As I lived with him through this, I have as close an insight as an outsider can have to it.

JJ Do you think that any release that stopped him drinking had anything to do with the painting? Was it necessary for him?

LK In a broad sense, everything you do has to do with your paint, but if you rephrase the question and, say 'Do I think if Pollock never drank in his life he would have done the kind of work he did?' I would be arrogant enough to say: 'Yes, I think he would have.'

JJ That's the answer I guess I wanted.

LK Because I do not believe that the core or stem or genius or whatever it is that constitutes the human being, and in Pollock, I'm speaking now of him, was tied up with the fact that he drank.

JJ No, the only reason I asked about the drinking was I wondered if it might not have been necessary for someone of his temperament to get at his unconscious by the release of tension through drinking?

LK I can't say. The fact of the matter is that in the two-year period, which is the only period I know about, where he literally did not take a drink, his work did not suffer one bit. The intensity of the work, the output didn't suffer. It would be nice perhaps to note that when Jackson got difficult, and remember I'm living with him, I'm taking a big load of it, he would say when he was out of it, and we talked about it a little bit, he would say, 'Try to take it, and I know how hard it is' – for me, that is, whatever the incident was – 'Try to think of it as a storm that comes and it will be gone.' Which was his way of trying to deal with things: a storm comes, it passes.

JJ It must have been very tough for you.

LK It wasn't easy for him, either.

JJ Well, for either of you. I wonder if in your contact with artists you remember any particular anecdote?

LK Any anecdote … Offhand it's a bit difficult. But there's one little story I do adore and this is: I now have met John Graham because of the show, and as Graham is quite close to Pollock at this point the three of us are seeing a good deal of each other, and we're walking up Greenwich Avenue one cold winter night and we're confronted by this man approaching us – very short with a long coat on down to his ankles practically, and John stops and speaks to this man and realises we don't know who he is. And he turns around and he says, 'Oh, you don't know each other, I'd like you to meet Lee Krasner and Jackson Pollock, the greatest painter in America, and this is Frederick Kiesler.'³ Now Kiesler was wearing a hat, and as I say, he had this long coat on that literally came down to the sidewalk, and he took his hat off, and with a long slow bow that went down to the sidewalk and slowly came up, at eye level, he said, 'North or South America?' It was delicious. And this, remember was at a time when the name Pollock was unheard of, but this is the way John Graham introduced Jackson. 'The greatest painter'. 'North or South America'!

JJ Do you think that Pollock left figuration behind reluctantly?

LK I don't think he ever left it behind. Because I now argue with, you know, all our authority on Pollock to date, because to begin with, Pollock never stopped swinging between where he chose to allow the image to be seen more clearly, or using his phrase 'veil the image', but that he ever left the image is not so. I am quoting Pollock on what he has to say about his work, and I get more stunned every time I read another article on who remembers what Jackson did when … to fit a little convenient piece of art history, to promote whatever they're promoting. PR work is what I call it.

JJ After those large drip paintings, towards the end of his life, he was still working on things that had an unmistakeable imagery.

LK Well, there was a full black-and-white show in '51 at the Betty Parsons Gallery, where he chose to allow the imagery to show once more. He always – this is his terminology – either let the image be seen more clearly or he chose to veil it.

JJ He went through that interest in mythology and mythological subjects, didn't he? Where the image is still apparent but it's no longer taken from nature in the cubist sense.

LK No because he tried not to get in the way of the painting. And his early background gives us his interest in Jung and the surrealists. He says, 'It becomes a mess if I try to interfere with what's coming through.' He accepts what comes through. And because of his belief in the subconscious holding more than the momentary view of the tree in front of him, it all fits into a picture that's very understandable of the source of how he worked.

JJ The large drip paintings contained, though veiled, a specific image?

LK He always – quoting Pollock – 'worked with the image.' There'd be a phase where he lets it through, there'd be a phase where he veiled it. I loathe the word 'drip'.

JJ I don't know how else to call it …

LK Well, you can't because this has become our definition of it and I think it's *Time* magazine that defined it that way. He does do the black-and-white show in '51, which follows this period where the image once more is allowed to come through, and following that are a good many other canvases where the image comes through and then once more veiling again, as in *Blue Poles*.

JJ Do you know why he gave up the brush?

LK No. I daresay he chose his material to work with what he had to say. On the brush: that first visit of Hofmann's, I think no-one was more shocked than when Hofmann saw Pollock's palette: cans of paint with brushes stuck in them. And Hans, who did everything but scrub his studio with lye at the end of each session – and I mean that not lightly – went to pick up the brush and a whole can came up with it, and he said, 'With zis you could kill a man!'

JJ When he came to run the paint off the stick onto the canvas you believe he really did have this under control, he was really a master of this technique?

LK He had it under control all right, he also used the accident.

JJ Yes, how much did he use the accident?

LK It was his judgement how much of it he used and how much not to use, which is no different than anyone who is working very wilfully and consciously makes a decision to do this or the other.

NOTES

ROY LICHTENSTEIN, PP.21–37

1 In New York.
2 John Rublowsky's *Pop Art*, published January 1965.
3 See Lichtenstein's *Brushstroke 1965*, Tate (pl.6).
4 The work of Franz Kline (1910–62) looked like it was executed in big, bold, spontaneous strokes.
5 *Woman with Flowered Hat* 1963, from Lichtenstein's Picasso series.
6 Rudolf Arnheim (1904–2007) was a German-born author, art and film theorist, and perceptual psychologist.
7 Roy Lichtenstein *This Must Be The Place* 1965.
8 Roy Lichtenstein *Roto Broil* 1961.
9 Kenneth Noland (1924–2010) was one of the best-known American colour field painters, although in the 1950s he was thought of as an abstract expressionist and in the early 1960s as a minimalist painter.
10 This quote is not entirely audible, but Juan Gris (1887–1927) said something similar here: 'I start from the cylinder to *create a* special kind of individual object. I *make* a bottle *out* of a cylinder.'
11 By 'the other thing' Jones means the abstract elements of the painting that are not simply the subject.
12 Ileana Castelli, nee Shapira, wife of Leo (co-founders of the Castelli Gallery).
13 Work from the Tremaine collection of contemporary American artists assembled by Burton and Emily Hall Tremaine.
14 Robert Scull (1915–86) American art collector with a world-famous collection of pop and minimal art.

AD REINHARDT, PP.39–55

1 Paul Tillich (1886–1965): American-German Protestant theologian and existentialist philosopher, author of *The Courage to Be* (1952) and *Dynamics of Faith* (1957).
2 Martin Buber (1878–1965): Austrian-Israeli philosopher who wrote about Jewish mysticism and his 'philosophy of dialogue', a form of existentialism.
3 Japanese Buddhist, scholar and author D. T. Suzuki (1870–1966) was instrumental in spreading interest in Zen and Shin to the West. He was nominated for the Nobel Peace Prize in 1963.
4 Ananda Coomaraswamy (1877–1947): Ceylonese Tamil philosopher who was largely credited with introducing ancient Indian art to the West.
5 Jacques Maritain (1882–1973): French Catholic philosopher with an interest in aesthetics, politics and education, who was instrumental in the drafting of the Universal Declaration of Human Rights.
6 André Malraux (1901–76): author, art theorist and French Minister for Cultural Affairs. Cf. this later interview: 'Though he teaches Oriental art history (at Brooklyn and Hunter colleges), Reinhardt denies any undue Eastern influences on his purist pursuits. "Artists," he says, "should have a kind of Malrauxian point of view, in which the whole history of art is known to and is part of them. Otherwise, they're idiots, children" (his lip curls) "or romantics."' – Grace Glueck, 'Mr. Pure', *New York Times*,

13 Nov. 1966.
7 George Kubler's short book *The Shape of Time: Remarks on the History of Things* (1962) challenges the notion of style by placing the history of objects and images in a larger continuum.
8 Apart from the ridiculousness of Reinhardt's paintings (black squares) having anything in common with Sir Joshua Reynolds's society portraits, this joke is based on the fact that Blake and Reynolds were famously at odds. Blake thought Reynolds lazy, academic and hypocritical.
9 Josef Albers (1888–1976): German-born artist and educator. He taught at the Bauhaus and Black Mountain College, headed Yale University's department of design, and is considered one of the most influential teachers of the visual arts in the twentieth century. He was also an abstract painter, a photographer, muralist and printmaker.
10 Hans Hofmann (1880–1966): German-born American painter, renowned as both artist and teacher. He is considered to have both preceded and influenced abstract expressionism.
11 Erich Fromm (1900–80) was a German social philosopher whose book *The Art of Loving* (1956) proposed that love was a skill to be honed in the way artists apprentice themselves to the work on the way to mastery, demanding of its practitioner both knowledge and effort.
12 The Institute of Contemporary Art in London.
13 László Moholy-Nagy (1895–1946): Hungarian painter, photographer, writer and professor in the Bauhaus school who advocated the integration of technology into the arts, and was a pioneer of modernist design.
14 Billy Rose (1899–1966): Broadway impresario.

CLAES OLDENBURG, PP.57–73

1 When someone delivers a car to a new owner.
2 Referring to Andy Warhol's eight-hour black-and-white film of the Empire State Building, *Empire* 1964.
3 Oldenburg is here referring to Jasper Johns's *Ale Cans* 1964.

SAUL STEINBERG, PP.75–87

1 Adolph Gottlieb (1903–74): first generation American abstract expressionist painter and sculptor.
2 Steinberg, originally a European, is conscious of identifying himself as American.
3 It is interesting that Pre-Raphaelite painting is cited by Jones as an example of particularly bad art. In the 1960s, Pre-Raphaelites – pious Victorian storytellers – were completely out of fashion and the antithesis of modern art.
4 Russian peasants.
5 Ben Shahn (1868–1969) was a Lithuanian-born American artist best known for his works of social realism, his left-wing political views, and his series of lectures published as *The Shape of Content* (1957).
6 Jugendstil, 'youth style' was the German equivalent of art nouveau.
7 Ugo Stille (1919–95): famous Italian journalist and editor of Italy's most authoritative newspaper,

the *Corriere della Sera* of Milan. In Italy, he was recognised as the best of the Italian correspondents in the United States, and a key point of reference for anyone wishing to understand that country.

8 This *apercu* perhaps explains why John Jones used the taped interviews in lectures, but did not put them into a book; the voices were closer to the real landscape.

ROBERT INDIANA, PP.89–101

1 Indiana is referring to the 'Kitchen sink' school of British painting. Named by David Sylvester in December 1954, just after Indiana returned to New York. The group of artists included John Bratby, Derrick Greaves, Edward Middleditch and Jack Smith, who painted scenes of everyday working-class life and represented Britain in the 1956 Venice Biennale. (See: https://www.tate.org.uk/art/art-terms/k/kitchen-sink-painters)

2 'The American Dream' is a recurrent phrase that appears in Indiana's work. At the time of this interview, Indiana had completed six paintings in what would become his longest running series of paintings, *The American Dream*. *The American Dream, I* had been purchased from his first New York exhibition by the Museum of Modern Art, New York, and helped launch his career.

3 Indiana is talking about the *Confederacy* series that addresses the civil rights struggle in the American south. The topic lasted. He intended to create one painting for each of the fourteen states that seceded from the United States in order to preserve slavery, leading to the US Civil War. Four paintings in the series were completed: *Alabama, Mississippi, Louisiana* and *Florida*.

4 The canvas identifies Selma, Alabama, scene of civil rights marches for voting rights for Black people, including 'Bloody Sunday', 7 March 1965, in which state troopers hospitalised seventeen people.

5 The Coenties Slip neighborhood, a three-block-long area on the East River at the southeasterly tip of Manhattan, where Robert Indiana lived in a former ship chandlery from 1956–65. His neighbours included the artists Ellsworth Kelly, Agnes Martin, Lenore Tawney, and Jack Youngerman. The name and the place are also commemorated in his work.

6 'Rose is a rose is a rose is a rose' is a line from the 1913 poem 'Sacred Emily' by Gertrude Stein (1874–1946). Stein suggested that it referred to a pre-Romantic moment when a rose was just a rose and not a symbol.

7 *I Saw the Figure 5 in Gold* 1928 by Charles Henry Demuth (1883–1935) was Indiana's favourite painting in the Metropolitan Museum of Art, New York. The title is taken from the poem 'The Great Figure' by William Carlos Williams (1883–1963). Inspired by Demuth's use of words in his art, Indiana painted *The Demuth American Dream No. 5* in 1963.

8 *The Calumet* of 1961, incorporates lines from Henry Wadsworth Longfellow's 1855 poem 'Song of Hiawatha.' 'Calumet is a town in Indiana ... and *The Calumet* is a heroic painting. It isn't about geography, it's about Longfellow and his poem *Hiawatha* and the continent's first citizens and again a great tragedy.' – Robert Indiana, Interview with Susan Elizabeth Ryan, 14 November, 1991, transcript, p.17;

Ryan papers, Robert Indiana Catalogue Raisonné Archive.

9 President Lyndon B. Johnson's wife, Lady Bird Johnson, had a campaign to beautify cities and remove billboards and junkyards from highways, which she thought would reduce tensions and improve welfare. Johnson supported the idea and the Highway Beautification Act had just been passed in the Senate on 16 September 1965 and in the House of Representatives on 8 October. It was that week's news.

10 Stuart Davis (1892–1964): American modernist painter, precursor of pop.

MAN RAY, PP.103–15

1 Adolphe Monticelli (1824–86): French painter, forerunner of the impressionists.

2 Victor Brauner (1903–66): Romanian surrealist painter and sculptor.

3 *Self-Portrait* by Man Ray, London 1963, republished London 1988.

4 Possibly he means art critic Henry McBride (1867–1962). As a writer during the 1920s for *New York Sun* and the avant-garde magazine *Dial*, McBride became one of the most influential supporters of modern art, both European and American, in his time.

5 Readymade: a term first used by Marcel Duchamp (1887–1968) to describe the works of art he made from manufactured objects.

6 291, the gallery owned and run by the photographer Alfred Steiglitz (1864–1946) at 291 Fifth Avenue, which ran from 1905–17.

7 Guillaume Apollinaire, *Calligrammes: Poems of Peace and War (1912–16)*, 1918, a book of concrete, or visual, poetry.

8 Comte de Lautréamont, *Les Chants de Maldoror*, 1898, a surreal poetic novel.

9 It is hard to know what Man Ray thought was tactless. Something in Jones's tone that was not respectful enough? An interruption? Jones sounds surprised. Perhaps it's a joke.

10 Cadaqués is a town on a bay in Catalonia in Spain, popular with artists including Salvador Dalí (1904–89) and Pablo Picasso (1881–1973).

HELEN FRANKENTHALER, PP.117–25

1 'Duck' is cotton canvas.

2 Surrealist Max Ernst (1891–1976) used techniques to stimulate images from his unconscious mind, and create accidental patterns.

3 Bennington College, Vermont – the visual and liberal arts college that Frankenthaler herself attended. She graduated in 1949.

4 An allusion, presumably, to a remark Frankenthaler made in the missing section.

ROBERT MOTHERWELL, PP.127–39

1 Max Weber (1881–1961), one of the first American cubist painters, who later returned to figurative Jewish subjects.

2 Diego Rivera (1886–1957): Mexican artist whose large frescoes helped establish the mural movement.

3 John Marin (1870–1953): early American modernist artist.

4 Alexander Calder (1898–1976): sculptor known for his mobiles.

5 John Graham (1886–1961): Ukrainian-born modernist artist.
6 For Motherwell, Greenwich Village was not grand, but by the time Jones lived there it felt like the *haut monde* (high society).
7 Thomas Hart Benton (1889–1975): American painter and muralist at the forefront of the regionalist art movement, along with Grant Wood (1891–1942) and John Steuart Curry (1897–1946), painting everyday scenes of us life.
8 Roberto Matta (1911–2002): Chilean-American surrealist artist and abstract expressionist.
9 William Baziotes (1912–63): American painter influenced by surrealism and a contributor to abstract expressionism.
10 Wifredo Lam (1902–82): Cuban artist who sought to portray the enduring Afro-Cuban spirit and culture. Also inspired by Pablo Picasso, Henri Matisse (1869–1954), Frida Kahlo (1907–54) and Diego Rivera.
11 Sidney Janis (1896–1989): wealthy clothing manufacturer and art collector who opened a gallery in New York in 1948. He exhibited the work of leaders of abstract expressionism, and also of European artists such as Pierre Bonnard (1867–1947), Paul Klee (1879–1940), Joan Miró (1893–1983) and Piet Mondrian (1872–1944). The critic Clement Greenberg said in a 1958 tribute that Janis's policy 'not only implied, it declared, that Jackson Pollock, Willem de Kooning, Franz Kline, Philip Guston, Mark Rothko, and Robert Motherwell were to be judged by the same standards as Matisse and Picasso, without condescension, without making allowances'.
12 Jsreal Ben Neumann (1887–1961): Austrian gallery owner, author and publisher who opened his gallery in New York in 1923, championing progresssive living artists.
13 Alfred Hamilton Barr Jr (1902–81): an American art historian and the first director of the Museum of Modern Art in New York.
14 Bradley Walker Tomlin (1899–1953) was one of New York School abstract expressionist artists. He participated in the famous *Ninth Street Show*.
15 John Edwin Canaday (1907–85): an American art critic, author and art historian.
16 *Possibilities* 1948 had contributions from the composer John Cage (1912–92) and the architect Pierre Chareau (1883–1950).
17 *Verve*: modernist Parisian art magazine published from 1937–60. The first cover featured artwork by Henri Matisse. Thirty-eight issues in ten volumes contained lithographs by prominent Parisian artists of the time, and early contributors included James Joyce (1882–1941) and Ernest Hemingway (1899–1961).
18 *Minotaure*: surrealist magazine published in Paris from 1933–9.

LOUISE NEVELSON, PP.141–53

1 Nevelson is surely referring to Rudolf Nureyev, who defected from Russia in 1961, danced with Margot Fonteyn in New York in April 1965, before a three-month us tour.
2 Louise married Charles Nevelson in June 1920, when she was twenty-one. His family, shipping magnates, disapproved of her practising art. She commented: 'My husband's family was terribly refined. Within that circle you could know Beethoven, but God

forbid if you were Beethoven.' They separated in 1932 and divorced in 1941.
3 Karl Nierendorf opened his eponymous gallery in New York in January 1937, on 53rd Street and across from the spot where the Museum of Modern Art would inaugurate its new building.
4 Norlyst Gallery, 59 West 56th St, New York.
5 Georges Mathieu (1921–2012): a French abstract painter, art theorist and member of the Académie des Beaux-Arts in Paris. He is considered one of the fathers of European lyrical abstraction.
6 Pierre Soulages (b.1919): a French painter, engraver, and sculptor.

JIM DINE, PP.155–69

1 Sidney Janis Gallery, 15 East 57th Street in Manhattan. It shared the fourth floor with the Betty Parsons Gallery and opened in 1948. In the 1950s it promoted the abstract expressionists, but the groundbreaking *International Exhibition of the New Realists* (autumn 1962), in a rented storefront at 19 West 57th Street, promoted pop art, and Motherwell, Rothko, Guston and Gottlieb left the gallery in protest. The gallery represented pop artists Claes Oldenburg (b.1929), Jim Dine (b.1935), Tom Wesselmann (1931–2004), George Segal (1924–2000), Öyvind Fahlström (1928–1976), and Marisol (1930–2016).
2 Robert Fraser Gallery, 69 Duke St, London. Dine had a celebrated show there in June 1965.
3 Homer Lusk Collyer (1881–1947) and Langley Wakeman Collyer (1885–1947), known as the Collyer brothers, were two American brothers who became infamous for their compulsive hoarding. For decades, the two lived in seclusion in their Harlem brownstone at 2078 Fifth Avenue (at the corner of 128th Street) in New York, where they obsessively collected books, furniture, musical instruments, and many other items, with booby traps set up in corridors and doorways to crush intruders. In March 1947, both were found dead in their home surrounded by over 140 tons of items they had amassed over several decades.
4 A reference to a spacewalk happening at the time, when Eugene Cernan became the third person to walk in space.
5 Master printer Chris Prater, founder with his wife Rose Kelly of Kelpra Studio.
6 Editions Alecto was a print publisher founded in Cambridge in 1960 by students Paul Cornwall-Jones and Michael Deakin. The company moved to London in 1962 and began selling graphics by contemporary artists, starting with *A Rake's Progress* 1963, a portfolio of etchings by David Hockney when he was still a student.

ROBERT RAUSCHENBERG, PP.171–83

1 Pablo Picasso made 'sand reliefs' over two weeks in the summer of 1930. For example, *Composition With Glove*. (Rauschenberg was born in October 1925).
2 Funny papers: the part of the newspaper with coloured comic strips.
3 Johann Wilhelm Klüver: electrical engineer at Bell Telephone Laboratories who lectured on art and technology and social issues to be addressed by the technical community, and founded Experiments in

Art and Technology.

4 John Jones was afraid of snakes.
5 'Painting relates to both art and life. Neither can be made – I try to act in the gap.' – Rauschenberg, from the exhibition catalogue *Sixteen Americans*, The Museum of Modern Art, New York, 1959.

MARCEL DUCHAMP, PP.185–97

1 Retinalism is just capturing optical data, or how things look.
2 Meaning with a step back, from a distance, with hindsight.
3 In the second field: Jones seems to mean in life rather than art.
4 The title of this work in English is *In Advance of the Broken Arm* 1915. (The fourth version of this work – after the lost original – is illustrated in pl.17.)

LOUISE BOURGEOIS, PP.199–217

1 The Vallée de la Bièvre is some 15 km outside Paris. The Bièvre river flows into the Seine in Paris.
2 Bourgeois's mother died in 1932, at least thirteen years after she contracted the Spanish flu, from which she never fully recovered.
3 The Académie Julian was a private art school founded in Paris in 1867 by Rodolphe Julian (1839–1907).
4 The Académie de la Grande-Chaumière: art school in Montparnasse.
5 In 1938 Bourgeois married the American art historian Robert Goldwater and moved to New York, where they raised three sons, the first of whom was adopted. Bourgeois's account here differs from some other accounts of their meeting.
6 The Académie Ranson was founded in 1908 in Paris. It was founded by the French painter Paul Ranson (1862–1909). He studied at the Académie Julian.
7 Roger Bissière (1886–1964): French painter known for his contribution to cubism, who also produced stained-glass windows for Metz cathedral. He was a friend to André Lhote (1885–1962) and Georges Braque (1882–1963) and influenced by Corot (1796–1875) and Picasso's neoclassical work.
8 Étienne Martin (1913–95): French non-figurative sculptor worked at the Académie Ranson.
9 François Stahly (1911–2006): German-French sculptor.
10 Robert Vlerick, sculptor, taught at the Académie de la Grande-Chaumière.
11 Vaclav Vytlacil (1892–1984): American artist and art instructor. Among the earliest advocates of Hans Hofmann's teachings in the US. Bourgeois studied with him at the Art Students League in New York.
12 Hans Hofmann (1880–1966): German-born American painter and teacher. His career spanned two generations and two continents, and influenced abstract expressionism.
13 Varian Fry, journalist, founded the Emergency Rescue Committee which helped people who escaped from the Nazis.
14 Fry died of a cerebral haemorrhage in September 1967.
15 Jacques Lipchitz (1891–1973), Lithuanian-American Cubist sculptor.
16 Surrealist painter Roberto Matta (1911–2002).
17 Office of Wartime Information.
18 Raymond Duncan (1874–1966): American dancer,

artist, poet, craftsman and philosopher, and brother of dancer Isadora Duncan. He opened a school for all the arts, the Akademia, at 31 rue de Seine.
19 The Bertha Schaefer Gallery of Contemporary Art in New York, founded 1944.
20 Alfred Hamilton Barr Jr (1902–81): American art historian and first director of the Museum of Modern Art, New York. He bought Bourgeois's *Sleeping Figure* 1950 in 1951 for the Museum. He was one of the most influential forces in the development of popular attitudes toward modern art.
21 Frederick 'Erick' Hawkins (1909–94): American modern-dance choreographer and dancer.
22 The Peridot Gallery founded by Louis Pollack in 1948.
23 Used in this context to mean withdrawn, distanced.
24 Stanley William Hayter CBE (1901–88): English painter and printmaker associated in the 1930s with surrealism and from 1940 onward, with abstract expressionism. One of the most significant printmakers of the twentieth century, founder of the legendary *Atelier 17* studio.
25 A steel engraving tool.
26 Harold Rosenberg (1906–78): American cultural critic who coined the term 'action painting' for what later became known as abstract expressionism. In 1967 he became the art critic of the *New Yorker*.
27 James D. Brooks (1906–92): American muralist, abstract painter, and winner of the Logan Medal of the Arts.
28 Philip Guston, born Phillip Goldstein (1913–80): Canadian-American painter, printmaker, muralist and draughtsman.
29 In about 1945, Charles Egan opened the Charles Egan Gallery at 63 East 57th Street. Egan's artists helped him fix up the gallery: 'Isamu Noguchi did the lighting … Willem de Kooning and Franz Kline painted the walls.'
30 Reuben Nakian (1897–1986): American sculptor and teacher of Armenian extraction. Greek and Roman mythology are recurring themes in his work.
31 Dwight Macdonald (1906–82): American writer, critic, philosopher and activist. Editor of the leftist magazine *Partisan Review*, and film critic for *Esquire* and 'The Today Show' in the 1960s.
32 George Segal (1924–2000): American painter and sculptor associated with pop art.
33 Epic.
34 *The Bride Stripped Bare by Her Bachelors, Even* (*La mariée mise à nu par ses célibataires, même*), often called *The Large Glass* (*Le Grand Verre*), is an artwork by Marcel Duchamp. It consists of two panes of glass and materials such as lead foil, fuse wire and dust. It stands at 2.7 m (9 ft) tall. Duchamp worked on the piece from 1915 to 1923.
35 Frederick John Kiesler (born Friedrich Jacob Kiesler) was an Austrian-American architect, theoretician, theatre designer, artist and sculptor.
36 From the ACA Galleries, 20th Street, New York, founded 1932.
37 Bourgeois is referring to salt lick, which is put out in blocks to deter deer from eating crops.
38 Apremont is a small village in southeast France, in the Savoy department, in the Rhône-Alpes.

GRACE HARTIGAN, PP.219–41

1 For a while Hartigan (who had already been married to Bob Jachens) was in a relationship with the painter Ike Muse (1914–2001). She moved to New York with him in 1945.

2 Alfred Leslie (b.1927) first achieved success as an abstract expressionist painter, but changed course in the early 1960s and became a painter of realistic figurative paintings.

3 Robert Goodnough (1917–2010): American abstract expressionist painter. Among the twenty-four artists included in the famous *9th Street Art Exhibition* (1951), and in all the *New York Painting and Sculpture Annuals* from 1953 to 1957.

4 Harry Andrew Jackson (1924–2011), born Harry Aaron Shapiro Jr, began his career as a marine combat artist, then later worked in the abstract expressionist, realist and American western styles. Grace Hartigan was briefly married to him. A 'frivolous' marriage, she said.

5 Philip Guston, born Phillip Goldstein (1913–80): Canadian-American painter, printmaker, muralist and draughtsman.

6 French surrealist Yves Tanguy (1900–55).

7 Milton Avery (1885–1965). His use of glowing colour and simplified forms was an influence on younger artists Adolph Gottlieb and Mark Rothko (1903–70).

8 David Smith (1906–65): American abstract-expressionist sculptor and painter, best known for his large steel abstract geometric sculptures.

9 William Baziotes (1912–63): American abstract-expressionist painter influenced by surrealism.

10 Robert L. Iglehart (1912–2008): chair of the art department at NYU from 1946. He was instrumental in fostering the abstract artists movement.

11 Anthony Peter Smith (1912–80): American sculptor, visual artist, architectural designer, and art theorist, a pioneering figure in American minimalist sculpture.

12 Sonja Sekula (1918–63): Swiss-born artist linked with the abstract expressionist movement, notable for her activity as an 'out' lesbian in the New York art world during the 1940s and early 1950s.

13 Musician John Cage. They all lived on Grand Street.

14 Robert De Niro Sr (1922–93): American abstract expressionist painter (and the father of actor Robert De Niro), much influenced by Matisse.

15 John Marin (1870–1953): a seminal American modernist, known for his abstract landscapes and watercolours.

16 Max Weber (1881–1961): one of the first American cubist painters, who went on to paint Jewish themes in his art.

17 Abraham Rattner (1865–1978): American artist, best known for his richly coloured paintings, often with religious subject matter.

18 John Jones went on to be a great enthusiast of the work of James Joyce. Is this the moment when his interest was piqued?

19 Bernard Buffet (1928–99): French expressionist painter and a member of the anti-abstract art group *L'homme Témoin*.

20 Andrew Wyeth (1917–2009): American realist, regionalist painter.

21 Hale Woodruff (1900–80): Black American painter who had studied in Paris, and in Mexico under Diego Rivera, and collected African art and taught at NYU for twenty years from 1946.

22 Jones would be forty in August 1966.

23 A cold water flat is an apartment that has no running hot water. They used to be common in Detroit, Chicago and New York City until the mid-twentieth century.

24 Robert Goldwater: first director of the Museum of Primitive Art in New York, 1957–73. Married to Louise Bourgeois.

25 James Thrall Soby (1906–79): author, critic, connoisseur, collector and patron of the arts.

YOKO ONO, PP.243–61

1 Chūya Nakahara (1907–37): Japanese poet shaped by dada and other forms of European experimental poetry. He was a leading renovator of Japanese poetry who died at the age of thirty, but wrote more than 350 poems.

2 Gakushuin University.

3 David Tudor (1926–96): American pianist and composer of experimental music.

4 La Monte Young (b.1935): American minimalist composer, musician and artist, a central figure in postwar avant-garde music.

5 Robert Morris (1931–2018): American sculptor, conceptual artist and writer. Prominent theorist of minimalism along with Donald Judd. He contributed to the development of performance art and installation art.

6 James Waring (1922–75): dancer, choreographer, costume designer, theatre director, playwright, poet, teacher and visual artist, based in New York from 1949. 'One of dance's great eccentrics', Waring's collage style of building dance works influenced the development of happenings staged in the late 1950s.

7 Yvonne Rainer (b.1934): experimental dancer, choreographer, filmmaker.

8 Yoko Ono married Toshi Ichiyanagi in 1956; they divorced in 1962.

9 Fluxus was a community of experimental artists founded by George Maciunas.

10 George Maciunas (1931–78): Lithuanian-American artist and founder of Fluxus artists' community.

11 Richard Maxfield (1927–69): composer, notably of electronic music.

12 AG Gallery, 925 Madison Avenue. Yoko Ono showed there in 1961.

13 'A Grapefruit in the World of Park': Ono's first musical composition (1961), a 'piece for strawberries and violins'.

14 A grapefruit is a cross between an orange and a pomelo, and occurred by chance.

JASPER JOHNS, PP.263–75

1 Targets were a recurring subject in Johns's paintings.

ISAMU NOGUCHI, PP.277–89

1 Gutzon Borglum (1867–1941) who sculpted Mount Rushmore.

2 Constantin Brâncuși (1876–1957): Romanian sculptor, painter and photographer living in France. One of the most influential sculptors of the twentieth century and a pioneer of modernism.

3 *Endless Column*: a recurrent motif in Brâncuși's sculpture from 1918 onwards. A pillar comprising a

series of alternating pyramids, upright and upside down.

4 Robert Sturgis Ingersoll, Sr. (1891–1973): president of the Philadelphia Museum of Art from 1948 to 1964.

5 The Budd Company: twentieth-century metal fabricator and supplier of body components to the automobile industry, and manufacturer of stainless steel passenger rail cars and defence products.

6 Some of Noguchi's furniture designs became iconic, including his coffee table and lamp.

7 Richard Buckminster Fuller (1895–1983): American architect, systems theorist, author, designer, inventor, and futurist who popularised the geodesic dome.

8 Mural entitled *History as Seen From Mexico*.

9 Nisei Writers and Artists for Democracy.

10 French artist Jacqueline Lamba (1910–93) married André Breton (1896–1966) and later David Hare (1917–92).

11 Franz Kline, action painter of the New York School, died in 1962 of rheumatic heart fever at the age of fifty-one.

12 Gordon Bunshaft (1909–90) at Skidmore, Owings and Merrill. US architect whose designs included Lever House in New York and the Beinecke Rare Book and Manuscript Library at Yale University.

13 The *Primary Structures* show of minimal sculpture that ran from 27 April to 12 June 1966 at the Jewish Museum in New York.

14 Baraka means, in Islam, the force of God that flows through physical things, which Noguchi seems to interpret as the force of humanity.

WILLEM DE KOONING, PP.291–307

1 Harry Holtzman (1912–87): abstract painter, teacher, close friend and authority on the work of the Dutch artist Piet Mondrian.

2 Balcomb Greene (1904–90): American artist and teacher. He and his wife, artist Gertrude Glass Greene (1904–56), were founding members of the American Abstract Artists organisation.

3 Ibram Lassaw, sculptor.

4 Mary Louise Cecilia 'Texas' Guinan (1884–1933): American actress and producer, and notorious hostess of nightclubs and speakeasies. The show was the musical *Padlocks of 1927*, a reference to the fact that her latest club had been padlocked by police.

5 Misha Reznikoff (1905–71): Ukrainian-American artist noted for such pictures as *The End of the Horse – Or New Deal* 1934 and *The Solidity of the Road to Metaphor and Memory* 1935.

6 Anton Refregier (1905–79): Russian-American painter and muralist active in WPA commissions, and an art teacher.

7 Tiflis is what Americans call Tbilisi, the capital of Georgia.

8 Stuart Davis (1892–1964): early American modernist painter known for bold jazz-influenced, proto-pop art paintings of the 1940s and 1950s, as well as his Ashcan School pictures. (The Ashcan School was a group of North American artists who used realist techniques to depict social deprivation and injustice in the American urban environment of the early twentieth century.)

9 George Overbury 'Pop' Hart (1868–1933): early twentieth-century American painter and watercolourist.

10 Niles Spencer (1893–1952): American painter of the precisionist school who specialised in urban and industrial landscapes.

11 The Works Progress Administration (WPA): employment programme created by President Roosevelt in 1935 during the Depression. Over eight years, the WPA put roughly 8.5 million Americans to work. Best known for public works projects, the WPA also sponsored the arts – employing tens of thousands of actors, musicians, writers and artists.

12 Burgoyne Diller (1906–65): American artist whose geometric abstracts are indebted to Mondrian.

13 The Williamsburg Federal Housing Project in Brooklyn.

14 Mercedes Matter (aka Jeanne Carles; 1913–2001): painter and founding member of the American Abstract Artists.

15 Regional painting involved realist scenes of small-town American life.

16 Julien Levy: New York gallery owner.

ED RUSCHA, PP.309–23

1 George Wittenborn: art publisher, and leading art book store.

2 Flyspeck: slang meaning to examine closely or in minute detail, scrutinise.

3 Edward Weston (1886–1958): masterly, innovative and influential US photographer.

4 *Primary Structures* was an exhibition of minimal art by young sculptors at the Jewish Museum in New York, 27 April – 12 June 1966.

5 Dan Flavin (1933–96): minimalist sculptor famous for making objects and installations out of fluorescent light fittings.

6 Harry N. Abrams founded Abrams in 1949, the first company in the United States to specialise in the creation and distribution of art books.

7 William N. Copley (1919–96) also known as CPLY, was an American painter, writer, gallerist, collector, patron, publisher and art entrepreneur.

LEE KRASNER, PP.325–40

1 Krasner first met Pollock in 1942.

2 Mondrian told Krasner: 'You have a very strong inner rhythm; you must never lose it.'

3 Frederick Kiesler (1890–1965): Austrian-American architect, theoretician, theatre designer, artist and sculptor.

ACKNOWLEDGEMENTS

I am greatly indebted to Claes Oldenburg, Yoko Ono and Ed Ruscha and to the estates of all the other artists in this collection for their kind permission to use the interviews so magnanimously consented to in 1965/6. I am also hugely grateful for the generous support of my sister Rachel Clark in letting me put this together: the contents of this book are her heritage as much as mine. And thanks particularly to radio producer Emma-Louise Williams whose beautifully crafted Loftus Media radio programme, *The American Art Tapes*, for BBC Radio's Archive on 4, created a way in to this project. And at Tate Publishing to John Stachiewicz and Jane Ace whose enthusiasm made this book happen, and to Emma Poulter who brought so many skills, plus her patient good humour, to the process. To Adrian Glew of the Tate archive for his help, and James Alexander for his elegant design. Also to Abigail Sparrow and Philippa Perry of the SP Agency who make everything possible and to Nicholas, Rebecca and Laura Clee, without whom nothing is possible.

CREDITS

COPYRIGHT CREDITS

PHOTO CREDITS

p.170 Robert Rauschenberg in his studio, 1966
 Photo by Sam Falk/ New York Times/ Redux/
 eyevine
p.184 Marcel Duchamp, New York, 1964
 Photo by Duane Michals, courtesy DC Moore
 Gallery
p.198 Louise Bourgeois in her studio in Italy
 contemplating *GERMINAL* 1967
 Photo by Studio Fotografico I. Bessi Carrara
 Artworks © The Easton Foundation/ VAGA at ARS,
 New York and DACS, London 2021
p.218 Grace Hartigan in her studio, 1965
 Photo by William L. Klender/ Baltimore Sun/ TCA
 Artwork © Estate of Grace Hartigan
p.242 Yoko Ono at her home in England, December
 1968
 Photo by Bob Thomas Sports Photography via
 Getty Images
p.262 Jasper Johns in front of *Target*, May 1959
 Photo by Ben Martin/ Getty Images
 Artwork © Jasper Johns/ VAGA at ARS, New York
 and DACS, London 2021
p.276 Isamu Noguchi, 1966
 Photo by Jack Mitchell/ Getty Images
 Artworks © The Isamu Noguchi Foundation and
 Garden Museum/ ARS, New York and DACS,
 London 2021
p.290 Willem de Kooning, East Hampton, New York,
 1985
 Photo by Chris Felver/ Getty Images
 Artwork © The Willem de Kooning Foundation/
 Artists Rights Society (ARS), New York and DACS,
 London 2021
p.308 Ed Ruscha, 1964
 Photo by Dennis Hopper
p.324 Lee Krasner, New York, February 1961
 Photo by Fred W. McDarrah/ Getty Images
 Artwork © The Pollock-Krasner Foundation ARS,
 New York and DACS, London 2021

COLLECTION CREDITS

Collection of The Easton Foundation plate 18
Art Gallery of Ontario plate 8
Museum of Fine Arts, Boston. Gift of Susan W. and
 Stephen D. Paine 1987.748 plate 12
Museum of Modern Art (MoMA), New York. Charles
 Mergetime Fund. Acc. num. 155.1970 plate 13
Museum of Modern Art (MoMA), New York. Gift
 of Leo Castelli in honor of Alfred H. Barr, Jr. Acc.
 n.: 79.1989 plate 16
Museum of Modern Art (MoMA), New York. Gift of
 The Jerry and Emily Spiegel Family Foundation. Acc.
 n.: 690.2006 plate 17
Museum of Modern Art (MoMA), New York. The
 Gilbert and Lila Silverman Fluxus Collection Gift.
 Acc. no.: 3203.2008 plate 20
Museum of Modern Art (MoMA), New York. Kay Sage
 Tanguy Fund. Acc. n.: 212.1977 plate 25
Collection of The Isamu Noguchi Foundation and
 Garden Museum, New York plate 22
Norton Simon Museum, Gift of the Men's Committee
 plate 24
The Perry Collection plate 19
Private collection plates 1, 2, 3, 4, 5, 9, 10, 11, 23
Tate plates 6, 7, 14, 15, 21

INDEX